Pope Pius XII
and the Holocaust

To
Elisabeth Maxwell

For she is a reflection of eternal light, a spotless mirror of the working of God, and an image of his goodness.

Wisdom of Solomon 7: 26

Edited and Introduced by
Carol Rittner and John K. Roth

Pope Pius XII
and the
Holocaust

Leicester University Press
London and New York

Leicester University Press
A Continuum imprint
The Tower Building, 11 York Road, London, SE1 7NX
370 Lexington Avenue, New York, NY 10017-6503

First published 2002 by Continuum by arrangement with University of Leicester

British Library Cataloguing-in-Publication Data
A catalogue record for this book is available from the British Library.

ISBN 0-7185-0274-4 (hardback)
 0-7185-0275-2 (paperback)

Library of Congress Cataloging-in-Publication Data
Pope Pius XII and the Holocaust/edited by Carol Rittner and John K. Roth.
 p. cm.
 Includes bibliographical references and index.
 ISBN 0-7185-0274-4—ISBN 0-7185-0275-2 (pbk.)
 1. Pius XII, Pope, 1876–1958. 2. Holocaust, Jewish (1939–1945) 3. Judaism–Relations–Christianity.
 4. Catholic Church–Relations–Judaism. 5. Christianity and antisemitism–History–20th century. 6. World
 War, 1939–1945–Religious aspects–Catholic Church. I. Rittner, Carol Ann, 1943– II. Roth, John K.

BX1378.P57 2001
282'.092–dc21 2001038319

Typeset by BookEns Ltd, Royston, Herts.
Printed and bound in Great Britain by Creative Print and Design Wales, Ebbw Vale

Contents

Contributors

Editors

Carol Rittner, R.S.M., a Sister of Mercy, is Distinguished Professor of Holocaust Studies at The Richard Stockton College of New Jersey. She is the author or editor of numerous books and essays, including *The Courage to Care: Rescuers of Jews during the Holocaust* (with Sondra Myers, 1986); *Different Voices: Women and the Holocaust* (with John K. Roth, 1993); *The Holocaust and the Christian World* (with Stephen Smith and Irena Steinfeldt, 2000); and *"Good News" after Auschwitz? Christian Faith within a Post-Holocaust World* (with John K. Roth, 2001). Rittner is a Fellow of the Aegis Trust (United Kingdom), a member of its Executive Steering Committee, as well as a Fellow of the Beth Shalom Holocaust Memorial Centre (United Kingdom) and a member of its Executive Committee.

John K. Roth is the Russell K. Pitzer Professor of Philosophy at Claremont McKenna College, where he has taught since 1966. In addition to service on the United States Holocaust Memorial Council and on the editorial board for *Holocaust and Genocide Studies*, he has published hundreds of articles and reviews and more than 30 books, including *A Consuming Fire: Encounters with Elie Wiesel and the Holocaust* (1979); *Approaches to Auschwitz: The Holocaust and Its Legacy* (with Richard L. Rubenstein, 1987); *Holocaust: Religious and Philosophical Implications* (with Michael Berenbaum, 1989); *Different Voices: Women and the Holocaust* (with Carol Rittner, 1993); *Ethics after the Holocaust* (1999); major contributions to *The Holocaust Chronicle* (2000); and *Holocaust Politics* (2001). His research appointments include a 2001 Koerner Fellowship for Study of the Holocaust at the Oxford Centre for Hebrew and Jewish Studies (United Kingdom). In 1988, Roth was named the U.S. National Professor of the Year by the Council for Advancement and Support of Education (CASE) and the Carnegie Foundation for the Advancement of Teaching.

Contributors

Doris L. Bergen is Associate Professor of History at the University of Notre Dame (Indiana), where she teaches courses on twentieth-century Europe, modern Germany, World War II, and the Holocaust. She is the author of *Twisted Cross: The German Christian Movement in the Third Reich* (1996) as well as numerous essays and articles on religion, ethnicity, and gender in the Nazi era, World War II, and the Holocaust. She taught previously at the University of Vermont. Bergen has been a fellow of the German Marshall Fund of the United States, the Alexander von Humboldt Foundation, and the Center for Advanced Holocaust Studies at the United States Holocaust Memorial Museum. She spent the year 2000 in Germany at the Max-Planck Institut für Geschichte in Germany, where she did research for a forthcoming book about chaplains in the *Wehrmacht* during the Nazi era.

James J. Doyle, C.S.C., a Holy Cross priest, is Ethicist-in-Residence at King's College (Wilkes-Barre, Pennsylvania), where he also serves as Alumni Chaplain. Doyle was a research associate at the Kennedy Institute, Center for Bioethics, Georgetown University, where he was Assistant Editor of the four-volume *Encyclopedia of Bioethics* (1978). For many years, he has been involved in ecumenical and interfaith activities in the Roman Catholic diocese of Scranton, Pennsylvania.

Eugene J. Fisher is Associate Director of the Secretariat for Ecumenical and Interreligious Affairs of the National Conference of Catholic Bishops (NCCB) in Washington, D.C., a position he has held since 1977. He has published more than 20 books and monographs, and over 250 articles, mainly in the field of Jewish–Christian relations. Fisher was appointed by Pope John Paul II to be Consultor to the Holy See's Commission for Religious Relations with the Jews and has served in that role since 1981. In 1985, he was named by the Holy See as a member of the International Catholic–Jewish Liaison Committee. In 1999, he was appointed as a Coordinator for the International Catholic–Jewish Historical Commission which examined the role of the Holy See during World War II and the Holocaust.

Eva Fleischner, Professor Emerita of Religion at Montclair State University in New Jersey, has contributed to Holocaust studies for more than 30 years.

She is the editor of *Auschwitz: Beginning of a New Era?* (1977) and the author of numerous scholarly essays, as well as the author (with Michael Phayer) of *Cries in the Night: Women Who Challenged the Holocaust* (1997). Fleischner was one of three Roman Catholic members, and the only woman, who served on the International Catholic–Jewish Historical Commission. Its task was to examine critically the 11 volumes of Vatican archival material relating to the Holy See's role during the Holocaust.

Albert Friedlander, Rabbi Emeritus of Westminster Synagogue, is Dean of Leo Baeck College in London. The author of many scholarly papers, he has also published more than a dozen books, including *Out of the Whirlwind: A Reader of Holocaust Literature* (1968); *The Six Days of Destruction: Meditations Towards Hope* (with Elie Wiesel, 1988); and *Riders Toward the Dawn: From Holocaust to Hope* (1994). Friedlander serves on numerous international boards, including the European board of the World Union of Progressive Judaism. He also is president of the Conservancy Foundation, an organization dedicated to preserving Holocaust books. His many awards include the Sir Sigmund Sternberg Award of the Council of Christians and Jews (United Kingdom) and the Order of Merit (Germany).

Gershon Greenberg is Professor of Religion at American University, Washington, D.C. He has served as Visiting Professor of Jewish Thought at Hebrew, Bar Ilan, Tel Aviv, and Haifa Universities in Israel as well as at the Free University of Berlin. He is the recipient of both a Fulbright Teaching Fellowship for Lithuania and a Skirball Fellowship in Hebrew Studies at Oxford. Greenberg has published many articles and book chapters about wartime Jewish religious thinkers and movements in reaction to the Jewish catastrophe during the Holocaust. His three-volume annotated bibliography of Jewish religious literature and the Holocaust was published by the Institute for Holocaust Research, Bar Ilan University. In 2001, Greenberg did research at the International Institute for Holocaust Research at Yad Vashem, focusing on Jewish religious practice in the Holocaust's camps and ghettos.

Michael R. Marrus is Professor of History, Dean of the Graduate School of the University of Toronto, and a Fellow of the Royal Society of Canada. He has been a Guggenheim Fellow, and a visiting fellow of St. Anthony's College, Oxford, and the Institute for Advanced Studies of the Hebrew University of Jerusalem. Among his books are *Vichy France and*

the Jews (with Robert Paxton, 1981); *The Unwanted: European Refugees in the Twentieth Century* (1985); *The Holocaust in History* (1987); and *The Nuremberg War Crimes Trial, 1945–46: A Documentary History* (1997). Marrus is one of three Jewish scholars who served on the International Catholic–Jewish Historical Commission established in 1999 to examine the role of the Vatican during the Holocaust.

Sergio I. Minerbi is an Israeli historian whose scholarly research focuses on the relations between the Roman Catholic Church and the Jews, especially concerning the Shoah. He was Senior Lecturer at the Institute of Contemporary Jewry at the Hebrew University in Jerusalem, then Professor in the Department of Political Science at Israel's Haifa University. Between 1961 and 1983, Minerbi served in various diplomatic posts for the State of Israel, including ambassadorships to Ivory Coast and Belgium and Luxembourg. He is the author of many essays and books, including *The Vatican and Zionism* (1990), and *Risposta a Sergio Romano: Ebrei, Shoah e State d'Israele* (1998).

John F. Morley, a Roman Catholic priest, is Associate Professor in the Department of Religious Studies at Seton Hall University, South Orange, New Jersey, and a member of the Advisory Council of the university's Institute of Judaeo-Christian Studies. In addition, he serves on the Church Relations Committee of the United States Holocaust Memorial Museum, Washington, D.C., and is also a member of the Commission on Interreligious Affairs of the Roman Catholic Archdiocese of Newark, New Jersey. Morley is the author of *Vatican Diplomacy and the Jews during the Holocaust, 1939–1943* (1980) and many other scholarly articles. A member of the International Catholic–Jewish Historical Commission established in 1999 to examine the role of the Vatican during the Holocaust, Morley is currently working on Vatican diplomacy and the Jews of Hungary during the Holocaust.

John T. Pawlikowski, O.S.M., a Servite priest, is Professor of Social Ethics at the Catholic Theological Union in Chicago, where he also serves as Co-Director for Catholic–Jewish Studies in CTU's Cardinal Bernadin Center. By presidential appointment, he has been a member of the United States Holocaust Memorial Council since its inception, serving on the Council's Executive Committee, Academic Committee, and Committee on Conscience. He chairs the Council's Church Relations Committee.

Pawlikowski has authored numerous books and articles on the Holocaust and on Christian–Jewish relations. His current projects include a book about the major non-Jewish victim groups during the Holocaust and a co-edited volume, *Ethics in the Shadow of the Holocaust*.

Michael Phayer is Professor of History at Marquette University. His two most recent books are *The Catholic Church and the Holocaust, 1930–1965* (2000) and *Cries in the Night: Women Who Challenged the Holocaust* (with Eva Fleischner, 1997), both of which deal extensively with Catholic–Jewish relations before and during the Shoah. During 1992–3, Phayer held a Senior Fulbright Research Fellowship that enabled him to study in Germany and other European countries where he did archival research about the Roman Catholic Church and the Holocaust. In 2001, he was a research fellow at the United States Holocaust Memorial Museum in Washington, D.C.

Richard L. Rubenstein is President Emeritus and Distinguished Professor of Religion and Director of the Center for Holocaust and Genocide Studies at the University of Bridgeport in Connecticut. He also is Professor Emeritus of Religion at Florida State University, where, for many years, he was Robert O. Lawton Distinguished Professor of Religion. Rubenstein's first book, *After Auschwitz* (1966), initiated the contemporary debate on the meaning of the Holocaust in Jewish and Christian religious thought. A revised, expanded edition was published by Johns Hopkins University Press in 1992. Rubenstein is also the author of *The Cunning of History* (1975); *The Age of Triage* (1983); and *Approaches to Auschwitz* (with John K. Roth, 1987). Rubenstein is a member of the Executive Committee of *Remembering for the Future* (United Kingdom), a Director and member of the Executive Steering Committee for the Aegis Trust, a genocide prevention organization in the United Kingdom, and a Director and member of Beth Shalom Holocaust Memorial Centre (United Kingdom).

Susan Zuccotti won the National Jewish Book Award for Holocaust Studies for her first book, *The Italians and the Holocaust: Persecution, Rescue, and Survival* (1987). She is also the author of *The Holocaust, the French, and the Jews* (1993). Zuccotti has taught Holocaust history at Barnard College in New York and at Trinity College in Hartford, Connecticut. Her important study, *Under His Very Windows: The Vatican and the Holocaust in Italy* (2000), received the National Jewish Book Award in the category of Jewish–Christian Relations.

He said to them, "But who do you say that I am?" Simon Peter answered, "You are the Messiah, the Son of the living God." And Jesus answered him, "Blessed are you, Simon son of Jonah! For flesh and blood has not revealed this to you, but my Father in heaven. And I tell you, you are Peter, and on this rock I will build my church, and the gates of Hades will not prevail against it. I will give you the keys of the kingdom of heaven, and whatever you bind on earth will be bound in heaven, and whatever you loose on earth will be loosed in heaven."

Matthew 16 : 15–19

And he said to him, "Lord, I am ready to go with you to prison and to death!" Jesus said, "I tell you, Peter, the cock will not crow this day, until you have denied three times that you know me."

Luke 22 : 33–34

What the world expects of Christians is that Christians should speak out loud and clear, and that they should voice their condemnation in such a way that never a doubt, never the slightest doubt, could rise in the heart of the simplest man. That they should get away from abstraction and confront the blood-stained face history has taken on today.

Albert Camus, "The Unbeliever and Christians",
in *Resistance, Rebellion, and Death*
Dominican Monastery of Latour-Maubourg, 1948

Carol Rittner and John K. Roth

Introduction: Calls for Help

I heard the doors being shut; I heard shrieks and cries; I heard desperate calls for help in Polish and in Yiddish. I heard the blood-curdling wails of women and children, which after a short time became one long, horrifying scream ... This went on for fifteen minutes. The engine worked for twenty minutes. Afterwards there was total silence.

Rudolf Reder, "Belzec"

In 1942, the most lethal year in Jewish history, Nazi Germany's "Final Solution" destroyed 2.7 million Jews. Scarcely any site in that destruction process was more devastating than Belzec, a Nazi killing center situated in southeastern Poland near the railroad station at a village on the main line between the cities of Lublin and Lvov (Lemberg). A specially constructed railroad spur, less than a mile long, led directly to the camp. During Belzec's brief but deadly operations in a nine-month period from March 17 until mid-December 1942, the relentless gassings and shootings mercilessly carried out by the German SS and their Ukrainian helpers accounted for about 600,000 Jewish deaths. Most of the Jews who were murdered at Belzec came from Poland, but transports from Austria, Czechoslovakia, and parts of pre-war Poland that had been incorporated into the Third Reich were sent there, too.

According to Margaret M. Rubel, a scholar whose work focuses on Belzec, a man named Rudolf Reder was one of only two known survivors from that death camp.[1] With thousands of other Jews from Lvov, Reder, a former soap manufacturer, aged 61, was deported to Belzec in mid-August 1942. All the Jews who entered Belzec were doomed, but Reder was one of the very few who were temporarily selected for work in the Jewish death brigade. The tasks of this unit—it numbered about 500 brutalized and malnourished prisoners whose ranks were frequently thinned and replenished—involved digging mass burial pits, disposing of corpses, sorting loot (including baskets of gold teeth and vast amounts of women's shorn hair), and maintaining the camp's gas

chambers, which used the carbon monoxide produced by a large engine said to have come from a captured Russian tank. Reder would spend about three months in Belzec. Toward the end of November 1942, he managed to escape his guards during a trip to Lvov to obtain building materials for the camp. Remembering the address of his Polish housekeeper, Reder went to her flat, and she gave him refuge until the Red Army liberated the city in 1944.

Reder's compressed testimony about Belzec is among the most disturbing survivor narratives to emerge from the Holocaust. Assigned to a variety of jobs, he came to know the camp all too well. It was a place, he said, that "served no other purpose but that of murdering Jews."[2] Every transport—typically there were three a day—got the same treatment. The arriving Jews were ordered to undress and to set their belongings aside. They were told that a bath awaited them before they would be sent to work. Each time people heard that deceptive speech, Reder underscores, he could see "the spark of hope in their eyes." His account continues:

> But a minute later, and with extreme brutality, babies were torn from their mothers, old and sick were thrown on stretchers, while men and little girls were driven with rifle-butts further on to a fenced path leading directly to the gas chambers. At the same time, and with the same brutality, the already naked women were ordered to the barracks, where they had their hair shaved. I knew exactly the moment when they all suddenly realized what was in store. Cries of fear and anguish, terrible moans, mingled with the music played by the orchestra. ... Before all six chambers were filled to capacity, those in the first had already been suffering for nearly two hours. It was only when all six chambers were packed with people, when the doors were locked into position, that the engine was set in motion.[3]

At Belzec, systematic murder combined with sadistic torture to produce circumstances in which the most one could really hope for was that death's arrival would be quick. After his liberation, Reder returned to Belzec to see what remained. He ends his narrative by observing that the Germans had "covered this graveyard for millions [sic] of murdered Jews with fresh greenery. ... The railway line was gone. Through a field I reached a young and sweet-smelling pine forest. It was very still. In the middle of it was a large sunny clearing ..."[4] No place, not even Auschwitz-Birkenau, revealed the Holocaust's essence more than Belzec, a camp, Reder said, that "heaved with mass murder."[5]

While Reder hid in Lvov, Pope Pius XII (1876–1958) worked in Rome. His tasks included writing the Christmas message that he would deliver to the world on December 24, 1942. Always one to choose words carefully, Pius wrote several drafts before he had crafted exactly what he wanted to say on that particular Christmas Eve. Vatican Radio broadcast the pope's lengthy homily, whose 26-page, 5000-word text took more than 45 minutes to deliver. Its broad theme focused on human rights and the social order, but only at its close—and very briefly at that—did Pius turn explicitly to the devastating atrocities that were integral to the world war that was being waged as he spoke. Employing calls for help very different from those that Rudolf Reder heard again and again at Belzec, Pius XII urged people of good will to reorient human life toward divine law. To drive home his call that people should vow to dedicate themselves to the restoration of a just and God-centered society, Pius spoke the pivotal words that remain one of the key flashpoints in the Holocaust-related controversy that continues to swirl about him. "Humanity," said the pope, "owes this vow to those hundreds of thousands who, without any fault of their own, sometimes only by reason of their nationality or race, are marked down for death or gradual extinction."[6]

In late 1942, it was possible, but improbable, that Pius XII had explicit knowledge of Belzec, for the specific identity of that place was not widely known at the time. With even greater certainty, one can say that Pope Pius XII had never heard of Rudolf Reder, but with equal confidence the following assertion can also be made: as Pius XII delivered his Christmas message in 1942, he knew both that Nazi Germany aimed to destroy European Jewry and that the destruction process, especially in eastern Poland, was far advanced.[7]

It is also possible, but implausible, that Reder heard the broadcast of the pope's 1942 Christmas message. Even in the unlikely event that a radio would have been available to him, the German jamming of Vatican broadcasts would have made it difficult to pick up the pope's signal. But if Reder had been able to hear Pius's address, would it still have been difficult for that Belzec survivor to pick up the pope's signal? Would it have been unmistakable to Reder that Pius firmly condemned Nazi Germany's murderous policies toward Europe's Jews? Would it have been perfectly clear that Pius XII was defending Reder's human rights, including his Jewish particularity, and taking an uncompromising stand against a regime that had constructed places such as Belzec for the sole purpose of murdering Jews?

If not unanswerable, such questions remain unsettled and unsettling. For that reason, the pope's 1942 Christmas message remains a lightning rod in debates about Pius XII and the Holocaust, which show no sign of abating in the near future. Pius's critics point out not only that this Christmas message was one of the few times that he spoke publicly about people who were being killed because of national or ethnic origins, but also that this sermon neither mentioned Jews or antisemitism nor named or denounced directly the perpetrators of the crimes that were being committed against European Jewry in particular. In sum, Pius's critics would think that Rudolf Reder could have taken scant comfort from Pius's 1942 Christmas address. Instead, they tend to regard that address as epitomizing the failure of Christianity's most visible and influential wartime leader to address the destruction of the European Jews as he should have done.

At the beginning of the twenty-first century, the defenders of Pope Pius XII have intensified their efforts. Their position on his 1942 Christmas sermon differs markedly from that of Pius's critics. At the time, his defenders argue, Nazi leaders correctly interpreted Pius XII to be attacking the Third Reich and defending the Jews.[8] In addition, they note that Pius was praised in the *New York Times*, as he had been previously, for his devotion to peace. Emphasizing evidence of this kind, the defenders argue that, far from falling short in fulfilling his Christian duty, Pius XII still deserves accolades of the sort that Margherita Marchione identifies. "During World War II, 1939–45, and for nearly twenty years after," she writes, "Pope Pius XII was almost universally regarded as a saintly man, a scholar, a man of peace, a tower of strength, and a compassionate defender and protector of all victims of war and genocide that had drowned Europe in blood for six years."[9]

Like other defenders of Pius XII, Marchione deplores the fact that these accolades have been increasingly questioned. Referring to what she calls "a campaign of vilification," she is not alone in suggesting that the questioning is more than academic.[10] For instance, David G. Dalin, a Jewish defender of Pius XII, provides an even more recent example of her allegation. Writing in the conservative *Weekly Standard*, Rabbi Dalin notes a "current torrent" of books about Pope Pius XII, which includes nine studies published in the 18 months prior to the February 26, 2001, appearance of his article, "Pius XII and the Jews."[11] Dalin's contention is that "the books vilifying the pope … have received most of the attention."[12] For three major reasons, he is deeply troubled by that

outcome. A word about each of those reasons can help to set the context for the chapters that follow here.

First, Dalin claims that the critics of Pius XII tend to distort and abuse historical evidence. They employ, he charges, an attacking technique that "requires only that favorable evidence be read in the worst light and treated to the strictest test, while unfavorable evidence is read in the best light and treated to no test." As many of the following essays help to show, a generalization as inaccurate as Dalin's will not bear scrutiny. Nevertheless, he is correct that the evidence about Pius XII and the Holocaust is contested and contestable. It was for that reason that the group of scholars who offer their contributions in these pages decided to meet at King's College in Wilkes-Barre, Pennsylvania, in April 2000. Convened by Carol Rittner and John Roth, the group wanted to assess the state of scholarship and debate about Pope Pius XII and the Holocaust. We wanted to do so, moreover, without the hype that surrounded John Cornwell's intentionally provocative *Hitler's Pope* or the polemical defenses of Pius that are illustrated by Dalin's journalism generally and his unsubstantiated claim above in particular.

This book emerged from face-to-face dialogue involving all of the 15 contributors. With our diverse Jewish and Christian identities and methodological approaches, plus our considerable individual and collective experience in Holocaust studies and religious studies, we considered questions such as the following: how should the Vatican's wartime policies be understood? Specifically, could Pope Pius have curbed the Holocaust by vigorously condemning the Nazi killing of Jews? Was Pius XII really "Hitler's pope," as Cornwell contended, or has he unfairly become a scapegoat when he is really deserving of canonization as a Roman Catholic saint instead? For both Jews and Christians, what implications flow from the legacy of Pope Pius XII and current interpretations of his true identity?

Not all of the books on Dalin's list had appeared when we convened at King's College, but the working papers we shared at that time were later revised and expanded in ways that take account of many of them. Meanwhile, our group benefited immensely from the insights of Michael Phayer and Susan Zuccotti, whose major books on Pius XII were in production when we met, and also from the scholarship of Eva Fleischner, Michael Marrus, and John Morley, who, at the time, were members of the International Catholic–Jewish Historical Commission, a six-person team of Roman Catholic and Jewish scholars. In 1999, the

Vatican's Commission for Religious Relations with the Jews and the International Jewish Committee for Interreligious Consultations had appointed the Historical Commission to analyze *Actes et documents du Saint Siège relatifs à la Seconde Guerre mondiale* (ADSS) which contains 11 volumes of Vatican archival material relating to World War II, the Holocaust, and the policies of the Vatican under Pius XII. (ADSS is published in 11 volumes, but the third contains two books of documents. Thus, some authors mention 12 volumes instead of 11. References to ADSS in this book correspond to the 11 volumes published by the Vatican from 1965 to 1981.) In addition to Fleischner and Morley, the Catholics on the Historical Commission included Gerald Fogarty. Bernard Suchecky and Robert Wistrich joined Marrus as the team's Jewish members.

The Historical Commission issued "The Vatican and the Holocaust: A Preliminary Report" in October 2000. By the end of July 2001, however, it suspended activity because the Vatican, citing "technical reasons," declined to open additional archival material beyond that contained in ADSS. Through Cardinal Walter Kasper, president of its Commission for Religious Relations with the Jews, the Vatican stated that the team of Catholic and Jewish scholars was never promised access to complete archival material dating after 1922. It also expressed hope that joint research could be reactivated "on new foundations." Kasper further indicated that the relevant archival material would be made available to scholars "as soon as the documents are catalogued and classified," but it was not specified when that might be. Meanwhile, defenders of Pius XII have launched the "Pius XII Oral History Project" to gather testimony that bolsters his image. At the time of this writing in late August 2001, controversy about these matters continued, and it unavoidably kept Pius XII in scrutiny's eye.

Dalin's second concern is that the critics of Pius XII tend to "usurp the Holocaust and use it for partisan purposes." In this case, Dalin thinks the partisan purposes are those of "liberal Catholics" who are battling "traditionalists" over "the future of the papacy" and who are finding that the Holocaust is "the biggest club" they have available. In a sense, says Dalin, much of the criticism about Pius XII is less about the Holocaust than about "using the sufferings of Jews fifty years ago to force changes upon the Catholic Church today." Such a simplistically polemical description scarcely makes recognizable the critics Dalin most has in mind—James Carroll and Garry Wills as well as Cornwell and Zuccotti

among them—but he is correct to this extent: issues surrounding Pope Pius XII and the Holocaust do have implications about how Christianity is best understood and therefore about who the leaders of that faith should be and how they ought to speak and act. To reduce that discussion to a polarized political struggle between conservatives and liberals, however, provides little help because that strategy constrains a debate that deserves to include voices outside the Roman Catholic community—those of Protestants and Jews, for example—and also because it restricts the open inquiry that must go forward if sound understanding is to be increased.

As for the claim that Pius's critics have usurped the Holocaust, Dalin trades in a now predictable technique in what John Roth calls "Holocaust politics."[13] This strategy frequently surfaces in disputes about how the Holocaust should be interpreted, remembered, and memorialized. Its accusation is that those with whom one disagrees are disrespecting or misusing the Holocaust, an indictment that claims high moral ground for the accuser, who presumes to know better than anyone else what proper interpretation, remembrance, and memorialization of the Holocaust entail. Closure on those questions should not be premature. They require more inquiry and discussion than the likes of Dalin want to give them.

Related to this strategy just noted is another accusation, namely that those who are accused of dishonoring the Holocaust often do so by creating what Dalin dubs a "monstrous moral equivalence" of one kind or another. In Dalin's interpretation, for example, Cornwell, Wills, and Carroll—each supposedly a vilifier of Pope Pius XII—are guilty of drawing invidious parallels between Pope John Paul II's traditionalism and Pope Pius XII's alleged antisemitism and between "the Vatican's current stand on papal authority" and charges about the Vatican's alleged "complicity in the Nazis' extermination of the Jews."

Once more, Dalin's claims are as dubious as they are sweeping. In addition, the larger point is that, more often than not, arguments that appeal to "disrespecting or misusing the Holocaust" or to "monstrous moral equivalences" are frequently made when what the sociologist Max Weber called "inconvenient facts" run against the views one is trying to defend. They are not scholarly strategies, but political and journalistic ones, that aim to silence opposition because they cannot refute it empirically.

As Dalin's article suggests, issues about Pope Pius XII and the Holocaust continue to be debated with headline-grabbing ferocity. Among other things, even as Catholic–Jewish relations continue to improve, controversy about Pius XII has sometimes affected those relations

adversely. One of this book's contributors, Eugene Fisher, the associate director of the Secretariat for Ecumenical and Interreligious Affairs for the U.S. National Conference of Catholic Bishops, responded wisely to this situation when he told our King's College symposium that "at some point, we Catholics and Jews will have to stop trying to communicate with each other through press releases and editorials and sit down with our best scholars to begin the serious work of reconciling our intertwined yet divergent memories of the Shoah. There is great urgency in this, in my view, since what is at stake is how we hand down the memory to our children." The contributors to this book have tried their best to work in the spirit of Fisher's urging, namely, to advance "the serious work of reconciling our intertwined yet divergent memories of the Shoah."

Rabbi Dalin's third major concern is that criticism of Pius XII overlooks and discounts Jewish testimony, some of it from Holocaust survivors, that, in Dalin's words, identified him at the time as "the world's most prominent opponent of the Nazi ideology." His citation of Albert Einstein, Chaim Weizmann, Golda Meir, Moshe Sharett, Rabbi Isaac Herzog, Rabbi Elio Toaff, and others notwithstanding, it may be the case that Dalin is the one drawing problematic moral equivalences when he claims that Pius XII was "genuinely and profoundly, a righteous gentile," for that Jewish honor is usually reserved for non-Jews who risked their lives, selflessly, to rescue personally Jews who were targeted during the Holocaust. Nevertheless, Dalin's basic point is well taken: there have been and still are Jews who speak highly of Pius XII, and their voices must be heard openly and evaluated with respect. That said, it remains a question for further inquiry to decide whether Dalin's final claim is justified: "The Talmud," he writes, "teaches that 'whosoever preserves one life, it is accounted to him by Scripture as if he had preserved a whole world.' More than any other twentieth-century leader, Pius fulfilled this Talmudic dictum, when the fate of European Jewry was at stake."

To advance inquiry about claims of that kind, this book contains chapters that provide variations on the following themes, which constitute its thesis: (1) Pope Pius XII must be understood in his particular historical context. Without condoning or endorsing policies or pronouncements that may well have been problematic, it is possible and important to understand why he acted as he did. (2) Pius XII put the well-being of the Roman Catholic Church—as he understood that well-being—first and foremost. A thoroughly human religious and political leader, he was neither demonic nor saintly. (3) In retrospect, Pius XII's priorities—

understandable though they are—not only make him an ambiguous Christian leader but also raise important questions about post-Holocaust Christian identity. (4) Jewish and Christian memories of the Holocaust will remain different, but reconciliation can continue to grow. On all sides, relations between Christians and Jews can be improved by an honest facing of history and by continuing reflection about what post-Holocaust Christian and Jewish identity ought—and ought not—to mean.

Since this book includes questions and reflections about post-Holocaust Christian identity, it is fitting to draw this introduction to a close by recalling the three epigraphs that govern the book as a whole. Two of them come from the New Testament. They refer to Simon Peter, that strong and devoted but somewhat mercurial disciple who confessed early on that Jesus was "the Messiah, the Son of the living God," but later—when Jesus' life was on the line—denied three times that he even knew the man. Christian tradition, especially in its Roman Catholic form, holds that it was to this all-too-human disciple that Jesus gave "the keys of the kingdom of heaven," calling Peter the rock on which the Church would be built.

Like his papal predecessors, Pius XII and the Roman Catholic Church understood his office to be the one, indeed the only one, that followed directly from the special trust and authority that Jesus bestowed upon Peter. It might be argued, however, that Simon Peter was a strange "rock" on which to build a church, for Christian tradition also has it that when he saw Jesus walking on the Sea of Galilee, "Peter got out of the boat, started walking on the water, and came toward Jesus. But when he noticed the strong wind, he became frightened, and beginning to sink, he cried out, 'Lord, save me!' Jesus immediately reached out his hand and caught him, saying to him, 'You of little faith, why did you doubt?' "[14] Later, Christian tradition also says, the resurrected Jesus asked Peter three times: "Do you love me?" Peter answered yes, and each time, as though the call for help needed special driving home, Jesus instructed him to "feed my sheep."[15]

The relationship between Jesus and Peter suggests that Christian identity and leadership are not matters of perfection, but they do require "feeding my sheep" or its moral equivalent. During the Holocaust, did Rudolf Reder and his Jewish brothers and sisters belong to that "flock" or its moral equivalent? Given the Jewish identities of Jesus and Peter, it would be hard not to think so, and yet the times that Christian denial was pronounced were many more than three.

That fact was one that led the philosopher Albert Camus to be skeptical about the good that Christianity could do. Nevertheless, even while he was skeptical about Christianity, he kept in contact with that tradition and urged Christians to practice better what they preached. Taken from "The Unbeliever and Christians," his 1948 discussion at the Dominican Monastery of Latour-Maubourg, this book's third governing epigraph reflects that relationship as it states one good measure that can be used to evaluate Christian conduct, including but by no means restricted to that of Pope Pius XII: Christians should avoid abstraction and confront history's "blood-stained face" in ways that speak out "loud and clear" in favor of those who are most in need. If that standard had been faithfully met, Belzec would not have existed, Rudolf Reder would not have received physical injuries that took 20 months to heal, and there would be no tortuous controversies about Pope Pius XII and the Holocaust. But Belzec did exist, Reder had memories from which he never recovered, and this book now plays its part in efforts to heal post-Holocaust wounds that remain open, raw, and sore.

If this book plays its part well, that result will owe much to the special people who helped the authors to give it life. On behalf of all the contributors, we express our gratitude to them, each and all. Father Tom O'Hara, C.S.C., President of King's College, welcomed and supported the work that the contributors carried out in the college's comfortable facilities during the Spring of 2000. Financial support came from the Holy Cross Priests and Brothers of the Eastern Province, and one of the book's contributors, Father Jim Doyle, C.S.C., of King's College, helped to plan and execute the conference that made the book possible. At nearby College Misericordia, President Michael MacDowell, his spouse Tina, and the Sisters of Mercy supported our work and extended their warm hospitality as well.

In England, Leicester University's Aubrey Newman learned about our project, urged us to submit a proposal to the Leicester University Press, and gave the support that resulted in a contract with the Continuum International Publishing Group, which has published the book under its Leicester University Press imprint. At Continuum, we have benefited immensely from the counsel and encouragement of editorial director, Janet Joyce, her capable assistant, Valerie Hall, and our superb editors, Lizzie Leroy and Sandra Margolies.

Special thanks also go to the art historian, Betty Rogers Rubenstein, who located the photograph of Pope Pius XII that appears

on the book's dust jacket, and to Susan Greenspun and David Ragsdale, students at The Richard Stockton College of New Jersey and Claremont McKenna College, respectively, who did extensive research for the bibliography and especially the chronology, whose ample information makes it unnecessary to repeat the details of Pius XII's life in this introduction. John Roth is especially grateful to the Oxford Centre for Hebrew and Jewish Studies, where a Koerner Fellowship for Study of the Holocaust enabled him to finish work on this project while on sabbatical leave in England during the Winter and Spring of the year 2001. The editors have dedicated the book to Elisabeth Maxwell, an impressive contributor to Holocaust and genocide studies, who has long been an inspiring benefactor for Holocaust scholars. Her friendship, kindness, and wisdom encouraged our work. Finally, the Holocaust scholar Jonathan Webber and his spouse Connie, the managing editor of *Polin*, called our attention to Rudolf Reder's newly translated memoir about Belzec just days before this introduction was written. We are grateful to them for helping us to set the introduction's tone and to focus the entire book in ways that, as Camus put it, "get away from abstraction and confront the blood-stained face history has taken on today."

Notes

1. Rubel has translated and annotated Reder's eyewitness account of his time in Belzec, which was originally written with the help of a woman named Nella Rost. This unusually important Holocaust document was published by the Jewish Regional Historical Commission in Cracow, Poland, in 1946, but it did not appear in English until 2000. See Rudolf Reder, "Belzec," trans. Margaret M. Rubel, in Antony Polonsky, ed., *Polin: Studies in Polish Jewry*, Vol. 13, *Focusing on the Holocaust and its Aftermath* (London: Littman Library of Jewish Civilization, 2000), 268–89.

2. *Ibid.*, 276.

3. *Ibid.*

4. *Ibid.*, 289.

5. *Ibid.*, 283.

6. This version of an often cited passage from Pius XII's 1942 Christmas homily comes from John Cornwell, *Hitler's Pope: The Secret History of Pius XII* (New York: Viking, 1999), 292. The use of the word *race* in the English translation, however, is not without problems. Susan Zuccotti, for example, argues that to translate *stirpe*, the Italian word used by Pius XII, as *race* ignores "subtle

differences between the two terms" and it would be better rendered as *descent*. See Susan Zuccotti, *Under His Very Windows: The Vatican and the Holocaust in Italy* (New Haven, Conn.: Yale University Press, 2000), 1, 329, n. 3.

7. Documents discovered in 2000, for example, indicate that the British envoy to the Vatican, Francis d'Arcy Godolphin Osborne, prepared almost daily reports for the pope about the atrocities that Nazi Germany was committing against the Jews. Osborne monitored BBC broadcasts and, especially from 1940 to 1943, passed along to the pontiff what he had learned. Osborne was by no means the pope's only source of information about the Holocaust. For more on the recently discovered documents and on Osborne generally, see Douglas Davis, "New documents: Pius XII had daily Holocaust briefings," *Jerusalem Post* (Internet edition), June 2, 2000, and Owen Chadwick, *Britain and the Vatican during the Second World War* (Cambridge: Cambridge University Press, 1986).

8. On this point, see Pierre Blet, *Pius XII and the Second World War: According to the Archives of the Vatican*, trans. Lawrence J. Johnson (New York: Paulist Press, 1999), 161. The extent to which Germans heard clearly that Pius XII was protesting against the slaughter of Jews is also a point of scholarly debate. For example, Michael Phayer writes as follows regarding the reaction to Pius's 1942 Christmas address: "A few months later, Pius wrote to Bishop Preysing in Berlin saying that his address was well understood. In reality, very few people understood him, and no one, certainly not the Germans, took it as a protest against their slaughter of the Jews." See Michael Phayer, *The Catholic Church and the Holocaust, 1930–1965* (Bloomington: Indiana University Press, 2000), 49.

9. Margherita Marchione, *Pope Pius XII: Architect for Peace* (New York: Paulist Press, 2000), 13.

10. *Ibid.*

11. Dalin, a rabbi and scholar who serves on the editorial boards of *Conservative Judaism* and *First Things*, concentrates on Jewish studies and history. His several books include *Religion and State in the American Jewish Experience*. In addition to Blet's *Pius XII and the Second World War*, Cornwell's *Hitler's Pope*, and Marchione's *Pope Pius XII*, Dalin's book list includes James Carroll, *Constantine's Sword: The Church and the Jews, A History* (Boston: Houghton Mifflin, 2001); Ralph M. McInerny, *The Defamation of Pius XII* (South Bend, Ind.: St. Augustine's Press, 2001); Phayer, *The Catholic Church and the Holocaust, 1930–1965*; Ronald Rychlak, *Hitler, the War and the Pope* (Columbus, Miss.: Genesis Press, Inc., 2000); Garry Wills, *Papal Sin: Structures of Deceit* (New York: Doubleday, 2000); and Zuccotti, *Under His Very Windows: The Vatican and the Holocaust*. Phayer and Zuccotti are contributors to the present volume, which appeared too late for Dalin to take account of it.

As this book went to press, another important study appeared—also too late for Dalin or the contributors here to take account of it. This work is David I. Kertzer's *The Popes against the Jews: The Vatican's Role in the Rise of Modern Antisemitism* (New York: Alfred A. Knopf, 2001). In ways that give Dalin no comfort, Kertzer's arguments focus not only on Pius XII but also on what he finds to be the Vatican's centuries-long anti-Jewish posture, which helped to set Jews up for the kill during the Holocaust. Even before Kertzer's polemical book appeared in late September 2001, debate about it had heated up and promised to be intense.

12. David G. Dalin, "Pius XII and the Jews," *Weekly Standard*, 6, No. 3, February 26, 2001, 31–9. We draw from the Internet edition of this issue of the *Weekly Standard*. According to Dalin, the "vilifying" books include those by Cornwell, Carroll, Wills, Zuccotti, and, to a lesser extent, Phayer. The defenders, Dalin claims, "have the stronger case," and they include Blet, Marchione, McInerny, and especially Rychlak. Dalin describes the latter book as "the best and more careful of the recent works, an elegant tome of serious, critical scholarship." In the following discussion, all the quotations from Dalin are from this *Weekly Standard* source.

13. For more detail on this topic, see John K. Roth, *Holocaust Politics* (Louisville, Ky.: Westminster John Knox Press, 2001).

14. Matthew 14 : 29 –31.

15. See John 21 : 15–17.

Carol Rittner and John K. Roth

A Chronology about Pope Pius XII and the Holocaust

Providing biographical and historical background for the chapters that follow, this chronology concentrates on the words and deeds of Pope Pius XII. It also aims to contextualize his life by including many events that took place before, during, and after his reign. Those events include key moments in the history of Nazi Germany, World War II, and the Holocaust. It is hoped that this outline will help to clarify what Pius XII knew about the Holocaust, how he responded to Nazi Germany's genocidal onslaught against the European Jews, and how his Holocaust-related knowledge and responses fit within the concerns that most occupied his attention. By extending the chronology beyond the date of Pius XII's death, it is also hoped that this summary will indicate how Roman Catholic teaching about the Jews and Judaism has continued to change after the Holocaust.

1849	Marcantonio Pacelli, grandfather of the future Pope Pius XII, founds, at the request of Pope Pius IX (*Pio Nono*), the Holy See's official newspaper, *L'Osservatore Romano*.
1870	In reaction to the seizure of the Papal States by the forces of Italian unification, Pius IX retreats within the walls of the Vatican. Thus begins a 60-year-long self-imprisonment of the Roman pontiffs.
1876 *March 2*	Eugenio Maria Giuseppe Giovanni Pacelli is born in Rome.
1894 *November*	Pacelli enters Capranica College to begin studies for the Roman Catholic priesthood. In 1896, for health reasons, seminarian Pacelli is granted extraordinary permission by Pope Leo XIII to continue his studies as a day student at the Capranica.

1899

March 2 Pacelli is ordained a Roman Catholic priest and assigned to the parish of Chiesa Nuova, where he stays until 1901.

1901 Cardinal Mariano Rampolla, Vatican Secretary of State, offers Father Pacelli a position in the Vatican Foreign Office.

1902 Pacelli receives his doctorate in Canon and Civil Law, *summa cum laude.*

1903

July 20 Pope Leo XIII dies; Cardinal Giuseppe Sarto is elected pope and takes the name Pope Pius X.

1904–16 Pacelli assists Cardinal Pietro Gasparri in his work codifying canon law.

1912 Pacelli is made Acting Secretary of the Vatican Foreign Office.

1914

June 28 A Serbian nationalist assassinates Archduke Francis Ferdinand of Austria at Sarajevo, setting off a chain of events which by the end of the Summer leads to the beginning of World War I.

August 20 Pope Pius X dies.

September 3 Cardinal Giacomo della Chiesa elected pope; he takes the name Benedict XV. Pacelli is promoted to Secretary of the Vatican Congregation of Extraordinary Ecclesiastical Affairs.

1917

April Pacelli appointed apostolic nuncio to Bavaria.

May 13 Consecrated an archbishop by Pope Benedict XV.

May 20 Pacelli leaves Rome for his new post in Munich, carrying Benedict XV's peace plan to end World War I.

June 29 Meets with Kaiser Wilhelm II to discuss the papal peace plan but fails to secure the Kaiser's agreement to peace talks.

October Pacelli returns to Rome.

October Bolshevik (Communist) Revolution in Russia.

1918
November 11 World War I ends.

1920
June 30 Pacelli is appointed the first apostolic nuncio to Germany.

1922
January 22 Pope Benedict XV dies.
February 6 Cardinal Achille Ratti elected pope; takes the name Pius XI.
October 31 Benito Mussolini and his Fascist party take control of the Italian government.

1929 During an attempted armed takeover of the Bavarian government, Apostolic Nuncio Pacelli confronts "an intruding gun-toting Communist revolutionary" in his Munich residence.
February 11 Italy and the Vatican sign the Lateran Pact, giving the pope sovereignty over Vatican City (109 acres located within the city of Rome).
December 16 Pope Pius XI names Pacelli a cardinal of the Roman Catholic Church.

1930
February 7 Pius XI names Cardinal Pacelli Vatican Secretary of State.

1931
Summer Pius XI publishes his encyclical *Non abbiamo biscogno (We Have No Need)*. In it, he denounces Benito Mussolini and his Fascist government in Italy.

1933
January 30 Adolf Hitler becomes Chancellor of Germany.
March 20 Dachau, a concentration camp, is established about ten miles northwest of Munich.
April 1 Nazi-organized boycott of Jewish businesses in Germany.
May 10 Nazis instigate the public burning of books by Jewish and non-Jewish authors opposed to Nazism.

Carol Rittner and John K. Roth

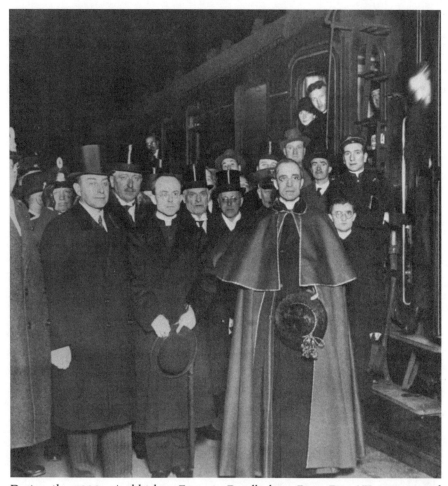

During the 1920s, Archbishop Eugenio Pacelli, later Pope Pius XII, represented the Vatican as apostolic nuncio to Germany. Shown here as he departed Berlin for Rome in 1929, Pacelli was named a cardinal of the Roman Catholic Church by Pope Pius XI on December 16 of that year. In early February 1930, he became Vatican Secretary of State as well.
© Bettmann/CORBIS.

July 14	Nazi party becomes the one and only legal party in Germany.
July 20	The Vatican signs a concordat with Nazi Germany, negotiated by Pius XI's Secretary of State, Cardinal Pacelli. While the concordat appears to protect key Church rights, it effectively dismantles Germany's Center Party, forces the withdrawal of the Catholic Church from

German political organizations, and enhances Hitler's legitimacy and prestige.

1935

September 15 The Nuremberg Laws are decreed at a Nazi rally. They contain two especially important provisions: (1) the Reich Citizenship Law (German citizenship belongs only to those of "German or related blood"); and (2) the Law for the Protection of German Blood and Honor (marriage and extramarital intercourse between Jews and persons of "German or related blood" are prohibited).

November 14 The First Ordinance to the Reich Citizenship Law enacts a classification system to define various degrees of Jewishness. (A person is defined as fully Jewish if he or she has three Jewish grandparents.) The ordinance specifies that "a Jew cannot be a Reich citizen."

1936

August The Olympic Games are held in Berlin.

October Cardinal Pacelli arrives in America for a whirlwind tour. He is the first Vatican Secretary of State (and future pope) ever to do so. He refuses to meet with President Franklin Roosevelt until after the November presidential elections.

October 25 Hitler and Mussolini sign a treaty forming the Rome–Berlin Axis.

1937

March 14 Pope Pius XI releases his encyclical *Mit brennender Sorge* (*With Deep Anxiety*), drafted in large part by Secretary of State Pacelli. It vigorously condemns racism, but it does not mention Hitler or Nazism by name.

March 21 Smuggled into Germany, the encyclical is read on Palm Sunday from the pulpits of all Catholic churches.

1938

March 13 *Anschluss*: Nazi Germany annexes Austria.

June 22 Pius XI asks John LaFarge, an American Jesuit priest, and two other Jesuits, Gustave Desbuquois and Gustav Gundlach, to draft an encyclical letter denouncing racism and antisemitism. Entitled *Humani Generis Unitas* (*The Unity of the Human Race*), it is not published.

September 1–3 The Italian government announces that foreign Jews can no longer establish residence in Italy. Jews naturalized after January 1, 1919, lose their citizenship and are considered foreigners.

September 30 Settlement reached by Germany, Great Britain, France, and Italy that permits Nazi German annexation of the Sudetenland in western Czechoslovakia.

November 9–10 Following the assassination of diplomat Ernst vom Rath by a young Jew in Paris, violence against Jews and Jewish property, instigated by Joseph Goebbels, Minister of Nazi Propaganda, erupts in Germany and Austria. Synagogues are burned, Jewish businesses looted, and Jews are beaten by Nazi thugs. Some 30,000 Jews are interned in concentration camps.

1939

January 30 Hitler tells the German Reichstag that a world war will mean "the annihilation of the Jewish race in Europe."

February 10 Pope Pius XI dies.

March 2 Cardinal Eugenio Pacelli is elected pope in the shortest conclave since the seventeenth century, and takes the name Pius XII.

March 12 The coronation of Pope Pius XII takes place in St. Peter's Basilica. Soon thereafter, Pius XII appoints Cardinal Luigi Maglione Vatican Secretary of State. When Maglione dies in 1944, Pius XII assumes the position himself.

March 14 At Berlin's instigation, the right-wing, pro-Nazi Catholic priest, Msgr. Josef Tiso, head of the clericalist–nationalist Hlinka party, declares Slovakia an independent state.

March 15 German troops enter Czechoslovakia and occupy Prague.

April 9 In his Easter Sunday sermon, Pius XII condemns violations of sanctioned treaties and defends the rights of nations to exist. He does not mention specific aggressors.

September 1 Germany invades Poland.

September 3 France and Great Britain declare war on Germany.

September 21 Cardinal August Hlond, Archbishop of Warsaw and Roman Catholic Primate of Poland, flees occupied Poland

A Chronology

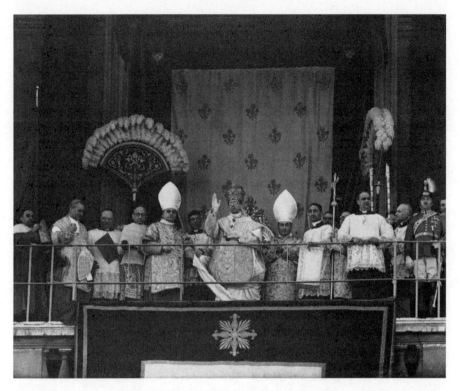

On February 10, 1939, Pope Pius XI died. Cardinal Eugenio Pacelli was elected his successor on March 2 in the shortest conclave since the seventeenth century, and took the name Pius XII. His papal coronation took place on March 12 and was the first to be filmed in its entirety and broadcast worldwide by radio. © Hulton-Deutsch Collection/CORBIS.

	and takes refuge at Castel Gandolfo, the papal summer residence outside of Rome.
October	Hitler gives the order for the so-called "Euthanasia program" in Germany. It is code-named T-4. To coincide with the beginning of the war, the order is backdated to September 1, 1939. In Slovakia, Msgr. Josef Tiso is elected president.
October 20	Pope Pius XII issues his encyclical *Summi Pontificatus* (*Of the Supreme Pontificate*, known in English as *Darkness over the Earth*). He uses powerful words to describe "the unity of the human race" but fails to denounce Nazi Germany and its aggression against Poland.

October– *November*	214 Catholic priests are executed in Poland; more than 1000 Catholic clergymen are imprisoned by the end of 1939. (Overall, about 2600, or 20 per cent, of all Polish clergy died at the hands of the Nazis; a much larger percentage was imprisoned.)
November 23	The Germans order Polish Jews to wear the Star of David.
December 25	Pope Pius XII delivers the first of his "Christmas addresses." He attacks the "premeditated aggression against a small, hard-working and peaceful nation on the pretext of a threat that neither existed, nor was intended, nor was even possible." He deplores the "disregard for dignity, freedom and human life that has brought about acts that cry to heaven for vengeance."

1940

January	First experimental gassing of mental patients in German asylums. More than 70,000 people perish before protests, spurred by a few church leaders, bring about the official termination of the Euthanasia program on September 1, 1941. In fact, however, the operation continues until the end of the war.
March 11	In an effort to prevent him from publicly criticizing the Nazi regime, German Foreign Minister Joachim von Ribbentrop meets with Pius XII.
April 27	Himmler orders the establishment of a concentration camp near Oswiecim (Auschwitz), the site of former Polish military barracks. It will become the largest killing center in the entire Nazi system of concentration and death camps.
May 10	Germany invades France, Belgium, and the Netherlands. *L'Osservatore Romano* condemns the invasion. Mussolini confiscates and burns all copies of the paper.
Late May	The Vatican transfers more than $7.5 million worth of gold bars to the United States.
June 10	Italy declares war on France and Britain. On the same date, Vatican Secretary of State Maglione asks Britain for a guarantee that the RAF will not bomb Rome.
September 5	In Slovakia, Vatican chargé d'affaires Msgr. Giuseppe Burzio writes a dispatch to Cardinal Maglione about

regulations against Slovakian Jews. On October 5, Maglione replies and instructs Burzio to keep him informed of the attitude of Slovakia's bishops.

Mid-October The Jews of Warsaw are ghettoized.

Mid-November The Warsaw ghetto is sealed.

1941

March 30 Hitler tells his military leaders that the forthcoming war against the Soviet Union will be one of "extermination."

June 22 Operation Barbarossa: Germany attacks Russia; the Axis powers label it a "Holy War." The *Einsatzgruppen* engage in mass killing. All of Poland falls under German domination.

July 31 Hermann Göring signs orders giving Reinhard Heydrich authority to prepare "the final solution of the Jewish question."

August 3 Count Clemens August Graf von Galen, the Roman Catholic Bishop of Münster, Germany, publicly protests the Nazi Euthanasia program.

August 29 Provost Bernard Lichtenberg of Berlin's St. Hedwig Cathedral publicly declares that he will include Jews in his daily prayers. On October 23, 1941, he is arrested and sent to Dachau. He dies on the way.

September 29–30 More than 33,000 Jews from the Ukranian city of Kiev are murdered by *Einsatzgruppe 4a* at Babi Yar ravine.

October Msgr. Burzio, chargé d'affaires in Slovakia, sends reports to the Vatican about vast numbers of Jews being shot by Germans.

October 10 Apostolic Nuncio to Turkey Angelo Roncalli has an audience with Pope Pius XII. In his diary, Roncalli writes concerning that audience, "He [the pope] asked me if his silence regarding Nazism was not judged badly."

November 12 In a note to Charles Sidor, Slovak minister to the Holy See, Vatican Secretary of State Maglione intervenes on behalf of baptized Jews and the rights of the Roman Catholic Church in Slovakia. The note is ignored.

November 21 Father Pirro Scavizzi, an Italian hospital train chaplain who frequently travels through Poland on trips between Italy and the Russian front, delivers a report from a Dominican priest to the Vatican. In it are contained the

complaints of Catholic Poles about the failure of the pope to protest their sufferings at the hands of the Nazis.

December 7 Japan attacks Pearl Harbor. The United States declares war on Japan. Four days later, December 11, 1941, the U.S. declares war on Germany.

December 25 The *New York Times* publishes the first of two editorials praising Pius XII for being a "lonely voice in the silence and darkness enveloping Europe."

1942

January 20 At Wannsee, a Berlin suburb, Reinhard Heydrich presides at a meeting of top Nazi officials to coordinate the "Final Solution."

February 15 First transport of Jews murdered with Zyklon B gas at Auschwitz I.

February 28 Archbishop Adam Stefan Sapieha of Cracow writes to Pius XII about the dreadful Nazi persecutions of Catholics—the concentration camps from which few return, the typhus epidemics, and the scarcity of food. He does not mention the Jews.

March 1 The Nazis begin construction of a new death camp at Sobibór.

March 13 Archbishop Angelo Rotta, Vatican nuncio in Budapest, passes on an appeal from the World Jewish Congress requesting that the pope attempt to persuade Msgr. Tiso (Slovakia) to cancel the deportation of Slovakian Jews. This is followed on March 14, 1942, by a note of protest to the Slovak government from Vatican Secretary of State Maglione. The note is ignored.

March 27 First deportation of Jews from France to Auschwitz begins.

March Chargé d'Affaires Burzio informs Cardinal Maglione that 80,000 Jews are likely to be deported from Slovakia to certain death; follows up with a report in May 1942 that the Jews were deported. During the same month, Gerhart Riegner of the World Jewish Congress sends a memo to the papal nuncio in Berne, Msgr. Filippo Bernardini, stating that there is sufficient information from a number of sources to verify Jewish exterminations.

April 26 The Catholic bishops of Slovakia issue a pastoral letter to

the faithful. The bishops have mixed beliefs regarding the actions that have been taken against the Jews.

May 12 Father Pirro Scavizzi personally writes to Pope Pius XII about Jews being murdered en masse; some of his details are inaccurate.

May 15 The Slovak Parliament passes post hoc authorization for deportations. Not one Catholic priest who is a representative to the Slovak Parliament votes against this measure.

July 15 For the first time, Dutch Jews are deported from Westerbork to Auschwitz.

July 22 Killing center at Treblinka becomes operational.

July 22– Mass deportations of Jews from the Warsaw ghetto are
September 12 under way. Some 300,000 Jews are deported, 265,000 of them to Treblinka.

August Minister of the Interior in Romania announces that all Jews will be deported. The papal nuncio in Bucharest, Archbishop Andrea Cassulo, together with the Swiss minister, Remi de Week, protest to the Romanian government.

August Croatian rabbi Miroslav Shalom Freiberger writes to Pope Pius XII asking for his help to save Jews in Croatia. Apostolic Visitor Abbot Giuseppe Ramiro Marcone is instructed by the Holy See to thank him for his letter but to do so prudently and tactfully.

August 4 First deportation of Jews from Belgium to Auschwitz begins. By the end of August 1944, approximately 29,000 Jews who had been living in Belgium when the Nazis invaded the country are dead.

August 30 French Bishop Pierre-Marie Théas reminds his parishes that all human beings are created by the same God, Christians and Jews alike, and that "all men regardless of race or religion deserve respect from individuals and governments."

Summer Belgium's Cardinal Josef-Ernest Van Roey, Archbishop of Malines, tells the Vatican that the persecution of the Jews is provoking a feeling of revolt among the general population of Belgium. From Croatia, Abbot Giuseppe Ramiro Marcone writes to Cardinal Maglione telling

him that Jews there are to be deported and killed. He also tells him that two million Jews have already met this fate.

September As Jews are being deported from France to their deaths, the Vichy Ministry of Information urges the press to remember "the true teaching of St. Thomas and the Popes ... the general and traditional teaching of the Catholic Church about the Jewish problem."

September 6 In a pastoral letter, Cardinal Pierre Gerlier, the Archbishop of Lyons, condemns the deportation of Jews from France.

September 26 Memos from Polish ambassador Kazimierz Papée and American Envoy Myron C. Taylor to Vatican Secretary of State Maglione report mass exterminations at special killing centers and mass deportations of Jews from various European countries.

October 3 The Polish Embassy at the Vatican sends two reports to Vatican Secretary of State Maglione describing the German atrocities against the Jews in Poland.

November American and British forces invade North Africa. Pius XII begins negotiations with the Allies and the Axis powers to declare Rome an "open city."

December 6 Pius XII formally requests the Italian Fascist government to withdraw from Rome, along with their German advisors.

December 12 Archbishop Anthony Springovics of Riga, Latvia, sends the pope information that most of the Jews of Riga have been murdered; only a few thousand remain in the ghetto.

December 18 Hoping to influence Pius XII's Christmas address, British minister to the Vatican Francis d'Arcy Osborne provides the Vatican with a dossier on Jewish deportations.

December 24 In his annual Christmas message, the pope deplores the bloodshed of war but fails to denounce the Nazis. In a veiled reference to Jews, Pius laments the "hundreds of thousands who, through no fault of their own, and sometimes only because of their nationality or race, have been consigned to death or slow decline." The *New York Times* again praises the pope for his devotion to peace.

December 30	Pope Pius XII tells an American representative that he regards the atrocity stories about Jews as an exaggeration "for the purposes of propaganda."

1943

January 2	In a letter from London, the Polish president Wladislas Raczkiewicz bluntly reminds Pius XII of statements made by his predecessors on behalf of Poland. He begs the pope to break his silence.
January 7–24	20,000 Jews from Germany, Belgium, Holland, and Poland are gassed at Auschwitz.
January 17	Berlin Bishop Konrad Graf von Preysing, the German Catholic prelate who consistently opposes the German government's Jewish policies, tells Pope Pius XII that he will resign unless the collaborative behavior of the other German bishops ceases.
March 6	Bishop Preysing writes to Pius XII about the February 27 to March 1 round-up of Berlin's Jews. Preysing asks the pope to speak out against it.
March 13	Hungarian Catholic activist Sister Margit Slachta meets with Pius XII and tells him that 20,000 Slovak Jews face death.
April 19	The Vatican writes to the government of Slovakia expressing its concern at the rumors that they are about to expel "the Jews who live in Slovakia without discrimination for women and children and without excepting even those who have entered the Catholic religion."
May 13	The German and Italian armies in Tunisia surrender to the Allies. The war in North Africa is over.
May 24	In a note to Vatican Secretary of State Maglione, Archbishop Alojzije Stepinac denies charges that Croatia committed any crimes, although he admits that "irresponsible" persons might have done so in the name of the state in 1941.
June 29	Pius XII issues his encyclical, *Mystici Corporis Christi* (*On the Supernatural Nature of Christ's Body*).
July 10	American and British forces land on Sicily and begin the liberation of Italy.
July 16	The Franciscan priest Father Marie Benoît has an

audience with Pope Pius XII during which he presents the pope with several documents describing the situation of Jews in France. He pleads for help in rescuing Jews in the Italian-occupied area of France.

July 19 Allied aircraft, intending to hit the railways in Rome, mistakenly bomb and badly damage the Basilica of San Lorenzo.

July 20 Pius XII drafts an angry message to President Roosevelt in which he writes, "As Bishop of this sacred City we have constantly tried to save our beloved Rome from devastation ... But this reasonable hope has, alas, been frustrated."

July 25 Mussolini resigns under pressure. He is arrested by order of the King of Italy and imprisoned on the island of Ponzo. Field Marshal Pietro Badoglio is appointed head of the Italian government.

September 3–8 The Allies invade the Italian peninsula. Italy surrenders. Marshal Badoglio signs an armistice with the Allies. The German army, accompanied by SS military units, moves into Italy.

September 9–10 The Germans enter Rome. Expecting a German onslaught, for the first time in history the doors to St. Peter's Basilica are closed in the daytime, along with the entrance to the Vatican at the Porta Santa Anna. Pope Pius XII opens hundreds of rooms to house refugees and those seeking sanctuary.

September 13 Nazi paratroopers are stationed around the parameters of Vatican City.

September 19 At the Vatican, Pius XII officially receives Field Marshal Kesselring, the commander of German forces in Rome.

September 26 SS Lt. Colonel Herbert Kappler, chief of the German security police in Rome, summons two of Italy's most prominent Jewish leaders to his office and demands 50 kilograms of gold. If it is not delivered, 200 Jews will be arrested and deported. The Vatican, whether spontaneously or after being asked, expresses its willingness to "loan" the Jewish community the balance of whatever amount they are unable to collect from their members.

September 28 By 4:00 p.m., the gold is delivered to Gestapo

	headquarters in the Via Tasso, Rome. The Vatican "loan" is not needed.
September 30	Pius XII issues his encyclical, *Divino Afflante Spiritu* (*On the Promotion of Biblical Studies*), in which he condemns the scriptural exegesis of the modernists.
October 1–2	When word leaks of an imminent German round-up of Jews in Denmark, the Danes begin the rescue of some 7200 Jews in their country.
October 16	Early in the morning, the German SS security and military police surround the ancient Jewish ghetto of Rome and begin arresting Jews. By the time the round-up ends, 1259 people are arrested. Children of mixed marriages are later released.
October 17	German ambassador to the Vatican Ernst von Weizsäcker reports to the German Foreign Ministry that the College of Cardinals has been "particularly dismayed" since the round-up of Jews in Rome is occurring below the "very windows of the Pope." Still, the pope continues to do all he can "not to burden relations with the German government and German agencies in Rome."
October 18	1007 Italian Jews are sent by train directly to Auschwitz, arriving on October 23, 1943. Of the original 1007 Jews deported, 16 return after the war.
November	Four bombs fall on Vatican City, slightly damaging St. Peter's Basilica and other structures.

1944

January 21	The Allies land at Anzio, 30 miles south of Rome.
February 9	Pius XII announces to his cardinals that he intends to remain in Rome for the duration of the hostilities. He gives them the option of fleeing the city, but all remain.
February 10	Allied forces bomb Castel Gandolfo, killing 500 refugees. Pius XII establishes soup kitchens throughout Rome; as many as 50,000 meals a day are served.
March 12	For the first time since the German occupation, Pius XII appears in public to an overflowing crowd in St. Peter's Square. He pleads with the world to protect Rome from the horrors of combat and modern warfare.
March 19	Germany occupies Hungary and begins subjecting

Pope Pius XII regularly used Vatican Radio to communicate his views, and in particular the radio broadcast of his 1942 Christmas message plays a prominent part in the Holocaust controversy that continues to swirl around him. © Bettmann/CORBIS.

	Hungary's Jewish population (some 825,000) to the Final Solution. Within days, Adolf Eichmann arrives to organize the deportations.
March 24	At the Ardeatine caves near Rome, 335 hostages, 70 of them Jews, are massacred in reprisal for an attack on March 23 against a German police unit as it marched through the Via Rasella in Rome; 33 German policemen were killed.
April 5	Hungarian Jews above the age of 6 are required to wear the Star of David.
June 3	The German army abandons Rome.
June 4	Rome is liberated by the American Fifth Army. Pius XII addresses another overflowing crowd in St. Peter's Square and praises the preservation of Rome.

June 6	D-Day: Allied forces land at Normandy.
June 25	Pope Pius XII sends Admiral Miklós Horthy a telegram asking him to stop the deportation of Hungarians "to an unknown destination" because of their race. The pope does not use the word "Jew" in his message.
July 19	Angelo Roncalli, apostolic nuncio to Turkey and the future Pope John XXIII, appeals to Horthy on behalf of 5000 Hungarian Jews with Palestinian visas. He provides baptismal certificates for Jews in hiding.
July 20	A group of German officers and dissident politicians attempts to assassinate Hitler by exploding a bomb in the conference room at the Führer's headquarters in Rastenburg, Germany. Hitler is shaken, temporarily deafened, but not seriously injured.
August 2–8	The internment and transit camp at Bolzano-Gries opens. The population eventually increases to more than 4000 with the arrival of prisoners from Liguria, Piedmont, Lombardy, Venice, Fruili, and Emilia Romagna provinces in Italy. The prisoners include Jews in mixed marriages, political hostages, Gypsies; 10 per cent are women and children.
October 5	The British Colonial Office agrees to allow 10,300 Jews to enter Palestine at the rate of 1500 each month. This policy replaces the offer made to the Jewish Agency the previous year, under which all Jews reaching Turkey would be allowed to enter Palestine.
October 20	At 5:00 a.m. the Hungarian police and Arrow Cross units begin an operation against Budapest's Jews; by evening, 22,000 are arrested and put in labor units to build fortifications.
October 28	By this date, nearly 430,000 Jews have been deported from Hungary to the German concentration and killing camps.
December 14	From the Bolzano-Gries transit camp, 150 prisoners are transported to Flossenbürg and Ravensbrück concentration camps; 80 of them are Jewish, and only four survive.
December 23	Adolf Eichmann leaves Budapest together with his *Sonderkommando*.

1945

January 27	Soldiers of the Red Army liberate Auschwitz.
April 11	American soldiers liberate Buchenwald.
April 15	British soldiers liberate Bergen-Belsen.
April 28	Italian dictator Benito Mussolini is executed.
April 30	Adolf Hitler and Eva Braun commit suicide in Hitler's Berlin bunker.
May 5	The presiding bishop of the German Catholic bishops' conference instructs his priests to say Mass in Hitler's memory.
May 7–8	V-E Day: Germany surrenders; the war in Europe is over.
August 6	An American B-29 drops an atomic bomb on Hiroshima, Japan.
August 9	An American B-29 drops an atomic bomb on Nagasaki, Japan.
August	Meeting in Fulda, the German Roman Catholic hierarchy produce an official statement in which they try to deal with "the matter of German guilt." Some critics claim it is intended "to clear Catholics at large of Holocaust guilt."
September 2	Japan surrenders; World War II is over.
October 19	The Protestant Evangelical Confessing Church issues the *Stuttgart Confession of Guilt*. It states, in part, "We accuse ourselves that we did not witness more courageously. ..."
November 20	The Nuremberg War Crimes Trials begin.
December 25	In his Christmas address, Pius XII warns against the growing power of Communist states in Europe.

1946

July 4	Following the disappearance of a Christian child at Kielce, Poland, a violent pogrom breaks out against the city's Jews. A mob storms the Jewish community center and murders 42 Jews, including two children. Other anti-Jewish pogroms break out across Poland. (The Christian child is later discovered unharmed in a nearby village.)
July 11	Cardinal August Hlond, Polish primate, blames the Jews of Kielce for the murderous pogrom against them on July 4.
September	Pope Pius XII condemns the Communist regime of

Marshal Josip Tito of Yugoslavia for its persecution of Catholics, including Archbishop Alojzije Stepinac.

1947 Msgr. Josef Tiso, former Prime Minister of Slovakia and a Hitler ally, is tried and executed in Czechoslovakia.

November 20 Pius XII issues his encyclical, *Mediator Dei* (*On the Sacred Liturgy*), which defines the participation of the laity in the Holy Sacrifice of the Mass.

1948 Pope Pius XII requests mercy for all Nazi war criminals condemned to death. His appeal is turned down by Deputy Military Governor General Lucius Clay.

April Through the Catholic Action movement, Pius XII mobilizes the Catholic Church in Italy to defeat Communists in the Italian parliamentary elections.

May 14 Britain's mandate to govern Palestine expires. Palestine is divided into the State of Israel and the Kingdom of Jordan. The Jewish National Council proclaims the independent State of Israel.

1950

November 1 Pius XII issues his encyclical, *Munificentissimus Deus* (*The Most Bountiful God*), in which he solemnly declares, *ex cathedra*, the dogma of Mary's Assumption into heaven.

1953

January 15 Pius XII names Archbishop Stepinac of Yugoslavia a cardinal of the Roman Catholic Church.

1954

February 14 Pius XII collapses while delivering an address on Vatican Radio.

1958

October 9 Pope Pius XII dies. He is eulogized at the United Nations by Golda Meir, Foreign Minister of the State of Israel, as well as by other Jewish leaders around the world.

October 20 Cardinal Angelo Roncalli is elected pope. He takes the name John XXIII.

1959

January 25 John XXIII announces his intention to convene an Ecumenical Council. It will become known as Vatican II.

1960 Pope John XXIII meets with Jules Isaac, author of *Jesus and Israel*, a book that links contempt for Judaism to central Christian teachings. The pope calls for a change in the Church's relations with Jews. He eliminates the words "perfidious Jews" from the Good Friday Catholic liturgy.

1962
October 11 Pope John XXIII opens the first session of Vatican II. More than 2200 cardinals, archbishops, and bishops from around the world meet in sessions held in St. Peter's Basilica. Protestant and Jewish clergy and scholars are invited as official observers.

1963
February 20 Rolf Hochhuth's play, *Der Stellvertreter* (*The Deputy*), sharply critical of Pope Pius XII's "silence" during the Holocaust, sets off an international furor when it opens in Berlin.

June 3 Pope John XXIII dies.

June 21 Cardinal Giovanni Battista Montini is elected pope. He takes the name Paul VI.

1965
October 28 The Roman Catholic bishops of the world, meeting during the final session of Vatican II, overwhelmingly approve the document, *Nostra Aetate* (*In Our Time*), which includes key statements regarding Catholic–Jewish relations. The document revolutionizes Catholic thinking and theology about Jews and Judaism by deploring antisemitism and rejecting the idea that Jews can be charged with the death of Jesus.

1965–81 The Vatican's Secretariat of State (external division) publishes 11 volumes of archival material pertaining to Pope Pius XII and World War II. The volumes are entitled *Actes et documents du Saint Siège relatifs à la Seconde Guerre mondiale* (ADSS).

1975
January The Vatican issues "Guidelines and Suggestions for Implementing *Nostra Aetate*."

1978

August 6	Pope Paul VI dies.
August 26	Cardinal Albino Luciani is elected pope. He takes the name John Paul I.
September 28	Pope John Paul I dies.
October 16	Cardinal Karol Wojityla of Poland is elected pope. He takes the name John Paul II.

1979

June 7 While on a visit to Communist Poland, Pope John Paul II celebrates Mass at Auschwitz, calling the death camp the "Golgotha of the modern world."

1985 The Vatican issues *Notes on the Correct Way to Present Jews and Judaism in Preaching and Catechesis.*

1986

April Pope John Paul II visits the Great Synagogue in Rome, the first pope ever to do so.

1993 The Vatican diplomatically recognizes the State of Israel and exchanges ambassadors with Israel.

1994

April 7 Under the leadership of Pope John Paul II, the Vatican organizes its first official memorial to the Jewish Victims of the Nazis. Among the guests at the Papal Concert to Commemorate the Holocaust were more than 200 Holocaust survivors.

1998

March 16 "We Remember: A Reflection on the *Shoah*" is issued by the Vatican's Commission for Religious Relations with the Jews.

1999

October The Vatican's Commission for Religious Relations with the Jews and the International Jewish Committee for Inter-religious Consultations announce the formation of an International Catholic–Jewish Historical Commission to examine critically the 11 volumes of archival material published by the Vatican's Secretariat of State (external

December	division) between 1965 and 1981. Three Catholic and three Jewish scholars are appointed to serve on the Commission. The Vatican's International Theological Commission issues the document *Memory and Reconciliation: The Church and the Faults of the Past.*

2000

March 12	Pope John Paul II, with his cardinals, officiates at a special penitential rite in St. Peter's Basilica, asking God's forgiveness for the sins, past and present, of the sons and daughters of the Church. Among the sins for which he asks pardon are sins against the Jewish people.
March 20–26	Pope John Paul II's historic visit to the Holy Land. He visits Jordan, Israel, and the Palestinian Authority, meeting with government and religious leaders, Jewish, Muslim, and Catholic. While in Israel, the pope visits Yad Vashem, the memorial to the six million Jews who perished during the Holocaust, where he rekindles the flame in the Hall of Remembrance, gives a speech, and greets Holocaust survivors, including a few from Poland.
September 3	Pope John Paul II beatifies (declares "blessed") Pope John XXIII, the twentieth-century pontiff who convened Vatican II (1962–5), the Ecumenical Council that focused on *aggiornamento* (renewal), and Pope Pius IX (Pio Nono), the nineteenth-century pontiff known for his opposition to modern culture, his "inflation" of papal power, and for the 1858 kidnapping of Edgardo Mortara. Many critics have suggested that, by beatifying Pius IX in tandem with John XXIII, the Vatican is, in effect, "balancing the ticket," putting forth in John a pope loved by the liberals and in Pius an icon of Catholic conservatism.
September 5	A new Vatican document, *Dominus Iesus* (*The Lord Jesus*), approved by Pope John Paul II, is issued by the Congregation for the Doctrine of the Faith and is presented at a news conference by Cardinal Joseph Ratzinger, the Vatican's chief doctrinal officer. The document concerns "the uniqueness and universality of salvation through Jesus Christ and the Church." It appears to deny that other world religions, including

Including 10,000 who lived in Rome, about 33,500 Jews remained in German-controlled Italy by the autumn of 1943. Several thousand were deported to Auschwitz. Along with nearly 1000 other Italian Jews, Lello Perugia reached Auschwitz from the Fossoli internment camp on June 30, 1944. More than 700 Jews from that transport were gassed on arrival. Perugia survived Auschwitz, although his three brothers died there. He is shown here in Rome's Apostles Square in April 2000 during a celebration of Italy's liberation from Fascism. AFP Photo/EPA/ANSA/Luciano del Castillo © AFP/CORBIS.

Judaism, can offer salvation independent of Roman Catholic Christianity.

September 10 One hundred and seventy Jewish scholars, including many prominent rabbis, sign a public declaration titled *Dabru Emet* ("Speak the Truth"), a Jewish statement on Christians and Christianity. More than three years in the making, *Dabru Emet* is wide-ranging in scope and addresses complex issues about scripture, theology, prayer, conversion, history, and eschatology that both separate and unite Jews and Christians.

October	The International Catholic–Jewish Historical Commission issues "The Vatican and the Holocaust: A Preliminary Report."
November 22, 29, and December 6	*L'Osservatore Romano* publishes a wide-ranging interview with Cardinal Joseph Ratzinger, prefect of the Congregation for the Doctrine of the Faith, which was originally published in the September 22, 2000, *Frankfurter Allgemeine Zeitung*. In the interview, he responds to the principal objection that critics raised against the declaration *Dominus Iesus*.
December 29	*L'Osservatore Romano* publishes "The Legacy of Abraham, Gift of Christmas," an article written by Cardinal Ratzinger, who says, "Even if the last abhorrent experience, the 'Shoah,' was perpetrated in the name of an anti-Christian ideology that sought to strike the Christian faith at its Abrahamic roots—in the people of Israel—it cannot be denied that a certain measure of insufficient resistance to these atrocities on the part of Christians is explained by the anti-Jewish legacy present in the souls of no small number of Christians."

2001

July 20	After the Vatican declines to open additional archival material, the International Catholic–Jewish Historical Commission suspends its study of the Vatican's role during World War II and the Holocaust.
July–August	Often focused on Pope Pius XII, renewed controversy erupts when the International Catholic–Jewish Historical Commission suspends its work because the Vatican, citing "technical reasons," declines to open archival material beyond that contained in ADSS. The Vatican states that the team of Catholic and Jewish scholars was never promised access to complete archival material dating after 1922. It also expresses hope that joint research can be reactivated "on new foundations" and indicates that the relevant archival materials will be made available to scholars "as soon as the documents are catalogued and classified," but does not specify when that might be. Meanwhile, defenders of Pius XII launch

the "Pius XII Oral History Project" to gather testimony that bolsters his image. The future remains clouded for future Catholic–Jewish research cooperation about the Vatican and the Holocaust.

Sources for Chronology

Carroll, James. *Constantine's Sword: The Church and the Jews, a History.* Boston: Houghton Mifflin Co., 2001.

Darkness Before Dawn: Fifty Years Ago, 1994 Days of Remembrance. Washington, D.C.: United States Holocaust Memorial Museum, 1994.

Phayer, Michael. *The Catholic Church and the Holocaust, 1930–1965.* Bloomington: Indiana University Press, 2000.

Rittner, Carol, and John K. Roth, eds., *Different Voices: Women and the Holocaust.* New York: Paragon House, 1993.

Rittner, Carol, Stephen Smith, and Irena Steinfeldt, eds., *The Holocaust and the Christian World.* New York: Continuum, 2000.

Roth, John K., *et al. The Holocaust Chronicle: A History in Words and Pictures.* Lincolnwood, Ill.: Publications International, Ltd., 2000.

Yahil, Leni. *The Holocaust: The Fate of European Jewry.* New York: Oxford University Press, 1990.

Zuccotti, Susan. *Under His Very Windows: The Vatican and the Holocaust in Italy.* New Haven: Yale University Press, 2000.

Exploring the Controversies Surrounding Pope Pius XII and the Holocaust

Many controversies swirl about Pope Pius XII and the Holocaust. Some have more merit than others, but how to sift and sort them depends on careful scholarship that explores the current state of the debate.

Reminding his readers to keep Pius XII's historical situation in mind, so that our judgment is not skewed by moralistic hindsight, Michael Marrus opens the discussion with an essay that defines ten issues concerning sound understanding of the Vatican's role during the Holocaust. These issues range from Christianity's long tradition of anti-Judaism to the personality of Pope Pius XII. Contending that it is wrong to say that Pius XII was silent about the Holocaust, and emphasizing the need for further research, John Pawlikowski argues that it would be wise, and ultimately helpful to Catholic integrity, if scholars were allowed to carry out their research without the prospect of Pius XII's canonization clouding the issues.

Eugene Fisher doubts that full release of the Holy See's archives is likely to result in startling new evidence. As he appraises the recent scholarship, he believes that Pope Pius XII deserves a higher status than his major critics have allowed him. Sergio Minerbi is not convinced. He thinks that Pius XII's diplomatic training, fear of provoking a schism in the German Church, and his belief that the Nazis could devastate the supreme interests of the Catholic Church led to his position regarding the Nazi state, which involved compliance, opportunism, and silence.

Doris Bergen concludes Part I by broadening the debate's horizons. She emphasizes that the controversy surrounding Pius XII and the Holocaust reflects a wide range of issues about the place of Christianity in the world today. The question of silence, or even active complicity in mass death, is not one related only to the Holocaust.

Bergen's essay probes a fundamental question: what are the responsibilities of the Church (or churches) in the world?

These five chapters do not agree on every point. Nevertheless, they are complementary because they sharpen the focus on so many crucial issues about Pius XII, the dilemmas he faced, and the roles he played during World War II and the Holocaust.

Michael R. Marrus

Pius XII and the Holocaust:
Ten Essential Themes

I begin with the paradox that I think underlies every consideration of the theme of this volume: on the one hand, there is the astonishing amelioration of Catholic–Jewish relations in the past 35 years, arguably more progress in the reconciliation between Catholics and Jews than in the entire history of Christendom; and, on the other, the continuing obstacle in that path posed by divergent understandings of the role of Pope Pius XII during the wartime massacre of European Jews. Significantly, the more progress we see in the first, the more the perception of the latter as "unfinished business" intensifies, making more difficult the healing and reconciliation so eloquently called for by Pope John Paul II.

What accounts for this juxtaposition? I can only assume that the issue of Pope Pius XII and the Holocaust has become symbolic in both communities, entangled in questions of both Catholic and Jewish self-definition, and colored at least as much by various present-day positions as by what happened half a century ago. As often when there is weighty interpretative baggage associated with our understanding of the past, it might help to see the issue in simpler terms. To this end, I propose that we consider reducing the historical part of the debate to a certain number of essentials—questions on which students of the issue can examine the historical record dispassionately, seek additional evidence, and come to agreements, or agree to disagree as historians so often do. In this short chapter, I propose ten issues or themes associated with an historical understanding of the role of the Holy See during the Holocaust. I stress "historical" because I avoid some of the theological, religious, or dialogical challenges raised by the conveners of the seminar upon which this volume is based. What follows, then, is a list of sometimes highly contentious issues, about which I offer some very brief commentary. For a fuller assessment, readers should engage the widely expanding literature on this topic—and await further research after what is hoped will be the

opening of the Vatican and other archival holdings, a process that will surely enrich the understanding of all students of this subject.[1]

Traditional anti-Judaism

Traditional Catholic anti-Judaism defines at least part of the context for the debate over Pius XII and the Holocaust. "We can be sure that Pacelli did not particularly care for Jews," historian István Déak writes laconically in a recent review—suggesting, through the conversational tone, both the lack of specific evidence for the statement and the undoubtedly anti-Jewish milieu in which Pacelli was born, raised, educated, and operated as a priest as well as pontiff.[2] If Déak is right, and I believe that he is, the reason has to do with the often unspoken anti-Judaism that was simply a part of the pre-*Nostra Aetate* Catholic Church. Traditional Catholic teaching saw the Jews as the people who had rejected Christ, who had conspired in his execution, and who sought to undermine or obstruct the teachings of the Church. Often linked with these views were the associations many Catholics had of Jews as champions of modernity: Bolshevism, secularism, materialism, atheism, rationalism, liberalism, capitalism, democracy were all, at one time or another, seen as inspired, invented, or promoted by the Jews. In consequence, the Catholic heritage of universalism, which played so important a role in pitting the Church against some aspects of Fascist dictatorships, often failed when it came to the persecution of the Jews during the period preceding, and extending into, the Holocaust.

This is a key point because, in debates about Pius XII, his defenders regularly point to denunciations of racism and the defense of Jewish converts as evidence of opposition to antisemitism of all sorts. But hand in hand with the opposition to racism as expressed in such statements as Pius XI's 1937 encyclical *Mit brennender Sorge* (in which Pacelli had a key role) or the so-called "Hidden Encyclical" of 1939, for example, went varying degrees of distaste for the Jewish people, and an operational assumption that governments were entitled to limit the role of Jews in society, and/or to take "defensive" measures against them—so long as such actions were consistent with the Church's understandings of "justice and charity."[3] Such attitudes were widespread if not universal within the Church, and persisted in the wartime period—and even to the

period when persecution turned into mass murder. There is every indication that this perspective was shared in the Vatican as well, conditioning views, in the Holy See, of the conduct of pro-Nazi regimes such as those in Slovakia, Croatia, Hungary, and Romania. And so far from opposing the Vichy persecution of Jews in France, to take one instance for which I have studied the evidence, we have every indication that the Holy See had no real quarrel with the 1940–1 anti-Jewish policies of the Pétain regime, according to which Jews were publicly vilified, segregated from the rest of society, robbed of their possessions, and interned in special camps.[4] More generally, while the Church often came to the defense of persecuted converted Jews, or "non-Aryan Catholics" as they were sometimes called, seeing state action against them as a violation of agreements that assigned to the Church the right to determine who was and who was not a Catholic, the Church was much less solicitous of Jews who remained Jewish.

Persecution, of course, was not the same as mass murder, and it is unclear what impact traditional anti-Judaism had on Vatican policies during the Holocaust, when Jews were being rounded up everywhere, and massacred by the tens and hundreds of thousands in Eastern Europe. In the case of France, some of the very clerics who supported Pétain and Vichy in 1940 and 1941 explicitly and pointedly denounced the round-ups and deportations of Jews during the second half of 1942. However, the pope was not among them. Pacelli may well not have cared for Jews, but there were certainly other reasons, as we note below, both for action and for inaction, and for assigning the priorities he did.

Vatican pre-war and wartime strategic priorities

Jews did not figure highly among the wartime priorities of the Holy See to say the least—and understandably enough, in the opinion of many historians. Foremost among these priorities, understood as a supreme value in its own right, was the safeguarding and promotion of the institutions, integrity, and the mission of the Church in a turbulent, dangerous world. Pursuing this goal during the 1930s, the Vatican regularly preferred conservative, authoritarian, or even Fascist regimes to those of the democracies (held to be susceptible to bouts of radicalism or socialism), or even worse, to the aggressively atheistic Soviet Union

where the Church was crushed and could not operate openly. Conservative, authoritarian, or even Fascist regimes were favored as well because of their promotion of social stability, their challenge to atheistic and materialistic Marxism, and because of their occasional patronage of the Church—as notably was the case in Spain where the Church had been traumatized, in the mid-1930s, by the anticlerical zeal, and sometimes murderous zeal, of the republican regime.

During the pre-war period the Vatican pursued its goals through the framework of concordats signed with close to a dozen states— agreements intended to define a sphere of action within which the Church could act without interference or in cooperation with state authorities. Hence the highly controversial Lateran Accords of 1929 and the agreement negotiated with Hitler's government in 1933.[5] Once the war was under way, the Holy See had not the slightest hesitation in proclaiming its neutrality: its mission could only be pursued, it felt, by standing above and apart from the belligerents, and by appealing to all to observe humanitarian restraints.

In wartime both the dangers and opportunities for the Church were heightened. Pius XII feared mightily that the Church could shatter through the impact of schisms, or could suffer great damage at the hands of its enemies; but, positively, he nourished the hope that the Holy See could play a constructive role—limiting the conflict or bringing an early end to the hostilities through negotiations among the belligerents. Undoubtedly, the Vatican overrated its capacities in this regard. John Conway refers to "the exaggerated hopes that Pius XII placed in his own and the Vatican's diplomatic skills at the beginning of his term of office, and the consequent sense of frustration, disillusionment and failure which came to haunt the Curia during the final cataclysmic years of the world conflagration."[6] Certainly, the Vatican's priorities militated powerfully against risk-taking in what were considered peripheral and subsidiary issues such as specific humanitarian interventions, particularly when these did not involve core concerns of the Holy See.

Personality of Pius XII

One of the most controversial of modern popes, Eugenio Pacelli is a man about whom historians sharply disagree, and are likely to continue to do

so. "An ambiguous person in even more ambiguous circumstances," acknowledges Thomas Stransky, in a preface to Pierre Blet's recent defense of the pope's wartime record, based upon the published documents of the Holy See in the wartime period.[7] Pius's personality, essential for an understanding of his policies, remains enigmatic. "He saw himself as Christ's most humble servant," notes István Déak, "yet no other pope in recent times has surrounded himself with more pomp and none enforced a more rigid etiquette."[8] Cardinal Secretary of State under Pius XI and an architect of the policy of concordats, he had a profound commitment to the spiritual and pastoral mission of the Church. Austere, pious, aloof, and committed—and here I think John Cornwell is right—to promoting the authority of the papacy and the centralization of its institutions over which he presided, he was probably the least disposed, of modern-day leaders of the Church, to dramatic gestures, diversion of efforts, or the "flaming protest" that many condemn him for not making. Reflecting the observations of many who were impressed by him, Cornwell refers to Pacelli's "detachment and timelessness within an earthly heaven set adrift from the mainland of life."[9] With the puzzling exception of his efforts to mediate between the British and the German opposition to Hitler in 1940, the pope's words and actions suggest the most painstaking reserve, an other-worldliness, a careful, even anguished weighing of alternatives, the utmost caution and circumspection. However judged, the result was a posture that accords ill with both modern-day conceptions of moral activism in the secular sphere and claims to ecumenical moral leadership frequently advanced on behalf of the Church in its religious domain. To us, what is frequently reflected in the carefully crafted language of the Vatican's diplomatic exchanges is, in the words of one sympathetic observer, "a kind of anxiously preserved virginity in the midst of torn souls and bodies."[10]

Knowledge of the Holocaust

Historians of the Holocaust regularly distinguish between having "information" and having "knowledge" of the murder of European Jews, between having access to the essential facts and fully grasping their significance—or having "awareness," the term Arthur Koestler used in this context.[11] On this matter, there seems no doubt that the

"information" was available. "Jews," wrote Cardinal Secretary of State Luigi Maglione in 1943. "Horrendous situation. 4.5 million Jews in Poland before the war, plus many deported there from other occupied territories. . . . There can be no doubt that the majority has already been liquidated. Special death camps at Lublin (Treblinka) and near Brest Litovsk. . . . Transported there in cattle trucks, hermetically sealed."[12] Information, yes. But "awareness"? My reading of the record shows that within the Vatican there was much the same unwillingness or inability or disinclination to grasp the real and singular significance of genocide that one sees elsewhere. For along with the information about mass slaughter was the constant urging in internal communications that the facts could not be verified and that it was impossible to check—plus the recourse to circumlocutions such as "severe treatment," plus the transparent irritation at the persistent appeals on behalf of the Jews. "The Holy See . . . could not control the exactness of all the news it received," noted Giovanni Montini, one of Pius's deputies and the future Pope Paul VI, as information poured in about the massacres of Jews in the East. "The same Holy See did not, however, miss any opportunity to intervene and help the Jews every time it could."[13]

Risks of "speaking out"

Much of the debate over the conduct of Pius XII during the Holocaust turns on an assessment of the risks of "speaking out"—the latter itself a category of speech that owes much to our retrospective assessment of the Holocaust and what should have been done or was not done at the time. Against the charge of failing to "speak out," there is advanced the contention of an essential dilemma faced by the Holy See: its influence on events was slight; and the risk of protesting symbolically was very great. How valid are such claims, and how much emphasis should we place upon them?

There are three elements of risk that historians can attempt to assess. First, there was the physical threat—no small matter, I think it is obvious, for a micro-state in the middle of the capital of Fascist Italy. Fears of Italian or German occupation were not completely illusory, as we know, probably peaking in September 1943; and nor was the apprehension that, at any moment, it was easily within the power of the Italians, and later the Germans, to close down the Vatican press,

silence the Vatican radio, and end communication with the outside world—not to mention cutting off the Vatican's water, food, and electricity.[14]

Second, there was what we might call the *essentialist* threat to the Holy See—the fear that its moral authority would evaporate if it "took sides" conspicuously, that doing so would shatter what remained of the universal standing of the Church, expose its weaknesses, and that if its calls for concrete actions were spurned the only result would be a humiliating and debilitating loss of authority. Commenting on the Vatican's failure to influence the Slovak head of state Josef Tiso, Pacelli's close associate Domenico Tardini lamented: "It is a great misfortune that the President of Slovakia is a priest. Everyone knows that the Holy See cannot bring Hitler to heel. But who will understand that we cannot even control a priest?"[15]

Third, there was the risk of making matters worse. Much debated with reference to the deportation of Dutch-Jewish converts from the Netherlands in 1942 (among whom was the Jewish convert Edith Stein, recently canonized by the Church), this dilemma seems to have been appreciated by the nuncio in Berlin, Cesare Orsenigo, whose apprehension was relayed to Montini on July 28, 1942.[16] For the Jews, it is often said, matters could hardly have been worse. But from the standpoint of contemporaries this was not always evident, of course. More important, in the case of the Vatican the fear seems regularly to have been felt that the wrath of the Nazis or their accomplices might well be visited upon the persecuted but relatively unscathed "non-Aryan Catholics"—not to mention what was left of the autonomy of the Church. In a great sea of suffering, as the pope undoubtedly saw it, there was indeed the possibility that things could be worse. This was the possibility that Pius XII reflected upon in his famous address to the College of Cardinals in 1943:

> Every word directed by Us in this regard to the competent authorities [to ease suffering], and every public allusion, should be seriously considered and weighed in the very interest of those who suffer so as not to make their position even more difficult and more intolerable than previously, even though inadvertently and unwillingly.[17]

To minimize these risks, Pius relied upon his corps of nuncios and other representatives to act in specific situations in the most diplomatically appropriate fashion.[18] The pope articulated this famously in his letter to Cardinal Konrad von Preysing of Berlin on April 30, 1943:

> We give to the pastors who are working on the local level the duty of
> determining if and to what degree the dangers of reprisals and of
> various forms of oppression occasioned by Episcopal declarations—as
> well as perhaps other circumstances caused by the length and mentality
> of the war—seem to advise caution, *ad majora mala vitanda* [to avoid
> greater evil] despite alleged reasons urging the contrary.[19]

Ad majora mala vitanda. Not a heroic guide to policy, nor one in which it
is easy to find a generous spirit, nor a strategy likely to be acclaimed by
subsequent generations. It was a policy virtually guaranteed, however, to
prompt debate about its rectitude and its efficacy—then, and even more
so, now.

Vatican culture, "Vaticanese," and Vatican bureaucracy

"The atmosphere of the Vatican [is not only] supranational and universal,"
commented the British minister to the Holy See d'Arcy Osborne after the
war, "it is also fourth-dimensional and, so to speak, outside of time. ...
They reckon in centuries and plan for eternity."[20] Historians David
Alvarez and Robert Graham comment on the intense "ecclesiastical
flavor" of Vatican City, seeing this as one reason that German espionage
failed, despite considerable efforts, to penetrate the Vatican and succeed
in its campaign against the Holy See. "Aside from laborers, gardeners,
guards, a few technicians in the museums and library, and a scattering of
junior clerks in a few departments, all posts in the Vatican were filled by
priests or members of religious orders," they write. "This community of
priests, nuns and brothers represented a largely closed society which
consciously recognized boundaries between itself and secular society, and
which encouraged only limited interaction across those boundaries.
Distinguished by dress, education, lifestyle and discipline from their
counterparts in the secular world, the ecclesiastical citizens of the Vatican
were also products of an administrative tradition and allegiance to the
Church and its Pontiff."[21]

The point here is that the Vatican was culturally and socially, if by
no means physically, isolated from the outside world. Its public discourse
was highly abstract and heavy with circumlocutions—"often so prolix
and obscure," Osborne complained, "that it was difficult to extract his
meaning from its extraneous verbal envelope."[22] Its actions bore the

stamp of other-worldliness as well. The pope's staff was made up of highly trained, deeply conservative bureaucrats, urbane but also aloof, and for whom precedent-shattering gestures were simply unthinkable. This was not the stuff of which modern-day protests are made.

Other circumstances inviting comparison

The Vatican's "response" to the murder of European Jewry can only be understood in the context of its reactions to other events, particularly those that we now might well see as inviting a similar "speaking out" that has been called for in retrospect. For the truth is that the Holy See did not "speak out" in the face of a whole series of issues, including some in which its theological commitments or institutional interests were far more engaged than was the case with the persecution and murder of European Jews. The Vatican failed to denounce the Italian aggression against Abyssinia in 1935, or the use of poison gas in that campaign; the Holy See did not protest against the Nazi regime's pre-war policies of forcible sterilization, or the so-called euthanasia campaign in wartime, or the imprisonment of hundreds of priests in places like Dachau, Mauthausen, and Sachsenhausen. Despite the urgent appeals of Polish clergy, the pope never explicitly condemned the Nazi occupation policies in Poland, with the attendant murder of some 20 per cent of the Catholic clergy; and Pius XII received the Catholic dictator of Croatia, Ante Pavelić, within days of a spectacular massacre of Orthodox Serbs. At issue in every one of these cases seems to have been an assessment—perhaps even an unarticulated assessment—of vital interests of the Church and the weighing of priorities. Sometimes, too, we detect a dulling of awareness of particular atrocities in the face of other preoccupations, simply experienced as an undifferentiated ocean of human suffering; and perhaps timidity as well, a fear of adverse consequences if there were a breach of neutrality. Occasionally, there is internal evidence of rational calculations that negative consequences would ensue if particular protests would be issued. (Sometimes, Vatican officials warned that they *might* be obliged to protest—a threat, real or feigned, intended to bring results without paying the price of a genuine protest.) And lastly, we should not ignore the presence, even within the Holy See, of a garden-variety timidity, sluggishness, bureaucratic thinking, lack of imagination or spirit, or simply

a disinclination to face the possibility of harsh consequences even if these were unlikely to ensue.

Chronological shifts

Gerhart Riegner, the World Jewish Congress representative in Geneva during the war, makes the point that during the first half of the conflict it never occurred to Jewish organizations to approach the Vatican in a collective appeal: Jews seemed to have simply assumed that they would be on unfriendly ground, and that the Vatican had no interest in their plight. In mid-1942, when Jews were desperate, they abandoned these hesitations.[23] This point reminds us that we must be attentive to chronology in our assessment of the role of the Holy See. Pressures mounted to denounce the massacres of Jews in the latter part of 1942, as d'Arcy Osborne records—and indeed he was part of that pressure. As with all neutrals, the policy of the Holy See shifted when it became evident that the Germans were going to lose the war—with the added complication, in the Vatican's case, of the great fears for the Church because of Soviet advances. This theme is of real importance for the understanding of the willingness of the Vatican to be much more vocal in its protests to the Hungarian authorities in 1944 than it had been earlier in the war in the cases of other countries.

Possible impact of alternative policies

A widespread assumption made in many of the criticisms of the Vatican during the Holocaust is that a "flaming protest" or some similar action might have saved substantial numbers of Jewish lives. To some degree, of course, this contention is indisputable. After any man-made catastrophe, we can always assume that *some* lives could have been saved. When it comes to the Holocaust, let it quickly be said, practically no one "did enough"—and interpretations that focus on what did *not* happen, as well as being driven by hindsight, often duck the historians' challenge to comprehend what actually *did* happen. Moreover, historians such as Yehuda Bauer, familiar with the Nazis' determination to destroy the Jews

whatever obstacles were put in their path, have cautioned us against exaggerating the practical capacity of the pope or anyone else radically to affect matters. The resources of the papacy to obstruct the murder of European Jews in any substantial way, John Conway concludes, "were woefully inadequate."[24] The most likely effect of more strenuous interventions, he concludes, was that the Vatican would have revealed its own impotence—and thereby diminished its capacity to make any headway in other areas, to which it assigned a higher priority. Susan Zuccotti makes a strong case that the pope might have dissuaded the Germans from deporting hundreds of Jews rounded up in Rome in 1943.[25] There are less persuasive claims that the Holy See might have stayed the hands of Catholic perpetrators or communicated warnings to Jews. As with all such historical speculation or "might-have-beens" there is no way of proving or disproving these hypotheses. Most of them, I find, assume a different set of Nazi priorities, a different Church culture, a different understanding of the dynamics of mass murder—not to mention a different pope—than I understand from what actually *did* happen. Of course, about these matters, and particularly the last, debate is legitimate and should be enriched by reflections on the various points I have enumerated in this chapter.

Legacy

I think that it is no accident that some of the strongest condemnations of the role of the Vatican during the Holocaust have come from Catholic writers.[26] Their discontent, and even outrage in some cases, is driven to a large degree by high expectations—based in part, as John Morley says, on the Church's own pronouncements about its role in the world, or perhaps based on their own religious formation, frustrations, or disappointments.[27] As a non-Catholic, without such religious points of departure, I approach the "failures" I detect with more equanimity. The Catholic Church of the day, it seems to me at least, placed far more importance on the protection of its mission in the world—saving souls and preparing for the world to come—than it did upon saving lives. But I see such an emphasis as a product of the Church's history, environment, and culture. "Mainly on the defensive against the state, nationalism, secularism and socialism," writes Leonidas Hill, "always preoccupied with

the preservation of its remaining rights, little could be expected from the Church in the age of genocide."[28]

The events of the Holocaust, however, have wrought changes for us all. Horrified, and justifiably so, by what we have learned humanity is capable of, and shamed and angered by the abandonment of the victims, we now value "speaking out" as a measure of historical rectitude and a goal for all responsible agencies. We continue to look back upon the massacre of European Jewry to understand the consequences of inaction or of failing to live up to our ideals. We draw these lessons from the historical record—but this does not mean that, in doing so, we are always fair to those whose actions we implicitly or explicitly criticize for their inadequacy. To some degree, I believe, we seek vicarious involvement in these events of World War II, for which most of us were not present and upon which we had no impact, by condemning those who did not live up to *what we would like to think we would have done*. But is this a way to write or assess history? You will appreciate that I have my doubts.

NOTES

1. Some recent works on this subject include John T. Pawlikowski, "The Vatican and the Holocaust: unresolved issues," in Marvin Perry and Frederick M. Schweitzer, eds., *Jewish–Christian Encounters over the Centuries: Symbiosis, Prejudice, Holocaust, Dialogue* (New York: Peter Lang, 1994), 293–312; John Cornwell, *Hitler's Pope: The Secret History of Pius XII* (New York: Viking, 1999); Pierre Blet, *Pius XII and the Second World War: According to the Archives of the Vatican* (New York: Paulist Press, 1999); Giovanni Miccoli, *I dilemmi e i silenzi di Pio XII: Vaticano, Seconda guerra mondiale e Shoah* (Milan: Rizzoli, 2000); Susan Zuccotti, *Under His Very Windows: The Vatican and the Holocaust in Italy* (New Haven: Yale University Press, 2000); and Michael Phayer, *The Catholic Church and the Holocaust, 1930–1965* (Bloomington: Indiana University Press, 2000).

2. István Déak, "The Pope, the Nazis, and the Jews," *New York Review of Books*, March 23, 2000, 46.

3. See Georges Passelecq and Bernard Suchecky, *L'Encyclique cachée de Pie XI. Une occasion manquée de l'Église face à l'antisémitisme* (Paris: La Découverte, 1995).

4. Michael R. Marrus and Robert O. Paxton, *Vichy France and the Jews* (New York: Basic Books, 1981), 200–2.

5. See Frank J. Coppa, ed., *Controversial Concordats: The Vatican's Relations with*

Napoleon, Mussolini, and Hitler (Washington, D.C.: Catholic University of America Press, 1999).

6. John Conway, "Records and documents of the Holy See relating to the Second World War," *Yad Vashem Studies*, XV (1983), 333.

7. Thomas F. Stransky, preface to Pierre Blet, *Pius XII and the Second World*, xv.

8. Déak, "The Pope, the Nazis, and the Jews," 44.

9. Cornwell, *Hitler's Pope*, 271.

10. Hansjakob Stehle, *Eastern Politics of the Vatican, 1917–1979*, trans. Sandra Smith (Athens, Ohio: Ohio University Press, 1981), 213.

11. Yehuda Bauer, "When did they know?," *Midstream*, April 1968, 51–8; David Cesarani, *Arthur Koestler, the Homeless Mind* (London: Heinemann, 1998), 208–9.

12. Pierre Blet, Robert A. Graham, Angelo Martini, and Burkhart Schneider, eds., *Actes et documents du Saint Siège relatifs à la Seconde Guerre mondiale*, 11 vols. (Vatican City: Libreria Editrice Vaticana, 1965–81) [hereinafter ADSS], 9: 274. Maglione misidentifies the location of Treblinka, which was northeast of Warsaw, not in the vicinity of Lublin, which his entry seems to imply.

13. ADSS, 8: 669.

14. See David Alvarez and Robert A. Graham, *Nothing Sacred: Nazi Espionage against the Vatican 1939–1945* (London: Frank Cass, 1997).

15. ADSS, 8: 598.

16. ADSS, 8: 608. See also *ibid.*, 569–70 and 737–8, where Orsenigo warns Montini and Maglione that making appeals about "non-Aryan" deportees could have an adverse effect upon the deportees' situation.

17. Quoted in Blet, *Pius XII and the Second World War*, 165.

18. On the nuncios, see the classic work by John Morley, *Vatican Diplomacy and the Jews during the Holocaust, 1939–1943* (New York: KTAV, 1980).

19. ADSS, 2: 318–27.

20. Quoted in Owen Chadwick, *Britain and the Vatican during the Second World War* (Cambridge: Cambridge University Press, 1986), 315–16.

21. Alvarez and Graham, *Nothing Sacred*, 176.

22. Quoted in Chadwick, *Britain and the Vatican*, 317.

23. Gerhart Riegner, "A warning to the world," *The Stephen S. Wise Lecture*, November 17, 1983, 5.

24. Conway, "Documents of the Holy See," 339.

25. Zuccotti, *Under His Very Windows*.

26. See, for example, Garry Wills, *Papal Sin: Structures of Deceit* (New York: Doubleday, 2000).

27. Morley, *Vatican Diplomacy and the Jews*, 16.

28. Leonidas B. Hill, "History and Rolf Hochhuth's *The Deputy*," in R. G. Collins, ed., *From an Ancient to a Modern Theatre* (Winnipeg: University of Manitoba Press, 1972), 149.

John T. Pawlikowski

The Papacy of Pius XII:
The Known and the Unknown

The response of Pope Pius XII to the challenge of the Holocaust has been the subject of much discussion since the appearance of Rolf Hochhuth's play *The Deputy*. This discussion has often become polemical, as we have seen again in the discussion of John Cornwell's recent book *Hitler's Pope*.[1] For some scholars such as Fr. Peter Gumpel, S.J., who has been examining the cause of Pius XII for possible canonization, there is little question that the pope responded with great courage and humanity to the plight of the Jews and other victims of the Nazis. He was responsible, according to Gumpel, for saving hundreds of thousands of Jews and therefore deserves eventual sainthood. Gumpel's view has found its way into the Vatican document on the Holocaust, "We Remember."[2] Those promoting the canonization of Pius XII often cite statements by Jewish leaders such as Dr. Joseph Nathan of the Italian Hebrew Commission, Dr. A. Leo Kubowitzki of the World Jewish Congress, and Israeli Prime Minister Golda Meir, who praised the pope publicly for his efforts on behalf of Jews. While these testimonials need to be included in any comprehensive assessment of Pius XII's papacy, they hardly represent the totality of thinking on Pius XII within the Jewish or Christian communities. There are trenchant critiques that must also be taken seriously in any overall evaluation of Pius's record during the critical period of the Holocaust, and it is simply unfounded to say that criticism of Pius XII only began with the onset of Hochhuth's play.

The critics of Pius XII, both Christian and Jewish, argue that his public silence regarding the Jews contributed to the staggering loss of Jewish and other lives under the Nazis. They seriously question the claim made by Gumpel and "We Remember" that he saved "hundreds of thousands" of Jewish lives. Rather they portray Pius XII as a rather cold, even callous personality marked by a deeply inward spirituality, whose principal concern was preserving the institutional well-being of the

Church and consolidating papal power. While some of these critics would admit that he made a few efforts to save Jews, Jewish rescue never became an important priority for him during the Nazi era. John Cornwell's book is an extreme example of such a perspective.

It is regrettable that the discussion about Pius XII has become so polarized. Such an atmosphere makes it difficult to pursue an open, well-researched evaluation of Pius XII. For that reason, it would be wise, and ultimately enhance Catholic integrity, if scholars were allowed to complete their research on his papacy without the immediate prospect of canonization hanging over their heads. Referring to the thorough investigation of the record of the Lyons, France, archdiocese during the Nazi era mandated by the archbishop of that city under the direction of respected historians, the late Cardinal Joseph Bernardin said, in a plenary address to the Vatican–Jewish International Dialogue in Baltimore (May 1992), that "it is only through candor and willingness to acknowledge mistakes where documentary evidence clearly warrants it that Catholicism can join in the pursuit of justice with full moral integrity."[3] The late cardinal's words, and the Lyons model, should become the framework for an investigation of Pius XII's record during the Nazi era.

An objective evaluation of the scholarly research thus far yields a very mixed picture. On the one hand, we now know from the published archives of the period released by the Vatican and intensely studied by a joint Catholic–Jewish team of scholars, as well as from other documentation, that Pius XII does not deserve the label of "silent" because most who hear that term interpret it to mean that he did nothing for Jews and other victims. There may be more of an authentic argument for the term in the restricted sense of his not going public with criticism of the Nazis with reference to the Jews. But the unqualified use of the term "silent" obscures the results of recent scholarship regarding some of the positive efforts Pius XII did undertake, almost exclusively through diplomatic channels. And the memoirs of the late Cardinal Henri de Lubac, S.J., a leader in the French Catholic resistance during World War II, show that at least some Catholics understood Pius XII's general public criticisms of the Nazis as applying primarily to the treatment of the Jews.[4]

The writings of Vatican archivists such as the late Fr. Robert Graham, S.J.,[5] and his present successor, Fr. Pierre Blet, S.J.,[6] demonstrate that Pius XII and his diplomatic representatives made important interventions in a number of places, particularly towards the end of the war. I have detailed a number of these interventions in previous writings

on the subject.[7] Let me summarize a few of the more significant ones here. In the early years of the war, the available archival materials do show some Vatican diplomatic pressure on countries with close ties to the Holy See—such as Spain and Portugal—to grant exit and transit visas to fleeing Jews. When the emigration option was gradually closed off between 1940 and 1942, the Catholic strategy, presumably developed in consultation with Pius XII, shifted to diplomatic protests over deportations. True, we have no available records indicating that there was a direct order from Pius XII in this regard (the policy was executed through the Vatican Secretariat of State). But the historically close connection between popes and their secretaries of state (the most important office in the Vatican next to the papacy) makes it quite reasonable to assume that Pius XII was apprised of these developments and gave at least tacit approval to their implementation.

Three countries in particular are generally singled out as the sites of important, if not critical, interventions by the Vatican under Pius XII. One is Slovakia. When it became known in March 1942 that some eighty thousand Slovak Jews were to be forcibly removed from the country, the Vatican's response was instantaneous. Protests came from the papal representatives in Bratislava and the papal nuncio in Hungary. And when another round of deportations was scheduled for 1943, the Vatican again raised its voice in denunciation of the proposal. Finally, in 1944, when it appeared that yet more deportations were in the offing, the Holy See instructed its representative in Slovakia to approach both the foreign ministry and President Tiso (a Catholic priest who in fact should have been disciplined more severely by the Vatican for his direct involvement with the Nazis) in its name. The representative's instructions were to make clear "that the Holy See expects from the Slovak authority an attitude in conformity with the Catholic principles and sentiments of the people of Slovakia."[8] In a follow-up action, Vatican officials spoke with the Slovak minister to the Vatican, presenting him with the following message: "The Holy See, moved by those sentiments of humanity and Christian charity that always inspire its work in favor of the suffering, without distinction of parties, nationalities or races, cannot remain indifferent to such appeals. ..."[9]

One of the most noteworthy and successful instances of Vatican activity for the security of Jews occurred in Hungary. Prior to 1944, this country's Jewish community enjoyed relative freedom despite the passage of severe antisemitic legislation before that time. The Hungarian

government had steadfastly refused to turn over its own Jewish citizens, as well as Jewish refugees from Poland and Slovakia, for the greater part of the Nazi era. But all that changed in March of 1944 when German armies advanced into Hungary. The previous leader of Hungary, Admiral Miklós Horthy, was eventually replaced by a local government composed primarily of fanatical antisemites of the Arrow Cross movement. Deportations to Auschwitz and Austria for forced labor and outright massacre now became the fate of the Jews.

Volume 10 of *Actes et documents du Saint Siège relatifs à la Second Guerre mondiale* contains massive documentation on the Holy See's central role in the international effort to save Hungarian Jews. While Admiral Horthy was still in charge after the Nazi invasion, the papal nuncio Angelo Rotta engaged in ongoing communication with Hungarian governmental officials, and with the Vatican, trying to find ways to bring the Jewish deportations to a halt. This furious activity by Rotta during the first part of the period of Nazi occupation culminated with the release of an "open" telegram to Admiral Horthy from Pius XII, which read in part: "We are being beseeched in various quarters to do everything in our power in order that, in this noble and chivalrous nation, the sufferings, already so heavy, endured by a large number of unfortunate people, because of their nationality or race, may not be extended and aggravated. As our Father's heart cannot remain insensitive to these pressing supplications by virtue of our ministry of charity which embraces all men, we address Your Highness personally, appealing to your noble sentiments in full confidence that so many unfortunate people may be spared other afflictions and other sorrows."[10]

This papal appeal was followed in quick succession by other international interventions, including a press campaign in Switzerland and a warning from British Foreign Secretary Sir Anthony Eden. The bombing of Budapest was also ordered by the Allies. These joint efforts resulted in a suspension of Jewish deportations by Horthy for which Jewish organizations and the War Refugee Board expressed special gratitude to the Vatican.

After Horthy was finally deposed, Rotta found his work on behalf of Jews far more difficult. With the assistance of the noted Swedish diplomat, Ambassador Raoul Wallenberg, he managed to arrange a meeting with the new Arrow Cross leadership. But he later admitted that his plea that the Jews be spared went nowhere. He found the Arrow Cross leadership filled with total contempt and hatred for the Jews. Yet

Rotta did not curtail his efforts. He looked for non-governmental ways to protect Jews. One scheme he devised was to issue "Letters of Protection," which had some positive effect in terms of postponing deportation for those who received them. It has to be said in all candor, however, that this scheme had its greatest success with baptized Jews for whom it served as a kind of "habeas corpus." Rotta's report to the Vatican claimed the issuance of more than thirteen thousand such documents. There is no indication that the Vatican leaders had any difficulty with Rotta's outreach to Jews.

There is no doubt that if one is to point to a bright spot in the official Catholic response to the plight of the Jews under the Nazis, Hungary would be it. That is not to say more might not have been done. But when one compares official Church efforts in Hungary (and there is no way Rotta would have acted totally on his own—his effort was too extensive) to those in other countries, Hungary clearly stands out. In his published memoirs—still available only in French—an important Jewish leader of the time, Dr. Gerhart Riegner of the World Jewish Congress, also acknowledges Vatican initiatives in Hungary as a positive contribution to Jewish rescue.[11] But, despite emphasizing the positive side of the Vatican's record in Hungary, he remains far less enthusiastic about Pius XII's overall record than either Robert Graham or Pierre Blet.

Italy is the third country where Vatican action is notable. The Vatican made some direct interventions on behalf of the Jews of Rome and supported the significant effort of religious convents and monasteries in Rome to hide Jews. While the hard documentary evidence for Vatican involvement in the latter effort may be a bit slim, it is impossible to imagine, given Church structures, that individual convents and monasteries would have acted as extensively as they did in terms of Jewish rescue if they had not felt considerable support, even if tacit, from the Vatican authorities who were present in their midst. Anyone who argues otherwise simply does not understand Church structure from the inside. In terms of political interventions with Nazi authorities over the fate of the Italian Jews, there is the example of the October 1943 meeting between the Vatican Secretary of State, Cardinal Luigi Maglione, and the Reich ambassador, Ernst von Weizsäcker, during which Maglione vigorously protested the special SS raid which had seized some one thousand Jews for transfer to Poland. He spoke of the pain experienced by Pius XII over this act and over the suffering of so many persons solely because of their race.

These examples by themselves are sufficient to undercut any accusation that Pius XII was totally indifferent to the Nazi onslaught against the Jews. He certainly was not "silent" if that is taken to mean he was totally callous and indifferent towards Jews in terms of Vatican policy. It is my fervent hope, as I have already said above, that the term "silent" will disappear from both scholarly and popular literature about Pius XII. Its continued use seriously impedes an honest examination of his complicated record.

Turning to the questionable aspects of the Vatican's posture towards the Holocaust under Pius XII, many questions come to the surface. The following are some that require continuing scrutiny by scholars if we are to reach a relatively complete assessment of his moral stature as a religious and world leader during one of the critical periods of the twentieth century.

In the first instance, there is the question of evaluating Pius XII's actions, or, better, non-actions, in the early years of the Third Reich. One of the basic flaws in the analyses provided by Frs. Graham and Blet is their failure to confront the following question: what if the pope had acted sooner, and more decisively, in the initial phases of the Final Solution? Upon close examination of their writings, one finds that the examples of papal interventions they cite come primarily from the latter period of the Holocaust. One argument sometimes heard is that the pope and other ranking Vatican officials were not fully cognizant of the extent of the Nazi attack on the Jews until this time. But Gerhart Riegner, in his memoirs and in his Stephen S. Wise lecture at the Hebrew Union College in Cincinnati in 1983, raised an important question to which Vatican officials have not adequately responded. In March 1942, Riegner assisted in the preparation of a joint World Jewish Congress/Jewish Agency memorandum at the request of the papal nuncio in Bern. This document detailed the plight of Jews in those countries where the Vatican was deemed to have particular influence because of a large Catholic population. Included on the list were Slovakia, Croatia, Hungary, Romania, and Vichy France. Riegner has noted that this detailed memorandum is not reproduced in the Vatican's officially released documentary collection covering the Holocaust era. While the receipt of the memorandum by the Vatican is acknowledged in the documentary collection, Riegner wonders why the actual text was left out. This is a good question, even though the text has been published elsewhere so there is no question of the Vatican's concealing the text of the

memorandum. But in my judgment the memorandum should have been reproduced in what is the primary scholarly resource for inquiry into the Catholic Church's role during the Holocaust. The document's absence does open the way for suspicion, valid or not, that the Vatican is trying to downplay its knowledge about the full extent of the attack on the Jews until rather late in the war. This document confirms that, fairly early in the Holocaust, Pius XII's Vatican was privy to extensive information about Jewish suffering and death under the Nazis. This finding was recently confirmed by the discovery in a flea market of messages from a British source to the Vatican at the beginning of the Nazi full-scale onslaught against the Jews. Establishing when the Vatican knew the full extent of the Nazi genocidal plan for the Jews is very important in assessing the quality of the Holy See's response, since many of the active interventions of Pius XII and his Curia come only towards the end of the war. These factors give legitimacy to the question that scholars such as Graham and Blet do not adequately address: what if Pius XII had acted much sooner, even in the limited ways he eventually did?

Riegner argues as well that, in the first years of Nazi rule, the Catholic Church, if interested in the Jewish question at all, tended to confine its interest to the situation of baptized Jews. Even in Hungary, as I have pointed out above, baptized Jews were accorded a significant portion of the "Letters of Protection" issued by Angelo Rotta. This strong emphasis on protecting only baptized Jews was especially pronounced in Germany. Ernst Christian Helmreich, a scholar fundamentally sympathetic to Catholicism's difficulties in responding to the Nazi regime, as well as providing research on internal Nazi documents which monitored Church activities in Germany, tends to support Riegner's assertion on this point.[12] These studies provide further indications that in the early days of Nazism the Vatican gave little priority to the protection of the Jewish community in Europe as a whole.

Riegner also recalls that, in the early years of World War II, Jewish organizations were very apprehensive about soliciting help from Rome, much more so than from the Protestant religious establishment. This reluctance was in large measure the result of perceptible sympathy for Nazism on the part of some Catholic bishops in Germany as well as a sense that the Vatican would do what it took to achieve a concordat with Hitler. To be fair, the reluctance of Jewish leaders such as Riegner to approach the Vatican for assistance was also due to a recognition of the Vatican's fragile "enclave" position within Fascist Italy. The perception of

deep Vatican reserve on the Jewish question within the Jewish leadership tends to confirm that the Vatican was sending out a message that the concordat was of the highest priority and it would not allow other issues to distract significantly from, or undercut, that primary policy goal. The Jewish leaders' assessment tends to confirm other critics of the Vatican on the concordat issue. Pius XII's motives were more honorable (and more in line with traditional Vatican diplomatic policy) in pressing for the concordat than the sinister interpretation of John Cornwell about the priority of the concentration of papal power would have it. Yet there is little question that the desire for the concordat, even though Pius XII was aware that Hitler might not faithfully observe it, muted Vatican concern for the Jews in the early days of Nazism and the war.

It was not until 1942 that Jewish organizations began to petition the Vatican for assistance on a regular basis. This change was less the result of a perceived change in Vatican policy than the outcome of a sense of growing desperation about the ever-worsening condition of European Jewry. In Riegner's view, the response to these Jewish appeals was not overwhelming. Overall, Riegner concludes that Vatican comprehension of the full extent of the Jewish catastrophe was very late in coming, if it was ever understood at all. Riegner cites as an example a conversation he had in October with Msgr. Montini—he later became Pope Paul VI—in which Montini strongly contested Riegner's claim that approximately 1,500,000 Jewish children had died under the Nazis.[13]

We also need to look at Pius XII's record immediately after the war ended. In several writings, most especially in *The Catholic Church and the Holocaust, 1930–1965*, Michael Phayer has devoted considerable attention to this facet of Catholic leadership and to Pius's actions in particular.[14] Phayer critiques Pius XII for not showing forthright leadership in the immediate post-war period, thus allowing for widespread ambiguity in Catholic circles, including formidable opposition to the Nuremberg Trials. In his analysis, he draws extensively upon the archives of Jacques Maritain, the eminent French Catholic philosopher, who resigned his post as French ambassador to the Vatican in protest over Pius's immediate post-war stance. Maritain, it seems, tried to convince Pius XII that he must address the issue of German collective responsibility, especially that of German Catholics, even though they were not directly involved in the activities of the Gestapo and the SS. In Maritain's view, collective responsibility could not be ignored. Pius XII, according to Phayer, refused to heed Maritain's advice. In fact, he took

steps to undermine the 1945 Fulda statement by the German bishops in which they argued that all those who took part in the atrocities had to be brought to justice. The Maritain archives need further investigation. Criticism from a Catholic of his stature cannot be dismissed out of hand.

The one issue about which I have some disagreement with Phayer is the so-called "rat line" which enabled some Nazis to find safe haven in Latin America with the cooperation of certain Catholics with Vatican connections. I do not deny the existence of such a "rat line," nor that there were Catholics involved. Without question, the Croatian College in Rome played an important part in helping Nazis escape, something that I regard as morally deplorable. But presently the evidence is quite insufficient to prove that such a "rat line" was formal policy at the Vatican or that a significant number of prominent Vatican leaders had any ties to, or even knowledge about, this effort. As a scholar, I always hold open the possibility that new evidence might come forth at some moment that would one day substantiate this thesis. Some lawyers in California have recently filed a suit to force open U.S. governmental archives which they claim will prove the accuracy of the "rat line" thesis. If there are such documents, I would urge their release. We are in an era when "transparency" is regarded as critical for moral integrity. But the "rat line" thesis should not be promoted until, and if, more substantial documentary evidence is brought forth.

One small piece of documentary evidence that relates to the "rat line" thesis supposedly exists in the national archives of the Argentine Republic. An archivist from there has described for me the content of a letter by Cardinal Giovanni Battista Montini to the Argentine government. Written right after the war, and supposedly in the name of Pius XII, Montini's letter asked the Argentine government to take in people under suspicion for aiding the Nazi cause. Until it is possible to read the actual text of this letter, it is necessary to reserve judgment. But if this letter does, in fact, say what the archivist has described and what has been reported in the press as well, it would mark the first documentary evidence we have linking Pius XII directly to the effort to save Nazi collaborators. In itself this document alone would not confirm the "rat line" thesis. But it would require us to continue to pursue this line of inquiry with renewed dedication. Research into the post-war activities of the churches, including the Vatican, is still in a developing phase. Hence it is too early for us to reach anything but tentative conclusions.

The research on Pius XII's response to the Nazi invasion of Poland

needs greater emphasis. The relations between the Vatican and Poland, as Michael Marrus has argued, provide a useful parallel study to the question of Pius XII, the Holy See, and the Jewish community during World War II. For in the case of Poland we have a staunchly Catholic community which, as historians are increasingly bringing to light, became nearly as critical as the Jews regarding the policy of reserve that prevailed in the Vatican of Pius XII.

Polish-American historian Richard Lukas has surfaced this issue in his writings on the Nazi attack against Poland. He recognizes the practical difficulties the Vatican faced with respect to Poland, in part due to the flight of Cardinal August Hlond, the primate, from the country, which caused considerable disruption in the Polish Church. Pius XII's cold reception of Hlond in Rome is considered one saving feature of the pope's overall approach to Poland. For Lukas, however, the balance sheet does not read well. He supports his evaluation with references to concrete reactions by Poles during the period.

"In the face of the persecution of the church of Poland," says Lukas, "the Vatican pursued a timid, reserved attitude."[15] This was probably the result of a constellation of forces—a sentimentality about Poland on Pius's part, a tinge of "Germanphilism," and fears that public denunciations would make matters worse for the Poles. It was not until June 2, 1943, that the pope finally issued a long-awaited statement. And here again, just as in the case of the Jews, Pius shied away from directly condemning the Nazis.

The 1943 statement, which admittedly did ease Polish–Vatican tensions, was an effort to counteract the widespread criticism that had grown up within clerical ranks because of the Vatican's seeming hesitancy on the Polish question. There were even Polish voices calling for the severing of ties with the Vatican. Some Poles, according to Lukas, were so upset at Rome that they left church at the mention of Pius's name. The Jesuits of Warsaw were so concerned about the situation that they published a defense of the Vatican's activities on behalf of Poland. And John Morley, who also raises the Polish question and sees Vatican inaction there as a result of the primacy in Vatican eyes of the relationship with Germany, relates that Rome explicitly instructed its nuncios on how to counter the mounting dissatisfaction with its approach to Poland.[16]

The question of Pius XII's attitudes towards liberalism and Bolshevism needs to be explored in greater depth. Was he so overcome by opposition to these ideologies, and their potential threat to the

survival of the Church, that he was willing to mute criticism of the Nazis in the vain hope that Nazism would provide a buffer against these "enemies" of the Church? This is especially the case with opposition to liberalism and its emphasis on human rights. Pius XII's papacy came at the end of a hundred years' war against liberalism on the part of the Vatican. I would contend that the lack of a human rights perspective significantly curtailed the Catholic institutional response to Nazism. I develop this thesis in greater depth in other published writings.[17] Without a commitment to human rights of the magnitude found in Pope John XXIII's encyclical *Pacem in Terris* (*Peace on Earth*), it was easier for the Catholic Church to dismiss the Jews as "unfortunate expendables," as some Holocaust scholars have termed them, within a narrow ecclesiology that focused primarily on the preservation of the Church as an institution. The significance of the signing of the concordat and the way in which the Center Party in Germany was neutralized by Pius XII need further investigation in this regard. While John Cornwell's interpretation of these papal developments is simplistic, as I have said above, he is correct in emphasizing the issue of the concordat in any evaluation of Pius XII's stance during the Nazi period.

There is a growing consensus among scholars that Pius XII's commitment to a "diplomatic" model of the Church at the level of the Vatican, flowing in large measure from his desire not only to preserve the Church as an institution, but also to ensure the continuation of the conservative social order he and his circle deemed essential for Catholicism's well-being, played an absolutely critical role in conditioning his response to the plight of the Jews, Poles, and other Nazi victim groups. Michael Marrus has argued, quite correctly I might say, that a policy of "reserve and conciliation" shaped Pius XII's approach and served as a general paradigm for the Vatican's diplomatic corps. In part, this approach may bear the stamp of his mentor Pope Benedict XV, who saw himself as a potential architect of European peace. For Marrus, the controlling reality in the administration of Pius XII was Church preservation. "The goal," says Marrus, "was to limit the global conflict where possible, and above all to protect the influence and standing of the Church as an independent voice." Fearful of internal conflict, even the possibility of a schism, and apprehensive of threats from the outside, "Pius XII exhibited great reluctance in terms of direct confrontation with the Nazis or the Italian Fascists."[18]

Behind Pius's "diplomatic" orientation in political affairs, there

seemed to lie a fundamental theological understanding of the Church as a "holy and spotless" reality whose true meaning went beyond this world. It is only in some of the Christmas addresses of the early 1940s that we begin to see hints that Pius may have concluded that a totally new social order was necessary, even from the perspective of the Church. While it would be difficult to prove decisively, it can at least be suggested that this general shifting of posture on the social order in Europe may have been responsible for his heightened commitment to Jewish and Polish security in the final years of the Third Reich.

A word needs to be added here about Pius's spirituality. John Cornwell maintains that a deeply inward spirituality conditioned Pius XII's approach to the Jews and other Nazi victims. Pius XII, he argues, saw little connection between his spirituality and concrete victimization in his day. Some reviewers of Cornwell's book have picked up positively on this analysis. Personally, I would agree with Msgr. George Higgins in playing down the significance of Pius's spirituality. There is no question that such an inward spirituality is apparent in Pius XII. But it was commonplace among the clergy at that time. This is not to defend it, but to say that, despite this spirituality, Pius XII clearly saw the need for the involvement of the Church in politics. It was only that the politics he chose did not make much room for the majority of Nazi victims. So the problem in my judgment was more the politics coupled with his ecclesiology rather than Pius's inward spirituality.

A cautionary note must be sounded as I bring this chapter to a close. While it is critical to focus on the record of Pius XII, we cannot ignore research into more regional Catholic responses. Such research is absolutely critical for any overall assessment of Catholicism's role during the Holocaust. We likewise need greater access to the remaining, unopened Vatican archives from this period, as well as access to relevant archives from national governments and individuals (such as Ambassador Maritain) with close connections to Pius XII. Since he left us no real diaries or personal letters, we need to obtain a better fix on how key people of the time regarded him.

In the light of the remaining gaps in research, the process of fully investigating Pius XII's record should not be short-circuited by raising him to the status of "blessed" or "saint." The initial investigative process in this regard can certainly continue, but no action should be taken until the scholarly assessment of his overall record is much more thorough. There is also need to widen the usual parameters of such a scrutiny

relative to sanctification with the inclusion of a wide range of scholarly evaluations of his papacy. He was no ordinary Christian, but the leader of Christianity's largest denomination during one of the Church's most challenging periods. Any final judgment on his moral stature must be viewed in that context.

NOTES

1. John Cornwell, *Hitler's Pope: The Secret History of Pius XII* (New York: Viking, 1999).
2. See the Holy See's Commission for Religious Relations with Jews, "We remember: a reflection on the *Shoah,*" footnote 16, in Secretariat for Ecumenical and Interreligious Affairs, National Conference of Catholic Bishops, *Catholics Remember the Holocaust* (Washington, D.C.: United States Catholic Conference, 1998), 55–6.
3. See Cardinal Joseph Bernardin, *A Blessing to Each Other: Cardinal Joseph Bernardin and Jewish–Catholic Dialogue* (Chicago: Liturgy Training Publications, 1996), 132.
4. See Henri de Lubac, *Christian Resistance to Anti-Semitism: Memories from 1940–1944* (San Francisco: Ignatius Press, 1990).
5. See Robert Graham, S.J., *Pius XII's Defense of Jews and Others: 1944–45* (Milwaukee: Catholic League for Religious and Civil Rights, 1987); Robert A. Graham, "When the Pope was accused of 'wanting and sustaining' the war: a symptomatic interlude of 1943," *Pro Fide et Iustitia* (Berlin: Duncker & Humboldt, 1984), 563–75; Robert Graham, "Die diplomatischen Aktionem des Heiligen Stuhl für die Juden in Ungarn im Jahr 1944 und Pius XII und seine Zeit," *Pius XII zum Gedächtnis* (Berlin: Duncker & Humboldt, 1977), 191–259; Pierre Blet, Robert A. Graham, and Angelo Martini, eds., *La Saint Siège et la guerre mondiale, juillet 1941–octobre 1942* (Vatican City: Libreria Editrice Vaticana, 1969).
6. Pierre Blet, S.J., *Pius XII and the Second World War According to the Archives of the Vatican* (New York: Paulist Press, 1999).
7. See John T. Pawlikowski, "The Vatican and the Holocaust: unresolved issues," in Marvin Perry and Frederick M. Schweitzer, eds., *Jewish–Christian Encounters over the Centuries: Symbiosis, Prejudice, Holocaust, Dialogue* (New York: Peter Lang, 1994), 293–312; John T. Pawlikowski, "The Catholic response to the Holocaust: institutional perspectives," in Michael Berenbaum and Abraham J. Peck, eds., *The Holocaust and History: The Known, the Unknown, the Disputed and the Reexamined* (Bloomington, Ind.:

Indiana University Press in association with the United States Holocaust Memorial Museum, 1998), 551–65; John T. Pawlikowski, "The legacy of Pius XII: issues for further research," *Catholic International* (October 1998), 459–62.

8. As quoted in Graham, *Pius XII's Defense of Jews and Others*, 21.

9. *Ibid.*

10. *Ibid.*, 29–30.

11. See Gerhart M. Riegner, *Ne jamais désespérer: soixante années au service du peuple juif et des droits de l'homme* (Paris: Les Éditions du Cerf, 1998). See also Gerhart M. Riegner, "A warning to the world: the efforts of the World Jewish Congress to mobilize the Christian Churches against the Final Solution," *The Inaugural Stephen S. Wise Lecture*, Cincinnati, Hebrew Union College–Jewish Institute of Religion, November 17, 1983.

12. Ernst Christian Helmreich, *The German Churches under Hitler: Background, Struggle, and Epilogue* (Detroit: Wayne State University Press, 1979), 364; Otto Dov Kulka, "Popular Christian attitudes in the Third Reich to National Socialist policies towards the Jews," in Otto Dov Kulka and Paul R. Mendes-Flohr, eds., *Judaism and Christianity under the Impact of National Socialism* (Jerusalem: Historical Society of Israel and the Zalman Shazar Center for Jewish History, 1987), 251–67.

13. Gerhart Riegner, "A warning," 11.

14. Michael Phayer, *The Catholic Church and the Holocaust, 1930–1965* (Bloomington, Ind.: Indiana University Press, 2000).

15. Richard Lukas, *The Forgotten Holocaust: The Poles under Nazi Occupation 1939–1944* (Lexington, Ky.: University Press of Kentucky, 1986), 16; and John T. Pawlikowski, "The Nazi attack on the Polish nation: towards a new understanding," in Hubert G. Locke and Marcia Sachs Littell, eds., *Holocaust and Church Struggle: Religion, Power and the Politics of Resistance*, Studies in the Shoah, XVI (Lanham, Md.: University Press of America, 1996), 33–44.

16. John Morley, *Vatican Diplomacy and the Jews During the Holocaust: 1939–1943* (New York: KTAV, 1980), 209.

17. John T. Pawlikowski, "Liberal democracy, human rights, and the Holocaust: the political and historical context of Pope Pius XII," *Catholic International* (October 1998), 454–8.

18. Michael Marrus, "The Vatican and the Holocaust," *Congress Monthly* (January 1988), 7.

Eugene J. Fisher

What Is Known Today:
A Brief Review of the Literature

My contention is that full release of the Holy See's archives would not result in very much startling new evidence about Pope Pius XII and the Holocaust, but would tend to confirm at least the basic outlines of what is already known. Full archival disclosure, however, might shed significant light on a large number of ongoing, more specific issues.

Current historical evidence

I believe that we have sufficient historical evidence available already to discern essential patterns, although new documentation could well enrich contemporary scholarly debates.[1] I say this, first, because the Holy See's documentation impresses me as reasonably representative, which is what the Vatican affirms. Indeed, this conclusion was a central one drawn by the six scholars, three Jewish and three Catholic, who studied the 11 volumes of materials already published by the Holy See but heretofore, it is fair to say, underused.[2] An additional measure of this kind can be seen in the varying responses to the material given earlier by scholars. For example, in books they published in the same year, 1980, two Catholic priests, Fathers John Morley and Michael O'Carroll, came up with very different findings, but their work interpreted similar evidence.[3] Second, a great deal of evidence is available from other sources, Jewish as well as Catholic, and it complements what one finds in the Holy See's published archival materials.[4]

In this context, I find intriguing and compelling Pope John Paul II's confident assertion during his meeting with Jewish leaders at the start of his 1987 visit to the United States:

It is fitting to recall the strong, unequivocal efforts of the popes against anti-Semitism and Nazism at the height of the persecution against Jews. Back in 1938, Pius XI declared that "anti-Semitism cannot be admitted" (September 6) and he declared the total opposition between Christianity and Nazism by stating that the Nazi cross is an "enemy of Christ" (Christmas Allocution, 1938). His successor, Pius XII, as is known, never wavered from Pius XI's staunch opposition to Nazism.

In addition, when Pope John Paul II came to the United States in 1987, he declared: "I am convinced that history will reveal ever more clearly and convincingly how deeply Pius XII felt the tragedy of the Jewish people and how hard and effectively he worked to assist them during the Second World War."[5]

Certainly John Paul II's judgments fit Pope Pius XI, whose German-language anti-Nazi encyclical *Mit brennender Sorge* in 1937 has been called "one of the greatest condemnations of a national regime ever pronounced by the Vatican."[6] There are, as well, some things that can be said with equal clarity about Pope Pius XII. This is the conclusion of Fr. John Pawlikowski after going through the multiple volumes of Vatican archival material, which includes guiding articles written by the English language editor, Fr. Robert A. Graham, S.J.[7] Pawlikowski states:

> In one sense Graham has ably performed his task. He has clearly demonstrated that simplistic claims about papal silence (during the Holocaust) are grossly overstated. There is absolutely no question that Pius and members of his administration in Rome undertook important initiatives in behalf of *all* Jews and not merely Jewish converts to Christianity. In fact, on the basis of Graham's evidence alone (which can easily be substantiated from other Christian and Jewish sources) we should permanently strike the word "silence" from all Christian–Jewish conversations about the role of institutional Catholicism during the Holocaust. There is a perfectly legitimate discussion to be pursued about the adequacy and the suppositions of Pius's and the Vatican's approach. But this is an altogether different issue from the charge of basic "silence." Those in the Jewish community who continue to allow this charge to go unchallenged are failing in their leadership responsibilities.[8]

Pawlikowski pursues this "legitimate discussion," letting the chips fall where they may in his viewpoint. Examining the existing evidence, he notes significant initiatives of the Holy See to ameliorate the condition of Jews in Hungary,[9] Slovakia, Romania, France,[10] and Italy.[11] Assessing

other available materials, he also notes evidence that shows "how great a part traditional Catholic antisemitism played," not so much "in determining the Vatican stance towards the Jews during the Nazi era" (this, rightly for Pawlikowski, is one of the "unresolved issues" of his title) but in Vatican policies regarding "several countries, including France, Germany and Poland."[12]

Pawlikowski's willingness to allow legitimate criticism of Catholic policy and even Vatican diplomacy adds, I believe, to the credibility of his quite justified rejection of the "silence" allegation. It is just such non-polemical, non-apologetic discussion that must prevail between Jews and Catholics working together on the same evidentiary material, country by country. Only analysis of that kind will establish the solid foundations of historical scholarship upon which a lasting historical consensus can be built.

One aspect I would add to Pawlikowski's approach is a plea that greater attention be paid to the context of the times in which the various actors, the pope included, were forced to make their day-to-day decisions. I mention this point because Pawlikowski's "tentative conclusions" raise questions as to whether "Pius's commitment to a 'diplomatic' church model at the level of the Vatican"[13] amounted to "a principle that appeared to curtail the Vatican's response" to what was happening not only to Jews but also to Polish Catholics under Nazi occupation.[14] While agreeing with Pawlikowski that the Church's willingness to engage with the issues of the modern world, which began with Pope John XXIII and received the support of the Fathers of the Church at the Second Vatican Council, marks a major trend in the Church today, I believe that scholars need to cast their nets more deeply into the history of the Papal States (and their dissolution, beginning even with the Napoleonic era) to understand how it was that the socially active and internationally involved papacy of the high Middle Ages became the "diplomatic" papacy of the mid-twentieth century.

Here, I would recommend on a popular level Anthony Rhodes's helpful *The Vatican in the Age of the Dictators*. This text shows something of the larger context and, indeed, historical constraints, within which the Holy See had to operate internationally during the period of the rise of Fascism and National Socialism. This is crucial for a proper interpretation of the mixture of public cautiousness and private activism undertaken by Pope Pius XII during World War II. Particularly helpful in this regard is the survey of the literature by Jewish historian Michael R. Marrus, which

illustrates the benefit of viewing the events of the mid-twentieth century within the larger context of Church history. Marrus's perspective enables him, unlike Rolf Hochhuth or other polemicists, to "see the policy of Pius XII as consistent with a longstanding tradition of Vatican diplomacy."[15] Likewise, Marrus is able to view the Holy See's public "posture of neutrality" as consistent with the fact that "the papacy maintained its reserve not (only) against Jewish appeals but in the face of others as well," such as those from Poland.[16] While by no means losing a critical edge with regard to the failures of Christians as "bystanders," among whom he includes the Holy See, Marrus is able to conclude on the basis of current scholarship that:

> Our understanding of church policy now extends considerably beyond Hochhuth's accusations and related charges of pro-German and antisemitic pressures at the Vatican. It is true that Pacelli feared the triumph of Bolshevism in Europe. But Vatican documents do not indicate a guarded pro-Nazism or a supreme priority of opposition to the Soviet Union. Indeed, they indicate in many ways that Nazism was the greater immediate threat to and persecutor of the Church. Nor do they reveal a particular indifference to the fate of Jews, let alone hostility to them. Rather, [they] suggest a resolute commitment to its traditional policy of reserve and conciliation. The goal was to limit the global conflict and above all to protect the influence and standing of the Church as an independent voice.[17]

Essential to Hochhuth's polemic and to much of the contemporary media's "take" on the issue is an implicit notion that "if only" the pope had spoken out more clearly all would have changed. This simplistic theory, like the discredited notion of papal "silence" debunked by Pawlikowski, should also be taken out of the discussion. Michael Marrus's survey of the literature in the field is able to cite scholars otherwise critical of the Holy See on this central point:

> In retrospect, some historians have come to appreciate the tactical caution of the Holy See. Guenter Lewy, for example, suggests that a "flaming protest" by the pope against the perpetrators of genocide would almost certainly have failed to move the German public and would likely have made matters worse—especially for the half-Jews or *Mischlinge*, as well as for practicing Catholics in Germany.[18]

The Holocaust and Christian responsibility

If all had been well, if Christianity in Europe had been doing its most basic job over the centuries preceding the Holocaust, it is very doubtful that six million Jews and millions of Roma (Gypsies), Slavs, and others would have been murdered by the Nazis. Modern languages would not have had the word *genocide*, which was invented precisely to describe what the Nazis tried and almost succeeded in doing to the Jews of "Christian" Europe—murder each and every child and adult. I would argue, however, that the issue at heart is not one of a Christian versus a Jewish interpretation of events, nor one that can be neatly categorized between pro- and anti-Christian or pro- and anti-Catholic stances.[19] Individual Christians were and are responsible for what they did or did not do. The larger issue of contemporary dialogue is not Christians but Christianity, not personal guilt but the objective impact of Christian teaching on the minds and hearts of Jesus' followers in their relations with their Jewish neighbors through the centuries.

Yosef Yerushalmi argued that if genocide, as our century has so tragically come to know it, had been latent in Christian teaching, an attempt at extermination would have come about in the Middle Ages when the Church held real power to enforce its beliefs: "There is no question but that Christian anti-Semitism through the ages helped create the climate and mentality in which genocide, once conceived, could be achieved with little or no opposition. But even if we grant that Christian teaching was a necessary cause leading to the Holocaust, it was surely not a sufficient one. . . . The Holocaust was the work of a thoroughly modern, neopagan state. . . . The slaughter of Jews by the state was not part of the medieval Christian world-order. It became possible with the breakdown of that order."[20]

Yerushalmi's statement is another way of framing a point made also by Pawlikowski, namely that something "new" must have entered into the sociohistorical picture to make the Holocaust possible. These new or "neopagan" elements broke the continuity between the Christian past and the secular, nationalistic present—even while cynically citing that past as precedent, as, for example, in the Nazis' infamous Nuremburg legislation.

What was that new element that slid into Western history with the "enlightenment?" Rabbi Arthur Herzberg has argued that the pagan

disease of antiquity was revived by the philosophies of the eighteenth century, especially by Voltaire's. Pawlikowski points to "Western liberalism's distorted attempt to create the universal person," which led to the dehumanization of "subhumans." Rabbi Irving Greenberg finds the turning point in the fact that when society is stripped of respect for a transcendent God, "secular authority unchecked becomes absolute ... leading directly to the assumption of omnipotent power over life and death on the part of the state."[21] Running through these theories is the challenge that while the centuries-long Christian teaching of contempt may have been a sine qua non in the complex of conditions that brought on the Holocaust, so too was the break-up of Christendom and the dissolution of its enduring moral values. The entry of the philosophical ideologies of racism and nationalism into Western culture brought with it the seeds of a tragedy virtually unthinkable before that time.

The issue that faces us as Christians today is not one of personal guilt for the past but of objective responsibility for the future. As an American born toward the end of World War II, I cannot feel personally guilty for what others may have done in another time and place. But as a Christian who wishes to take some pride in membership in the one Body of Christ, I cannot escape a sense of responsibility concerning the use to which the teachings of my Church have been put. The religious tradition I hold dear did have its role to play in the tragic events of the Shoah. For the Church as such, improving Catholic teaching about Jews and Judaism on all levels today is not a luxury but an essential task, as Pope John Paul II has said again and again on so many occasions.

As Catholics, we can count ourselves neither absolutely guilty nor wholly guilt-free. We remain responsible for the past and yet hope-filled for the future. There is, as all the scholars involved in the dialogue can amply attest, much work to be done. The old forms of theological anti-Judaism and secular antisemitism still exist in our communities today. As they have in the past, so they can still join themselves to various ideologies of Left and Right in any given society. As Christians we must be ever alert to identify and resist all "hatred, persecutions, and displays of antisemitism directed against Jews at any time and by anyone" (Second Vatican Council, *Nostra Aetate*, No. 4).

Recent developments

As the twenty-first century gets under way, the scholarly debate about Pope Pius XII and the Holocaust has been enriched by new contributions, while the media controversy has been intensified by renewed accusations. In the former category, I would place Fr. Pierre Blet's *Pius XII and the Second World War: According to the Archives of the Vatican* (Paulist Press, 1999). The last surviving member of the team of four Jesuits who edited the 11-volume publication of tens of thousands of documents from the Vatican archives related to World War II and the Holocaust, Blet weaves together material from the introductions to each of the volumes with archival material from other sources and his own ongoing studies.

The result has the advantage of setting the controversy over Pius XII and the Jews into the larger historical context of the vastly complex array of wartime challenges faced by the Holy See. It is most instructive to trace the development of Vatican policy as it first tried to keep the war from happening, then to keep Catholic countries such as Italy and Poland out of it, and finally simply to do what it could to help the Church in Europe survive the maelstrom of the most destructive and chaotic period in human history. Tragically, the fate of Europe's Jews, who faced incredibly harsh realities, was not high on the Vatican's priorities until toward the end of the war—for example, in the remarkable attempts by Archbishop Angelo Rotta in 1944–5 to save Hungarian Jews. But how the Vatican faced such a plethora of life-and-death issues day by day, with the survival of the Church itself at stake, can help one understand how very vulnerable and, indeed, increasingly "helpless" (to use Blet's word) the leadership of the Catholic Church felt itself to be as the vast destruction reached higher and higher crescendos.

Blet's book, of course, does not put to rest the significant questions about Vatican perceptions and policies during World War II. But it should disabuse any objective reader of the tendency to come up with simple answers, either "pro" or "con," with regard to the small group of Italian priests whose watch it was within the Holy See during those terrible and terrifying years.

In the category of advancing scholarship, I would also put Susan Zuccotti's meticulously detailed study, *Under His Very Windows: The Vatican and the Holocaust in Italy* (Yale University Press, 2000). Although I

disagree with many, in fact most, of her conclusions, I do so on the basis of the evidence she herself presents in such full abundance. Zuccotti mined sources not studied before, combining the results with the fruits of what scholars before her have done. She makes a contribution to the field, despite the ridiculously sensationalist title of the book, which comes from a letter sent to Berlin by Germany's ambassador to the Holy See and thus betrays the author's a priori tendency to take a negative approach to the Holy See on virtually every issue her study raises.

The popular, semi-fictional book by John Cornwell, *Hitler's Pope: The Secret History of Pius XII* (Viking, 1999), not only has a superhyped title, it remains throughout sensationalist and unreliable both in general theory and in presentation of details. According to Cornwell, Pacelli is not only solely responsible for the rise and triumph of Hitler in the 1930s, but is also responsible for the outbreak of World War I as well! Here, the circle is squared. Nazi Germany is let off the hook and virtually all the woes of the twentieth century are laid at the feet of a lone Italian Catholic. It is a sad commentary on the secular media that this blatantly anti-Catholic screed was ever published, much less hyped into best-seller status by its unscrupulous publisher. Sadly, James Carroll's *Constantine's Sword: The Church and the Jews, A History* (Houghton Mifflin, 2001), relies quite heavily on Cornwell for the period of World War II, which simply perpetuates the virtual demonization of Pius XII that seems to be the trend *du jour*.

Books about Pius XII that belong in yet a third category have also appeared as a new century begins. This category recalls an earlier era when anti-Catholicism was regnant, politically, on the American landscape, and the beleaguered immigrant community of Catholic ethnics needed to have their spirits shorn up. It is the category of apologetics. Professor Margherita Marchione, a member of the Religious Teachers Filippini, has produced one of the best examples of this genre, *Pope Pius XII: Architect for Peace* (Paulist Press, 2000). Marchione sets out boldly and unabashedly to defend the wartime pope, marshaling fact after fact in his defense. A defect of this traditional genre of Catholic writing is that it can fail to take into account evidence contrary to its goal. An advantage is that, since it starts out with a sympathetic attitude toward its subject, such writing can achieve, at times, a deeper understanding of the person and the times than an antagonistic or even "dispassionate" stance can provide.

Falling more (but not entirely) into the category of objective,

"dispassionate" scholarship is Ronald Rychlak's well-researched and engagingly written volume, *Hitler, the War and the Pope* (Genesis Press, 2000). Issued by a small publishing house, it will not get the attention or reach the large market attained by John Cornwell's simplistic and venomous personal attack on Pius. This is unfortunate because Rychlak's book, like Zuccotti's, contains a wealth of well-presented and thoughtfully digested facts that anyone wishing to understand Pius XII and his times must have at hand. Rychlak paints with a broader brush than Zuccotti's relatively narrow focus on the Italian peninsula. As a professor of law at the University of Mississippi, he brings a litigator's skills to the evaluation of evidence. In ways that I find refreshing and instructive, he is admirably hard-nosed about the facts.

About the time that Rychlak's book appeared, the historian Michael Phayer, another Catholic, published *The Catholic Church and the Holocaust, 1930–1965* (Indiana University Press, 2000). When one adds previous works by Catholic scholars Pierre Blet, Susan Zuccotti, and Margherita Marchione, this is a very impressive display of Catholic scholarship in a field that very much needs solid scholarship after the undue adulation the secular press gave to the overhyped Cornwell polemic. It is to be hoped that the current volumes will raise the level of scholarly debate far beyond that of Cornwell's yellow journalism.

Both Rychlak and Phayer explicitly reject Cornwell's virtually demonic portrait of Pius XII and bring to bear on the subject a wide range of historical material that refutes—convincingly, I believe—Hochhuth's premise in *The Deputy*, namely that Pius XII was "silent." While both Rychlak and Phayer argue that Pius's public utterances may or may not have been adequate to the times, Pius acted on numerous occasions to save thousands of Jewish lives. And, Rychlak and Phayer agree, the notion that more pointed protests by the pope in defense of the Jews would have influenced in any way the behavior of the Nazis or altered the course of the genocide is utter nonsense, although Phayer does believe it might have emboldened the hierarchy to be more active in opposition. Both authors, unlike many previous ones who have taken up the subject, are familiar with and make good use of the Vatican's 11-volume collection of its own wartime documents.

Rychlak's book is distinctive because it is written from the probing, no-holds-barred point of view of a very good prosecuting attorney who knows how to weigh evidence with legal precision. From this point of view, the case against Pius is very thoroughly demolished

since much of it depends not on evidence, but on speculation. For its part, Phayer's book features the very important role that Catholic women played both during the Holocaust in directly saving Jews and after the Holocaust in raising the conscience of the Church to grapple with its implications. In my own mind this fact (and Phayer is absolutely correct that this has been untold too long) is epitomized by the Sisters of Sion, whose convents all over Europe hid thousands of Jews. Although Phayer does not take up their particular story, in the Sisters of Sion convent in Rome alone there were 187 Jews, who were fed by a Vatican truck that weekly made the rounds of convents and monasteries in which Jews were hidden.

Both authors appreciate the complexity and ambiguities of European Catholic behavior toward Jews during the Holocaust, and both present forthrightly the change in Catholic thinking brought about by the Second Vatican Council. Phayer provides useful chapters on the history of the pioneers, especially in Germany, who laid the groundwork for the Council's great breakthrough. Indeed, one of the strengths of Phayer's book is the vast knowledge of twentieth-century German Catholic history—his academic speciality—that he brings to his study.

Ironically, Phayer's emphasis on German Catholic history also becomes one of the weaknesses of his book. Whether writing about the period of the Shoah or what led up to the Council, Phayer tends to focus so heavily on the German Church that he loses sight of the wider realities of the war. He pays far too little attention, for example, to the fascinating and historically crucial role of Vatican–U.S. diplomacy during the war, and builds so high the role of the German bishops during the Council that the reader may lose sight of the equally significant influence of the American and the French hierarchies in making *Nostra Aetate* a reality.

Finally, in one rather bizarre chapter, Phayer illustrates that even trained scholars, if they are not careful, can fall prey to hoaxes. Specifically, Phayer uncritically repeats one of the fervid theories of the very productive conspiracy-mongers Mark Aarons and John Loftus, whose *Unholy Trinity* (St. Martin's, 1992) popularized the notion that the Holy See had intentionally helped Nazi war criminals to escape Allied justice after the war. This theory, however, is only the beginning of that book. Had Phayer read beyond the first few chapters, he would have seen Aarons and Loftus draw Stalin and Hitler together in a vast plot along with Pius XII. And, in their next book, they drew Allen and John Foster Dulles into further variations of their "world conspiracy" theories. By

taking seriously such rantings, Phayer mars an otherwise useful contribution to contemporary scholarship.

Now, the reader may ask, did I find in all this new scholarly writing, each with its strengths and weaknesses, much that was new? In many ways, yes. In the past five years, I have learned an immense amount that is new to me about Pope Pius XII and the Holocaust. While the material in Blet's book is not new, being taken in the main from previously published introductions, I had never sat down with those texts and read them through together. As outlined above, what emerges is a portrait of an institution: the Vatican and its leadership were carefully attuned to cope with one set of historical circumstances that had affected the Holy See over the course of several centuries. Then, a world at war created a miasma, which, with unprecedented rapidity, turned into a maelstrom of issues for which nothing in their collective training could possibly have prepared them. How one judges their actions and reactions to it all depends very much on the criteria of judgment one brings to bear and, to a certain extent, how rigorously one is able to refrain from judging them in the light of post-Holocaust awareness of the full extent of the evil visited upon the world by National Socialism. Zuccotti's book is breathtaking in its marshaling of detail, much of it the result of original research. Throughout, however, her criteria of historical judgment are harsher and, in the end, more post-Holocaust than I believe objective scholarship allows. The Rychlak book, on the other hand, may be vulnerable to the charge of being too lenient in its criteria of judgment (and I personally lean in that direction, too, it must be admitted). Yet it makes a very solid contribution to historical understanding, since it succeeds as well as any book I have read in setting the issues within the larger historical context, which is absolutely vital to any rendering of judgment, and teaches a rigorous restraint in discriminating between the actual facts and the human temptation to fill in gaps in facts with speculation.

More books on these issues are already scheduled for publication, and troves of new evidence have recently been unearthed. The latter includes archives in Eastern Europe opened after the fall of the Soviet empire, the recently released documents showing the detailed under-standing that the United States and Great Britain—but not the Vatican—had of the Holocaust through breaking what Germany thought was an unbreakable code for its messages during the war, and the diary of Adolf Eichmann. The Eichmann diary seems to show, beyond doubt, that Pius XII's 1943 threat to go public in opposition to the deportation of the Jews

of Rome was not only understood by the Germans but also worked, as is evidenced by the fact that the deportations stopped and the vast majority of Rome's Jews were thus saved directly by the action of Pius XII.

In the end, I find that the essential outlines of moral and historical judgment as drawn by Marrus and Pawlikowski are remarkably durable, even in the twenty-first century. So after reading and wrangling with the more recent work noted above, I tend toward the opinion that the framework for understanding an incredibly complex period will not change essentially in the near future even though the filling-in of many details unknown a half-decade ago will result in ever new questions, insights, and shifts in perspective.

NOTES

1. The first part of this chapter is excerpted from an article in *The Priest* (August/September 1995).
2. Pierre Blet, Robert A. Graham, Angelo Martini, and Burkhart Schneider, eds., *Actes et documents du Saint Siège relatifs à la Seconde Guerre mondiale*, 11 vols. (Vatican City: Libreria Editrice Vaticana, 1965–81). The October 2000 report of the six scholars can be found on the website: *www.b'naib'rith.org*. I served as Catholic Coordinator for the project, which was co-sponsored by the Holy See and the International Jewish Committee for Interreligious Consultations. Three members of the team, Eva Fleischner, Michael Marrus, and John Morley, are contributors to the present book.
3. John Morley, *Vatican Diplomacy and the Jews during the Holocaust 1939–1943* (New York: KTAV, 1980), and Michael O'Carroll, C.S.Sp., *Pius XII, Greatness Dishonoured: A Documented Study* (Dublin: Laetare Press, 1980).
4. For an excellent scholarly survey of the literature in the field, see John T. Pawlikowski, "The Vatican and the Holocaust: unresolved isues," in M. Perry and F. Schweitzer, eds., *Jewish–Christian Encounters over the Centuries: Symbiosis, Prejudice, Holocaust, Dialogue* (New York: Peter Lang, 1994), 293–312. I will not try to duplicate Fr. Pawlikowski's effort here, though I will make use of it, as shall be apparent. For a very interesting article making use of Jewish archival materials documenting, for example, the correspondence between Archbishop Amleto Giovanni Cicognani, the papal delegate in Washington from 1933 to 1958, and Jewish leaders, see Gershon Greenberg, "American Catholics during the Holocaust," in Noel Kernan, ed., *Peace/Shalom after Atrocity: First Scholars Conference on Teaching the Holocaust* (Greensburg, Pa.: Seton Hill College, 1989), 37–51.

5. John Paul II, "The Miami address to Jewish leaders," *Origins*, Vol. 17, No. 15, September 24, 1987, 241. One speculation concerning what might still be in the Vatican archives may involve material—as some British and German diplomatic documents would seem to indicate—concerning Pius XII's contacts with anti-Nazi Germans during World War II. This data would be significant given the Holy See's strict neutrality in its public utterances throughout the war. See, for example, Ulriche Schlie, "The Pope and anti-Nazi Germany," *30 Days*, No. 2, 1992, 65–7.

6. Anthony Rhodes, *The Vatican in the Age of the Dictators, 1922–1945* (New York: Holt, Rinehart & Winston, 1973), 204. Several times the encyclical explicitly condemned Nazi racial ideology and its theory of Blood and Soil (*Blut und Boden*). Pius XI was likely to have relied on his Secretary of State, Cardinal Eugenio Pacelli, the future Pius XII, in preparing this stern and unequivocal condemnation of idolatrous Nazism.

7. Robert A. Graham, S.J., *Pius XII's Defense of Jews and Others: 1944–45* (Milwaukee: Catholic League for Religious and Civil Rights, 1987). The Catholic League has more recently paired Father Graham's work with an earlier study written by Dr. Joseph Lichten of the Anti-Defamation League of B'nai B'rith and aptly entitled "A question of judgment: Pius XII and the Jews" (1963).

8. Pawlikowski, "The Vatican and the Holocaust," 297–8. Strong support among Jewish scholars for such a position in defending Pius XII can also be found in the work of Israeli diplomat Pinchas E. Lapide, *Three Popes and the Jews* (New York: Hawthorn Books, 1967).

9. Numerous records show that the papal nuncio, Archbishop Angelo Rotta, and his associate, Tibor Baranski, worked tirelessly on their own and in collaboration with Swedish diplomat, Raoul Wallenberg, to save Jewish lives. In addition to evidence cited in Pawlikowski, O'Carroll, and Morley, one may add Harvey Rosenfeld's assessment in *Raoul Wallenberg: Angel of Rescue* (Buffalo, N.Y.: Prometheus Books, 1982), 72–81.

10. Pawlikowski cites the recently published memoirs of Henri de Lubac, a leader of the French resistance and later a cardinal of the Church, to illustrate that Pius XII's carefully nuanced phrases were seen in France as stern condemnations of Nazism and support for resistance. See Henri de Lubac, *Christian Resistance to Anti-Semitism: Memories from 1940–1944* (San Francisco: Ignatius Press, 1990). De Lubac's strong stance and those of his close Catholic colleagues against Nazism during the occupation, of course, are set in poignant relief by the fact that it was not necessarily the rule, but to some extent the exception, among all of their fellow citizens. For a Jewish assessment that takes into account the Holy See's sense of the situation, see Michael R. Marrus, "French churches and the persecution of Jews in France 1940–1944," in Otto Dov Kulka and Paul R. Mendes-Flohr,

eds., *Judaism and Christianity under the Impact of National Socialism* (Jerusalem: Historical Society of Israel and the Zalman Shazar Center for Jewish History, 1987), 305–26.

11. One may cite, for example, Alexander Ramati, *The Assisi Underground: Priests Who Rescued Jews* (New York: Stein and Day, 1978), and Susan Zuccotti, *The Italians and the Holocaust* (New York: Basic Books, 1987).

12. For amplification, see Kulka and Mendes-Flohr, eds., *Judaism and Christianity under the Impact of National Socialism,* and Helen Fein, *Accounting for Genocide: National Responses and Jewish Victimization during the Holocaust* (Chicago: University of Chicago Press, 1984).

13. Pawlikowski, "The Vatican and the Holocaust," 305.

14. *Ibid.,* 306. When considering what the Nazis were doing to the Polish clergy and leadership and what was happening to the Jews under Nazi domination, Pawlikowski emphasizes similarities in the responses of the Holy See and Pope Pius XII. His conclusion, which I believe to be correct, is that what lay behind the pope's restrained style of public utterance, far from showing animosity toward either Jews or Polish Catholics, was his sense of diplomatic correctness. The fact that the pope responded similarly to the plight of Jews and Polish Catholics, of course, is one further major factor disproving the Hochhuth thesis of personal papal apathy toward the plight of Jews.

15. Michael R. Marrus, *The Holocaust in History* (Hanover: University Press of New England, 1987), 179–83.

16. *Ibid.,* 182. In an essay otherwise critical of the Holy See, Hannah Arendt cites one of what may have been a number of crucial changes in the historical record made by Hochhuth in his play, *The Deputy.* In this case, Hochhuth sought to erase the record of Vatican consistency with regard to public responses to appeals such as those from Poland no less than those from Jewish sources. As is apparent, such consistency would have been quite threatening to Hochhuth's theme of special papal indifference to Jews. At the end of *The Deputy's* fourth act, Arendt notes, Hochhuth substituted the key word "Jews" for "Poles" in a statement attributed to Pius: "As the flowers in the countryside wait beneath winter's mantle of snow for the warm breeze of spring, so the *Jews* must wait, praying and trusting that the hour of heavenly comfort will come." Arendt does not give a citation for the papal statement quoted in her essay. See "Hannah Arendt: guilt by silence?," in Eric Bentley, ed., *The Storm over the Deputy* (New York: Grove Press, 1964), 87. In a play that presents itself as history, such changes in the record (for example, by adding a voluminous "historical" addendum to its published text) should be sufficient to destroy whatever lingering credibility Hochhuth's polemic may have maintained.

17. Marrus, *The Holocaust in History,* 182.

18. *Ibid.*, 183. In support, Marrus cites Guenter Lewy, *The Catholic Church and Nazi Germany* (New York: McGraw-Hill, 1965), 304–5, and Ernest C. Helmreich, *The German Churches under Hitler* (Detroit: Wayne State University Press, 1979), 365.

19. For a fuller version of the ideas synthesized in this section, see Eugene Fisher, "The Holocaust and Christian responsibility," *America*, February 14, 1981.

20. Yosef Hayim Yerushalmi, "Response to Rosemary Ruether," in Eva Fleischner, ed., *Auschwitz: Beginning of a New Era? Reflections on the Holocaust* (New York: KTAV, 1977), 103–4.

21. Cited in Fisher, "The Holocaust and Christian responsibility." See also the essays of all three—Yerushalmi, Herzberg, and Greenberg—in the Paulist Press volumes, *Interwoven Destinies* and *Visions of the Other* (1993–4).

Sergio I. Minerbi

Pius XII: A Reappraisal

When considering the deeds and omissions of Pope Pius XII, head of the Roman Catholic Church during the Second World War, many questions arise. First, did Pius XII know about the massacres of Jews by the Germans? Could he have done anything to prevent Hitler from exterminating the Jews? Had he raised his voice against the horrors perpetrated by the Nazis, would he have been heard, or would he only have worsened the victims' conditions? Can proper historical research be conducted while the Vatican's archives remain closed? In the light of these questions, an additional issue comes to mind: should Pius's beatification process continue? In his 1999 book, John Cornwell raises doubts about the legitimacy of that process. "If it succeeds," he writes, "Pacelli's policies will be dramatically confirmed—endorsing the modern ideology of papal power and justifying Pacelli's wartime record."[1] The Vatican's March 16, 1998, publication of "We Remember: A Reflection on the *Shoah*," which glorifies Pius XII, proves that the Roman Catholic Church has decided to defend his memory in any event, although the motivations of Pius XII's behavior still remain at least questionable.

Antisemitism

Antisemitism could have been an obvious motivation for Pope Pius XII's questionable conduct during the Holocaust. At the end of the nineteenth century, there were widespread signals of the Church's antisemitism, such as the series of articles published by the Jesuit review, *Civiltà Cattolica*. Eugenio Pacelli entered the Secretariat of State in 1901 to work with Msgr. Umberto Benigni (1862–1934), who was one of the most active antisemites in the Church.[2] In 1890, Benigni published his first article on ritual murder, strengthening the old antisemitic prejudice by writing: "the rabbinic race kills small Christians for the Easter of the Synagogue." He

claimed that the Jews and the Freemasons were secretly plotting to dominate the world. Eventually, in 1911, Pacelli replaced Benigni in the Secretariat of State.

Nevertheless, I do not consider Pacelli's later papal behavior to be solely influenced by the antisemitism of his entourage. Of course, antisemitism was an expression of Catholic theology at the time. It was a widespread conviction that the Jews were supporting subversive movements such as liberalism, socialism and Bolshevism; the Jews were presumed guilty of deicide as well. In 1917, when the Bolshevik revolution erupted in Russia, it offered further proof in the eyes of the Church that again the Jews and Freemasons were guiding the Bolshevik movement, the worst enemy of the Catholic Church and of civilization. Msgr. Benigni wrote in 1921: "We fight against Israel not of the Pentateuch but of the Talmud; ... we fight in Israel all the traditional antisocial and antichristian groups of Talmudists, of the high international Jewish banking, the golden calf, of the Jewish Bolshevik international, the red wolf."[3] Such ideas undoubtedly helped to prepare the ground for the Nazi massacres and contributed to public indifference about Jewish plight.

In the late 1920s and in the 1930s as well, there was again a strong feeling that a Jewish–Masonic conspiracy was threatening the Church and Western Europe. Pope Pius XI, Pius XII's predecessor, said to a group of Polish pilgrims on October 4, 1929: "The enemy is working in our midst. I have in mind the Masonic sect spreading its perverse destructive principles even in Poland."[4] Catholic antisemitism was particularly visible in Poland, where Cardinal August Hlond, Primate of Poland, wrote as follows in his pastoral letter of February 29, 1936: "It is a fact that Jews are waging a war against the Catholic church. ... They constitute the vanguard of atheism, the Bolshevik movement, and revolutionary activity." According to Cardinal Hlond, Jews were spreading pornography, fraud, usury, prostitution, but one was not to incite anti-Jewish violence. He wrote: "It is good to prefer your own kind when shopping, to avoid Jewish stores and Jewish stalls in the marketplace, but it is forbidden to demolish a Jewish store. ... It is forbidden to assault, beat up, maim or slander Jews."[5] Hlond seemingly did not understand that, while hiding behind dubious moral standards, he was, in fact, inciting his flock directly against the Jews, his instructions to the contrary notwithstanding.

Some scholars have suggested the existence of a conspiracy, with the participation of the Church, to abandon the Jews to their fate during

the Holocaust. It is not necessary to take this theory so far: by limiting themselves to the exchange of diplomatic notes instead of making serious efforts to save the Jews, the Church's highest authorities in fact abandoned the Jews to their fate. At the same time, one must remember that there were many cases of Jews who were hidden in monasteries and other Catholic institutions, in Italy and elsewhere, and whose lives were saved in that way. My feeling is that the Church was often passive, avoiding specific instructions to the bishops and above all intent on avoiding conflicts with the Nazis. The fact that the Church refrained from action was in itself the problem, even if there was not a direct conspiracy against the Jews. Effective resistance against the Nazi machine required a great deal of courage, hope, and a penetrating political awareness. Under Pius XII, the Roman Catholic Church often lacked these qualities.

Appeals to Pius XII

More than one prominent Church member appealed to the Vatican to speak out against Nazi persecution. In 1933, for example, Edith Stein urged Pope Pius XI to write an encyclical on the Jewish question. In March 1937, while Pacelli was his Secretary of State, Pius XI issued *Mit brennender Sorge*. Protesting against persecution of the Catholic Church, the pope wrote: "If the race or the people, if the State in a certain form, ... have an essential place in the natural order, whoever elevates them as the supreme norm, also of religious values, making them divine ... perverts and falsifies the order created by God, and is far from true faith in God." These are strong words, but they were expressed only to defend Catholics in Germany. Jews are not evoked even once in the whole encyclical, or, to be more precise, they are indirectly recalled in a sentence about Jesus. The pope writes that it is blasphemy to take the Old Testament out of the Church; to do so is akin to rejecting Jesus, "who took human nature from a people, who later had to nail him on the cross. The Ancient Testament found its fulfillment, its end and its sublimation in the New Testament." At the end of this document, the pope reiterated his wish to re-establish true peace between the Church and Germany. So even this almost unique example of public reproach against the Nazi regime had as its only objective the defense of the Church itself. The encyclical said nothing about the Nazis' anti-Jewish persecutions. The

unnamed Jews, however, were indirectly recalled as those who had nailed Jesus to his cross.

A year later, Pius XI did not mention Kristallnacht, the Nazi pogrom that devastated German Jewry, in any official declaration. Before his death, he apparently wanted to condemn Germany's racism in a new encyclical, but his death interrupted that project.[6] When Pius XII succeeded to the papacy in 1939, he did not think it fit to publish this "forgotten encyclical."

Pius XII went out of his way to ensure religious peace with Nazi Germany, and in 1939 he even went so far as to abandon Msgr. Sproll, a courageous bishop who opposed Nazism.[7] Pius XII's actions in the latter case were similar to those of Pius XI, who had sacrificed Don Luigi Sturzo[8] to the Fascists, and John Paul II, who later abandoned Lech Walesa to Jaruzelski in 1982. In these cases, the supreme interest of the Church prevailed over moral considerations. Nevertheless, some bishops appealed to Pius XII, asking him to raise his voice against Nazi Germany.

In 1940 the Bishop of Berlin, Konrad von Preysing, wrote to Pius XII: "The Holy See cannot renounce bringing the religious situation in Germany before world public opinion." Some years later, on January 23, 1943, Preysing, who had a continuing correspondence with the pope, wrote again to Pius XII criticizing the papal nuncio, Cesare Orsenigo, and asking whether, in a time of anti-Jewish persecution, it was desirable that the pope should be represented through an ambassador to the Reich government.[9] Cardinal Theodor Innitzer, Archbishop of Vienna, also wrote to the pope to deplore Orsenigo's silence about the systematic massacre of Jews in Germany and Poland. "He [Orsenigo] is too frightened and is not interested in things as serious as these." On February 4, 1941, the same Cardinal Innitzer wrote again to the pope about the indiscriminate deportation of 60,000 Jews from Vienna.[10] Pope Pius XII received advice in 1940 from Cardinal Eugene Tisserant, who pressed him to publish an encyclical stressing the personal duty of each Catholic to obey his own conscience. "I fear," wrote Tisserant, "that history will reproach the Holy See with having practiced an accommodating policy of selfish convenience and nothing more."[11]

In many paragraphs of his book, *Pius XII and the Second World War*, Pierre Blet, an apologist for Pius, suggests that the Vatican did not know what exactly was happening to the Jews deported by the Nazis. As late as March 1943, according to Blet, "the real destination of the deportees remains shrouded in mystery."[12] Indeed, he adds, "as long as

the war lasted, the fate of the deportees was shrouded in obscurity."[13] Nevertheless, the facts related by Blet himself do not fully justify these claims.

At a very early stage, the Secretariat of State and the pope himself knew the truth about the Jews' fate, as a few examples can prove. Pius XII received detailed reports from Cardinal Hlond and the Polish government in exile; from an Italian diplomat, Soro, who had been witness to Nazi killing of Jews in Warsaw in September 1939; from the pro-nuncio in Slovakia, Giuseppe Burzio, as well as from Father Scavizzi, a military chaplain. Here are some details of these reports.

On February 26, 1940, Cardinal Hlond wrote to the Vatican's Secretary of State, Cardinal Luigi Maglione, that the Germans might bring "new terrible massacres of Polish lives."[14] According to the Vatican's own documents (ADSS), in May 1940, Pius XII received an Italian diplomat who had returned from Warsaw a few days earlier. The diplomat said that it was impossible to have a clear idea of the sadism and cruelty of the Gestapo, led by Himmler, "a true criminal" who wished to destroy the Polish people.[15] Pius XII's notes most probably refer to the private audience he gave Giovanni Vincenzo Soro, who had been Second Secretary at the Italian embassy in Warsaw and remained there until March 18, 1940, helping Jewish and non-Jewish Polish citizens to escape.[16] He received instructions to do so by the Italian Ministry of Foreign Affairs. Knowing Soro personally, I think that it is more than probable that he informed the pope about the killing of the Jews by the Nazis which he had himself witnessed at the end of September 1939.

Furthermore, as early as October 27, 1941, the pro-nuncio in Slovakia, Giuseppe Burzio, wrote to the Secretary of State about what he had heard from a local rabbi about the systematic murder of the Jews in Poland. This was one of the first written reports about the organized massacre of Jews by the Nazis. Later, Burzio was also very active in sending accurate and timely reports to the pope about the massacre of the Jews. In March 1942, Burzio wrote that the deportation of the Jews was "the equivalent of condemning a great part of them to death."[17]

One of the most important witnesses was Don Pirro Scavizzi, an Italian chaplain assigned to a hospital train, who sent four detailed reports to the Holy See and was even received twice by Pius XII. For some reason, the editors of the Vatican's documents ignored two of his reports, but, in the mean time, the full text of the four reports has been published in a book about Scavizzi.[18] The first report was sent immediately after his

arrival in Lvov on October 30, 1941. According to Scavizzi's information, since the Germans had arrived in Lvov in July 1941, Jews had been herded, like animals, into old cattle wagons, and "after some days of this martyrdom they had been killed."[19] In his report to Pius XII of January 1942, Scavizzi includes this sentence: "It is evident that the intention of the occupying Government is to eliminate the highest possible number of Jews by killing them ... in places where beforehand very big grave-pits had been excavated, imposing this work upon the Jewish men themselves. The number of Jews killed until now, in such a way, is evaluated at one million."[20] Scavizzi sent another report to the pope in April 1942: "The system of the great grave-pits excavated by the Jews under the control of the SS is now common in the Ukraine; groups of men, women and children are pushed into them and then they are killed by machine guns."[21] Then, in his fourth and last report to the pope, dated October 7, 1942, Father Scavizzi said: "The elimination of Jews, by mass assassination, is almost total ... They say that two million Jews have already been killed." When the pope received him, Scavizzi told him everything, and Pius XII "wept like a child and prayed like a saint."[22]

Most of this information, which was received from reliable sources, reached the Holy See before the meeting in Rome between Myron Taylor, the personal representative of the American president, Franklin Delano Roosevelt, and Cardinal Maglione, the Vatican's Secretary of State, which took place on September 26, 1942. How could Maglione have written to Taylor on October 10 that he had no specific information to confirm the August 30 report about mass murder of Jews, which had been sent by the Geneva office of the World Jewish Congress? He obviously had enough information, but preferred to remain skeptical and to shut his eyes.

Even according to the apologetic Blet, at the end of 1942 a report was sent to the Secretariat of State by a "counselor" at the Vatican's diplomatic mission in Berlin.[23] The report's source was Msgr. Giuseppe Di Meglio, a secretary to the nuncio from 1938 to 1942, when he returned to the Secretariat of State.[24] Having been recalled to the Vatican, Di Meglio brought with him a full report on the situation of the Jews, including details about the concentration camps and the inhuman treatment of deported Jews. Dated December 9, 1942, this report has been published among the documents of the Holy See. It is especially important because it was written by a member of the Vatican's diplomatic service and because of its detailed description of the persecutions against the Jews.

The historian John Morley translated this report in full into English. Here is a telling sentence: "Certain ecclesiastics and lay Catholics have noted with amazement that till now the German episcopate has made no collective manifestation on the question of the grave mistreatment afflicted upon the Jews."[25] Thus Di Meglio not only brought home a detailed report on the deportation and the killing of the Jews, but also undermined the theory that German Catholics would not support a public expression of disapproval by the pope. In his report, Di Meglio also wrote:

> An Italian journalist, recently returned from Romania, gave me, some time ago, a long account concerning the brutal methods against the Jews, adopted in that country, above all through German instigation. He recounted to me that an entire train was filled up with Jews; every opening was carefully blocked up, in such a way that not even a breath of air could pass through. When the train reached a preestablished destination, the survivors were very few, namely those who finding themselves near an opening, not completely closed up, were able to breathe a little bit of air.

This dramatic description is very similar to the one given by Curzio Malaparte in his historical novel *Kaputt*.[26] Malaparte had been a war correspondent, and in 1941 he was in Romania. His book gives a detailed description of the terrible pogrom in Jassy. Among other things, he wrote: "The unfortunate people packed into the sealed cars had shrieked and moaned begging the soldiers to remove the wooden boards nailed over the windows. About two hundred Jews had been piled into each car, and those wretched people were unable to breathe."[27] While in Berlin, Malaparte probably went to see Di Meglio and told him what he had seen in Romania. *Kaputt* was published in 1944 in Naples. It was perhaps the first piece of literature in Europe to give a first-hand description of the massacre of the Jews.

No opposition to Nazism

Pope Pius XII felt that he could not openly antagonize the Nazi regime, because he saw the Third Reich as a key opponent of Bolshevism, which Pius regarded as an immense danger to his Church. Furthermore, Pius XII

worried about a schism in the German Catholic Church; he was mostly interested in consolidating the Catholic Church's status in Germany. The pope also feared that the Nazis would retaliate and harm the supreme interests of the Church. In addition, as a diplomat he was used to solving problems through written documents. However, the Nazis did not give this approach very serious consideration. When Pacelli invited Cardinal Adolph Bertram of Breslau, Cardinal Karl Joseph Schulte of Cologne, and Cardinal Michael Faulhaber of Munich, and Bishops Konrad von Preysing of Berlin and Clemens August von Galen of Münster to the Vatican in January 1937, it appeared that 55 notes sent to the German government by the Vatican since 1933 had gone unanswered. Clearly, written messages were useless, but for years this approach continued to be Pope Pius XII's major mode of action.

Pius XII chose a low-profile line of conduct, compliance, opportunism, and silence. The Roman Catholic Church did save some Jews, although far fewer than the 800,000 sometimes cited. Even in Italy, the degree to which clear-cut rescue instructions from the pope affected the situation remains unclear. Particular attention should be given to the pope's stand before and after October 16, 1943, when the Germans seized and deported 1022 Roman Jews under the windows of the Vatican.[28]

On September 24, 1943, Heinrich Himmler, head of the SS, sent an order to SS Obersturmbannführer Herbert Kappler directing that "all Jews must be transferred to Germany where they will be liquidated."[29] According to Kappler's testimony in his post-war trial, SS officer Theodor Dannecker arrived in Rome during the first week of October 1943. His task was to organize the deportation of Rome's Jews.[30] Shortly after Dannecker's arrival, the British intelligence service knew about his project and transmitted the news to its American colleagues. Neither agency did anything to warn the Jewish community, nor did the BBC include any warnings in its radio broadcasts. The pope also knew about the impending round-up, perhaps receiving advance notice from German Ambassador Ernst von Weizsäcker, whom he received on October 9.[31] According to a strange report, published in ADSS, Pius XII supposedly told the ambassador: "If one must make the deportation of the Jews, it is good to do it quickly." This was quoted by a German officer, as we know from an internal note of the Secretariat of State of October 23, which qualifies the quotation as "evidently false" but provides no satisfactory explanation for the qualification. "The pope knew," Michael Phayer writes, "that they [the Jews] were going to be seized but failed to warn

them; the incident occurred in the immediate vicinity of Vatican City; and after the Jews had been deported, the pope failed to condemn Germany for its barbarity."[32]

On the day of the round-up, Secretary of State Cardinal Luigi Maglione summoned Weizsäcker. ADSS includes a handwritten report of their conversation. "I wanted to remind him," wrote Maglione, "that the Holy See was, as he himself noted, so cautious in order not to give German people the impression of having done or wishing to do even the smallest thing against Germany in a terrible war. But I also had to tell him that the Holy See should not be put in a situation where it was necessary to protest."[33] The conversation took place while the round-up was under way. Far from condemning the Germans, what mattered most to Maglione was to assure the ambassador that the Holy See was not taking any action against Germany.

Two German diplomats, Kessel and Gumpert, suggested that the Vatican should send an official protest for the action against the Roman Jews. But the Holy See did not want to endanger its relations with Germany, and the compromise was to write a letter that would be signed by Bishop Alois Hudal, the rector of the German college of Santa Maria dell'Anima in Rome. The letter was addressed to General Rainer Stahel and stressed that, in the interests of the good relations with the Vatican, Msgr. Hudal asked that the arrest of Jews would be suspended in Rome and its surroundings. The German authorities knew better. They were confident that Pius XII would not react publicly, partly because of the deal that General Karl Wolff, the chief of Nazi police in Italy, had made with the Vatican. According to Wolff's testimony, his proposal was as follows: "I will protect your ecclesiastical institutions and you will act in your field in order to foster obedience [of the Italian population] to the German authorities."[34] For his part, Wolff acknowledged that the Church had kept the Italian people quiet, and without the support of the Church he could not have done his job so successfully.[35]

Apparently, the pope also believed that German threats to kidnap him and to occupy the Vatican and plunder its vaults had to be taken seriously. In any case, until Rome's liberation in June 1944, the Vatican did not impede further raids against the city's Jews. Various evaluations place the number of Jews deported from Rome after October 16, 1943, between 1069 (according to Fausto Coen) and 1700–2000 (according to Michele Tagliacozzo). Even the lower estimate is higher than the number of Jews seized on October 16.[36] Hidden in Catholic institutions, an

estimated 4000 Jews were saved in Rome. The number of Jews saved by lay Italians was probably even higher, but the question is whether the Catholic institutions acted upon an order or a request by Pius XII. The fact that several bishops, such as Msgr. Elia Dalla Costa in Florence or Msgr. Boetto in Genova, actively saved Jews could indicate that they had received instructions from above, but we have no proof of such instructions.[37] Morley gives an important judgment about the behavior of the Holy See in these events:

> The greatest fault of Vatican diplomacy in the face of the October 16 raid was not so much that it remained silent, but that the German officials involved felt rather assured at this late date in the war that the Vatican would do nothing to jeopardize its relations with Germany. They had witnessed likewise, a lack of concern by the Vatican for the fate of the Jews who had been deported from all other countries. To deport Jews from Rome itself, under the eyes of the Pope, was risky, but they took the chance and in so doing proved that their impressions of Vatican diplomacy were correct.[38]

Thousands of Jews were saved in Budapest (Hungary) thanks to documents sent by Msgr. Angelo Giuseppe Roncalli, the nuncio in Istanbul, and thanks to the nuncio in Budapest, Msgr. Angelo Rotta. These are examples of covert local operations, necessarily limited, and they do not fundamentally change Morley's judgment about the Vatican itself. By failing to condemn Hitler publicly, by assuring German diplomats that the Holy See would not do anything against Germany, the highest authorities of the Church sent out a message that the Jews were expendable.

Why did Pius XII not raise his voice?

Whether Pius XII should have publicly protested against Nazi atrocities was a question raised early and repeatedly during the war inside the Roman Catholic Church itself. Cardinal Hlond, who had escaped to Rome when the Germans invaded his country on September 1, 1939, was among the first to urge Pius to protest. On December 21, 1939, Hlond sent the pope a detailed report, which stressed the violence and killing in Poland, including the arrest of Jews, Catholic clergy, and Polish

intellectuals.[39] The Polish government in exile also sent the pope a report on January 21, 1940, saying that the Nazis had killed 18,000 representatives of the leadership class in Poland. On February 9, 1940, Hans Frank, the head of the *Generalgouvernement* in Nazi-occupied Poland, announced that one million Jews had been concentrated in the area under his jurisdiction. Inside the Vatican, Msgr. Montini, later to become Pope Paul VI, asked how long the pope could remain silent.[40]

Hlond later went to London, where he sent a letter to the pope on August 2, 1941. In Poland, he wrote, "the love for the Pope and the Holy See is unfortunately diminishing." At the time, German propaganda was spreading the idea that the pope had abandoned the Polish cause and had given his consent to put the Polish nation under slavery in the future Hitlerian Europe. Taking these developments into account, Hlond added that perhaps the moment had come "for an explicit word of His Holiness on Poland."[41] Hlond wrote further: "We hear that the Poles are complaining that the pope does not protest against crimes when the Germans have three thousand Polish priests killed in concentration camps, that he does not speak out in condemnation when hundreds of priests and members of Catholic Action, including papal chamberlains, are shot to death, all exterminated without the slightest offense on their part."[42] On November 3, 1941, Archbishop Adam Stefan Sapieha of Cracow asked, in Blet's words, for "an explicit condemnation or at least a message of comfort" from the pope.[43]

For the most part, Pius XII decided to keep silent, although in 1942 he had already written a protest against Nazi atrocities and anti-Jewish persecution. He decided to burn all the pages he had written. His reasoning, according to Pius's housekeeper, Sister Pasqualina Lehnert, was that "if the letter of Dutch bishops [a protest read from the pulpits on April 19, 1942] cost the killing of 40,000 human beings, my protest would cost perhaps 200,000. It is therefore better to do silently all I can for this poor people."[44]

This excuse is a very poor one for the pope's silence. With his knowledge, Jews were massacred while he kept quiet. How could his public condemnation have worsened their situation? What could be worse than mass killing in Ukraine or mass murder in the gas chambers at Auschwitz? In addition, the pope published the reasons for his silence, namely "in order not to make their situation more difficult and insupportable," as he said to the College of Cardinals in the Vatican on June 2, 1943.[45] This defense notwithstanding, the pope revealed the secret of his weakness and left the way open to further Nazi massacres.

The possible outcome of a public condemnation of the Nazi killing of the Jews

History should be written according to solid facts, not speculative hypotheses. In this case, however, there is a great deal of circumstantial evidence to support the thesis that much Nazi killing could have been stopped or at least limited. Here is some of that evidence.

1. On January 27, 1940, Msgr. Giovanni Battista Montini received Fritz Menshausen, a German diplomat, who protested against Vatican Radio broadcasts about Poland on the grounds that they "could provoke a reaction against Germany in the world press and in the public opinion" and therefore should be stopped. This meeting shows that the Germans were sensitive to media reports and public opinion. A public declaration by the pope would have dramatically influenced the press and public opinion.[46]

2. In France, on August 7, 1941, before introducing the new Vichy laws against the Jews, Marshal Henri Philippe Pétain sent Léon Bérard, his ambassador to the Holy See, to the Vatican's Secretariat of State to ask for its opinion on the new anti-Jewish measures. The ambassador was able to report that the Holy See had no reservations about Vichy's antisemitic laws, which eventually contributed to the death of 70,000 French Jews. The ambassador could add that, according to the doctrine of the Church at the time, "Jews should not have authority over Christians. It was legitimate, therefore, to prohibit them from certain public offices and to restrict their entry into universities and professions."[47] It is not unthinkable that a protest by the Vatican against the Vichy measures would have made a significant difference.

3. Dr. Josef Tiso, a priest, was the President of Slovakia during the war.[48] Pius XII sent him some notes asking for the interruption of the deportation of Jews, but no threat of excommunication was included in the letters. A Catholic priest would have been impressed by such a threat and may have acted accordingly to avoid the excommunication. According to Morley "an unambiguous statement from the

Vatican condemning the deportation of the Jews would more than likely have affected the nation's leaders."[49]

My claim is that a public statement of protest by Pope Pius XII during the early months of World War II could have had the following results:

1. Such protests would have posed serious difficulties for Nazi Germany in so far as the discipline of Catholic soldiers was concerned, many of whom would probably have refused to cooperate in killing the Jews had there been a clear statement by the pope condemning the persecutions. But such a confrontation with the Nazi regime could also have provoked a schism in the German Catholic Church, and Pius XII attached paramount importance to avoiding a split between the German Church and the Holy See.

2. Spreading news of the imminent danger among the Jews could have convinced more of them to attempt escape. In March 1940, for example, my mother, Fanny Ginzburg Minerbi, went to Warsaw with an Italian passport and could still bring her parents back to Rome. The main problem at that time was the lack of material means, especially the absence of visas for any country ready to receive Jewish families. Nevertheless, with better early warnings, I think more Jews could have been saved, especially if a public statement by the pope had been aimed at helping more Jews to obtain life-saving visas.

3. The Bishop of Münster, von Galen, publicly denounced the Nazis' killing of innocent sick people in his sermon of August 3, 1941. "Woe unto the German people," he said, "when innocents not only could be killed, but their slayers remain unpunished."[50] Because of the ensuing public protest, the so-called euthanasia program was officially halted. Lewy writes: "That German public opinion and the Church were a force to be reckoned with in principle and could have played a role in the Jewish disaster as well—that is the lesson to be derived from the fate of Hitler's euthanasia program."[51] Forceful protest from the Vatican would probably have had results of the kind to which Lewy alludes.

4. According to Blet, Msgr. Alois Hudal, who was politically

very close to the German Reich, wrote to General Rainer Stahel, the military governor of Rome, on October 16, 1943, asking him to stop the arrests of the Jews. He threatened that the pope could even decide to make a public protest at a time when Germany had every interest to avoid it.[52] Hudal's letter had no practical result because the Germans knew that Pius XII was unlikely to speak out. If the Germans had had reason to think differently, their response might well have been different, too. The German authorities were very interested in obtaining a good opinion from the pope. In 1943, for instance, Weizsäcker, the German ambassador to the Holy See, had been instructed to elicit a public statement from the Vatican that the behavior of the German army in Rome toward the Vatican had been proper, which indeed he got.[53]

The Holy See's policy regarding the Holy Land

To appraise further the Vatican's stand toward Jews during the Holocaust, it is relevant to notice the Holy See's opposition to Zionism. My research on Vatican policy during and after World War I indicates that this opposition started very early.[54]

As early as April 29, 1917, Pacelli received Nahum Sokolow, a prominent Zionist leader. Pacelli asked precise questions about the Holy Land. He wanted to know how the Zionists defined the "Holy Places" and the future borders of the proposed Zionist territory.[55] Subsequently, Sokolow spoke with Secretary of State, Cardinal Pietro Gasparri, and learned about the Holy See's wide territorial claims in Palestine. On May 4, 1917, Pope Benedict XV, who stressed the importance of the Holy Places, received Sokolow in a private audience and added that appropriate arrangements would be made "between the Church and the Great Powers."[56] Then, on December 18, Cardinal Gasparri told the Belgian envoy, Jules Van den Heuvel, "The transformation of Palestine into a Jewish state would not only endanger the Holy Places and damage the feelings of all Christians, it would also be very harmful for the country itself." A few days later, on December 28, the pope himself expressed his fear to the British representative, John de Salis, that Great Britain "might

agree to forgo direct control over affairs [in Palestine] and hand it over to the Jews to the detriment of Christian interests."[57] The Vatican's concern continued. In January 1919, while the Peace Conference was opening at Versailles, Cardinal Gasparri told the Belgian envoy: "Britain has apparently assumed an obligation towards the Jews, to whom they will hand over part of the administration in Palestine. ... It seems the British politicians fail to appreciate the dangers of this solution for Christian interests in the Holy Land."[58]

There are many more examples of the Holy See's declared worry about a Zionist "invasion" of Palestine. In his Consistorial speech of March 10, 1919, Benedict XV included this sentence: "For surely it would be a terrible grief for us and for all the Christian faithful if infidels were placed in a privileged and prominent position; much more if those most holy sanctuaries of the Christian religion were given into the charge of non-Christians."[59] A few days later Gasparri said: "The danger we most fear is the establishment of a Jewish state in Palestine." On June 13, 1921, the pope again stated that the Jews "must in no way be put above the just rights of the Christians."[60]

The Holy See pursued its struggle against Zionists in Palestine as far as sending an official protest to the Council of the League of Nations on May 15, 1922, with the purpose of delaying or possibly canceling approval for the League's British mandate over Palestine. The Holy See, Gasparri wrote, could not agree to "the Jews being given a privileged and preponderant position in Palestine vis-à-vis other confessions."[61] Eventually the mandate was approved, but the Holy See's hostility toward Zionism did not relent.

Thousands of Jews could have been saved from the Holocaust if they had been allowed to enter Palestine under the British mandate, but the Holy See's anti-Zionist policy, so evident during the 1920s, scarcely changed during World War II. Entering Palestine was already difficult for Jews because, on the eve of the war, the British had drastically restricted Jewish immigration to Palestine to appease the Arabs. Jewish immigration was made still more difficult because of the Catholic Church's persisting hostility toward Zionism.

The introduction to Volume 9 of ADSS, the wartime documents published by the Holy See, reads as follows: "The political intentions implied in the immigration to Palestine under such a sponsorship [of the Zionist movement] could not be totally ignored by the Holy See."[62] At a time when any act of rescue was of extreme importance for European

Jews, the Holy See found time instead to weigh the political implications of such actions rather than take ethical initiatives. Politics, not morality, dictated this policy.

The list of wartime, anti-Zionist pronouncements and policies from the Vatican is too long for enumeration here. Suffice it to say that the Vatican's position provided no help for Jews, including Jewish children, who might have found refuge in Palestine if the Vatican's concerns had been more in that direction. In its concern for the Holy Places, the Vatican took a political stand that safeguarded its own interests rather than the lives of desperate Jews. Although there is some parallel between the political activities of the Holy See and those of the British government, both resulting in the needless killing of many Jews, there is one big difference. The Holy See did not merely function as a political body among other nations; it claimed, above all other states, to be the beacon of morality to all Western civilization. As such it failed shamefully.

Jewish and Christian memories of the Holocaust

From the very beginning of his pontificate, Pope John Paul II has defended the memory of Pius XII, especially before Jewish audiences. This was the case in his first meeting with a Jewish delegation, on March 12, 1979, when he received the representatives of the International Jewish Liaison Committee. On that occasion, John Paul II said, "I am, moreover, happy to evoke in your presence today the dedicated and effective work of my predecessor Pius XII on behalf of the Jewish people."[63] In the same spirit, John Paul II spoke to Jewish leaders in Miami on September 11, 1987, when he said: "I am convinced that history will reveal even more clearly and convincingly how deeply Pius XII felt the tragedy of the Jewish people, and how hard and effectively he worked to assist them during the Second World War."[64] Consequently, it was no surprise when the Church started Pius XII's beatification process.

One can argue that no Jew has any right to interfere with the decisions of the Church to beatify any one of its own flock. The Jews cannot interfere in the internal matters of the Church, and they do not have a say about such matters. But this is only true in so far as the internal matter is not directly connected to Jews. The canonization of Edith Stein

as well as the beatification of Pius XII are directly related to the Jews, and the Jews should therefore speak up and express their views, including their opposition. Moreover, if the Jewish–Catholic dialogue is to be a real dialogue, and not merely a series of unilateral declarations, it is the duty of the Catholic Church to discuss such matters with Jews before the beatification becomes finalized. In our times, the Church decided not to beatify Queen Isabella when the protests of the Amerindians were raised against that initiative. The least the Church could do now, in the light of Jewish protests, is to postpone the beatification of Pius XII until the Vatican's archives have been opened and assessed by competent scholars.

Questions about Pope Pius XII and his actions during World War II remain, above all, moral issues. Aptly, Giovanni Miccoli wrote that the silence of Pius XII "is the symptom of a crisis, the sign of incapability and lack of ability [of Pius XII] to face and understand the new and terrible problems that contemporary reality was raising."[65] The best moral judgment about Vatican diplomacy is given by Morley, whose well-researched book concludes that "Vatican diplomacy failed the Jews during the Holocaust by not doing all that it was possible for it to do on their behalf. It also failed itself because in neglecting the needs of the Jews, and pursuing a goal of reserve rather than humanitarian concern, it betrayed the ideals that it had set for itself."[66]

In the relations between Jews and Catholics, there are some issues that are irreconcilable—for example, the proposition that there is no salvation outside the Church, which Cardinal Joseph Ratzinger reaffirmed in September 2000.[67] Nevertheless, on historical questions concerning the Shoah, a common ground of discussion and even a consensus can be found. Books such as Morley's *Vatican Diplomacy*, or the anthology *The Holocaust and the Christian World*, provide a sound basis for a consensus of that kind.[68]

NOTES

1. John Cornwell, *Hitler's Pope: The Secret History of Pius XII* (New York: Viking, 1999), 382. See also my critical article, "The Holy See who saw but said nothing," *Haaretz*, November 26, 1999.
2. Cornwell ignores this fact. For more detail on Benigni, see Maria Teresa Pichetto, *Alle radici dell'odio, Preziosi e Benigni antisemiti* (Milan: F. Angeli, 1983), 108.

3. Pichetto, *Alle radici dell'odio*, 119.

4. Cited in Ronald Modras, *The Catholic Church and Antisemitism: Poland, 1933–1939* (Chur, Switzerland: Harwood, 1994), 45.

5. Cited in *ibid.*, 345.

6. See Georges Passelecq and Bernard Suchecky, *The Hidden Encyclical of Pius XI*, trans. Steven Rendall (New York: Harcourt Brace, 1997).

7. See Léon Papeleux, *Les Silences de Pie XII* (Brussels: Vokaer, 1980), 62.

8. Luigi Sturzo (1871–1959), a priest and a politician, became the leader of the Partito Popolare Italiano (a Catholic party) in 1919. He opposed Fascism and was obliged to go into exile in the United States in 1926 when political parties were abolished in Italy. He returned to Italy in 1946.

9. Pierre Blet, Robert A. Graham, Angelo Martini, and Burkhardt Schneider, eds., *Actes et documents du Saint Siège relatifs à la Seconde Guerre mondiale*, 11 vols. (Vatican City: Libreria Editrice Vaticana, 1965–81), 9: 16. Hereafter cited as ADSS.

10. Pierre Blet, *Pius XII and the Second World War: According to the Archives of the Vatican*, trans. Lawrence J. Johnson (New York: Paulist Press, 1999), 144.

11. See Papeleux, *Les Silences de Pie XII*, 89. Letter of Cardinal Tisserant to Cardinal Suhard (Paris), June 11, 1940. The full text is in Saul Friedländer, *Pius XII and the Third Reich: A Documentation* (New York: Alfred A. Knopf, 1966).

12. Blet, *Pius XII and the Second World War*, 162.

13. *Ibid.*, 167.

14. See ADSS, 3: 119.

15. See ADSS, 3: 137, notes of Pius XII, May 11, 1940.

16. My judgment is based on a conversation with Soro and on the testimony of my mother, Fanny Ginzburg Minerbi. See also Saul Friedländer, *Pius XII and the Third Reich*.

17. See ADSS, 8: 453. See also John F. Morley, *Vatican Diplomacy and the Jews during the Holocaust, 1939–1943* (New York: KTAV, 1980), 79.

18. M. Manzo, *Don Pirro Scavizzi, Prete Romano (1844–1964)* (Casale Monferrato: Piemme, 1997). I thank Dr. Manfredo Macioti for this source. See Manfredo Macioti, "Il silenzio di un Papa: un enigma storico," *La Critica Sociologica*, n. 134, *Estate* 2000.

19. Manzo, *Don Pirro Scavizzi*, 128.

20. *Ibid.*, 216.

21. *Ibid.*, 230.

22. *Ibid.*, 130.

23. Blet, *Pius XII and the Second World War*, 150–1.

24. Monica M. Biffi, *Mons. Cesare Orsenigo, nunzio apostolico in Germania (1930–1946)* (Milan: NED, 1997), 99.

25. ADSS, 8: 738–42. Blet refers to and quotes from this report. See *Pope Pius*

XII and the Second World War, 151–2. For Morley's English translation, see his *Vatican Diplomacy*, 252.

26. Curzio Malaparte, *Kaputt* (Evanston, Ill.: Northwestern University Press, 1995).
27. *Ibid.*, 170.
28. Fausto Coen, *16 ottobre 1943* (Florence: Giuntina, 1993), 133.
29. See Michele Tagliacozzo, "La Comunità di Roma sotto l'incubo della svastica," *Quaderno del CDEC*, No. 3, Milan, November 1963, 9.
30. See Roberto Katz, *Sabato nero* (Milan: Rizzoli, 1973).
31. ADSS, 9: 519; Notes de la Secrétariat d'État, October 23, 1943.
32. Michael Phayer, *The Catholic Church and the Holocaust, 1930–1965* (Bloomington: Indiana University Press, 2000), 98.
33. ADSS, 9: 505; notes of Cardinal Maglione.
34. Contrary to John Cornwell's claim, this testimony has been published previously by Giorgio Angelozzi Gariboldi, *Pio XII, Hitler e Mussolini, Il Vaticano fra le dittature* (Milan: Mursia, 1988), 214.
35. Cited from Cornwell, *Hitler's Pope*, 315.
36. Susan Zuccotti, *L'Olocausto in Italia* (Milan: Mondadori, 1988), 155.
37. Sergio I. Minerbi, *Un ebreo fra D'Annunzio e il sionismo: Raffaele Cantoni* (Rome: Bonacci, 1992), 124.
38. Morley, *Vatican Diplomacy*, 194.
39. See Giovanni Miccoli, *I dilemmi e I silenzi di Pio XII, Vaticano, Seconda guerra mondiale e Shoah* (Milan: Rizzoli, 2000), 39.
40. See *ibid.*, 40.
41. Gariboldi, *Pio XII*, 147.
42. Blet, *Pius XII and the Second World War*, 80.
43. *Ibid.*
44. See Gariboldi, *Pio XII*, 148.
45. See *ibid.*, 158.
46. See Miccoli, *I dilemmi e I silenzi di Pio XII*, 48.
47. See Friedländer, *Pius XII and the Third Reich*, 92.
48. Tiso (1887–1947) became President of Slovakia in 1938. After the war, he was executed for his Nazi collaboration.
49. Morley, *Vatican Diplomacy*, 101.
50. See Guenter Lewy, *The Catholic Church and Nazi Germany* (New York: McGraw-Hill), 265.
51. *Ibid.*, 267.
52. See Blet, *Pius XII and the Second World War*, 216.
53. Phayer, *The Catholic Church and the Holocaust, 1930–1965*, 98.
54. See Sergio Minerbi, *The Vatican and Zionism* (New York: Oxford University Press, 1990).
55. *Ibid.*, 108.
56. *Ibid.*, 111.

57. *Ibid.,* 120.

58. *Ibid.,* 122.

59. *Ibid.,* 131.

60. *Ibid.,* 148.

61. *Ibid.,* 179.

62. See ADSS, 9: 44.

63. Eugene J. Fisher and Leon Klenicki, *Spiritual Pilgrimage, Pope John Paul II* (New York: Crossroad, 1998), 5.

64. *Ibid.,* 107.

65. Giovanni Miccoli, "Chiesa e Società dal Concilio Vaticano I al pontificato di Giovanni XXIII," in Cesare de Seta, ed., *Storia d'Italia,* Vol. V/2 (Turin: Einaudi, 1973), 1533.

66. Morley, *Vatican Diplomacy,* 209.

67. See *Dominus Iesus,* Congregation for the Doctrine of the Faith, September 5, 2000.

68. See Carol Rittner, Stephen D. Smith, and Irena Steinfeldt, eds., *The Holocaust and the Christian World: Reflections on the Past, Challenges for the Future* (New York: Continuum, 2000).

Doris L. Bergen

An Easy Target? The Controversy about Pius XII and the Holocaust

The debates around Pope Pius XII reflect some painful issues about Christianity and the Holocaust that do not seem to lose their urgency over time. An event at the United States Holocaust Memorial Museum in Washington, D.C., illustrates my point.[1] In 1993, the museum hosted a conference that included a session in which scholars analyzed Christian responses to the murder of European Jews during World War II.[2] The papers were interesting, but the discussion that followed was more memorable, even though there was time for only a few remarks from the floor. Three women spoke, all of them Jewish survivors of the Holocaust. How was it possible, the first asked, that the pope could have cared more about the institutional health of the Church than its moral integrity?[3] When one of the presenters explained the Vatican's vulnerability to Italian Fascist and subsequently National Socialist power, the woman posed another question. What is it to have faith in God, she wanted to know, if the pope, God's representative on earth, eschews martyrdom, and even discomfort or difficulty for himself and his followers, in favor of accommodation to the forces of evil?

The second woman raised a different concern. She had been liberated from Bergen-Belsen in 1945 but remained for some time in a displaced persons' camp. A papal emissary visited the camp to ask its occupants what the Vatican could do for them. Tell the pope to get our children back, the woman urged, speaking on behalf of a small group of survivors. What she and the others wanted was for the pope to issue an appeal to all Catholics who had sheltered Jewish children during the war, calling on them to return the children to their relatives, if possible, or to the Jewish community as a whole.[4] Those were Jewish children, the woman insisted, and they needed to number among the remnant that came out from the war alive. So why had the pope not called for their return?

Doris L. Bergen

The third woman had been hidden by a priest in Belgium.⁵ He had saved many Jewish children, she said, and instructed her and the others in Judaism as best he could. When the war was over, he personally sought out relatives or Jewish organizations to take in every single child. What made that man different, the woman wondered? Why had his faith inspired courage, respect, and profound empathy when so many other Christians, including the pope, had failed?

Those women's questions—about the Church's priorities, its post-war loyalties, and the range of behaviors among its members—extend far beyond the individual person of Pius XII. Nevertheless, they all referred to him because, for them, as for many other people, the pope has a metonymous function: he stands in for the Church, even for Christianity as a whole. In the specific context of the Holocaust, "the pope" can serve as a kind of shorthand symbol representing broader issues of Christian agency and responsibility. Viewed in this light, the controversy around Pius XII is neither just about the Vatican nor relevant only to Catholics. On the contrary, in this dispute are embedded fundamental challenges to the role of Christianity in the world, past, present, and future.

Has John Cornwell's book and the fire it has drawn to Pius XII promoted the kind of open discussion needed to do justice to the issues at stake? Certainly *Hitler's Pope* has sparked productive conversations: the meeting from which this volume emerged is a wonderful example. Nevertheless, there are also troubling aspects to the controversy and the particular shape it has taken. By reducing a complex set of issues to one man and a few, often predictable debates, we risk closing off rather than opening up our inquiry. Instead of responding to challenges like those raised by the three people at the Holocaust Museum—or at least helping Christians to engage such questions honestly—the uproar around Pius XII threatens to drown out all but a few polemical voices. In the rest of this chapter, I would like to suggest some ways in which the spotlight on Pius XII jeopardizes more searching critiques of Christianity. We need, I argue, a broader, more complex perspective, for Pius XII has become an easy target—too easy historically, politically, and, above all, morally to accommodate a self-critical and open-ended study of Christian involvement in genocide.

Crimes worse than silence? Historical considerations

The popular attention on Pius XII focuses on two related charges: that he was antisemitic, and that he remained silent in response to the murder of European Jews.[6] These are crucial matters, and it is right that they be examined and re-examined from all angles. Many studies of these issues, however, neglect the wider context. As a result, they tend to overlook important aspects of Pius XII's behavior during World War II, to disregard the involvement of non-Catholic Christians, and to avoid discussion of Christians as perpetrators of the Holocaust.

As John Pawlikowski and Gerhard Weinberg have reminded us, Pius XII was not only reticent in defense of Jews. In 1939, Pius likewise responded with silence to the Germans' slaughter of thousands of Polish Catholic intellectuals, including many priests—clergy in his own Church.[7] The Vatican was only slightly more outspoken on behalf of handicapped victims of the Nazi program of murder, although these targets also included many Catholics and inmates of Catholic-run hospitals and asylums.[8] As for the approximately three million Soviet prisoners of war whom Germans killed or allowed to die of starvation or disease in 1941–2, no one seems to notice that the pope did not protest on their behalf,[9] nor do even the sharpest critics mention Pius XII's failure to denounce the murder of hundreds of thousands of Roma (Gypsies) during World War II.[10]

Pius XII, in other words, maintained a consistent record, if not of total silence, certainly of extreme diplomatic caution in speaking out on behalf of the victims of Nazism. Cornwell, to his credit, acknowledges this pattern, in particular with regard to Polish Catholics; he attributes it to the pope's agenda to expand the power of the Vatican. Cornwell may be right about Pius XII's motives, but a self-perpetuating dynamic also seems to have been at work. Each failure to protest must have made it harder to speak out the next time, because to do so would mean admitting the earlier error of silence.[11] Seen in this light, the Vatican's failure during World War II goes even deeper than the pope's ineffectual response to the persecution and murder of Jews. Somehow the Vatican refused in general to engage with human desperation, to share the suffering of a world torn by "mass death,"[12] to show humanitarian leadership and solidarity with people outside the Church—a role, admittedly, that few in the 1930s and 1940s expected the pope to play—or even to demonstrate concern for the lives of Catholic priests.

Doris L. Bergen

Any discussion of papal negligence raises the question of power. Would it have made any difference if Pius XII had protested German atrocities—loudly, publicly, and repeatedly?[13] At some level, of course, we cannot know. It is unrealistic to assume that Pius XII alone could have turned the tide of the Holocaust, but it would be equally misguided to conclude that he was therefore powerless. Would it have made a difference if German generals, judges, lawyers, doctors, professors, or teachers had refused to cooperate with programs of persecution and killing? Of course it would have, because the Nazi system depended on the cooperation of these and other groups. The Vatican in contrast exercised "only" moral authority, but to a regime obsessed with public opinion, as Hitler's was, moral opponents could be the most dangerous of all.

We know that Hitler worried about public papal disapproval; he believed the Vatican wielded real power.[14] Others shared that conviction: in 1940, Lord Halifax, the former British Foreign Secretary, wrote to Lord Fitzalan, a prominent English Catholic, urging him to secure a papal denunciation of Hitler because, in his words, "Catholics everywhere need to be strengthened by authority in their resistance to Nazi blandishments."[15] Italian military chaplains serving on the Eastern Front in 1941, who witnessed Hitler's "war of annihilation" against the Soviet Union, also believed in the pope's influence. Some of them sent Pius XII reports of atrocities they had seen against civilians, especially Jews, and implored him to protest.[16] Power is partly in the eye of the beholder, and although not quantifiable, papal power existed in the perception of non-Catholics as well as Catholics. Indeed, the almost obsessive interest in Pius XII more than half a century after the war ended is itself an indirect testimony to the pope's importance.

The legacy of the Nazi era, however, belongs to all Christians, regardless of confession. Undue concentration on Pius XII ends up drawing attention away from the actions and inaction of Christians who were not Catholic, but Protestant or Eastern Orthodox. Admittedly the pope provides a convenient focal point, which makes discussing Catholic responses simpler than trying to make sense of the complicated organization of the rest of Christianity. A few facts, however, remind us that it is inappropriate to generalize from "Catholic" to "Christian."

By the outbreak of World War II, despite years of Nazi anti-Christian propaganda, more than 95 per cent of Germans were still baptized, tax-paying members of an established Christian church. About

two-thirds of them were Protestant (Lutheran, Reformed, and United).[17] With regard to Christian antisemitism and opposition to Jewish emancipation, subjects Richard L. Rubenstein has described so powerfully in his contribution to this volume, European Protestants and their Orthodox counterparts did not lag behind Catholics, even if their prejudices sometimes took different forms.[18] Every Christian group in Europe came into direct contact with the crimes of the Holocaust. A few, like the Jehovah's Witnesses, suffered persecution themselves.[19] Most, however, aligned themselves with the persecutors rather than the victims. Even small, marginalized groups like the Mennonites in Ukraine witnessed attacks on Jews and Gypsies. Some Mennonites benefited materially from their neighbors' misery, and in individual cases they joined the ranks of the perpetrators.[20]

As Elie Wiesel has pointed out, not all victims of the Holocaust were Jews, but all Jews were victims. A mirror-image claim holds true, too. Not all Christians were bystanders or perpetrators, but all of the bystanders and perpetrators were Christians. Of course not all were personally committed, genuine exemplars of living faith, but then again neither were those slaughtered as Jews necessarily observers or even members of the Jewish religion. Rather, those who implemented the Holocaust were Christians in the sense that they were raised in homes, schools, and churches where the Christian Bible was read and taught, where the birth and death of Jesus marked the high points of the year, and where the Lord's Prayer and Christian hymns were as familiar as the Grimm brothers' fairy tales.

By emphasizing papal silence—"sins of omission"—the debate around Pius XII can obscure even more terrible sins of commission. Christians were not merely inactive in the Holocaust: they did the killing. A few examples illustrate. As General Commissioner in "White Ruthenia" (Belorussia), Wilhelm Kube presided over some of the most brutal German acts of the Second World War.[21] Kube was also a Protestant and one of the founders of the "German Christian Movement." An inmate of Jasenovac, the infamous camp where Croatian Fascists slaughtered Serbs, Jews, and Gypsies, describes a Ustashe officer there who used to make the sign of the Cross each night before going to sleep.[22] The ethnic German thugs who rampaged through Poland plundering and killing in the fall of 1939,[23] the shooters at Babi Yar, the guards who terrorized inmates in camps from Mauthausen to Majdanek—these men and women called themselves Christians, and many were active members of their religious

communities. Even if the perpetrators did not kill in the name of Christianity, the overwhelming majority found it possible to reconcile their acts with continued adherence to their religious traditions. Painful as it is to confront the wartime failures of the Vatican, it is even harder to admit that Christians made the Holocaust. Debates about papal silence cannot do justice to the explosive power of that fact.

Means to whose ends? The Holocaust in the limelight

In 1993, Raul Hilberg remarked that he had studied the Holocaust when few people cared about it, and he would continue to do so now in the limelight.[24] Hilberg recognized that the popularity of the field would bring its own difficulties, many of which are evident in the controversy around Pius XII. The current fashion for Holocaust studies in all forms is bound to attract opportunists along with serious scholars and to reward oversimplification as well as profundity.[25] The power of public interest in turn opens the door to what Moshe Zuckermann and others have called "instrumentalization": using—and sometimes abusing—the Holocaust as a means to other, often political ends.[26] In some cases, fascination and horror at the Holocaust have paradoxically become a substitute for engagement in the anguish of our own world.

In a climate of right-wing violence in Germany, Holocaust denial, and backlash against settlements paid to Jewish survivors and forced laborers by European firms and organizations, it is uncomfortable even to raise such issues. However, it is important that they be addressed by people committed to the field instead of becoming a means of attack. The point is not to discourage interest in the Holocaust but to encourage it to be honest and reflective. As someone who makes a living researching and teaching about Nazi Germany and the Holocaust, I am also aware that my concerns need to be self-critical.

Perhaps it is unfair to point out that John Cornwell was ideally situated in 1999 to spark a controversy around Pius XII. A renowned British journalist associated with Cambridge University, Cornwell had the talent and training to produce an accessible, popular book and the publishing connections to help catapult it onto the best-seller lists. Neither Protestant like Rolf Hochhuth, whose play *The Deputy* unleashed a storm of controversy in Germany in the early 1960s,[27] nor Jewish like

Saul Friedländer, whose scholarship on Pius XII remains essential for anyone in the field,[28] Cornwell could point to credentials as a "believing Catholic."[29] Advance publicity and the book's dust jacket promised access to secret Vatican sources, and the story of Cornwell's "Damascus experience" heightened the drama. Reporting that initially he had been keen to vindicate Pius XII against charges of silence in the Shoah, Cornwell evidently changed his mind when confronted with the archival record.

The commercial success of *Hitler's Pope* should not detract from the importance of the topics it raises, nor should scholarly snobbishness be grounds to dismiss the book. Still, it is hard to read the dramatic title and see the provocative photographs without sensing marketing experts at work—and feeling manipulated. Somehow Cornwell's account, with its almost conspiratorial theory of papal aggrandizement, plays to a public eager for sensational yet predictable presentations of the past and tilts toward Saul Friedländer's characterization of kitsch as "precisely the neutralization of 'extreme situations,' particularly death, by turning them into some sentimental idyll."[30]

It is easy to accuse people of instrumentalizing the Holocaust when one disagrees with them. More difficult is to determine whether causes to which one subscribes constitute misuse. Is it instrumentalization or historical justice if Cornwell used *Hitler's Pope* to derail the beatification of Pius XII? In either case, according to recent reports, he and those who share his reservations may at least have succeeded in effecting postponement.[31] What about opponents of ecumenism who seize on Cornwell's book as a way to disrupt Catholic–Jewish rapprochement? Thanks largely to the efforts of Popes John XXIII and John Paul II, relations between Catholics and Jews, though far from perfect, are probably the best they have ever been. Cornwell's revelations of antisemitism in the Vatican and papal priorities that put institutional power at the top and humanitarian concerns near the bottom may not be new, but they come at a moment where there is real progress that could be undone. Do attempts to undermine that dialogue constitute instrumentalization or legitimate protection of particular interests? At the very least it seems all such positions call for examination and disclosure of motives.

Hitler's Pope raises other awkward questions about the uses of the past. Cornwell's assault on the Vatican's prestige comes at a time when Catholicism faces serious problems. An aging clergy and increasing

difficulty recruiting new priests; conflicts over women's roles; disputes about the place, if any, for homosexual priests and parishioners; disagreements over reproductive rights, social justice, and political engagement—the list could continue. Accusations of inaction and even complicity in atrocities that have become emblematic of the twentieth century's worst crimes further damage the Church's cause. Given this context, it is no surprise that some of Pius XII's defenders seem more eager to shut down questioning than to risk open discussions of the past. By the same token, some of Pius's accusers seem more interested in scoring points against the Catholic hierarchy than in locating something at least close to historical truth. In this polarized situation, where is the space for careful, balanced reflection?

Meanwhile, popular interest and media attention add their own challenges to institutional integrity. As every public relations professional knows, at some level, all publicity is good publicity. There is no denying that many of the recent headlines about the Catholic Church have involved the Holocaust, Israel, and Judaism. Troublesome as it is, such coverage has benefits for the Church; at least, one can say, we are not irrelevant—we too were there at the center of world historical developments. But does the lure of the limelight sometimes obscure basic principles? Are there occasions when ecclesiastical leaders have used debates about the Holocaust more to assert the Church's importance than to examine its collective conscience? Raising these questions does not imply the existence of some insidious publicity stunt; public relations in any organization respond to popular moods, and adjustments to trends are almost automatic. My point instead is that institutions, like individuals, need to acknowledge the power that comes with control of history and seek ways to ensure they exercise it responsibly and self-critically.

In *The Holocaust in American Life*, Peter Novick argues that an exclusive focus on the Nazi victimization of Jews serves to downplay oppression of other people. Making the Holocaust "the benchmark" of evil works against sensitizing us to atrocity, Novick maintains; instead it contributes to "trivializing crimes of lesser magnitude."[32] Novick's accusation needs to be nuanced: as anyone with experience in the field of comparative genocide studies knows, individual survivors and scholars of the Holocaust have done much to raise awareness of crimes against non-Jews.[33] Nevertheless, Novick points to a real problem of particular relevance for Christians. Has the emphasis on the Vatican and the

Holocaust become a way to avoid thinking about more recent Christian failings? It is, after all, easier to regret and repent for sins past—especially those committed before many of us were even born—than it is to examine our behavior in the present.

Who has asked forgiveness for the abysmal failure of Christians all over the world in the face of genocide in Rwanda—the most Christian country in Africa, where many clergy numbered among the killers and the killed, and where church buildings became key sites of murder?[34] Who has apologized for either the silent impotence or the violent involvement of Christians in the wars in Croatia, Bosnia-Herzegovina, and Kosovo?[35] What about Christians in the so-called "Dirty Wars" in Latin America, where some clergy stood by the downtrodden whereas others became the confidants of power? In short, neither Christian silence nor Christian brutality was unique to the Holocaust. Remembering the Shoah does not mean accusing as if we occupied a place of innocence, nor is it enough to invoke hackneyed phrases like "never again." Meaningful remembering requires engagement, humility, and willingness to recognize that the past is a challenge to us in the present.

The temptations of closure

Perhaps the most disturbing aspect of the controversy around Pius XII is its drive toward closure. No matter which side of the debate one considers, one sees the impulse for resolution. Beatification or demonization of Pius XII, apologies, reconciliation, forgiveness—all reflect a yearning to be done with it, to close the book once and for all on discussions of Christian responsibility in the Shoah.

That longing for an ending, preferably a happy one, typifies much of the current interest in the Holocaust. It is evident in the closing scenes of Steven Spielberg's *Schindler's List*;[36] in former German Chancellor Helmut Kohl's reference to the "blessing" of a birth too late to be held responsible for the war; and in the enthusiasm for memoirs that end with photographs of the survivor surrounded by smiling children and grandchildren. Christians may be especially susceptible to redemptive interpretations of the Holocaust, because the heart of Christianity is the miracle of atonement through blood.

With regard to the Holocaust, however, the comfort of closure is

cold and false. Some wrongs are too big ever to right. Instead of redemption or purification, the legacy of the Holocaust is pain, grief, upheaval, and loss. Brutality, we learn from that past and its repercussions, is contagious. When Stalin's NKVD, forerunners to the KGB, interrogated survivors of Nazi incarceration, they showed particular interest in the details of German torture. Their goals were not humanitarian; rather they hoped to find ways to perfect their own methods.[37] Right-wing extremists still rally under the swastika, and relations between the perpetrators' generation and their descendants remain strained by the knowledge, often concealed, of participation in horror.

Even the Christian concept of forgiveness, as Katharina von Kellenbach has pointed out, proves inadequate in the face of horrendous crimes. With its focus on perpetrators rather than victims, it has been invoked to ease the consciences of the guilty without offering justice for those who suffered at their hands.[38] Christian appeals for forgiveness, both human and divine, can be expected to rouse Jewish anger or at best resentment in the future as they often have before. The past remains a permanent scar on the face of Christianity that neither blaming it all on Pius XII nor circling the wagons in defense and denial can conceal.

So what can be done? As scholars we can work to uncover the complexity of Christian involvement in the Holocaust. Neither mourning nor "working through" the Shoah is possible without informed confrontation with the past,[39] and meaningful Christian–Jewish dialogue can only be based on honesty. Perhaps most important, we can accept the impossibility and undesirability of closure. Here I agree with Michael Geyer that "the only possible and conceivable history after the rupture of civilization in World War II, present as yet only in its inceptions, is ... a multiple and contestatory history."[40] Pius XII is part of that history, but so are the women whose questions introduced this chapter. The process of answering them has barely begun.

NOTES

Many thanks to Carol Rittner, John Roth, and all those who participated in the symposium on Pius XII at King's College, Wilkes-Barre, Pennsylvania. I am also grateful to Laura Crago for her help.

1. The December 1993 meeting was hosted by the Research Institute at the United States Holocaust Memorial Museum (now the Center for Advanced Holocaust Studies). Papers have since been published as *The Holocaust and History: The Known, the Unknown, the Disputed, and the Reexamined*, ed. by Michael Berenbaum and Abraham J. Peck (Bloomington: Indiana University Press, 1998).

2. Speakers at the session were Franklin Littell, John Pawlikowski, and Doris L. Bergen. John Roth moderated, and Gerhart Riegner responded.

3. On the Catholic Church during the war, important early works include: Gordon Zahn, *German Catholics and Hitler's Wars: A Study in Social Control* (New York: Sheed and Ward, 1962, reprinted by University of Notre Dame Press, 1989); Guenter Lewy, *The Catholic Church and Nazi Germany* (New York: McGraw-Hill, 1964); and Saul Friedländer, *Pius XII and the Third Reich* (New York: Alfred A. Knopf, 1966). More recent studies that make important and, at times, controversial contributions to the same topic include: Pierre Blet, *Pius XII and the Second World War: According to the Archives of the Vatican*, trans. Lawrence J. Johnson (New York: Paulist Press, 1999); John Cornwell, *Hitler's Pope: The Secret History of Pius XII* (New York: Viking, 1999); Michael Phayer, *The Catholic Church and the Holocaust, 1930–1965* (Bloomington: Indiana University Press, 2000); Susan Zuccotti, *Under His Very Windows: The Vatican and the Holocaust in Italy* (New Haven, Conn.: Yale University Press, 2000); and James Carroll, *Constantine's Sword: The Church and the Jews, A History* (Boston: Houghton Mifflin, 2001).

4. In the discussion, Gerhart Riegner shared his experiences negotiating with the Vatican after the war to try to effect the return of Jewish children.

5. On Christian rescuers of Jews, especially children, in Belgium, see the film by Myriam Abramowicz and Esther Hoffenberg, *Comme si c'était hier* (*As If It Were Yesterday*) (New York: 1980).

6. A "pre-Cornwell" example is James Carroll, "The silence," *New Yorker*, April 7, 1997, 59–62.

7. See Pawlikowski's chapter in this volume. Weinberg commented on this topic during discussion at the conference on "Humanity at the limit: the impact of the Holocaust experience on Jews and Christians," University of Notre Dame, April 1998. On German treatment of Polish gentiles during World War II, see Richard C. Lukas, *The Forgotten Holocaust: The Poles under German Occupation, 1939–1944* (Lexington, Ky.: University Press of Kentucky, 1986).

8. On the program to murder people deemed handicapped, see Henry Friedlander, *The Origins of Nazi Genocide: From Euthanasia to the Final Solution* (Chapel Hill: University of North Carolina Press, 1995); also Michael Burleigh and Wolfgang Wippermann, *The Racial State: Germany 1933–1945* (New York: Cambridge University Press, 1991); and Michael

Burleigh, *Death and Deliverance: "Euthanasia" in Germany c. 1900–1945* (New York: Cambridge University Press, 1997).

9. The best study of German treatment of Soviet prisoners of war is Christian Streit, *Keine Kameraden: Die Wehrmacht und die sowjetischen Kriegsgefangenen 1941–1945* (Stuttgart: Deutsche Verlags-Anstalt, 1978).

10. On the Nazi murder of Gypsies/Roma, see Michael Zimmermann, *Rassenutopie und Genozid: Die nationalsozialistische "Lösung der Zigeunerfrage"* (Hamburg: Hans Christians Verlag, 1996).

11. James Carroll observes a similar dynamic at work in the refusal of Pope John Paul II to admit errors by his wartime predecessor and connects the ongoing phenomenon of papal silence to the doctrine of infallibility.

12. The phrase "mass death" is from Michael Geyer, "The place of the Second World War in German memory and history," *New German Critique*, 71, Spring–Summer 1997, 9.

13. For an example of arguments that at least the United States, Great Britain, and France could not have made much difference in the Holocaust, see William D. Rubinstein, *The Myth of Rescue: Why the Democracies Could Not Have Saved More Jews from the Nazis* (London: Routledge, 1997). John Conway and others have made similar claims that the Vatican and other Church bodies could not have made much difference.

14. It is no coincidence that one of Hitler's first major foreign policy successes in 1933 was the signing of a concordat with the Vatican. Cornwell shows this event from the papal perspective, but it was also a significant triumph for the new National Socialist regime.

15. Quoted in Chris Hastings, "Churchill sought Catholics' help to pressure Pope: Vatican's silence on Nazis frustrated Britain, letters show," *The Sunday Telegraph*, reproduced in *Edmonton Journal*, May 28, 2000, A3. Thanks to Peter Wynn for this reference.

16. I would like to thank Kevin Madigan for describing to me this correspondence between Italian military chaplains and the Vatican.

17. See data from the Ministry of Church Affairs, "Zusammenstellung über Kirchenaustritte und Kirchenrücktritte bezw. Übertritte, ermittelt nach den von den Kirchen veröffentlichten Zusammenstellungen," no author [1940], in Bundesarchiv Koblenz, R 79/19. These materials have been relocated within the German federal archives since I used them.

18. On Christian antisemitism, see Donald Niewyk, "Solving the 'Jewish problem'—continuity and change in German antisemitism, 1871–1945," *Leo Baeck Yearbook* (1990), 369; also Yehuda Bauer, "Vom christlichen Judenhaß zum modernen Antisemitismus—Ein Erklärungsversuch," in *Jahrbuch für Antisemitismusforschung*, 1, ed., Wolfgang Benz (Frankfurt: Campus Verlag, 1992), 77–90. Specifically on German Protestants, see Uriel Tal, "On modern Lutheranism and the Jews," *Leo Baeck Yearbook*

(1985); Wolfgang Gerlach, *Als die Zeugen Schwiegen: Bekennende Kirche und die Juden* (Berlin: Institut Kirche und Judentum, 1987); and Susannah Heschel, "Nazifying Christian theology: Walter Grundmann and the Institute for the Study and Eradication of Jewish Influence in German Church Life," *Church History*, 64, No. 4, Dec. 1994, 587–605.

19. A good overview is the film *Jehovah's Witnesses Stand Firm against Nazi Assault* (Watchtower Society, 1995).

20. One Mennonite woman from Ukraine reported in 1946 that of course she knew about the killing of Jews; many Jews lived nearby, and a member of her own community had a Jewish husband. German SS men poisoned that woman's child before its mother's eyes, she said. Interview with Anna Braun, September 20, 1946, in David P. Boder, "Topical autobiographies of displaced people," Bound Section 4, Chapter 16, 28–9, United States Holocaust Memorial Museum Archive, Washington, D.C. (hereafter USHMMA). On Mennonite observers of mass shooting of Gypsies in Ukraine, see the two-part article in the Canadian Mennonite publication *Der Bote*, Summer 1998. According to that eyewitness account, Germans offered local Mennonites the clothes of the dead Gypsies. Information on Mennonite SS and Mennonites convicted after the war for crimes against Jews comes from interviews I conducted in Petershagen and Bielefeld, June 1998.

21. On Belorussia under German occupation, see Christian Gerlach, *Kalkulierte Morde: Die deutsche Wirtschafts- und Vernichtungspolitik in Weissrussland 1941 bis 1944* (Hamburg: Hamburger Editions, 1999).

22. Account of Vladko Macek, leader of the Croatian Peasants' Party, in Jonathan Steinberg, "The Roman Catholic Church and genocide in Croatia, 1941–1945," in Diana Wood, ed., *Christianity and Judaism: Papers Read at the 1991 Summer and the 1992 Winter Meeting of the Ecclesiastical History Society* (Oxford: Blackwell Publishers, 1992), 463.

23. See Christian Jansen and Arno Weckbecker, *Der "Volksdeutsche Selbstschutz" in Polen 1939/40* (Munich: R. Oldenbourg Verlag, 1992).

24. Opening remarks by Raul Hilberg at the conference of the Research Institute at the United States Holocaust Memorial Museum, Washington, D.C., December 1993.

25. The fascination with the Holocaust is the subject of a number of recent books, for example: Tim Cole, *Selling the Holocaust: From Auschwitz to Schindler, How History Is Bought, Packaged and Sold* (New York: Routledge, 1999); Hilene Flanzbaum ed., *The Americanization of the Holocaust* (Baltimore: Johns Hopkins University Press, 1999); and Peter Novick, *The Holocaust in American Life* (Boston: Houghton Mifflin, 1999). The most extreme—and problematic—discussion of related issues is Norman Finkelstein, *The Holocaust Industry: Reflections on the Exploitation of Jewish Suffering* (New York: Verso, 2000).

26. Moshe Zuckermann, *Zweierlei Holocaust: Der Holocaust in den politischen Kulturen Israels und Deutschlands* (Göttingen: Wallstein, 1999).

27. Rolf Hochhuth, *The Deputy* (New York: Grove Press, 1964).

28. Friedländer, *Pius XII.*

29. See, for example, mention of Cornwell's Catholicism in the reviews and discussion of *Hitler's Pope* on Amazon.com, August 2000.

30. Saul Friedländer, *Reflections on Nazism: An Essay on Kitsch and Death* (New York: Alfred A. Knopf, 1984), 27.

31. Tom Gross, "Fury over plan to beatify 'anti-Semite' Pope," *Sunday Telegraph*, August 20, 2000, 23. Under discussion here are plans to beatify Pius IX. According to Gross: "Objections to the move are quite distinct from those against plans to beatify another pontiff, the wartime Pope, Pius XII, who has been dubbed 'Hitler's Pope' because of his alleged failure to criticize the Nazi round-up and subsequent murder of European Jews. The latter beatification proposals are thought to have been quietly suspended following concerted pressure from Jewish objectors and liberal Catholics." Thanks to Judith Meyers for drawing my attention to this report.

32. Novick, *Holocaust in American Life*, 14.

33. Some examples of scholars of the Holocaust who have pioneered studies of atrocities or acts of genocide against non-Jews are Henry Friedlander, Helen Fein, Sybil Milton, Gabrielle Tyrnauer, Henry Huttenbach, and Guenter Lewy.

34. See Tim Longman, "Christian Churches and the genocide in Rwanda," paper delivered at the Conference on Genocide, Religion, and Modernity, United States Holocaust Memorial Museum, May 1997; also Hugh McCullum, *The Angels Have Left Us: The Rwandan Tragedy and the Churches* (Geneva: WCC Publications, 1995); and Philip Gourevitch, *We Wish to Inform You That Tomorrow We Will Be Killed with Our Families: Stories from Rwanda* (New York: Farrar, Straus and Giroux, 1998).

35. On religion and wars in the lands of the former Yugoslavia, see Sabrina P. Ramet, *Balkan Babel: Politics, Culture, and Religion in Yugoslavia* (Boulder: Westview Press, 1992); Paul Mojzes, *Yugoslavian Inferno: Ethnoreligious Warfare in the Balkans* (New York: Continuum, 1994); and Michael Sells, "Religion, history, and genocide in Bosnia-Herzegovina," in G. Scott Davis, ed., *Religion and Justice in the War over Bosnia* (New York: Routledge, 1996), 23–43.

36. See discussion in Scott L. Montgomery, "What kind of memory? Reflections on images of the Holocaust," *Contention*, Vol. 5, No. 1, Fall 1995, 79–103.

37. Ilya A. Altman, "The Holocaust and the NKVD," paper presented at "Remembering for the future 2000," Oxford, July 2000.

38. Katharina von Kellenbach, "Christian discourses of forgiveness and the

perpetrators," paper presented at "Remembering for the future 2000," Oxford, July 2000. The paper appears in John K. Roth and Elisabeth Maxwell, eds., *Remembering for the Future: The Holocaust in an Age of Genocide*, 3 vols. (New York: Palgrave, 2001), 2, 725–31.

39. On self-delusion as an obstruction to mourning, see the essay by Sigmund Freud, "Mourning and melancholia" (1917), in *The Standard Edition of the Complete Psychological Works of Sigmund Freud*, ed. and trans. James Strachey, 24 vols. (London: Hogarth, 1953–74), 14, 237–60; also Dominick LaCapra, "Revisiting the historians' debate: mourning and genocide," *History & Memory*, 9, Nos. 1–2, Fall 1997.

40. Geyer, "The place of the Second World War," 39. Saul Friedländer's work is also a warning against yielding to the longing for closure. See his *Memory, History, and the Extermination of the Jews of Europe* (Bloomington: Indiana University Press, 1993); *Nazi Germany and the Jews, Vol. 1, The Years of Persecution, 1933–1939* (New York: HarperCollins, 1997); and "Trauma, transference, and 'working through' in writing the history of the Shoah," *History & Memory*, 4, No. 1, Spring/Summer 1992; see also works by Lawrence Langer, including *Admitting the Holocaust* (New York: Oxford University Press, 1995).

Understanding the Man
and His Policies

It is an understatement to say that Pope Pius XII provokes strong and contentious reactions. They involve his personality, even his spirituality, as well as his policies. Part II concentrates on factors in these areas that have been poorly understood or overlooked.

Focusing on Pius XII's extensive correspondence with his German bishops, Eva Fleischner analyzes that data for clues about the religious convictions that shaped Pius's personality and the theological principles that informed his policies. She finds the pontiff to be deeply religious but not in ways that were likely to make his voice pronounced in defense of European Jewry. Gershon Greenberg extends this perspective by concentrating on Pius XII's understanding of the crucifixion, showing how that outlook both reflected and amplified attitudes about Jews that may have hindered Pius's efforts on their behalf.

Turning more explicitly to Vatican politics, John Morley probes Vatican records to grasp the Holy See's stance toward developments late in the Holocaust—specifically those surrounding the Nazi onslaught against the Hungarian Jews, which began in March 1944. Assessing what Pius XII knew about these developments and how he reacted to them, Morley emphasizes that there were instances when the pope intervened publicly, but the nature of those instances leads to questioning rather than satisfaction when Pius's actions are evaluated.

More questions, and of a different kind, are raised by Richard Rubenstein's view of Pius XII's understanding of the role responsibilities he faced as leader of the Roman Catholic Church. Rubenstein believes that too many analyses of Pope Pius XII assume that the pope either recognized or should have recognized a moral obligation to rescue Europe's Jews in so far as it was within his power to do so. Instead of making this assumption, Rubenstein pushes the inquiry in different directions: did the pope have any compelling reason to recognize a moral

obligation to rescue Jews? Could it even be that the pope regarded the demographic elimination of Europe's Jews as a benefit for European Christendom?

Fleischner, Greenberg, Morley, and Rubenstein carry the debate about Pius XII into relatively uncharted waters. As they do so, the complexity and significance of the debates about Pope Pius XII intensify and deepen.

Eva Fleischner

The Spirituality of Pius XII

With the exception of Adolf Hitler himself, arguably no other World War II leader or public figure arouses more passion than Pope Pius XII. Whatever the controversy or criticism that swirls around Franklin Delano Roosevelt or Winston Churchill, for example, it scarcely contains the harsh judgments heaped on Pius XII. Yet, it can be argued, given the power and resources available to them, their record is no better than his. Indeed, theirs is in some ways worse. Roosevelt, for instance, can ultimately be held responsible for sending the *St. Louis*'s ill-fated Jewish refugees back to Europe, where the Nazis eventually murdered many of them. Far from being increased during Roosevelt's watch, American immigration quotas that could have benefited Jews went unfilled.

Whatever revisionist history is bringing to light about Roosevelt, excuses for his Holocaust-related "shortcomings" are found. To mention only a few of the "explanations," Roosevelt had difficulty getting the United States into the war, and the "Jewish issue" would have complicated matters further; the country was just emerging from the Depression, and people were afraid that Jews would take their jobs; the climate in Congress was deeply antisemitic. Many defenses for Roosevelt are made, and they are often accepted, at least sufficiently to keep the debate restrained when his record about explicit intervention against the Holocaust is concerned. With Pius XII the situation is different. When excuses are made or explanations offered for him, they are often dismissed as special pleadings that deserve scant respect. When these reactions abound and persist, what is going on? How do we explain the vituperation and venom—I use those words advisedly—directed against this man? Several reasons occur to me:

1. The pope is different from other leaders or heads of state. The institution he heads, the Roman Catholic Church, makes claims to truth and to a prophetic voice that are not found elsewhere. The Church's claim to be God's representative on

earth, to speak in the name of God, with a more than human moral authority, results in the pope's being held to the higher standard which the Church claims for itself.

2. Jewish friends have more than once told me that they grew up (in the late 1940s and 1950s) with what one of them calls "the myth of Catholic power." They sincerely believed that all the pope had to do was to say a word (or give an order) and all Catholics, all over the world, would carry out his command. Of course, that has never been the reality. The pope's power is far more limited than many Jews have often believed. Nevertheless, is Pius XII still being judged according to this myth that was so prevalent during the time of his reign?

3. In a recent discussion of Pius XII, I heard the view expressed that the Roman Catholic Church, more than any other institution, has come to represent "the Sacred" for our world, even for our very secular world. If that perception is at all valid, it might help to account for the continuation of an intense focusing on Pius XII.

4. Jews today are at long last free to speak their minds, to voice their criticism of Christianity, without fear of death, expulsion, or pogroms. I welcome this situation, which is long overdue. Perhaps one natural outcome of this new-found freedom is that age-old, long suppressed resentments and anger, caused by centuries of suffering at the hands of Christians (often, though not always, of the Roman Catholic Church), are finally being expressed. Understandably, these feelings are directed at Pius XII, the most visible Christian leader during the Holocaust years.

Those four possibilities do not exhaust the options. I believe, however, that they shed light on the special scrutiny that Pius XII continues to receive, especially if these factors are linked to another consideration, one that is very important—but not much discussed—in efforts to understand and appraise this particular pope. To use a currently fashionable and perhaps overused term, I refer to the *spirituality* of Pius XII. Drawing especially on the second volume of *Actes et documents du Saint Siège relatifs à la Seconde Guerre mondiale* (ADSS), which contains Pius's letters to the German bishops from 1939 to 1944, I will identify key elements in his

religious outlook and then suggest how his spirituality and the controversy surrounding his conduct during the Holocaust may be related.[1]

Because of their literary form these letters are more revealing of Pius XII's inner life and deepest concerns than are official documents; some are, indeed, highly personal. At the same time, it should be pointed out that ten out of a total of 124 letters are addressed to the body of German bishops. For the most part, these are in Latin, which gives them an official character. Furthermore, throughout all of these letters, even at their most intimate, the pope's personal, spiritual concerns are generally interwoven with his concerns for the situation of the German Church under Nazi rule. He worries, for example, about infringement of the concordat negotiated between the Vatican and the Third Reich in 1933. He fears that Catholic institutions, especially schools, will be closed. He is anxious about the dangers to which Nazi propaganda exposes Germany's Catholic youth. He deplores the difficulties of priestly training under the Nazi regime.

These emphases indicate that Pius XII took the fate and future of the German Church to be extremely important. Nonetheless, it is also possible to discern in these letters certain recurring themes that provide an insight into the life and faith of Pius XII. I shall approach my subject under several headings. All quotations from the letters themselves will be given in my English translations and with the page references to ADSS noted in the body of the chapter.

Pius XII as a man of prayer

It appears that the main lines of Pius XII's spirituality were already present at an early age. For instance, the young Eugenio Pacelli served as an altar boy, loved to play at "saying Mass," and as a child gave up favorite foods for the souls in purgatory. Among his lifelong favorite books was Thomas à Kempis's *The Imitation of Christ*, a popular fifteenth-century classic of Catholic devotion, which emphasized an interior, solitary, and ascetic religious life. Pacelli learned the entire book by heart. His vocational choice of the priesthood, to which he was ordained at the age of 23, came as no surprise to those close to him.

Supplementing numerous testimonies by people who had met or known Pius, the letters in the second volume of ADSS bear ample testimony to the fact that the pope's inner life emphasized prayer. Indeed,

he seems to have considered prayer—along with the Mass and a spirit of sacrifice—to be the one unfailing resource available to him throughout the war. To put the point differently, it could be said that Pius XII regarded prayer as his chief "weapon" against Hitler's government.

As the following examples illustrate, variations on this theme run through most of the letters in the second volume of ADSS: "We do not lose courage . . . , especially because we know that hardly ever before did the people of Germany pray as much as they do at present" (2: 75). Again: "We pray and sacrifice daily for our brothers and children in Germany" (2: 104). And: "We ask you and your flock to pray and sacrifice" (2: 107). Or: "We thank you for all the proofs of your fidelity, especially for remembering us constantly at Mass, and for your never-flagging bond with us in prayer" (2: 114). "We shall increase our prayer and sacrifice [for God's mercy on the Catholic Church in Germany]" (2: 125). "We continue to work and pray without discouragement for you in the certainty that the Lord 'will not permit you to be tried beyond your strength, but will, with the temptation, also provide the good ending so that you can endure' (1 Cor. 10:13)" (2: 133). "Through our prayers, blessings, and hopes we are daily, indeed hourly, with our sons and daughters in Germany" (2: 151). "The powerful storm of prayers and sacrifices cannot fail" (2: 189). And again: "we pray to God Almighty not only daily, but almost every hour, that he might bring the present war, which is among the greatest horrors humanity has ever experienced . . . [to a peaceful end]" (2: 240).

Many more examples could be given, but the pope's letters suggest that prayer was Pius's "solution" for every difficulty or crisis, no matter how large or small—whether the issue was the closing of Catholic schools, the hope for an end to the horrors of war, the sufferings of bombardment victims, the prison death of Bernhard Lichtenberg, a German priest who defied the Nazis, or the execution of Fr. Alfons Wachsmann, another priest who resisted. Pius understood his prayers to be concrete support for those in need as well as a source of consolation and affirmation of faith and trust in God for himself.

Devotion to Mary

The pope's devotion to Mary was a marked aspect of his life of prayer. This aspect of his spirituality can also be traced back to Pacelli's early

priesthood. The young Pacelli said his first Mass at the altar of the Virgin in the basilica of Santa Maria Maggiore on April 3, 1899. Three examples from Pius's letters suffice to make the point. The first speaks about [the consecration of the cathedral] "which your Catholic ancestors erected over the centuries in faith, trust, devotion, and love in honor of Mary. Thus the praise of Mary, which rises in a thousand forms in memorials throughout Germany, also today in the Catholic Diaspora, where love of Mary used to flourish abundantly, finds, in the midst of a difficult and uncertain time, a worthy, happy, and significant continuation." In the same letter, Pius adds: "Rarely did the Catholic faith and those who confess it stand in such urgent and great need in your country of the powerful protection of the most holy Virgin, help of Christians ... Hasten for refuge to the mother of Christianity and ask her to take care of the church of your country: that God may send her priests ... that he might at last hear your daily prayers for the freedom of the Church, and grant that its vast and inexhaustible power might be used for the salvation of souls and the greater good of the entire people" (2: 78).

"On the threshold ... of 1940," Pius writes to a German bishop on another occasion, "we recommend the country most urgently to the blessed Virgin and mother of God, Mary. May she hold her protective hand over you and your families, over your Catholic faith" (2: 113). In a third instance, Pius extols "Maria, the great mediatrix of grace," and his counsel is to "beseech the Queen of Peace" (2: 207; see also 312 and 329). Going beyond these letters, it should be pointed out that it was Pius XII who, in 1950, declared the Assumption into Heaven of Mary to be a feast of the universal Church, thereby raising an ancient belief to the level of dogma.

The Eucharist's importance

An expansion of the theme of Pius XII as a man of prayer involves the central importance of the Eucharist, or Mass, in his life. His letters often refer to the Eucharist simply as "sacrifice." ("The sacrifice of the Mass" remains a term commonly used by Catholics in referring to this central act of worship.) Thus, Pius assures the Bishop of Mainz that "we too remember always, and today still more urgently, you and your people before God in the holy sacrifice" (2: 98). And: "We remember the dead and living in prayer and at Mass" (2: 338).

A papal predecessor, Pius X, very possibly played a central role in Pacelli's love of the Eucharist. Known to the world primarily as the main actor in the Modernist controversy, Pius X was responsible for restoring the Eucharist to its central place in Catholic devotion and in providing access to the sacrament for ordinary Catholics through daily communion—a practice that had been completely lost during the Middle Ages.

Pius XII's love of the liturgy may also have been due to Pius X. Pacelli's letters show that, even at the height of the war, the availability of the liturgy and its correct "performance" for German Catholics remained one of his major concerns. On one occasion, Pius wrote:

> The liturgy ... is the domain of the bishops, and you have done well to see to it that communal devotions take place in the spirit of canon law. The Church will generously affirm that a healthy psychological effect, the aesthetic beauty of the liturgy ... heightens the effect also among simple people, contributing to genuine prayer. But the clergy and people must not forget that what really counts remains at all times the work of grace, which is available to each individual ... even if the eternal forms are less attractive. (2: 178, and also 213, 333, 339)

The pope's love for the liturgy obviously did not exclude careful attention to detail. Even in the midst of the most abnormal and difficult circumstances in which German Catholics found themselves, he insisted that careful attention be paid to correct "performance" and minute detail in strictly following liturgical rules. While in one instance he advises adapting the external framework of the liturgy to circumstances if necessary (2: 213), in another he is concerned to preserve "the purity" of the sacramental action undiluted (2: 333). In this latter case, the canon lawyer in him, to whom the observance of even the smallest rules is important, may be speaking.

Suffering as redemption and purification

Another major theme in trying to understand Pius's life of faith is his approach to suffering. Christian views that link suffering, redemption, and purification are as old as Christianity itself. They go back to Christ's passion and death which, according to Christian faith, brought new life to the world. (In the words of the Good Friday liturgy: "Behold, by the

wood of the Cross, joy has come to the whole world.") In fact, however, the roots of these beliefs are far more ancient still and can be found in texts of the Hebrew Bible. In parts of Second Isaiah, particularly, the mysterious figure of the Servant, beloved by God and innocent of wrongdoing, freely accepts suffering for the wrongs done by his people ("by his stripes we are healed").

As indicated by many passages in his letters, this biblical view of suffering deeply informed Pius's spirituality (see 2: 200, 201, 211, 299, 324, 364). Typically, he takes suffering—whether his own, that of Germany, or that of humanity—to be closely tied to the suffering of Christ, from which suffering derives its meaning. His use of terminology supports this view. Pius refers to his "crown of thorns" and speaks frequently about "the way of the cross." Thus, in expressing his sympathy to the Bishop of Rothenburg, who is ill, Pius writes:

> We need not remind you to offer your sickness for the preservation of your country and for peace. Where human efforts ... are often helpless in face of the demonic powers of destruction, suffering which is accepted before God is perhaps the most precious gift that we shepherds of the Church are able to bring at this time. (2: 211)

In another place, Pius clearly has "the way of the cross" in mind when he says:

> As in the case of the divine Master there may be times in his mystical body, the Church, when difficulties force it to tread on the path of suffering rather than a path crowned with success. (2: 201)

And again: "The more the Church's path becomes a *Via Crucis* (a way of the cross), the nearer she is to God, and God to her" (2: 299).

Atonement, penance, and punishment

"For our sins we are punished"—this too is a biblical theme, and it informed the spirituality of Pope Pius XII. While Pius does not explicitly mention the "sins" committed by the Nazi regime (or the German people?), the German terms he uses—*Busse* (penance) and *Heimsuchung* (affliction)—imply that he has that biblical view of punishment in mind. Thus, referring to the victims of bombing in Hamburg, he writes as

follows: "We urge/warn our sons and daughters in Hamburg in fatherly love that, as the punishing hand of the Lord lies so heavily upon their city, they not lose faith in divine providence, but rather accept the mysterious councils of the Most High in all humility, accepting the misfortune that has come upon them in a spirit of penance and conversion, in a spirit of works of charity toward each other ... a spirit of Christian patience and endurance" (2: 338). And to the Bishop of Limburg, on March 5, 1944: "We are confident that the bitter events of this moment will awaken in them a living sense of the other, the eternal world, a spirit of penance, and the will for a purified Christian way of life" (2: 369). In these examples, it must be emphasized, the pope addressed the German bishops in wartime circumstances and tried to give them hope by suggesting a meaning for their suffering and that of their people. To apply these words to other, non-German, innocent victims of the war would have been grossly inappropriate (see 2: 373, 384).

The burden and responsibility of the papal office

Pius's letters contain yet another theme relating to suffering. This time, however, the emphasis is personal and existential more than theological. Stressing to the bishops how he feels weighed down by the demands placed upon him as "supreme shepherd" of the universal Church, the pontiff frequently writes as though he seeks to unburden himself to them (see 2: 165, 274, 324, 365). As illustrated by his letter to Cardinal Michael Faulhaber on August 15, 1942, his words even express some self-pity: "We do not deny, beloved son, that the 'burden and heat of the day' which became our lot as we embarked upon the office of supreme shepherd have grown with each day and hour. It is a burden which would weigh down shoulders even stronger than ours, were it not that we feel the closeness, again and again, of heavenly grace, for which the Church prays" (2: 274). And to the bishops of Germany on August 6, 1940: "God has given us the heavy responsibility and painful task ..." (2: 165). And again: "These were for us days of penance and prayer, because of the heavy responsibility and constantly growing burden which Providence has placed on our shoulders" (2: 208).

In some cases, Pius apparently regarded his inability to see clearly what to do—to speak out or remain silent—as part of his suffering:

"Where the pope would like to shout, he is forced to wait and keep silence; where he would act and help, he must wait patiently" (2: 201 and see also 365). This passage, and there are many similar ones, suggests that Pius may have been beset by doubts as to whether he was making the right choice in not speaking out. His strong approval of the courageous protest or action of individual German bishops—for example, Clemens August von Galen of Münster and Konrad von Preysing of Berlin—lends support to this possibility.

At the same time, Pius's feeling of heavy responsibility indicates his exalted view of the papal office, an outlook consistent with the doctrine of papal infallibility proclaimed by the First Vatican Council in 1870. Until Vatican II and Pope John XXIII, this lofty view of the pontiff's supreme spiritual authority and power characterized the post-Vatican I papacy.

Divine providence and the Church's universal mission

Pius's spirituality was further characterized and sustained by his faith in divine providence, which to him meant that the goodness of God's grace would ultimately triumph over evil (see, for example, 2: 75, 113, 118, 133, 171, 183, 189, 202, and 365). Writing to Cardinal Adolf Bertram, the Archbishop of Breslau, Pius quotes St. Paul: "God will not permit you to be tempted beyond your strength, but along with the temptation will also provide a good outcome" (1 Cor. 10 : 13). And to the Bishop of Gurk, in a letter dated August 7, 1940, he writes: "We leave the destiny of the German Church after the war to Divine Providence, in complete trust" (2: 171).

Reflecting and buttressing this confidence in divine providence, a final, complementary aspect of Pius's spirituality should be mentioned in this survey. Pius's August 6, 1940, letter to the German bishops illustrates the fact that he held an exalted view of the Church's universal mission to match both his faith in providence and the papacy's high view of itself. In that letter, Pius refers to "the Church of Christ, which is sent to all peoples in all ages." He also speaks about "the preaching of the gospel of Jesus Christ, the giving of the means of salvation entrusted to her by the Lord, in all tongues and lands with the same devotion and love, regardless of cultures. ... Mother Church has only children," Pius adds, "no stepchildren" (2: 160f). This view of the Church's mission is embedded

in an important wartime encyclical, *Mystici Corporis Christi* (*Of the Mystical Body*), which Pius published on June 29, 1943. Pius's late wartime letters to the German bishops frequently refer to this encyclical.[2]

To sum up the elements of Pius XII's spiritual life that I have identified, a profile emerges of a pope who in every respect typifies a traditional Catholic (Christian?) ideal of piety and sanctity: devoted to prayer and sacrifice, Pius attempts to live compassionately in fidelity to his understanding of God's will and his responsibility to safeguard the freedom and well-being of the Church entrusted to him. With this profile of Pius's spirituality in mind, I will conclude by turning to reflections about his post-Holocaust reputation and some of the implications contained in the controversy about it.

The legacy of Pope Pius XII

If Pius XII is eventually destined for sainthood in the Roman Catholic Church, I suspect that the spiritual features highlighted in this chapter will be crucial in driving the canonization process forward. Without any doubt, Pius was a man of great holiness and interiority, as is attested to by many who knew him or even met him only briefly. Thus, for instance, Bishop Raymond Lucker, one of the most liberal American bishops, recalled 50 years later the unforgettable impression of goodness and sanctity the pope made on him when, as a young seminarian, Lucker briefly met Pius in Rome. Writing in the *National Catholic Reporter* (March 31, 2000, 21), Lucker said:

> I always looked up to Pope Pius XII. He was the pope during my formative years of adolescence, of my seminary days and the early days of my priesthood. ...
>
> Pius had a reputation for holiness. He had an ascetic, even an aloof look, tall, thin, with penetrating eyes. I admired him. I *revered* him. ... He was an engaging teacher, speaking out on many topics. In 1957 I had the opportunity to meet him and speak with him briefly at a papal audience. A year later he died.
>
> Pius XII was a great pope. ... He was a great teacher, a strong leader, a holy man. He was a prophet who helped lead the church to reform and renewal. He made mistakes, yet the Spirit of God continues to build on his greatness.

Why, then, the controversy surrounding his beatification, the necessary first step on the way to canonization and sainthood? Let me suggest two reasons, the first of which is—or ought to be—obvious to all, including the authorities in Rome. First, to beatify or canonize a person surrounded by controversy is unwise, as well as bad politics. Saints are supposed to inspire, not to divide and be bones of contention, signs of contradiction and dissent. In the case of Pius XII, it is not only Jews who object to his beatification, but many faithful Catholics as well. Second, if Pius had been a private citizen, or a monk, his holiness might indeed amply qualify him for sainthood. But history made him pope not only at one of the most critical junctures in the Roman Catholic Church's life but also at a crucial watershed period in the entire history of the West. In the face of one of the most brutal dictatorships the world has known, which led to the murder of millions of innocent Jews and other victims, neither Pius's personal holiness and trust in prayer nor his chosen tool of quiet diplomacy was enough.

Clearly, Pius was a sensitive man, not impervious to the sufferings of the war's victims, whether within or outside the Church. Nevertheless, the means with which he chose to fight the evil were inadequate. What was needed was a strong, prophetic voice. Pius thought he had spoken with such a voice, at least in his 1942 Christmas message. That it was not heard—or, if heard, not understood—is part of the tragedy of this man and of the Church he governed.[3]

What is to be done? Let me mention a recent personal experience, and a historical event, which may have some bearing on that question.

The experience

In early April 2000, I participated in the King's College seminar that led to this book. As its essays reveal, that small group of scholars included Catholics, Protestants, and Jews. One of the scholars, Gershon Greenberg, an Orthodox Jew, made a contribution that I continue to ponder. "There is a question I need to ask of you, especially of the Catholics present," he said in his gentle, probing way. "Did the question of martyrdom never arise? Did the pope, and those around him, ever consider that he should perhaps be ready to be killed, if he spoke out publicly against the evil of Nazism and in defense of the Jews?"

None of us had an answer for Gershon. I know the idea had not

even occurred to me. I have since asked myself, Why not? After all, some of the early popes had been martyred (by the Romans). And we have a saying in the Church that "the blood of martyrs is the seed of the Church."

The historical event

March 24, 2000, marked the twentieth anniversary of the murder of Oscar Romero, the Archbishop of San Salvador. The anniversary occasioned many tributes and commentaries. Romero was no politician. He was conservative by nature. He was viscerally opposed to violence of all kinds, including the violence of the growing guerilla movement. But he saw and listened. And what he heard and saw radicalized him. In his weekly Sunday sermons, broadcast over the diocesan radio station—it was repeatedly blown up and off the air but never for long—he listed each atrocity committed by the armed forces (who were the instrument of the oligarchy in power): tortures, imprisonments, burnings of homes and churches, killings and expulsions of priests. It was too much for those in power, and they gave orders for his murder, which was carried out so efficiently that a single bullet, fired from a distance, went through Romero's heart as he celebrated Mass. Instead of being silenced, however, his voice and example still reverberate throughout the world.

"It would be sad," Romero said shortly before his death, "if priests were not being killed when Salvadorans are being killed." He was willing to risk his own life, as well as the lives of his priests, to change the structure of his institution into that of a community of service. He was an authentic martyr, not only for his Christian faith but also for justice. The tradition of the Roman Catholic Church in El Salvador, dating back to its origins, has been to find ways of accommodation with the state. That has generally been Rome's policy worldwide for some centuries. It has been so under Pope John Paul II, who told Romero to find ways to get along with the government.

With Gershon Greenberg's question still fresh in my mind, I began to wonder if, consciously or unconsciously, Romero's might not be the kind of witness the world has wanted—however impossibly—from Pius XII. And I asked myself, further, why martyrdom, at least as a possibility, was not even considered as a viable option during the Shoah. Had the Church become too big and powerful? Romero was archbishop in

a poor country; he (eventually) saw the poor daily and lived in their midst. In reading the Vatican documents published in ADSS, one often gets the impression that "the Jews" are an abstraction—one group of victims among many others: prisoners of war, the starving population of Greece, the German victims of allied bombardments, and so on. (I believe this is one of the differences between Pius XII and John Paul II. John Paul grew up with Jews, had close friends among them, some of whom perished in the Shoah.)

Is our secular world today perhaps hungry, deep down, for prophetic witness? After all, the impact of a Mohandas Gandhi or a Martin Luther King, Jr., continues to have power to inspire. If this is so, then no matter what we, or any number of archivists and historians, may find out about Pope Pius XII, the archival findings will come up short. We already know that we shall not find genuinely prophetic words or actions, except in the cases of some remarkable individuals—Bernard Lichtenberg is a shining example. The French archbishop Jules-Gerard Saliège and some of the bishops in the Dutch hierarchy are among the exceptions that prove the rule: few of those who spoke and led prophetically during the Holocaust's darkness were part of the Church's elite.

There is another aspect of the Romero saga that is relevant for my concerns in this chapter. While Romero was alive, the Church hierarchy feared him. Since his death, the groundswell of his popularity has been so strong that the Church, which opposed(s) the theology of liberation, has begun formal steps toward his canonization. But—and this is where I see some similarity to the post-Holocaust circumstances surrounding Pius's reputation—the Church is trying to "sanitize" and domesticate Romero. "Our priest tells us," one Salvadoran woman said, "that we must revere Romero because he was prayerful, humble, and obedient." Obedient, yes, but only to the law of God. "The law of God—Do not kill—should prevail over the order to kill another person," Romero had said. "No soldier is obligated to obey an order that goes against the law of God. It is an immoral order."

Many of Romero's fellow bishops in El Salvador openly opposed him during his lifetime. Some even urged Rome to replace him. But today they realize they cannot challenge him openly. So they try to make him into a Mother Teresa figure—prayerful, devout, dedicated to the poor, but unthreatening to the system.

To return to Pius XII: his chances for sainthood hinge on his reputation for personal holiness. Again and again, his defenders stress that

he was a "good man," a holy man. Many women and men today find Pius's concept and embodiment of holiness—prayer, sacrifice, penance— too narrow and other-worldly. Particularly amidst the Holocaust's shadows, they doubt its fidelity to the teaching and example of Jesus: "Greater love than this no one has, than to lay down one's life for one's friends."

NOTES

1. See Pierre Blet, Robert A. Graham, Angelo Martini, and Burkhart Schneider, eds., *Actes et documents du Saint Siège relatifs à la Seconde Guerre mondiale*, 11 vols. (Vatican City: Libreria Editrice Vaticana, 1965–81). The Vatican has not yet opened its archives for a full exploration by scholars, but the volumes in this work contain a selection of documents (for example, public statements, correspondence, and memoranda) that the Jesuit editors found especially relevant for understanding Pius XII and his Secretariat of State during the Second World War. The documents appear in their original languages: Italian, French, German, Spanish, Latin, and English. All of the introductions and notes are in French.

2. While Pius XII is often—and rightly—contrasted with Pope John XXIII, it should be noted that Pius's view of the Church as the Body of Christ, an image also used by the Jesuit theologian Henri de Lubac, is far closer to Vatican II's image of the Church as the People of God than it is to Vatican I's "top-down" model.

3. In a recent article on Pope John XXIII, John Komonchak asks about "the relation between the personal holiness of the Pope and his public achievements. Those are not always coincident; there have been effective popes who were not saints, and holy men who were not good popes. It is possible, for example, to regard Pius X as a saint and to think that his reign, on more than one count, was disastrous. Celestine V was so inept that he resigned after six months. His bull of canonization says, without obvious irony, that his lifelong pursuit of holiness had ill prepared him for the papacy, and it praised him for resigning lest some disaster fall upon the Church" ("Remembering good Pope John," *Commonweal*, August 11, 2000, 12).

Gershon Greenberg

Crucifixion and Holocaust: The Views of Pius XII and the Jews

The religious premises of Pius XII, a man of faith absorbed in the transhistorical, mythic realities of the Roman Catholic Church, should be factored into the probe into his diplomatic activity during the Holocaust. Here I wish to offer a preliminary inquiry into Pius XII's view of Jewish suffering during the Holocaust vis-à-vis the crucifixion, and suggest that Pius XII chose to fix his eyes on the historical role of the Jews in the crucifixion but not on their present historical plight, and to confine Christ's expiational suffering on the cross to the Church but not to include the suffering of Jews as Jews.

The eclipse of Judaism

Pius XII viewed Jews and Judaism through the partition of the crucifixion, which cast Hebrew Scripture, institutions, and rituals into oblivion. They did not appear to him as living entities, let alone as the particular target that they were for the Nazis. Nor did they belong to the world of suffering, except to the possible extent that they were potentially part of the Church.

 The pope's Christianity was rooted in the crucifixion. In his June 29, 1943, encyclical *Mystici Corporis Christi* (*MCC*) he stated that Christ "completed His work on the gibbet of the cross," that "the Church was born from the side of Our Savior on the cross like a new Eve," that "He founded the Church by His blood and that its members gloried in His thorn-crowned Head" (*MCC*, paras. 28, 33, and 2). In *Mediator Dei* (1947) he explained that the crucifixion remained the center of Christian life as passage from damnation to redemption: "He desired to be immolated upon the cross 'as a propitiation for our sins, not for our sins only but also for those of the whole

world' [1 John 2:2] and He daily offers Himself upon our altars for our redemption, that we may be rescued from eternal damnation and admitted into the company of the elect." Christ, whose work was completed on the cross, was "borne by the Supreme Pontiff" (*MCC*, para. 44). The import was summarized by Gerard Mitchell in April 1944:

> Christ as Head is ruler of the Church. The Pope as Successor of St. Peter is His Vicar, and rules the Church externally and visibly as Christ's representative on earth. But Christ and His Vicar constitute only one Head of the Mystical Body. It is a dangerous error, therefore, the *Encyclical* [*MCC*] warns us to suppose, that one can accept Christ as Head of the Church while refusing loyalty to His Vicar on earth.[1]

In his capacity as Vicar of Christ-the-crucified, Pius XII declared that Christ "was not sent but to the sheep that were lost of the house of Israel" (*MCC*, para. 29). But those he came to save rejected him with violence: he "was persecuted, calumniated and tortured by those very men whom he had undertaken to save" (*MCC*, para. 3).[2] By their rejection of Christ—their instrumental indispensability to the crucifixion and its redemptive value appears to be irrelevant—the Jews and their religion (specifically Law, Synagogue, and ritual sacrifice) relegated themselves to oblivion:

> By the death of our Redeemer, the New Testament took the place of the Old Law, which had been abolished. ... [O]n the gibbet of His death Jesus made void the Law with its decrees, fastened the handwriting of the Old Testament to the Cross, establishing the New Testament in His blood shed for the whole human race. To such an extent, then, says St. Leo the Great, speaking of the cross of Our Lord [in *Sermon* 58: 3], "was there affected a transfer from the Law to the Gospel, from the Synagogue to the Church, from the many sacrifices to one Victim, that, as Our Lord expired, that mystical veil which shut off the innermost part of the temple and its sacred secret from the main temple was rent violently from top to bottom." (*MCC*, para. 29)[3]

Pius XII regarded Hebrew Scripture as the spiritual prefiguration of the New Testament. He thought that "what was said and done in the Old Testament was ordained and disposed by God with such consummate wisdom, that things past prefigured in a spiritual way those that were to come under the new dispensation of grace" (*Divino Afflante Spiritu*, September 1943, para. 26). But the advent of the New Testament also meant the death of Hebrew Scripture: "On the Cross, then, the Old Law died, soon to be buried and to be a bearer of death, in order to give way

to the New Testament, of which Christ had chosen the apostles as qualified ministers" (*MCC*, para. 30). Not only did Hebrew Scripture die; according to Jerome's letter to Augustine, cited by the *MCC* editor (1943), Jewish rituals were deathly and Christians who observed them would be cast down to hell. After all, according to John's gospel, "This was why the Jews sought all the more to kill him, because he not only failed to observe the Sabbath but also called God his father, making himself equal with God" (John 5 : 18).[4] With the cross, Judaism was cast into the shadow and the Church began to reign:

> [F]rom the time when the Son of man was lifted up and glorified on the Cross by His sufferings, she is divinely illumined. For then, as Augustine notes [*DP, pecc. Orig.*, XXV, 29] with the rending of the veil of the temple it happened that the dew of the Paraclete's gifts, which heretofore had descended only on the fleece, that is on the people of Israel, falls copiously and abundantly (while the fleece remained dry and deserted) on the whole earth, that is on the Catholic Church, which is confined by no boundaries of race or territory. (*MCC*, para. 31)

Pius XII's identity as Vicar of Christ-the-crucified identified him with the moment on the cross in which the New Testament and Christ the Redeemer began to live and the religion of the Jews died. If in Pius XII's mind the Jewish people were bound up with their Judaism (i.e., religion), then they too would have died as a vital national entity. This could help account for why Pius XII's statements about wartime suffering appear to be oblivious to the suffering of Jews, Hitler's prime target, as such. For Pius, suffering was a universal matter, but he understood the universal as fundamentally Christian, and Jews and Judaism were outside his Christian/ universal world of religious reality. In *Summi Pontificatus* (October 20, 1939) he referred to the present "Hour of Darkness" (Luke 22 : 53) in which violence and discord bring indescribable suffering on humankind.

> Do we need to give assurance that Our paternal heart is close to all our children in compassionate love, and especially to the afflicted, the oppressed, the persecuted? The nations swept into the tragic whirlpool of war are perhaps yet only at the "beginnings of sorrows" [Matthew 24: 8] but even now there reigns in thousands of families death and desolation, lamentation and misery. (para. 106)

In his 1942 Christmas message he spoke of humanity's commitment to return society to divine Law: "Humanity owes this vow to hundreds of thousands of people, who through no fault of their own and

solely because of their nation or their race, have been condemned to death or progressive extinction."[5] In *MCC* he spoke of the "endless throng of unfortunates for whom we weep" (para. 107); and in *Divino Afflante Spiritu* of the "sorrowful times, when almost all peoples and nations are plunged in a sea of calamities, when a cruel war heaps ruins upon ruins and slaughter upon slaughter" (para. 52). Pius XII specifically cited Christian suffering and spoke of the resolution of the suffering in the Church:

> The blood of countless human beings, even noncombatants, raises a piteous dirge over a nation such as Our dear Poland, which, for its fidelity to the Church, for its services in the defense of Christian civilization, written in indelible characters in the annals of history, has a right to the generous and brotherly sympathy of the whole world. (*Summi Pontificatus*, para. 106)

Pius spoke of the children of the Church who—presumably over the generations—were infused by God with supernatural love and "rejoiced to suffer assaults for Him, and to face and overcome the hardest trials, even at the cost of their lives and the shedding of their blood" (*MCC*, para. 72). He called for Christian neighborly love: "How can we claim to love the divine Redeemer if we hate those whom He has redeemed with His precious blood, so that He might make them members of His Mystical Body?" (*MCC*, para. 74). He also spoke of spiritual escape from the calamities into the eternal realm of the Church:

> We know that if all the sorrows and calamities of these stormy times, by which the countless multitudes are being sorely tried, are accepted from God's hands with calm submission, they naturally lift souls above the passing things of earth to those of heaven that abide forever, and arouse a certain secret thirst and intense desire for spiritual things. Thus, urged by the Holy Spirit, men are moved, and, as it were, impelled to seek the kingdom of God with greater diligence; for the more they are detached from the vanities of this world and from inordinate love of temporal things, the more apt they will be to perceive the light of heavenly mysteries. (*MCC*, para. 4)

Beyond this, the Church shared in the suffering of those who were "not yet joined" to the Church:

> The Church, the Bride of Christ, is one; and yet so vast is the love of the divine Spouse that it embraces in His Bride the whole human race without exception. Our Savior shed His Blood precisely in order that

He might reconcile men to God through the Cross, and might constrain them to unite in one Body, however widely they may differ in nationality and race. True love of the Church, therefore, requires not only that we should be mutually solicitous one for another as members of the same Body, rejoicing in the glory of the other members and sharing in their suffering, but likewise that we should recognize in other men, although they are not yet joined to us in the Body of the Church, our brothers in Christ according to the flesh, called together with us, to the same eternal salvation. (*MCC*, para. 96)

But the Jews were neither of the Church nor among those "not yet joined" to the Church. In the encyclicals, they were those who defied the one who was crucified to save them.

There are questions that need to be explored: if suffering coincided with the Church and those "not yet joined" to the Church, how did Pius XII view the suffering of non-Roman Catholic Christians? Did the exclusion of Judaism from history as defined by the cross necessarily mean the exclusion of the Jewish people?[6] Did Pius XII allow for the vitality of a Jewish culture emptied of religion which may have been included in the "not yet joined" category? Was it possible that even those who once defied Christ could still potentially join the Church? Lastly: did the suffering of Catholics, associated with the torments of the Redeemer (*MCC*, para. 108) with whom they were co-workers in carrying out redemption, expiate for the alleged sins of the Jews such as to bring them into the "not yet joined" category?[7] Pending the answers to these questions, my tentative conclusion is that for Pope Pius XII the ancient Jewish response to Christ excluded Jews from contemporary inclusion in the Church's definition of sufferers.[8]

Jewish perspectives

While the crucifixion was grounds for Pius XII to exclude the Jews from the Church, by tragic irony Jewish thinkers were accepting the religious principles of the crucifixion—and doing so because of the Holocaust. In February and March 1939, two ultra-Orthodox religious nationalist (Mizrahi) ideologues in Palestine applied the themes of Isaiah's Suffering Servant, which Christian theologians since the Church Fathers had grafted onto the crucifixion, to Israel's current suffering.[9]

Yeshayahu Wolfsberg, addressing the current troubles, averred that Christians wrongly interpreted Isaiah 53 to mean that a single individual would assume responsibility for the sins of all and atone for them. According to Judaism's morality, the sins themselves could not be assumed by someone who did not commit them. But the suffering that ensued from sin could be taken over by others, and the nation of Israel did so collectively. Wolfsberg was confident that the world would recognize that the people of Israel were suffering in that way, and were doing so because God assigned this mission to them. The suffering was not on account of sins committed by the Jews themselves—if this were so, the innocent would not be suffering. God assigned the nation of Israel alone, lest the world be destroyed by unabated suffering for widespread sin. He added that the troubles in Germany and Austria over the last year, now reaching a peak, brought "a new level in the scroll of suffering, a new link in the chain of troubles imposed upon [Israel] to bear witness to [Israel's] task as servant of God." Wolfsberg stressed that "this position is far removed from offering justification for the slaughter. In no way at all would it support any right to attack or destroy."

Shlomo Zalman Shraggai also accepted the application of Isaiah's text to the current troubles. He did not accept the separation between assuming responsibility for suffering and assuming responsibility for sin, because the suffering atoned for the sin ("He was wounded for our transgressions, he was bruised for our iniquities ... and the Lord hath laid on him the iniquity of us all" (Isaiah 53:5–6), and biblical commentators (Rashi, Radak, the Metsudat David) stated that Israel's suffering was in atonement for the crimes of the nations. Shraggai also objected to the notion that because suffering was a divine mission it offered consolation; and that, "without this explanation we lose our meaning." He continued:

> It may be possible to identify an urge to live for the sake of others and see this as an historical task. But to suffer for others? Only those with the greatest sensitivity to others could derive "sublime pride" from this, and see it [in Wolfsberg's terms] as occupying such a lofty place that it would be impossible to renounce or despair over it. Most of Israel [in fact] accepted the bold words of Ezekiel the prophet: "The son shall not bear the iniquity of the father, neither shall the father bear the iniquity of the son" [Ezekiel 18:20]—[which meant, according to Radak, Isaiah 53:4] "Let alone one person for another, and let alone one nation for another."[10]

Ultra-Orthodox Jewish thinkers during the war spoke of the co-suffering of God and man (albeit not of the suffering of their mediator); of God's pain together with the pain of Israel (see *Midrash Shemot Rabbah* 2: 5). In the Warsaw ghetto, the Hasidic rabbi Kalonymus Kalman Shapira wrote that God suffered infinitely from Israel's tragedy, and even removed himself to a secret realm lest his infinite suffering destroy the world (*Midrash Eykha Rabbah.* Proem 24. *Hagigah* 5b). Shapira believed that if the Jew could expand his consciousness to reach God's suffering and bring his suffering into God, it would be possible to lessen it. In Jerusalem (December 1944) the Musar (moralistic movement) leader Yehezkel Sarna wrote that God was crying over Israel's tragedy now, as once he cried over the destruction of the Temple (*Midrash Eykha Rabbah* 1: 1). This enabled the Jew to begin to shed tears—each of them precious to God (*Midrash Shoher Tov al Tehillim*, Ch. 80). In Tel Aviv (1947), the Hasidic rabbi Hayim Yisrael Tsimerman assured his congregants that God was present in Israel's trouble (Psalm 91 : 15) and shared the pain, citing: "When a man suffers, to what expression does the *Shekhinah* (divine presence) give utterance? My head is heavy, my arm is heavy. If the Holy One, blessed be He, is thus grieved over the blood of the wicked, how much more so over the blood of the righteous that is shed?" (*Hagigah* 15b).[11]

Suffering's redemptive dimension was also enunciated by the ultra-Orthodox. Within war-torn Europe the rabbi of Simleul-Silvaniei, Transylvania, Shlomo Zalman Ehrenreich, believed that the suffering of Jews brought redemption closer. In Bratislava, Shlomo Zalman Unsdorfer brought the legacy of the binding of Isaac (*Akeidah*) forward to the unfolding tragedy, blended it with actual sacrifice, and identified it as a prelude to redemption. He also spoke of a metaphysical connection between the suffering and the redemption, the sufferings as the birth pains of the messiah.

For Ya'akov Mosheh Harlap in Jerusalem, the sufferings of the Holocaust signaled the entry into the world of the Mashiah ben Yosef, who brought darkness with light because the full messianic light could not have been absorbed at once by the world. He would be followed by the Mashiah ben David, bringing the full light of redemption. The dialectical relationship between the suffering of the catastrophe and the light of redemption was present among Agudat Yisrael (Halachically strict ultra-Orthodox) and Mizrahi thinkers in Palestine and America.[12]

In the DP (Displaced Persons) camp of Ulm near Munich,

Bentsiyon Firer spoke of Israel's sole relationship with the nations as one sacrifice, of which the Holocaust was the culmination and as such the onset of redemption. The colossal outflow of blood belonged to the birth of the messiah. For some, the Holocaust transformed Israel's suffering into a sacrifice for universal redemption. According to Simhah Elberg of Shanghai, Treblinka was a collective *Akeidah*, taken to its extreme with actual sacrifice. With it, Israel's blood would atone for the sins of all and redeem the world. For others, Israel suffered for her own redemption only. In Brooklyn, Habad Hasidim envisioned the destruction of all gentiles who did not bear the imprint of Noah's laws, and in Jerusalem, Harlap envisioned the destruction of everyone without a Jewish soul.[13]

Some Jewish thinkers took the next step, and identified the suffering with the crucifixion itself. On September 18, 1943, Abba Hillel Silver, the Reform Jewish Zionist leader, declared at the American Jewish Conference in Pittsburgh that Israel's suffering for the sins of others amounted to a crucifixion—and must stop:

> From the infested typhus-ridden ghetto of Warsaw, from the death block of Nazi occupied lands where myriads of our people are awaiting execution by the slow or the quick method; from a hundred concentration camps which befoul the map of Europe; from the pitiful ranks of our wandering hosts over the entire face of the earth comes the cry: "Enough. There must be a final end to all this, a sure and certain end! How long is the crucifixion of Israel to last? Time and again we have been stretched upon the rack for other people's sins. Time and again we have been made the whipping boy for blundering governments, the scapegoat for defeat in war, for misery and depressions, for conflict among classes."[14]

Jewish art explicitly identified Jewish Holocaust suffering with Christ's crucifixion. As described by Ziva Amishai-Maisels, in *White Crucifixion* (1938), Marc Chagall depicted Jesus "The Nazarene, King of the Jews," with head covered and wrapped in a *Tallit* (prayer shawl)-loincloth, surrounded by Jews fleeing pogroms; a Nazi soldier breaking into a Torah-ark (originally there was a swastika on his armband) and the patriarch and Rachel the matriarch in mourning. The work was inspired by a German *Aktion* on June 15, 1938, in which 1500 Jews were taken to concentration camps; the deportation of Polish Jews at the end of October 1938; and by the outbreak of pogroms in November, including Kristallnacht. In *The Way to Calvary* (1941), he depicted fellow Jews,

several of whom were crucified in a burning village, helping Jesus—again in a *Tallit*-loincloth—move along. A soldier raises his whip—like the typical Nazi overseer during a transport. In *Yellow Christ* (c. 1941), Chagall painted Christ, again in a *Tallit*-loincloth, consoling refugees leaving a burning village for an immigrant ship. They pause in their flight at the foot of the cross. In *Yellow Crucifixion* (1943), he portrayed Jesus wearing *Tefillin*, as well as a *Tallit*-loincloth. An open Torah scroll, illuminated by a candle held by an angel sounding a shofar, covers his right arm; an earlier sketch depicts a scroll with slaughtered children. The cross is planted in a burning *shtetl*, from which Jews are trying to escape; Jews wander on the right, and Mary and the infant Jesus flee to Egypt at the bottom. They do not escape, but move left to join others drowning on a sinking refugee ship. The work was inspired by the sinking of the *Struma* in the Black Sea in February 1942 with 769 Jewish refugees aboard. In *The Crucified* (1944), Eastern European Jews are being crucified in the street of a pillaged and burning *shtetl*. The work was a response to the news of the liquidation of the ghettos and to the destruction of Vitebsk during the war. In *Obsession* (1943), contemporaneous with the crushing of the Warsaw ghetto uprising, the cross falls in a village street and a three-branched candelabrum founders in the hands of a Jew. Chagall also lined these words of poetry: "A Jew passes with the face of Christ. / He cries: Calamity is on us. / Let us run and hide in the ditches."[15]

Christian views

By contrast to Pius XII, later Christian thinkers looked away from the Jews' role in the crucifixion and its divisive reverberations and echoed the Jewish wartime thinkers' identification of Holocaust suffering with the themes of crucifixion and its ramifications for reconciliation. There were already signs of this during the war.

The Apostolic Delegate Amleto Giovanni Cicognani in Washington, D.C., removed Jewish guilt for the crucifixion from the relationship to Catholicism and by his action included Jews in the Church's universe of suffering. He condemned the Pharisees for pretending to have Israel's spiritual welfare at heart but really leading them from the path of salvation. He believed that the Incarnate Son of God completed the divine revelation initiated by the patriarchs and

prophets of the Old Law. Christ became man to redeem mankind, was wounded for mankind's iniquities (citing the Suffering Servant in Isaiah 53 : 4–5) and shed his blood for the remission of sins of many (Matthew 26 : 28). But Cicognani's enemies were atheism and paganism, materialism, instinct, and selfishness—which refused to bring into human conscience the moral responsibility Christ provided—not those involved with crucifying Christ.[16] He took specific actions to alleviate Jewish suffering: he met with representatives of American ultra-Orthodox, Conservative, and Reform Jews in Washington and communicated their concerns to the Vatican. The United States War Refugee Board's executive director, John W. Pehle, wrote to U.S. Secretary of State Edward R. Stettinus that messages to Cicognani "would produce results more quickly than [messages] sent directly through the American delegate to the Vatican." Cicognani's communications dealt with 15,000 Yugoslavian Jews on the Italian island of Arbe, who were threatened with deportation to Poland in Spring 1943; ultra-Orthodox refugee yeshivah students in Shanghai's Hong Kew ghetto in the Summers of 1943 and 1944; Polish Jews with South American passports in Bergen-Belsen in November 1944; Romanian Jewish community leader Wilhelm Filderman, who was condemned to Transnistra in Summer 1943; 16,000 Lithuanian Jews, including yeshivah heads, being deported to Germany in October 1941; Hungarian Jews threatened with extermination in 1944; and Auschwitz inmates in imminent danger of being killed in the Autumn of 1944.[17]

The anti-Fascist Christian artist Otto Pankok grafted crucifixion onto the Jews of the Holocaust—and the Fascist press attacked him for blasphemy and philosemitism: "Christ is consciously represented as a Jew with all the racial characteristics of this race. It is only by chance, that by contrast, the torturers are the opposite type." In the preface to *The Passion* (1936), Pankok wrote that Jews' torture and death remained vital over the centuries; that the cycle of succumbing and overcoming, individually and collectively, repeated itself over the generations. Jesus, he said, had asked whether man was the image of God or the animal, and the answer was in terms of love and decency. His *Jesus of the Passion* referred to Jewish victims (along with Gypsies) in Nazi Germany. *Man of Sorrows* cited "Jesus of Nazar[eth], King of the Jews."[18]

In the 1970s, a series of Christian thinkers sought to reconcile the suffering of Christ with the suffering of the Jews, without diminishing either. Jürgen Moltmann stipulated that God participated in the suffering

of humankind (i.e., the crucifixion). He included the people of Israel in particular. The Holocaust was the crucifixion's most dramatic revelation: God was at Auschwitz, where suffering and death were taken into him: "In the cross of Christ, God took absolute death upon Himself in order to give His infinite life to man condemned to death;" "God is not dead. Death is in God; God suffers by us. He suffers with us. Suffering is in God." Indeed, "God is not only there in the suffering; the suffering is also in God Himself. It exists between God and God. God is not only involved in history; history is also in God Himself." Moltmann transcended the exclusivity of Jesus' suffering or the absorption of Jewish suffering into Christian suffering by speaking of Christian and universal experiences simultaneously. "A direct relationship between God and man, severed from the person and history of Christ, would be inconceivable from a Christian standpoint." God's suffering, even through Auschwitz, was inextricable from the person of Christ. At the same time, divine participation in human suffering was a universal experience, accessible beyond the Christian experience, and one which allowed for Jewish particularity. God suffered with the suffering of Israel and did so directly. His Shekinah (divine presence) entered exile with them and felt affliction with the martyrs. For Moltmann, the theology of the cross was already implicit in Judaism with first-century rabbinic theology—separate from the crucified Christ. Without surrendering Christ for Christians, he maintained the suffering of God in Israel's Auschwitz.[19]

In 1974, Marcel Jacques Dubois spoke of how the particularity of Jewish suffering and the suffering of Christ completed each other. To the Christian, the mystery of the crucifixion transfigured suffering and death and thereby vanquished them. With Christ, "turmoil and death are but the mysterious crucible of a resurrection already operative." In the Jewish tradition, Israel's suffering was to redeem the world. Dubois invoked the Suffering Servant: "A thing despised and rejected by men, a man of sorrows and familiar with suffering, a man to make people screen their faces ... and yet ours were the sufferings he bore, ours the sorrow he carried. ... By force and by law he was taken; would anyone plead his cause? Yes, he was torn away from the land of the living" (Isaiah 53 : 3–4, 8). For Dubois, "The Calvary of the Jewish people, whose summit is the Holocaust, can help us to understand a little better the mystery of the cross." The mystery of Golgotha led to the "transcendent intelligibility of the Holocaust." The crucifixion of Jesus and the suffering of Israel fulfilled one another: "What the Christian can truly see is that to the eye of faith,

Jesus fulfills Israel in her destiny of suffering servant; and that Israel, in her experience of solitude and anguish, announces and represents, even without knowing it, the mystery of the Passion and the cross." Dubois declared that, by uniting the passion of Christ with that of the people from whom Christ came, Chagall had shed light on both.

In 1975, Franklin Littell focused on the crucifixion of the Jews:

> The crucifixion [in the Holocaust] and resurrection of the Jewish people [in the Holy Land] is a sign that God is not mocked, that pride brings the biggest battalions low in the end, that the Author and the Judge of history blesses the Suffering Servant and brings the human hero low. Do the baptized still believe these truths, or must they be numbered among the blind and deaf when the Messiah comes?

It was left to Franklin Sherman to say that the agonizing God, his suffering and death symbolized by the crucifixion, should be a source for unity between Jews and Christians. Already under Cyrus, Darius the Persian, and Antiochus Epiphanes, Sherman pointed out, crucifixion was a fact for Jews—independent of Jesus. After the Roman siege of Jerusalem, Josephus reports that "there was not enough room for the crosses, nor enough crosses for the condemned." In this vein, Clemens Thoma stated that "Auschwitz is the most monumental sign of our time for the intimate bond and unity between Jewish martyrs—who stand for all Jews—and the crucified Christ."[20]

Conclusion

In June 1943, Pius XII drew attention to the belief that Jews tortured Christ and defied his attempt to save them. He defined the Church's concern for suffering in terms of Roman Catholics and those "not yet joined" to the Church. The Jews who were suffering and being killed in the Holocaust were apparently not eligible for inclusion—unless the pope believed that they separated themselves from their ancient predecessors and were potential joiners. His choice to divide Jews from the act of crucifixion, its suffering and redemption, and remove them to an area outside his concern, contrasted with Jewish thinking at the time. While Pius XII excluded them because of the crucifixion, Jewish thinkers were including themselves by speaking of the Holocaust in its terms. They

spoke of victims in terms of Isaiah's Suffering Servant, of the co-suffering of God and man, and of the redemptive dimension to suffering—which for some was exclusive to Israel, for others not. Abba Hillel Silver and Marc Chagall were explicit about the crucifixion. Some Christians shared the Jewish view during the war; in the 1970s, Christian thinkers affirmed Chagall and implicitly denied the view of Pius XII. For them, the Holocaust was bound together with the Suffering Servant and the crucifixion; indeed it enabled deeper understanding of the cross. They understood the Holocaust as a source for deep unity between those who suffered in Auschwitz and the one who suffered on Golgotha.

The subject requires further study of those who influenced Pius XII's theological reflections, of his apostolic nuncios and delegates as well as of contemporary theologians (notably Romano Guardini and Jacques Maritain). Tentatively, I would suggest that Pius XII's fixation on ancient Jewry prevented him from an openness to the commonality between the Church and Judaism with regard to crucifixion, and from fulfilling his prophetic assignment, which would have recognized the triadic relationships among crucifixion, Golgotha, and Auschwitz that were anticipated by Chagall and enunciated eventually by Marcel Dubois.

NOTES

I would like to thank the contributors to this book for their learned critiques; in particular, John Pawlikowski for leading me to the Christian theologians of the 1970s.

1. Gerard Mitchell, "The encyclical *Mystici Corporis Christi*," *The Irish Ecclesiastical Record*, 80, No. 916, Fifth Series, Vol. 63, April 1944, 217–27. See also Joseph Clifford Fenton, "The *Mystici Corporis* and the Definitions of the Church," *The American Ecclesiastical Review*, 128, No. 6, June 1953, 448–59.

2. *Humani Generis Unitas*, the so-called hidden encyclical of 1938 attributed to Pius XI, of which Pius XII was allegedly aware, did not speak of torture:

> [Jesus Christ's] mission and His teaching were the completion of the historic mission and teaching of Israel; His birth, life sufferings, death and resurrection from the dead, were the fulfillment of Israel's types and prophecies. ... The Savior, whom God had sent to His chosen people after they had prayed and longed for Him for

thousands of years, was rejected by that people, violently repudiated, and condemned as a criminal by the highest tribunals of the Jewish nation, in collusion with the pagan authorities who held the Jewish people in bondage. Ultimately, the Savior was put to death. [para. 135]

See Georges Passelecq and Bernard Suchecky, *The Hidden Encyclical of Pius XI*, trans. Steven Rendall (New York: Harcourt Brace, 1997), 2, 248–9.

3. In his next sermon St. Leo stated: "You have drawn all things to Yourself, Lord, when all the elements expressed the same feeling in condemning that crime perpetrated by Jews. With the lights of heaven darkened and day turned to night, even the earth shook with unaccustomed motions and all creation turned its back on the practices of the wicked." St. Leo the Great, "Sermon 59," in *The Fathers of the Church: St. Leo the Great. Sermons*, trans. Jane Patricia Freeland and Agnes Josephine Conway (Washington, D.C.: Catholic University of America), 253–60.

4. Jerome, "Epistle 112," in *The Correspondence (394–419) between Jerome and Augustine of Hippo*, trans. and ed. Carolinne White (Lewiston: Mellen, 1990), 112–41. See also Michael Connolly, "An encyclical and a centenary," *The Irish Monthly*, September 1944, 363–74; Joseph Bluett, "The theological significance of the encyclical *Mystici Corporis*," *The Catholic Theological Society of America. Proceedings of the Foundation Meeting* (New York City: June 25–6, 1946); and Ignatius McGuiness, "*Mystici Corporis* and the soul of the Church," *The Thomist*, 11, No. 1, January 1948, 18–27.

5. Pius XII did not cite religion or Judaism, but Assistant to the American Special Envoy to the Vatican Harold Tittmann reported that Pius XII meant the mass deportation and persecution of Jews. Saul Friedländer, *Pius XII and the Third Reich: A Documentation* (New York: Alfred A. Knopf, 1966), 133–4.

6. The connection I have made between the eclipse of Hebrew Scripture, synagogue, and ritual and the eclipse of the Jewish people is enunciated by Gregory Baum. Speaking of John Pawlikowski's "Theology of Substitution," whereby the Christian Church is the people of God, the heir of the covenant, the bearer of the divine promises, the true Israel, in whom God has announced a love embracing all human beings, which replaces the Israel of old, he writes that "the theology of substitution is so much part and parcel of the Christian imagination that it operates in the mind of theologians even after they have decided to adopt a more positive approach to Jewish religion. ... When they deal with the central Christian teaching on Christ and Christian redemption they fall quite spontaneously into the traditional way of speaking which presupposes that Jews no longer exist."

Baum also refers to Pius XII's removing offensive passages about Jews

from the Catholic liturgy—and this would have to be considered before drawing a conclusion about his views of the Jews. See Baum, *Christian Theology after Auschwitz* (London: Council of Christians and Jews, 1976), 8.

7. See Friedrich Jürgensmeier, *The Mystical Body of Christ as the Basic Principle of Religious Life*, trans. H. Gartner Curtis (London: George E. J. Coldwell, 1939), 197.

8. See Pius XII, *Summi Pontificatus* (October 20, 1939); *Mystici Corporis Christi* (June 29, 1943); *Divino Afflante Spiritu* (September 30, 1943); *Mediator Dei* (November 20, 1947). All are found in Claudia Carlen I.H.M., ed., *The Papal Encyclicals 1939–1958* (Raleigh, N.C.: McGrath, 1981). *MCC* was issued by Pius XII on the feast of the Holy Apostles Peter and Paul in 1943, appeared in *Acta Apostolicae Sedis*, 35, No. 7, and was translated into English, divided into parts, chapters, and sections, with captions by Canon Smith. (See Michael Connolly, "An encyclical and a centenary," 363–74.) It appeared in English in 1943, published by the National Catholic Welfare Conference in Washington, D.C. See also Vincent A. Yzermans, *The Major Addresses of Pope Pius XII* (St. Paul, Minn.: North Central, 1961), and Michael Chinigo, ed., *The Pope Speaks: The Teachings of Pius XII* (New York: Pantheon, 1957).

9. On Christian appropriation of Isaiah 53, see Christopher Markschies, "Der Mensch Jesus Christus im Angesichts Gottes-Zwei Modelle des Verständnisses von Jesaja 53 in der patristischen Literatur und deren Entwicklung," in *Der leidende Gottesknecht: Jesaja 53 und seine Wirkungsgeschichte* (Tübingen: J. C. B. Mohr, 1996), 197–248.

10. Yeshayahu Wolfsberg, "Penei Hador: Eved Hashem," *Hatsofeh*, 3, No. 342/ whole No. 350, February 10, 1939, 6. Shlomo Zalman Shraggai, "Be'aspeklariyah Shelanu: Yesurei Yisrael," *Hatsofeh*, 3, No. 360, March 3, 1939, 6–7. For a classical Jewish view of the Suffering Servant and Jesus' assuming the sin and suffering of others, see Orobio de Castro, "Prevenciones divinas contra la vana Idolatria de las gentes," in *The Fifty-third Chapter of Isaiah According to Jewish Interpreters*, II, trans. S. F. Driver and Adolf Neubauer (New York: KTAV, 1969), 450–531.

11. See Nehemiah Polen, *The Holy Fire: The Teachings of Rabbi Kalonymus Kalman Shapira, the Rebbe of the Warsaw Ghetto* (Northvale, N.J.: Aronson, 1994). See also Gershon Greenberg, "A Musar response to the Holocaust: Yehezkel Sarna's *Liteshuvah Velitekumah* of 4 December 1944," *Jewish Thought and Philosophy*, 7, Fall 1997, 1–38; and "*Tamim Pa'alo* (1947): Tsimerman's absolutistic explanation of the Holocaust," in *In God's Name: Religion and Genocide in the Twentieth Century* (Oxford: Berghahn, 2000).

12. See Gershon Greenberg, "The religious response of Shlomo Zalman Ehrenreich (Simleul-Silvaniei, Transylvania) to the Holocaust (1940–1948)," *Studia Judaica*, 9, 2000; "The suffering of the righteous according to Shlomo Zalman Unsdorfer of Bratislava, 1939–1944," in John K. Roth

and Elisabeth Maxwell, eds., *Remembering for the Future: The Holocaust in an Age of Genocide* (New York: Palgrave, 2001), 3 vols., 1, 422–38; and "The Holocaust apocalypse of Ya'akov Moshe Harlap," *Jewish Studies*, 40, 2000.

13. See Gershon Greenberg, "Holiness and catastrophe in Simhah Elberg's religious thought," *Tradition*, 25, No. 5, November 1991, 39–64; "From *Hurban* to redemption: Orthodox Jewish thought in the Munich area, 1945–1948," *Simon Wiesenthal Annual*, 6, 1989, 81–112; "Amalek in Holocaust-era ultra Orthodox Jewish thought," in Jacques Rozenberg, ed., *Purity, Impurity and Race: The Ethical Debate Following the Nuremburg Trials* (Albany: State University of New York Press, 2001); and "Redemption after the Holocaust according to Mahaneh-Yisrael Lubavitch, 1940–1945," *Modern Judaism*, 12, February 1992, 61–84.

14. Abba Hillel Silver, *Conference Record*, September 1, 1943, 4–5.

15. Amishai-Maisels, "Christological symbols of the Holocaust," *Holocaust and Genocide Studies*, 3, 1988, 457–81; "The Jewish Jesus," *Journal of Jewish Art*, 9, 1982, 84–104; and "The crucified Jew," in *Depiction and Interpretation: The Influence of the Holocaust on the Visual Arts* (Oxford: Pergamon, 1993), 178–97. The Jewish view of Amalek as Edom (i.e., Rome equals Christianity) was also changing (for example, with Elhanan Wasserman of Baranowicz in 1938 and Moshe Efraim Moshkowitz of Yabozna, Eastern Galicia, in 1939), while Christianity itself was being seen as both good and bad. In 1937, Eliahu Botchko of Montreux wrote that early Christians had sought to fulfill the ideals of Torah, until they were undermined by medieval paganism. In *Hurban Yahadut Eiropah* (1947), Moshe Prager of Benei Berak pointed to the good work of Cardinal Michael Faulhaber of Munich and Irene Harand of Vienna, while Yehudah Leib Gerst of Bergen-Belsen wrote that modern Christianity had been undermined by Nazism. See Elimelekh Horowitz, "Midoro shel Mosheh ad Doro shel Mashiah: Hayehudim mul Amalek Vegilgulo," *Tsiyon*, 64, No. 4, 1999, 425–54. See also Gershon Greenberg, "Wartime Orthodox Jewish thought about the Holocaust: Christian implications," *Journal of Ecumenical Studies*, 35, Nos. 3–4, Summer–Fall 1988, 483–95; "Yehudah Leib Gerst's religious ascent through the Holocaust," *Holocaust and Genocide Studies*, 13, No. 1, Spring 1999, 62–89; and "Orthodox Jewish theological responses to Kristallnacht: Hayim Ozer Grodzensky and Elhanan Bunem Wasserman," *Holocaust and Genocide Studies*, 3, No. 4, 1998, 431–44, and 4, No. 4, 1989, 519–21.

16. Cicognani did praise Pius XII for offering "every moment of his time to heal the wounds of humanity and to multiply works of charity" (citing 2 Cor. 11:29) and for having "distinguished himself as a champion of this universal brotherhood [such as to] rank in the history of the world as one of the great benefactors of the human race." Amleto Giovanni Cicognani, *The

Addresses and Sermons of His Excellency the Most Reverend Archbishop Amleto Giovanni Cicognani, I (New York: Benziger Brothers, 1938), 1–7, 70–87; II, 1938–42 (Paterson: St. Anthony Guild Press, 1942), 106–7, 131–8, 170–3, 196–8, 240–3, 327–9, 339–55, 382–94; III, 1942–51 (Paterson: St. Anthony Guild Press, 1952), 103–6. See Robert Trisco, "Archbishop Cicognani, Apostolic Delegate, Apostle of the Word, spoken and printed," in *The Church's Mission of Evangelization: Essays in Honor of His Excellency, the Most Reverend Agostino Cacciavillan, Apostolic Pro-Nuncio to the United States of America, On the Occasion of His Seventieth Birthday, 14 August 1996* (Steubenville, Ohio: Franciscan University, 1996), 371–86. Msgr. Trisco, who studied Cicognani's personal papers at the library of the seminary of his native diocese in Fuenza, tells me that he found nothing to account for his attention to Orthodox Jews.

17. Pehle to Edward R. Stettinus, June 12, 1944 (WRB papers, Box 2, FDR Library) as cited in Haim Genizi, *American Apathy: The Plight of Christian Refugees from Nazism* (Ramat Gan: Bar Ilan University, 1983), 65. See also Gershon Greenberg, "American Catholics during the Holocaust," *Simon Wiesenthal Annual*, 4 (1987), 175–201, and "Catholicism: Holy Land of Christ's crucifixion," in *The Holy Land in American Religious Thought, 1645–1948* (Lanham: University Press of America, 1989), 289–322. Also important is John Morley, *Vatican Diplomacy and the Jews during the Holocaust, 1939–1943* (New York: KTAV, 1980).

18. Pankok, "Als die Sonne," in *Die Passion* (Gutersloh: Gerd Molin, 1936), xvii–xix. See also the articles by Amishai-Maisels cited in note 15 above.

19. Jürgen Moltmann, "The crucified God and the apathetic man," in *The Experiment Hope* (Philadelphia: Fortress, 1975), 69–84. Baum concludes that Moltmann subscribed to the theology of substitution (for example, "Only the recognition of God in Christ and above all in the crucified one makes possible the dialogical life in the Spirit"). This would remove particular Jewish suffering and sublimate it into exclusively Christian suffering as identified with Christ's crucifixion. See Baum, *Christian Theology after Auschwitz*, 11.

20. Marcel Jacques Dubois, "Christian reflections on the Holocaust," *SIDIC*, 7, No. 2, 1974, 4–15. Franklin H. Littell, *The Crucifixion of the Jews* (New York: Harper and Row, 1975), 98–9. Franklin Sherman, "Speaking of God after Auschwitz," *World View*, 17, September 1979, 26–30. Clemens Thoma, *A Christian Theology of Judaism* (New York: Paulist Press, 1977), as cited by Pawlikowski, "Christology after the Holocaust." See John T. Pawlikowski, "Christology after the Holocaust," *Encounter*, 59, No. 3, Summer 1998, 345–68.

John F. Morley

Pope Pius XII, Roman Catholic Policy, and the Holocaust in Hungary: An Analysis of *Le Saint Siège et les victimes de la guerre, janvier 1944–juillet 1945*

This chapter is one result of my work as a member of the International Catholic–Jewish Historical Commission (three Jews and three Catholics), established in November 1999 by the Holy See's Commission for Religious Relations with the Jews (CRRJ) and the International Jewish Committee for Interreligious Consultations (IJCIC). The task of the Historical Commission was to review *Actes et documents du Saint Siège relatifs à la Second Guerre mondiale* (ADSS)—published between 1965 and 1981, its 11 volumes of documents deal with the Vatican's activities during World War II—and to propose questions or take note of problems associated with these sources.

Here I present some of my work on the tenth volume, *Le Saint Siège et les victimes de la guerre, janvier 1944–juillet 1945*, which was published in 1980. My chapter's purview is limited by the charge given to us to study the Vatican's published documents. The chapter relies on the documents published in Volume 10. In that sense, it is "one-sided," not because of any basic inaccuracy or inconsistency, but because all the sources are from the Holy See's records. Other sources are available but, with minor exceptions, they are not used in this chapter.[1] Unless otherwise indicated, references are to document numbers, not pages, of ADSS.

My colleagues and I wrote six papers, which were sent to Cardinal Edward Cassidy, President of CRRJ, in the Summer of 2000. From these papers, the group developed 47 questions. A report with these questions was brought to Rome and formally presented by us to Cardinal Cassidy

and to IJCIC at the end of October 2000. Our questions can only be answered by officials of the Vatican's Secretariat of State who have access to the appropriate archives. At the time of this writing, in late 2001, the Historical Commission hoped to receive replies, clarifications, and explanations regarding the issues we raised.[2]

I debated what approach to take in my analysis of Volume 10 of the Vatican documents. I decided to follow the lead of the editors, who list categories of Vatican interests and activities at the beginning of each volume. The one immediate advantage of this focus is that it places Holocaust reaction within the total framework of all that the Holy See's Secretariat of State was doing during those wartime years. Even though we who are specialists in the field of Holocaust studies have a tendency to look only at the reaction of the Vatican to that which directly concerns our Holocaust research, it is important to realize how widespread and varied were the activities of the Secretariat of State during these years. That was the *Sitz-im-Leben*, the real-life situation, of the Vatican personnel involved.

There is, however, a real disadvantage to this procedure as well. Certainly, it does reveal the complexity and variety of the activities that the Holy See pursued on behalf of "the victims of the war." This is something positive. On the other hand, such a detailed analysis also reveals the priorities of Vatican authorities during this period. It is disheartening, for example, to realize how much effort was expended on behalf of Italy and its interests, far more than for any other nation or people. This appears to me to be an attitude of chauvinism that goes beyond what would be expected from Pope Pius XII in his role as Bishop of Rome and Patriarch of Italy. One also sees in the expression of these concerns for war victims in Italy or for Italian soldiers an attitude of toughness and righteousness not paralleled in the response to the suffering of war victims in other countries, or to the Jews subject to atrocities all over Europe.

The major focus of this chapter, however, will be on the situation in Hungary in 1944–5. Not only was Hungary viewed as a place of refuge for Jews up until the German occupation of March 1944, but also it was the nation where the Nazis made their last cataclysmic effort to destroy all Jews. This hatred of the Jews was so intense that the German government expended time, effort, personnel, and materiel to accomplish this goal in Hungary, at a time when the German army was retreating to the west as Soviet troops began to occupy Hungarian territory. It was, in many ways, an example of the triumph of prejudice over reason,

antisemitic ideology being given priority over military needs. In addition, Hungary may be viewed as unique during Holocaust times because it was the only country in which Pope Pius XII intervened publicly on two occasions and where the nuncio worked in collaboration with other diplomats.

The tragedy of Hungary

It is arguable whether one can determine levels of suffering or persecution, but, if one can, the tragedy of Hungary during 1944–5 would hold a unique position. Not only did the deportation of the Jews start two years later than in other European countries, and with German military prowess on the defensive, but also it was accomplished with amazing speed. Hundreds of thousands of Jews were killed within a matter of weeks. In addition, by this time, the role of Auschwitz and the other death camps was widely known.

It would help, I think, to divide my analysis of Hungary into four time periods. The first involves the first three months of 1944 (and the years preceding, of course) before the German occupation of March 19, 1944. The second starts with the German occupation and includes the beginning of the deportation of the Jews. For my purposes, this period ends with Pius's June 25 telegram to the Regent of Hungary, which introduces the third period, and the aftereffects of that intervention. The final period begins with the regent's removal from power on October 15, and the imposition of the Arrow Cross's Fascist leadership.

Early in 1944, there were appeals from the World Jewish Congress that came through Archbishop Amleto Cicognani, the apostolic delegate to the United States, asking the Holy See to intervene with Hungarian authorities to accept and assist Jews from Poland. During the first months of 1944, Hungary was seen as a place of refuge for Jews. Cardinal Luigi Maglione, Secretary of State of the Holy See, informed Archbishop Angelo Rotta, the nuncio in Budapest, of this appeal and instructed him to take whatever steps he thought were "possible and opportune" (31, 40, 49. All references in this section, unless otherwise noted, are to documents in ADDS, Volume 10). My impression from previous research is that there were many more appeals from Jewish groups in this regard.

The situation changed dramatically and tragically after the German occupation of Hungary in mid-March 1944. On March 25, after the United States War Refugee Board had petitioned him, Cicognani passed on its request that the Holy See take urgent measures to protect the Jews in Romania and Hungary now under threat of persecution and extermination because of the German invasion (117). Instructions were sent by Maglione to Archbishop Andrea Cassulo, the nuncio in Bucharest, and to Rotta, again using the phrase about taking steps that they thought were "possible and opportune" (117, n. 4). Appeals also came to the Holy See from the Chief Rabbi of Palestine, who stated that the plight of the Jews of Hungary was now "perilous in the extreme," and that "only the urgent intervention of ... the Pope can save hundreds of thousands of human lives from the horrors that befell them in Romania and Poland" (124).

Two replies from Rotta to Maglione are of interest. His dispatch of March 30 to Maglione described the new governmental ministers as being nationalists but with a Christian background. In addition, he gave his opinion that he did not think that there was any danger of persecution of the Jews, although their lives would be difficult (125). The Vatican, therefore, was receiving information from its nuncio in Budapest that was contrary to that coming from other sources.

A week later, Rotta informed Maglione that he had intervened with the government for some mitigation of the decrees against the Jews and succeeded only in the modification of some of the regulations for baptized Jews. He did not think it "opportune" to take any further steps at that time (137).

On April 19, a long report was sent by Rotta to the Vatican. He indicated to the Secretariat of State that the first of the anti-Jewish decrees was the obligation to wear the yellow star, obligatory also for the baptized Jews, even if they had been Christians for a long time. There were other prohibitions in this decree forbidding Jews to remain in certain careers or professions. The nuncio wrote:

> In the first audience that I had with the President of the Council, I informed him that I thought that it was my duty as Nuncio to recommend a sense of moderation in the measures already enacted against the Jews, asking that due regard be given to the baptized Jews. ... I returned ... to make him see how unjust the measures taken were, that they demonstrated an ignorance of the value of baptism, and brought dissension to many families. (153)

All that the archbishop gained from this intervention was an easing of the regulation of the yellow star for priests and nuns of Jewish background.

Less than two weeks later, on April 28, Rotta sent another dispatch to the Holy See. He now reported that the campaign against the Jews had intensified, that they had been totally excluded from commerce, their stores closed, their homes requisitioned, and some had been forced into a ghetto. He commented to his Vatican colleagues:

> Being that these decrees are basically racist, many thousands of baptized Jews have been gravely affected by such draconian measures, all the more so because the government has established a central Jewish committee for its convenience in carrying out these decrees, [and] Christians are at the mercy of this committee, who naturally attempt to give them up, in the first place, to satisfy governmental demands.

Rotta also described these regulations as being "inhumane and unchristian," and indicated that "the Holy Father would be profoundly saddened realizing that also in Hungary, which up to that time had gloried in being a Christian nation, a course was being established in contrast to the doctrine of the Gospel" (172).

Four issues are noteworthy in these documents. Rotta did not protest against the intrinsic evil of the anti-Jewish decrees but asked only that "moderation" be used in enforcing them. This was a response that was typical of other Vatican representatives in the face of anti-Jewish laws and actions. On the other hand, in a protest to the Minister of Foreign Affairs, he described these governmental regulations against the Jews as being "inhumane and unchristian," and contrary "to the doctrine of the Gospel."

A second consideration involves the rights of the baptized Jews. Rotta was particularly concerned about those who had been Christian for a long time and were now being subjected to a series of prohibitions. The government was ignorant of the value and effects of baptism.

A third aspect, which again has parallels in other situations, was a reference to the hostility of Jews against Christians of Jewish background. Rotta complained not only about the anti-Jewish measures being enacted against baptized Jews, but also that these Christians were subject to the central Jewish committee established by the government to expedite its dealings with the Jews. These Christians were at the mercy of this committee, Rotta claimed, and their interests were often sacrificed to satisfy governmental demands.

Finally, Rotta also complained about the unrealistic and "excessive prudence" of the Hungarian bishops and their leader, the Primate of Hungary, Cardinal Justinian Seredi. Rotta, however, could inform the Secretary of State on May 1 that Seredi had eventually spoken to a high government official about the proposed racial laws but could not obtain any exemptions for baptized Jews. The nuncio described the government officials as being "fanatical racists" (255).

There is a most interesting, indeed illuminating, account of Vatican thinking at this time in an unsigned memo in the Secretariat of State, dated May 22. Harold Tittmann, the chargé d'affaires of the United States at the Vatican, had brought memoranda on the Hungarian racial question to the Secretariat. It was the Vatican bureaucrat's opinion that Tittmann would prefer that the United States and the Holy See work together in confronting the racial question. The Vatican official suggested that this was a "delicate, almost dangerous" matter, and that the Holy See should not follow, or appear to follow, the American approach, particularly in the Jewish question. He concluded that "the action and activity of the Holy See must remain independent and its own" (201).

This point of view appears to have been used by Msgr. Domenico Tardini, one of Maglione's principal assistants, in speaking with Tittmann on May 26. First of all, Tardini suggested, the Holy See had always been interested in aiding the persecuted Jews. This work began with Pope Pius XI and was continuing with Pius XII. Tardini added that, even though the action of the Holy See in this regard might parallel that of the United States, it must, for various reasons, remain independent (212).

On May 23, Rotta reported to Maglione that, in addition to his oral protests to government officials, he had also sent two notes to the government on May 15. He realized that they would probably not be effective, but he wanted to document the nunciature's position in the matter and also that of the Holy See. There is, in addition, the summary of a conversation that Rotta had with a former high government official. It would seem to have had some impact on the nuncio's attitude toward the anti-Jewish legislation. This official indicated that he was not enthusiastic about the anti-Jewish measures taken and the way in which they were applied. He cautioned, however, that one had to understand the difficult conditions facing Hungary. Russian troops were at the border of the country, and there was the danger of internal revolutionary movements. Such a situation necessitated strong measures against the Jews who were generally sympathetic to the Bolsheviks (207).

Rotta's two written interventions, made on May 15, shortly after the deportations began, were addressed to high government officials, the Minister of Foreign Affairs and the president of the Council. He was very blunt in his remarks to the minister, accusing the government of injustice in refusing to make exemptions for the baptized Jews, and describing as "inhumane" the method in which the decrees were carried out. All of his efforts had been unsuccessful and the deportation of the Jews was about to take place. He added that *"Everyone knows what deportation means in practice"* (emphasis mine). The nuncio added that, if the government's campaign against the Jews violated the natural and divine laws, then the Holy See would have to protest energetically. To the president of the Council, Rotta wrote:

> The simple fact of persecuting people for the sole reason of their racial origin is a violation of the natural law ... But to take anti-Semitic measures, without taking into account the fact that very many of the Jews by the reception of baptism have become Christians, is a grave offense against the Church.

He also mentioned the possibility of a protest by the pope to this official, expressing the hope that the pope "in his role as Supreme Pastor of the Church, guardian of the rights of all his children and defender of truth and justice, ... would not be obliged to raise his voice in protest" (207). Rotta's approach was typical of the Vatican diplomats of his time. What was not typical, and, indeed, is noteworthy, was his remark, in referring to the deportation of hundreds of thousands of people, that *"Everyone knows what deportation means in practice."*

One cannot help but be amazed at the nuncio's straightforwardness in these statements. To imply that deportation meant something far more sinister than just relocation, and, likewise, to hint that Pius XII might feel justified in protesting against the situation in Hungary, were remarks of a type not usually uttered by Vatican diplomats. Admittedly, it is not certain that any possible protest by the pope would go beyond the rights of the baptized Jews, but nevertheless any intervention by him during these years would have been unprecedented.

The government's reply of May 27 is not published in ADSS, but on the day after he sent the above report with the two attachments, Rotta, on May 24, telegraphed Maglione that deportations, under the guise of mandatory labor, were actually taking place in the most inhumane way. He used this occasion to mention that a direct step by the

Holy See might be useful, a suggestion that was possibly among the factors leading to the pope's telegram a month later (209).

Meanwhile, Cicognani in Washington was often the recipient of petitions and requests from various Jewish groups. Thus, on June 9, he cabled Maglione with the information that he had received from a Jewish group that the extermination of the Jews of Hungary was continuing, and that the number involved was about one million people. The delegate also relayed the request of this committee that the pope should make a public appeal in the strongest terms that the Jews should be spared. These Jewish officials felt that such a papal statement would be very impressive to Hungarian Catholics, and that with this appeal and the efforts of bishops, priests, and lay people, the government could not continue the massacres. They were convinced, Cicognani added, that such a word from Pius XII would be very effective (225).

It is frustrating to read this message from the delegate in Washington, both because of its content and also because of Maglione's response. It is pitiable, and, indeed, painful, to realize that these and other Jewish officials believed that the pope would intervene on behalf of the Jews of Hungary, and that, when he did, the results would be effective. Maglione's follow-up, moreover, is quite puzzling and disappointing. Cicognani's cable was received on June 9, but it was not until June 17 that Maglione communicated the information to Rotta with the request that he verify the report about the extermination of the Jews of Hungary (225).

In the meantime, Rotta was in touch with Maglione on June 10, sending him the copy of another note sent to the government on June 5. The nuncio indicated that baptized Jews were included in the anti-Jewish campaign, which was carried out with great force and violence. He knew that the pressure for these regulations came from outside the country, but there were fanatical Hungarians willing to cooperate (227).

In his note to the Minister of Foreign Affairs, Rotta dealt with the question of baptism and its effect upon the Jews. He criticized the government for not accepting the beneficial effects of Christianity upon the Jews and repudiated allegations that the baptisms of the Jews were of doubtful sincerity. He reminded the minister that many of the Jews had converted to Christianity before the antisemitic laws were enacted.

It must also be pointed out that Rotta, like the nuncio in Romania, foresaw good effects in the future as a result of the conversions of Jews at the present. He expressed his belief that after one or two generations the

descendants of Jews who converted to Christianity would no longer show any ethnically Jewish characteristics.

There are other issues to be considered in this note. The nuncio, as he had done on May 15, returned to the problems faced by the baptized Jews who had been forced by governmental regulations to subject themselves to the decisions and actions of the Jews, resulting, as he said, in "tragic circumstances" for them. He was obviously very concerned about Jews having any authority over other Jews who had converted to Christianity. In addition, Rotta spoke very strongly against the resumption of the deportation process and the recent decision to deport all Jews, no matter what their religion. He also complained about the inhumane conditions in the concentration camps and the fact that priests were forbidden to minister to the baptized Jews, whom he called the "unfortunate children of the Church." Most remarkable of all, however, was the tone of mockery and disbelief that the archbishop used in responding to the government's claim that deportations were only being used to fulfill the needs of obligatory labor service. The nuncio was scornful of such an excuse, pointing out to the minister that he questioned what kind of work, if any, people over 70, infants, and the sick could do. He reacted with unmitigated disdain to the government's justification that Jews being sent away for labor service could take with them their families, including aged, sick, and young relatives: "When one realizes that Hungarian workers who have been sent to Germany for labor are forbidden to take their families with them, one is truly astonished to see that only to the Jews is given this great favor" (227, attachment).

Maglione's June 17 telegram to Rotta, inquiring about the accuracy of the reports about the extermination of the Jews, received an immediate response. The reports were true, and, as the nuncio said, about 300,000 Jews had already been deported. One-third of these were sent away for labor service, but it was not known what happened to the other two-thirds. There were also rumors of annihilation camps. What was true, though, was that these Jews were treated horribly both during transport and in the concentration camps. Rotta also used this occasion to remind the Secretary of State that he had recently told government officials that the true purpose of deportation was already well known. Finally, he responded to Maglione's inquiry about the Hungarian bishops by informing him that Seredi, in the name of all his colleagues, had intervened with the government at the end of April, but there had been no public, group protest by the Hungarian hierarchy (233).

Pope Pius XII's intervention and its aftermath

Pius XII's June 25 telegram to Admiral Miklós Horthy, the Regent of Hungary, is of extreme interest and importance to a study of this period. It appears that several factors were involved in the decision to send this message. There is evidence that consideration of such an intervention had begun on June 12, soon after Rotta had communicated to the Vatican that baptized Jews were also destined for deportation (see Blet, *Pius XII and the Second World War*, 194). In addition to Rotta's telegram of June 18 verifying the facts of extermination and the rumors of death camps, there were two other sources of information that influenced Pope Pius XII to send his telegram.

The immediate impetus was probably twofold. On the morning of June 25, Maglione heard from Rotta that his latest efforts on behalf of baptized Jews were unsuccessful, that the deportations were continuing, and would soon affect areas where Christians of Jewish origin were residing. There was, however, another dimension to Rotta's communiqué. He again referred to the "excessive prudence" of the Hungarian bishops and described it as a source of scandal for many Catholics. He urged his Vatican superiors to put pressure on Seredi so that he would actively intervene to attempt to save those who could still be saved. Rotta proposed this because he feared that the honor of the Church was being compromised by the hierarchy's lack of action (242).

At the same time, ominous information from the U.S. War Refugee Board (WRB) was given to Maglione by Tittmann. According to the message, the contents of which were considered authentic by American officials, "the present authorities in Hungary have undertaken to persecute the 800,000 Jews in Hungary and are planning their mass slaughter both in Hungary and after deportation to Poland merely because they are Jews." In addition, the WRB warned the people of Hungary about the consequences of this treatment of the Jews. The WRB concluded with a request that may have had an impact on the papal decision to send the telegram:

> We earnestly hope, therefore, that His Holiness may find it appropriate to express Himself on this subject to the authorities and people of Hungary, great numbers of whom profess spiritual adherence to the Holy See, personally by radio, through the Nuncio and clergy in Hungary, as well as through a representative of the Holy See who might for that purpose be specially dispatched to Hungary. (241)

The end result of this information and these requests was the telegram sent by Pius XII on June 25 to the Regent of Hungary. The pope indicated that he was being asked on all sides to intervene on behalf of those unfortunate people who were suffering so grievously because of their nationality or race (243; for translation of the full text, see Blet, *Pius XII and the Second World War*, 194–5). Horthy replied on July 1 that he wanted to assure the pope that he would do all possible to make sure that humanitarian Christian principles would be maintained (250).

The concrete results of the pope's intervention were not as clear-cut or as positive as might have been expected or desired. It is true that the regent ordered a suspension of the deportations on July 6 (250, n. 6). Rotta made this known to Maglione in his telegram of July 14 and added his hope that there was the possibility of the expansion of exemptions for the baptized Jews. Pius was so pleased with this news from Rotta that he directed that it be made known to anyone asking about it (265).

The Vatican's sense of pride and accomplishment might not have been as well-founded as Church officials would have liked to believe. For example, an appeal, originating with the Chief Rabbi of Palestine, Isaac Herzog, was received on June 30 and referred to the 700,000 Jews of Hungary already deported or soon to be deported. The Secretariat of State's reply on July 3 did not refer to the statistics but used the familiar refrain that the Holy See was doing as much as it could do on behalf of the Jews of Hungary (249).

In addition, the Polish ambassador to the Holy See, Kazimierz Papée, presented Maglione with a very alarming report two weeks later. It was probably the most accurate information received by the Secretariat of State. According to the ambassador, German authorities had brought about 400,000 Jews from Hungary to Auschwitz, where they had been killed. It was the Polish government's opinion that the extermination of the Jews of Hungary was following the same pattern as that of the Jews of Poland (263). The published volumes from the Holy See reveal no evidence of the Vatican's reply to Papée.

Similar, although not as ominous, news arrived from one of the Holy See's own representatives. Cassulo, the nuncio in Bucharest, wrote on July 28 describing in sympathetic terms the situation of the unfortunate Jews who had been forced to leave their homes and live in concentration camps (280).

On the other hand, however, several times during the month of July, officials of the Holy See demonstrated great eagerness to share the

news of the pope's telegram (254, 262, 270, 274, 281). Likewise, they rejoiced in the expressions of gratitude that came from various Jewish groups (253, 270, n.3, 273, 295).

Toward the end of July, the nuncio in Berne, Archbishop Filippo Bernardini, sent to the Secretariat of State a four-page summary of a document called the "Auschwitz Protocol." Much has been written about this document, but what is of particular interest for our purposes is that the archbishop revealed his worry to Maglione: since Swiss newspapers had been carrying many accounts of Protestant efforts on behalf of the Jews of Hungary, with nothing published about parallel Catholic efforts, people would believe that the Catholic Church in Hungary had done nothing to help and save Jews (364).

The last communication between Maglione and Rotta, a telegram, was dated August 20. The nuncio was informed that the information about the improvement in the situation of the non-Aryans in Hungary was well received, and he was directed to thank the regent on behalf of the pope for his efforts in this regard (307). This telegram is of no interest in itself, since its contents are quite perfunctory. I point it out because Maglione's name is used as the source. He had been out of Rome since the beginning of the month, because of his deteriorating health, and had returned to his family home in Casoria, where he died on August 22. There were several other communications during these weeks of August that identified Maglione as the source. It may have been possible for the cardinal to have remained in contact with his office by telephone or by courier, but it is not likely because of his health and the military situation. Bureaucratic and diplomatic procedures were probably the reason for the use of his name, but, nonetheless, the practice and motivation are of interest.

Msgr. Domenico Tardini, Secretary of the Congregation for Extraordinary Ecclesiastical Affairs, and Msgr. Giovanni Battista Montini, Substitute of the Secretariat of State, had been Maglione's two principal assistants. Pius XII, however, did not appoint a successor to Maglione and acted as his own Secretary of State, with Tardini and Montini assisting him. Each of them had specific responsibilities and lines of authority, but, in practice, such differentiation was not always apparent. All instructions for Rotta, after this date, came from Tardini.

One of the amazing aspects of Rotta's role as nuncio in Budapest was his collaboration with the representatives of the other neutral governments accredited to Hungary. As dean of the diplomatic corps,

Rotta was their leader and spokesman on three occasions when they brought complaints and protests to the attention of the government authorities. The first of these complaints and protests, dated August 21, was sent to the Minister of Foreign Affairs under Rotta's signature and those of the envoys of Sweden, Switzerland, Spain, and Portugal. These statements, issued less than two months after Pius XII's telegram to Horthy, contradicted any notion that there had been real improvement in the conditions of the Jews in Hungary. The diplomats bluntly expressed their surprise and sorrow that the deportation of Hungarian Jewry was going to resume. They wrote that they "have been informed—from absolutely certain sources—of what is meant by deportation in most cases, even if it is disguised under the name of work outside the country." It was "absolutely inadmissable," they added, "that people be persecuted or killed for the simple fact of their racial origin" (308).

The next day, Rotta's telegram to the Secretariat of State—no longer addressed to Maglione, of course—brought somber news. Rotta mentioned the previous day's intervention. In addition, he expressed his fear of the consequences of the strong German pressure to deport the non-baptized Jews. He described the Hungarian government as reluctant to deport them and Horthy as being determined to resist. "It was hoped," the nuncio concluded, "that the deportation would not take place but any surprise was possible" (396).

At the end of August, Horthy instigated political changes in Hungary. Rotta reported them in a September 5 cable in which he informed Vatican officials that there had been no deportation of Jews and that the situation was fearful but quiet (309). Contrary information, however, was received the next day in a telegram sent directly to the Vatican from the London office of the World Jewish Congress. The Congress sought Pius's intervention in Hungary because, in spite of Horthy's promise, deportations at the rate of 12,000 per day were continuing (321, n. 1).

In mid-October, there was a tremendous political upheaval in Hungary. Horthy's attempt to conclude an armistice with the Allies on October 15 culminated in his arrest and forced departure for Germany. The pro-Nazi Arrow Cross party was installed in government. As a result, Rotta wrote on October 18, the campaign against the Jews had been resumed with great cruelty (359). At this very time (October 18), the London office of the World Jewish Congress again appealed to the Holy See, citing the planned deportation of 300,000 Jews from Hungary. They

expressed the hope that the pope's intervention "may avert this appalling tragedy," and, naïvely perhaps, felt confident that this appeal to save doomed people would not be ignored (355).

Similarly, and almost simultaneously, on October 19, Cicognani cabled a message to the Secretariat of State from a group of rabbis and Jewish leaders in the United States. They, too, were concerned about the desperate situation of the Jews in Hungary. They petitioned Pius to speak to the Hungarian people on Vatican Radio to encourage them to protect Jews (361). Tardini's response to this ominous news was to ask Rotta, as Maglione had once done, to send him whatever information was pertinent to these matters (365). Cicognani's role as a channel of requests from American Jewish groups to the Vatican was again in evidence on October 25 when he cabled a proposal, which not only was unique but also naïve and Utopian, that the pope declare all the churches of Hungary as places of refuge with the right of asylum. In addition, the Jewish leaders asked that the bishops and priests receive Jews in the churches to spare them from death (375).

Because the origin of some of this information was the London office of the World Jewish Congress, Tardini shared it with Archbishop William Godfrey, the apostolic delegate in London, on October 20. After a passing reference to the recent Jewish appeals, Tardini appeared more interested in giving the Vatican credit than in facing the tragic facts brought to his attention. He was aware, as he wrote, that the delegate knew "how much has been done by the Holy See, particularly in these last months for those of the Jewish race in Hungary ..." and how the personal intervention of the pope with the regent had brought about a suspension of the deportations and an improvement in their conditions. Such a response, which referred to an event four months earlier, seems disappointing and self-serving, for it ignored or minimized the catastrophic change in events in Hungary. Tardini did add, however, that the Holy See would continue to monitor the situation of the Jews in Hungary and would do everything possible to bring relief to them (362).

Myron Taylor, President Franklin D. Roosevelt's representative to Pius XII, gave the pope a copy of the October 18 information from the World Jewish Congress. In his notes, Tardini indicates that the Holy See should respond fully and warmly to Taylor (and, presumably, to others). He also noted his opinion that the use of the phrase that the Holy See would do whatever was possible seemed like "bureaucratic indifference." Tardini's pragmatism can be seen in his final remark that, even though

little can be obtained from these various efforts, there was all the more reason to show the interest and concern of the Holy See (357).

Tardini and Rotta telegraphed each other on October 23. The Vatican official described to the nuncio the pope's sadness over the situation in Hungary. In words that would be used again, he added the point that "pressing appeals continue to reach us imploring the intervention of the Holy See on behalf of persons who are exposed to persecution and violence because of their religious confession, race, or political convictions." Tardini also encouraged the archbishop to continue his benevolent activity, together with the bishops, "supporting as much as possible the paternal kindness of the August Pontiff and demonstrating to all that the Catholic Church leaves nothing untried in order to accomplish, in these present difficult conditions, its universal mission of charity" (370).

Rotta was unaware of this telegram when he informed the Secretariat of State on the same day that the new government had repealed all concessions given by the previous administration and was on the verge of annulling mixed marriages between Hungarian Christians and Jews. He added that he had conferred with two government officials several days previously and had insisted, in the name of the Holy See, on three matters: an improvement of conditions for the Jews, that there be no attempt to annul marriages, and that concessions already granted remain valid (371). Just the day before he sent this telegram, Rotta had sent a brief message to the Secretariat of State informing the Vatican that Seredi had ordered that a collection for the benefit of all the refugees be taken on October 29 in all the churches of Hungary (368). This routine and seemingly innocuous message, particularly in the context of the deteriorating situation in Hungary, appears, at first glance, to be of no consequence. It was, however, the source of Pius XII's second intervention in Hungary, as he sent a public message to Seredi.

As the editors said, in their introduction to Volume 10 of ADSS, the pope's letter gave the appearance of a typical word of support for an important act of charity. It was, however, far more than that, since it was Pius's response to those seeking a radio broadcast by him, or a declaration of the right of asylum for churches. He placed his remarks directly in the context of the Hungarian tragedy:

> While pressing appeals continue to come to Us from this nation [Hungary] appealing for Our intervention in defense of those persons

exposed to persecution and violence because of their religious confession, race, or political convictions, it has given Us great comfort to learn that Your Eminence, conforming to the universal mission of charity always exercised by the Catholic Church and supporting Our constant concern to relieve the suffering caused by the war ... has established a day of prayer and aid.

Pius also referred to his prayers that "in conformity with the principles of humanity and justice, the sufferings already so grievous from this terrible conflict will not become worse" (376). Noteworthy in this letter is the pope's use of the same terminology employed by Tardini in his October 23 telegram to Rotta (370), when he referred to people "exposed to persecution and violence because of their religious confession, race, or political convictions." Tardini would again use this phrase when he quoted from Pius's letter to Seredi in a telegram to Cicognani on November 3 (385).

More disturbing news came from Rotta toward the end of November. On November 26, he telegraphed the Secretariat of State that the campaign against the Jews was again in force and all Jews were required to live in ghettos. He mentioned, too, that the Arrow Cross party believed that it could do anything against the Jews. The nuncio added that he and his staff were continuing their efforts on behalf of Jews, and, particularly, the converts. In addition, he referred in passing to another joint effort of the representatives of the neutral nations (407). Rotta continued his efforts to keep the Vatican informed by sending a long report (not a telegram) on the following day, with the protest of the neutral governments attached.

Earlier, on November 17, Rotta and the Swedish minister, on behalf of their colleagues, sent another memorandum to the Hungarian government. In his cover letter, the nuncio observed that there was little hope among the diplomats of any positive result from this intervention because of the "fanatical hatred" of the Arrow Cross toward the Jews, but they viewed their effort as a gesture appealing to Christian and civil conscience (408).

Another aspect of Rotta's November 27 report requires analysis, which will be done below, but at this point it is pertinent to look first at the contents of the letter sent by the neutral diplomats to the Minister of Foreign Affairs on November 17. The diplomats recalled, first, that three months earlier they had intervened with the government, attempting to prevent further deportations. As they wrote, the diplomats felt that they had

been successful and "hundreds of thousands of human lives were saved." In their November 17 statement of protest, they concentrated on two facts. Government officials, after the October 15 change of government, had assured them categorically and solemnly that there would no longer be any deportations or destruction of Jews. In spite of this assurance, the representatives indicated that they had learned that the deportation of Jews had resumed and was being pursued with "ferocious energy." In response to the government's claim that obligatory labor in foreign countries, not deportations, was involved, the diplomatic group wrote:

> But the Representatives of the Neutral Governments know very well the horrible reality which for most of these unfortunate people is disguised in this term [obligatory labor]. It is enough to realize that even small children, the elderly, and the sick are taken away to be convinced that this is not a question of work, while also the atrocities that accompany the transport make foreseeable what will be the end of this tragic exodus.

Furthermore, the diplomats indicated that they felt obliged by a "sentiment of humanity and Christian charity" to make known their regret at all of this, and to make three requests. They first asked that the decision to deport the Jews be revoked and all regulations against them be suspended. Second, they sought decent treatment for those actually required to work in concentration camps. Finally, and this would be of extreme importance, they requested that those Jews who were under the protection of the various neutral governments accredited to Budapest should be treated in the way to which the Hungarian government had already agreed (408, attachment).

Now, as mentioned above, it is necessary to look again at Rotta's report of November 27, to which this diplomatic protest was attached. Reporting to Tardini, Rotta said: "The Nunciature, for its part, has done whatever was possible to alleviate such suffering, intervening with the various governmental offices involved and issuing more than 13,000 letters of protection, which have served—at least for a certain period of time—to prevent many Jews, and particularly baptized Jews, from being deported" (408). This report did not reach the Holy See until the end of February 1945, when it was read by Pius himself. Tardini was so thrilled by the nuncio's actions in distributing the letters of protection that he jotted down the notation, *"Bravo Msgr Rotta!"* and suggested that this information be shared with the British and American representatives at the Vatican.[3]

Meanwhile, Tardini's response to Rotta's telegram of November 26 was sent on December 4, and began with a description of the pope's sadness over the news sent by him. Rotta was encouraged to continue his efforts with the authorities on behalf of those being persecuted. Pius concluded his brief remarks with praise for Rotta: "The Holy Father relies on your constant and multiple actions with the most excellent episcopate and the well-known generosity of Hungarian Catholics" (412).

Another telegram followed from Rotta on December 11. He indicated that he would not depart from Budapest even though government officials had moved to a safer area. There are some words missing in the text, but it appears that the nuncio was telling the Secretariat of State that, because of the continuing arrests of priests and persecution of Jews, it would be impossible for the nunciature to leave the city. It was his hope that, when Budapest was occupied by the Russians, an event he thought imminent, his presence and that of the nunciature could have a positive effect, if the Russians respected it and the Allies supported it[4] (415; see also Vol. 11, 418 and 420).

Two days before Christmas, with Rotta as their leader and spokesman, the representatives of the neutral states (Portugal, Spain, Sweden, and Switzerland) brought their third protest to the Hungarian Minister of Foreign Affairs. They stated that they were aware that the government had confined all Jews to the ghetto, but they concentrated on obtaining the release of children from this obligation. They admitted that the possibility of civil disorders might require certain protective measures, but there was no such fear with regard to children. They continued:

> It is said that the Jews are the enemies of Hungary; but even in a state of war, right and conscience condemn any sort of hostility directed against children. Why oblige these innocent children to live in an environment that very much resembles a prison and where these small children see nothing else than the misery, suffering and despair of the old people and women, all of them being persecuted for the sole reason of their racial origin? (424)

There is no specific indication of how or when this document arrived at the Secretariat of State. There is a reference to a communication from the nuncio on that same date (December 23), indicating that he had protested over the growing acts of hostility against the Church. Presumably a telegram was involved, but it is not noted as such (424, n. 2). Apparently

this was the last wartime contact between Rotta and the Vatican, for nothing in Volumes 10 or 11 of ADSS reveals any further exchanges.

There was, however, one last dramatic appeal on behalf of Hungarian Jews sent by Cicognani on December 27. He passed on the appeal of a group of American and Canadian rabbis begging the pope to continue his efforts to save from extermination the Jews remaining in Hungary (426). Tardini's response to Cicognani on January 3, 1945, indicated that communication with Budapest was no longer possible. Furthermore, he pointed out that not only had the nunciature and the Hungarian hierarchy been constantly involved on behalf of the Jews, but also that the pope had recently donated a generous sum of money to the nunciature (430).

Conclusion

According to Volume 10 of ADSS, with these final episodes the account of the Holocaust in Hungary, and, in particular, the role of the nuncio, Archbishop Angelo Rotta, draws to a close. It is not surprising that Rotta demonstrated the attitudes typical of the Vatican diplomats of his day. His education and diplomatic training, and the instructions he received from the Secretariat of State, would certainly have contributed to his outlook, values, and methodology, as they would have done for his diplomatic colleagues as well. Rotta saw his primary responsibility as representing and defending the rights of the Church and its members.

As all the other nuncios did in nations with similar problems, Rotta protested infringements on the rights of Catholics, even if of Jewish origin. Attempts to deny the validity of their baptisms and to label or group them with Jews were viewed as offenses against the Church and vehemently brought to the attention of government authorities. Rotta also tried to convince officials that the effect of baptism on Jews could change their ethnic characteristics within a generation or two. The nuncio in Bucharest had made a similar observation.

Vatican diplomacy, in general, agreed that governments could take certain measures to protect their nations from the influence or power of Jews. Removing Jews from certain areas of society and certain professions was seen as a legitimate protective effort by the state to control, as it was thought, the secular, materialistic, and often Bolshevik

tendencies of Jews. The Vatican criticized these policies only when it concluded that they were not being enforced in a just, humane, and moderate fashion. Thus, Rotta did not protest against the basic injustice of Hungarian actions against the Jews, but asked only for moderation in their application, and that baptized Jews be exempted from them. This was a typical response from the various nuncios.

Rotta also appeared to believe that Jews felt hostility toward Christians, and, particularly, toward baptized Jews. It is a source of surprise and joy, however, to add that the nuncio in Budapest was atypical in a number of ways. He went beyond the limitations imposed on a Vatican diplomat on various occasions. For example, in dealing with government officials, he made no attempt to conceal his knowledge of what deportation really meant. During another such meeting, he expressed his disbelief by mocking and scorning the idea that those being deported were actually going off to work in foreign countries. In ecclesiastical matters, Rotta did not hesitate in his reports to the Secretariat of State to criticize the leading Church authority in Hungary, Seredi, for his passivity in regard to the Jewish question. He also suggested that the Hungarian hierarchy was misleading ordinary Catholics by its lack of action. Rotta was also a realist and believed that, even if certain efforts on behalf of the Jews were not successful, the honor of the Church was preserved by the intervention because it demonstrated the Church's charity and concern for all people.

The most remarkable and distinctive aspect of the nuncio's role in Budapest was his collaboration with the representatives of the other neutral nations posted there. He was their leader and spokesman on three occasions in bringing protests to the government. In most European nations, the nuncio of the Vatican was considered the dean of the diplomatic corps, but there is no evidence that any other nuncio was involved with other diplomats in joint actions. It was a humanitarian gesture that went beyond the normal proprieties of Vatican diplomacy, but one that was necessary during those months in Budapest. It is uncertain, however, how his superiors reacted to this collaboration. Rotta informed them, but there is no indication of their reaction, whether positive or negative.

The final indication that Rotta went beyond the normal constraints of Vatican diplomats was his distribution of the 13,000 letters of protection. He does not indicate any great effort to scrutinize the baptismal status of those receiving these documents. It is generally assumed that they were given to all in need.

Whether Rotta felt ambivalence in his life during these months when the full fury of the Holocaust was directed against the Jews of Hungary and of Budapest is a question that cannot be answered. What is apparent and praiseworthy, however, is that he was a nuncio who remained faithful to his diplomatic obligations, but was able to transcend them, and, indeed, maybe even to subordinate them, during these months in Budapest.

NOTES

1. In the late 1990s, Father Pierre Blet, S.J., one of the four original editors of ADSS, published *Pius XII and the Second World War: According to the Archives of the Vatican*. It summarizes the published documents, and occasionally my chapter draws upon Blet's work.

2. The report with the questions may be found in *Origins: CNS Documentary Service*, November 9, 2000, Vol. 30, No. 22, 342–51. It should be noted, too, that there was consensus that individuals in the Historical Commission could publish their own papers.

3. Another issue involving Rotta's use of documents was clarified in a statement made on August 1 by Archbishop Angelo Roncalli, the apostolic delegate in Istanbul. Roncalli indicated to an American official that he had sent several thousand "Immigration Certificates," provided by the Jewish Agency for Palestine, to the nuncio in Budapest. Through the nuncio's contacts and efforts, these documents were distributed to those for whom they were intended, enabling "their owners to escape transportation [deportation] and to obtain the necessary permissions for emigration."

4. As a point of interest, the arrest of one of the Hungarian bishops, Jozsef Mindszenty, by Arrow Cross troops, should be mentioned. In his December 11 telegram, Rotta referred to the arrest and his persistent efforts on behalf of Mindszenty. Tardini's response (December 6) instructed the nuncio to continue to insist to government authorities, in the name of the Holy See, that the regulations against the clergy should be rescinded. There was nothing surprising in this part of the directive. Tardini added, however, that Rotta should warn the authorities that the Holy See would not tolerate similar measures in the future without protesting (415, n. 2; see also Vol. 11, 451).

Richard L. Rubenstein

Pope Pius XII and the Shoah

The role of Pope Pius XII during World War II has been a subject of
debate and controversy at least since Rolf Hochhuth's sensational play,
Der Stellvertreter (*The Deputy*), first attracted international attention in
1963.[1] Hochhuth, a German Protestant, portrayed the pope as a heartless
cynic who sought to act as mediator between the Western Allies and
Germany, thereby preserving the balance of power in Europe and
preventing a Stalinist victory in the heart of Central Europe. As portrayed
by Hochhuth, the pope was prepared to permit individual Catholics and
Church institutions to engage in humanitarian acts of rescue for the very
few Jews who could establish contact with them. On several occasions, he
was willing to offer generalized words of disapproval concerning the ill-
treatment inflicted on unidentified helpless groups. Nevertheless, as is
well known, he never issued a statement explicitly condemning the
mass extermination of the Jews or urging Catholic non-cooperation in
the extermination project concerning which he was very well informed.
Hochhuth depicts Pius as coldly unwilling to say a word on behalf of
Rome's Jews even as SS transports carrying the Jews to Auschwitz
passed by St. Peter's Square at the beginning of their journey. He also
depicts Pius XII as more concerned with the falling price of the
Vatican's holdings in Hungarian railroad stocks as the Red Army
advances on Budapest than with the fate of the Jews.

Hochhuth sparked a controversy that continues to this day. The
play also had the effect of eliciting the publication by the Vatican of many
of its wartime documents. A year after the appearance of *The Deputy*,
Pope Paul VI made an exception to the rule that Vatican archives remain
secret for 75 years and directed that some documents be edited for
publication by a group of Jesuit scholars. The fruit of their labors
appeared in the volumes entitled *Actes et documents du Saint Siège relatifs à
la Seconde Guerre mondiale* that appeared between 1965 and 1981.[2] A
summary of *Actes et documents* by Pierre Blet, S.J., the last surviving editor
of the collection, has recently been published in English.[3] Blet's volume

stresses the extraordinary complexity of the situation confronting the leader of a universal Church with millions of communicants on both sides engaged in a bitter and devastating war against each other. There is, however, continuing controversy concerning the integrity and comprehensiveness of some elements of the collection made public in *Actes et documents.*

Hochhuth's play was followed by a number of scholarly and not so scholarly works on the role of both the Catholic and Protestant Churches during the Holocaust.[4] One of the most controversial and denunciatory is that of John Cornwell, *Hitler's Pope: The Secret History of Pius XII.*[5] In the course of his research, Cornwell became convinced that Pius XII's entire career was fundamentally "a bid for unprecedented papal power that by 1933 had drawn the Catholic Church into complicity with the darkest forces of that era."[6] Cornwell's work is thus one of the most sweeping indictments of the pope ever written by a knowledgeable Catholic. Both the book and its author have been bitterly attacked. Nevertheless, it is highly significant that Owen Chadwick, one of the world's foremost church historians, has written in *The Tablet,* the United Kingdom's leading Roman Catholic weekly: "this book is not another conventional tirade about silence during the Holocaust. It is a serious study of a very complex character tossed about in the most tragic series of crises ever to afflict Europe" (September 25, 1999).

Those who regard papal silence as justified tend to argue that speaking out would have led to greater evil and that the pope's silence enabled the Roman Catholic Church to rescue some Jews unobtrusively. Others deny that the pope was silent, pointing to his Christmas 1942 radio message in which he called upon all men to vow to dedicate themselves to the service of the human person and a divinely ennobled human society. The pontiff then listed several reasons why this vow ought to be obligatory, one of which is that: "Humanity owes this vow to hundreds of thousands of people who, through no fault of their own, sometimes only by reason of their nationality or race, are marked down for death or gradual extinction."[7]

The pope's critics are unimpressed. They see the Christmas message as a skilled diplomat's carefully crafted attempt to placate those who pleaded with the pontiff to condemn the mass slaughter while giving no offense to the Nazis. They point out that the message is *a statement of what the living owe the dead,* not a call for an end to the slaughter. Moreover, neither the victims nor the perpetrators are identified.

Cornwell is indignant that the pope scaled down the three million killed by Christmas 1942 to "hundreds of thousands" and that he described the victims as "sometimes" chosen "only by reason of their nationality or race." John Cornwell argues that the pope knew very well that the Jews, including thousands of baptized Jews, were being exterminated without exception because of their race. Cornwell also notes that the pope criticized totalitarianism without identifying any totalitarian country and without condemning the Germans for their actions. According to Cornwell, Mussolini made the most appropriate comment on the Christmas message when he said to his son-in-law, Count Galeazzo Ciano, "This is a speech of platitudes which might better be made by the parish priest of Predappio," Mussolini's native village.[8]

When one reviews the literature, both for and against, on Pope Pius XII, it is apparent that, with few exceptions, both his critics and his defenders share an underlying assumption, namely, that the pope either recognized or should have recognized a moral obligation to rescue Europe's Jews in so far as it was within his power. There is, however, a fundamental question that neither the pope's critics nor his defenders pose: *could it be that Pius regarded the demographic elimination of Europe's Jews as a benefit for European Christendom? Put differently, did the pope recognize any moral obligation whatsoever to rescue Jews?* It is my conviction that the pontiff recognized no such obligation and that he did regard the demographic removal of Europe's Jews as a benefit for European Christendom. In setting forth this hypothesis, I acknowledge that, although trained as a theologian and an historian of religion, I am not a church historian. Indeed, I am indebted for much of my information to scholars who are included in this volume. In any event, our knowledge of the past always remains partial. In all likelihood, considerable material concerning the pope is yet to be disclosed. If such be the case, the best that we can do is to attempt to offer a plausible interpretation of the pope's policies and motives, with the understanding that our hypotheses could be falsified as new information becomes available. What is unacceptable is to dismiss an hypothesis by pointing out the author's linguistic deficiencies or his/her ignorance of documents that remain unspecified. An hypothesis can be falsified but not by rhetorical strategies.

Toward the end of John Cornwell's book, the author offers his bitter judgment concerning Pope Pius XII. Cornwell contends that the pope's "failure to utter a candid word about the Final Solution in progress

proclaimed to the world that the Vicar of Christ was not moved to pity and anger. From this point of view he was the ideal Pope for Hitler's unspeakable plan. He was Hitler's pawn. He was Hitler's Pope."[9]

I categorically reject that judgment. The evidence presented by Cornwell himself does not validate the designation of Pius XII as "Hitler's Pope." Throughout his adult career Eugenio Pacelli had a paramount mission: namely, to defend and strengthen the Church against the movements that sought to weaken or destroy it at a time when the world's most important Christian nations were locked in the most destructive life-and-death struggle in all of human history, and Russia, Europe's most populous nation, was governed by a regime ideologically committed to the obliteration of the Christian religion and its institutions. Moreover, as pope, Eugenio Pacelli understood himself to have been chosen by God for the most awesome responsibility with which any human being could be charged, to serve as Vicar of Christ on earth. In his eyes, no wartime leader, no matter how powerful, not Churchill, Hitler, Roosevelt, nor Stalin had a responsibility remotely comparable to his. Eugenio Pacelli was prepared to negotiate and enter into agreements with any political leader, provided that, in so doing, he could foster the interests of what he regarded as unquestionably the one true Church and humanity's sole medium of redemption. Under no circumstances was he ever willing to serve as any man's tool, least of all of Adolf Hitler.

One virtue of John Cornwell's controversial study of Pope Pius XII is that it stresses the importance of the pope's family background for an understanding of the pontiff's role before and during World War II. According to Cornwell, the path that led to Pius's possible canonization began with his grandfather Marcantonio Pacelli, a lay canon lawyer who became one of the most trusted officials in the pontificate of Giovanni Mastai-Ferretti, Pope Pius IX, popularly known as *Pio Nono*. Marcantonio was also one of the founders of *L'Osservatore Romano* (1861). When Pio Nono became pope in 1846, he became the sovereign, theoretically by divine right, of a band of territory across the middle of Italy that included Rome, Bologna, Parma, and Modena. He began his term of office with a number of acts of benevolence toward his Jewish subjects. He abolished the *predica coatta*, the requirement that Jews attend compulsory sermons by a priest who used the occasion to demonstrate the evils of Judaism and the joys of conversion. He also ordered the gates to Rome's ghetto torn down in spite of strong opposition from the lower classes.[10]

The revolutionary upheavals throughout Europe in 1848 led to

demands for constitutional government in Rome to which Pio Nono acceded, temporarily accepting the oxymoron of the Sovereign Pontiff as constitutional ruler.[11] The resulting instability in both domestic and foreign affairs culminated in the assassination on November 15, 1848, of Count Pellegrino Rossi, the pope's first minister, whereupon Pio Nono fled to Gaeta in the kingdom of Naples accompanied by Pacelli.[12]

On April 10, 1850, Pio Nono and his entourage returned to Rome under the protection of Napoleon III's troops. Upon his restoration, he ordered Rome's Jews to return to the ghetto. Whatever inclination he had to compromise with liberalism and nationalism evaporated in exile. Having experienced what he took to be the dangerous religious and political legacy of the French Revolution, especially the civic emancipation of the Jews, Pio Nono and his successors until Vatican II were firmly committed to its undoing. This is a fact of considerable importance when we consider the attitude of *all* branches of the Christian Church in Europe toward the legal disabilities imposed upon the Jews in the 1930s and in the greater German Reich, its allies, and client states during World War II. Pius IX's compulsory return of the Jews to the ghetto reflected a fundamental attitude shared by all his successors until Pope John XXIII.

That attitude was further strengthened by the First Vatican Ecumenical Council, which began on December 8, 1869. Pio Nono had summoned the council to deal with contemporary problems confronting the faithful, such as the rising influence of rationalism, liberalism, and materialism. In September 1870, Piedmontese troops entered Rome and proclaimed it Italy's capital, thereby interrupting the council. Infuriated, the pope declared himself a prisoner in the Vatican and, on October 20, 1870, suspended the council indefinitely. The Piedmontese seizure of Rome did not prevent the promulgation of the dogma of papal infallibility, the most important item on the papal agenda at the council.[13] In effect, the pope responded to the loss of temporal authority by asserting his absolute spiritual authority. Even before 1870, Pio Nono had published the Syllabus of Errors (1864), listing 80 of the "principal errors of our times," the most famous being the view that "the Roman Pontiff can and should reconcile himself to and agree with progress, liberalism, and modern civilization."

The ultramontanist views of the pope were quite naturally shared by Marcantonio Pacelli and his son Filippo, father of the future Pius XII. Filippo was also a canon lawyer in the pope's service. Eugenio was born on March 2, 1876. Both Marcantonio and Filippo were poorly paid but

intensely loyal to the papacy. They regarded the Church as threatened on all sides by the destructive forces of the modern world. In 1870, both Marcantonio and Filippo rejected the opportunity to become well-paid senior bureaucrats in the new Italian state. They were devoted to the restoration of the status quo ante that included an end to the political emancipation of the Jews.

The pre-Vatican II Church emphatically rejected a conception of pluralist society in which Jews would enjoy the same political rights as Christians. With a few notable exceptions, the Roman Catholic Church actively supported Europe's antisemitic movements from the time of the French Revolution until the end of World War II. In fairness, however, we must emphasize that the Church was opposed to racist antisemitism and never advocated a policy of extermination as did the National Socialists. Unfortunately, under twentieth-century conditions, exclusion of a group from membership in the community in which it is domiciled can sometimes be functionally equivalent to a death sentence. The Harvard sociologist Orlando Paterson has characterized such exclusion as "social death."

The case of Edgardo Mortara is of especial significance in understanding the attitude of the pre-Vatican II Church toward the Jews in the nineteenth century and afterwards.[14] On June 23, 1858, two members of the military police of the Papal States in Bologna, acting on orders of the Inquisitor, removed 6-year-old Edgardo Mortara from the custody of his parents on the grounds that he had been baptized and, hence, was a Christian. In attempting to recover their child, the parents learned that a serving girl formerly in their employ claimed that she had secretly baptized the child as an infant fearing that he might otherwise die of an illness and be condemned to everlasting damnation. The Inquisition in Bologna ordered the seizure on the grounds that no Christian child could be raised by Jewish parents. That neither the child nor his parents had any knowledge of the alleged involuntary conversion at the time of the seizure made absolutely no difference. The case became a cause célèbre throughout Europe and North America. In spite of extraordinary diplomatic and media pressure on behalf of Edgardo's return, the pope had taken a special interest in the boy and refused to return him to his parents, a position that received very wide support in Catholic circles. Eventually, Edgardo became a priest.

In the context of this chapter, the Mortara case demonstrates the extremes to which the Church was prepared to go, where it had the

power, to prevent Jews, in this case Edgardo's parents, from being in a position to "undermine" the faith of someone believed to be a Christian. Although the Church was unable to prevent Jews from challenging its symbolic universe in those countries in which Jews had been emancipated, within the Papal States the Inquisition was alive and well until the end of papal sovereignty in 1870, and no such freedom was tolerated.

The Church's opposition to Jewish emancipation has frequently been characterized as reactionary, undemocratic, and antisemitic. By contrast, the Church regarded such opposition as defensive in character. Claiming that it alone was in exclusive possession of "the keys to the Kingdom" and that "error" could have disastrous and unending consequences for the soul of the believer, the leaders of the Church believed that they had no choice but to seek a cognitive monopoly in matters spiritual in those territories where their followers predominated. The emancipation of the Jews constituted one of the most, if not the most, revolutionary challenges to the Church's cognitive monopoly within European Christendom since the Cathari movement of the early thirteenth century that led to the Albigensian Crusade. The Church could not and did not take Jewish emancipation lightly. With the granting of civic and political rights to the Jews in the nineteenth and twentieth centuries, the Church found itself confronted by what it regarded as an internal enemy against which it no longer seemed to possess effective resources.

Opposition to Jewish emancipation was repeatedly and emphatically expressed in the pages of *Civiltà Cattolica*, a Jesuit political journal founded in 1850 with Pio Nono's active encouragement. The journal speedily became the unofficial organ of the Holy See, and, at least in the period leading up to Vatican I, it was Pio Nono's custom to read *Civiltà Cattolica* in proof before its publication.[15] *Civiltà Cattolica* took the lead in asserting the claims of the Vatican in the Mortara case. It accused those who sought the return of the boy to his parents of viciously maligning the pope and the Church.[16] If one wishes to understand the attitude of the Vatican toward Jews and Judaism before Vatican II, there are few, if any, better sources than *Civiltà Cattolica*.

For example, in 1881 and 1882, *Civiltà Cattolica* published a series of articles claiming that the ritual murder of Christian children and the use of their blood in the Passover meal was a Jewish religious obligation. The journal also accused the Jews of desecrating consecrated Hosts. John Cornwell observes that these libels, which had persisted since the twelfth

century, gave rise to the belief that the Jews used magic in order ultimately to destroy Christianity.[17] Even the Holocaust could not eradicate these beliefs among the hierarchy and laity in parts of Eastern Europe. In the twentieth century, the myth that the Jews were determined to destroy Christianity and Christian civilization was given renewed strength by the widespread dissemination of the notorious forgery known as *The Protocols of the Elders of Zion*.[18]

In 1890, *Civiltà Cattolica* published a series of articles entitled "Concerning the Jewish Question in Europe." With absolutely no basis in fact, the author asserted that the Jews started the French Revolution to gain civic equality and to institute a "virulent campaign against Christianity." The author called for the segregation of the "race that nauseates" from the rest of the population and the abolition of their civic equality, a theme often repeated in the journal.[19]

Civiltà Cattolica was also deeply involved in the celebrated case of Captain Alfred Dreyfus, the only Jewish member of the French General Staff, who was falsely accused of espionage for Germany in 1894 and sentenced to life at hard labor on Devil's Island. When the real culprit, Major C. F. Walsin-Esterhasy, confessed before fleeing the country, the army refused to admit error. Commenting on the army's refusal, on February 5, 1898, *Civiltà Cattolica* expressed the opinion that "the Jew was created by God to serve as a spy wherever treason is in preparation." The journal also explicitly advocated an end to Jewish emancipation: "The Jews allege an error of justice. The true error was that of the *Constituante* which accorded them French nationality. That law has to be revoked. ... Not only in France, but in Germany, Austria, and Italy as well, the Jews are to be excluded from the nation. Then the old harmony will be re-established and the peoples will again find their lost happiness." Given this viewpoint, the Vatican could see little, if anything, wrong in the measures taken in National Socialist Germany and elsewhere in Europe before and during World War II that resulted in the progressive disenfranchisement of the Jews.

There is little, if anything, in the *Civiltà Cattolica* articles concerning the Jews to which the young Pacelli could have taken exception. *Civiltà Cattolica* was not a marginal rag but one of the most respected and authoritative organs of the papacy, and throughout his career Pius XII acknowledged the Jesuits as his special mentors.[20] Cornwell is not wide of the mark when he asserts that a groundswell of vicious antipathy toward Jews was promoted in the only circles to which Pacelli

had access. This is in stark contrast to the experience of Pope John Paul II, who knew and had friendly relations with real Jews as a young man in Poland and who grew up in Cracow within an hour's drive from Oswiecim, or Auschwitz as we know it.

From the start of his career, Pacelli was on a fast track. Given his family background, it was inevitable that the Vatican bureaucracy would carefully monitor his development from the time that he began his theological studies. And they were not disappointed. A brilliant student, possessed of a superb memory and vastly superior intelligence, he was recruited into the Vatican bureaucracy by a priest destined to become one of the Church's most influential leaders in the first half of the twentieth century. Early in 1901, Monsignor Pietro Gasparri, an authority on canon law who had recently been appointed the Vatican equivalent of Foreign Minister, called on the Pacelli family and invited Eugenio to join him in the Secretariat of State. The 25-year-old priest was astounded. The Vatican's Foreign Minister had called on him at home and asked him to join him in his labors! The partnership was to last 30 years until Pacelli himself succeeded Cardinal Pietro Gasparri as Secretary of State in 1930.

Pacelli completed his doctoral dissertation in 1904. The subject was prophetic for his later career and for an understanding of his relations with the Third Reich, at least in its initial phase. The subject was the nature of concordats, that is, treaties between the Vatican and sovereign states. In the same year, Pacelli was appointed secretary to Gasparri, then serving as president of the Papal Commission on Codification. In 1917 the commission brought forth the monumental *Corpus iuris canonici*, the Code of Canon Law. The code, very largely the work of Gasparri and Pacelli, was a comprehensive codification of canon law that exhaustively regulated conditions within the Church in the spirit of Pio Nono's very conservative First Vatican Council of 1870. It is undoubtedly one of the most important documents in the history of the modern Church.

Upon the completion of the Codex, Pacelli was consecrated an archbishop and appointed papal nuncio to Bavaria. In his official capacity, Pacelli met many of the principal leaders of imperial Germany, but the event that made the most profound impression on him took place at the very end of World War I. On November 7, 1918, the 800-year-old Wittelsbach dynasty, the royal house of Bavaria, collapsed and was succeeded in Munich by three revolutionary socialist regimes whose highly visible leadership included a number of Jewish intellectuals, literati, and revolutionaries.[21]

The revolutionary interlude ended in a right-wing bloodbath, but not before the Reds entered Pacelli's compound, pointed a gun at his breast, demanded his limousine, and threatened to kill him. In later life, Pacelli often alluded to this incident. In the eyes of the victorious right-wing, the Bavarian Republic and the two subsequent Soviet Republics constituted a "pogrom against the German people staged by Jews."[22] A violent wave of antisemitism ensued in Munich, then becoming the birthplace and spiritual capital of the National Socialist movement.

Ultimately, the Munich Revolution proved to be a disaster for Germany's Jews, the great majority of whom had no sympathy for Bolshevism. And its effect on Pacelli was to prove enduring. *For Pacelli, the Communist revolution was not something that happened in distant Russia.* He experienced it directly. He also saw the right-wing nationalist forces that suppressed the revolution as defenders of Christian civilization against the assault of rootless, godless Communists, many of whom were Jews. That lesson was never to leave him. If he had any doubts concerning the destabilizing consequences of Jewish emancipation and the Jews' entrance into European intellectual and political life before Munich 1919, he had none thereafter. His experience certainly added credibility in his eyes, if indeed he needed further credibility, to *Civiltà Cattolica*'s views on the place of Jews in Europe.

Let us also recall that *The Protocols of the Elders of Zion*, with its myth of a Jewish conspiracy for world domination, was introduced into Munich during this decisive period by the Nazi ideologue Alfred Rosenberg and White Russian émigrés. It was their "proof" that the Bolshevik Revolution had been the result of a Jewish conspiracy to dominate the world and destroy Christianity. Unfortunately, the events of 1919 greatly enhanced the credibility of the forgery in the minds of conservative Germans.

Nor was the conviction that Marxism and Bolshevism were bastardized forms of Judaism restricted to German racists. The *Protocols* were widely disseminated in Europe, America, and Japan and served to equate Bolshevism and Judaism. The belief that Judaism had spawned Bolshevism was widely held throughout the inter-war period and even later.[23] Before the rise of the Christian left in recent decades, Marxism was quite properly regarded as actively anti-Christian. No political threat to Christianity comparable to the Bolshevik Revolution had ever before erupted in the midst of Europe. In so far as the European symbolic universe was Christian, the impressive sacrifices made by German Jews on

the battlefield during World War I counted for nothing. Instead, they were blamed for Bolshevism and regarded as agents of corrosion, disorder, and decay.

A quixotic rebellion similar to Munich, also led by left-wing Jews, took place in defeated Hungary after World War I.[24] On March 21, 1919, a Hungarian soviet republic came to power under the leadership of Béla Kun, a doctrinaire Bolshevik and the son of a Jewish village clerk. Kun succeeded to power after the demise of Hungary's first post-war regime led by liberal provisional president, Count Mihály Károlyi. With Serb, Czech, and Romanian troops installed in defeated Hungary, Kun claimed that Bolshevik Russia would come to Hungary's aid if a Communist government were installed. No such help came, but Kun, a rigid Communist ideologue, applied "brutal and extreme" measures against both the nation's rural and urban populations to maintain his regime.

In July 1919, Kun led an unsuccessful military campaign against the Romanians. When the Hungarians were defeated on August 1, 1919, Kun fled to Vienna. Unfortunately, 18 of 29 leading members of the short-lived Communist regime were Jewish. In the eyes of the Hungarian public, Communism was equated with Judaism, a claim generally current among members of the European right. On November 16, 1919, Admiral Miklós Horthy entered Budapest at the head of a counter-revolutionary army and installed a government whose aim was to purify Hungary from Communism. In the ensuing White Terror, supported by Horthy, most victims were Jews. In addition, a large number of "patriotic" organizations were formed, with the dual aim of nullifying the Treaty of Trianon and "purifying" Hungary of the allegedly harmful influence of Jews and Judaism.

We cannot detail the harsh role played by both the Catholic and Reformed Churches in the movement to "purify" Hungary of Jewish influence, save to note that in the 1930s and 1940s the movement had the wholehearted support of both churches, with the exception of some weak protests against the inclusion of Jewish converts in the increasingly severe anti-Jewish measures. The objective that met with widespread approval was the removal of Jews from public life and the undoing of Jewish emancipation. As regent, Miklós Horthy was fond of saying, "As far as the Jewish Question is concerned, I have been an anti-Semite all my life." Horthy did not favor extermination as did the radical wing of the Arrow Cross movement.[25] Nevertheless, by the 1940s, extermination was increasingly looked upon with favor by large numbers of Hungarians,

both lay and clerical, as the most effective method of eliminating Jews and Judaism. When Baron Vilmos Apor, Bishop of Gyor, took the wholly atypical step of constantly pleading with Cardinal Justinian Seredi, the Primate of Hungary and, like Pope Pius XII, a canon lawyer, to use his influence to restrain the government from cooperating in the deportations to Auschwitz, he received an absolute refusal.[26] At the time, Seredi knew the fate of Hungarian Jews at Auschwitz. Apart from converts to Christianity, Seredi had no interest in the fate of the Jews.

From the point of view of the Church, one of the most dangerous entailments of Jewish emancipation was the rise of a class of Jewish writers, journalists, academics, and radical intellectuals who had no stake in the traditional order that had condemned them to pariah status. In the case of the radical intellectuals, their lack of genuine contact with either workers or peasants did not deter them from devoting themselves to the "liberation" of the underprivileged with lasting and disastrous consequences.

In the eyes of the European right, perhaps the strongest confirmation of the equation of Bolshevism with Judaism was the role of Lev Davidovich Bronstein, an atheistic Jew known to history as Leon Trotsky, in the Russian Revolution. Trotsky was one of the principal organizers and leaders of the Bolshevik Revolution and the Soviet regime, playing a part subordinate only to Lenin. In March 1918 Trotsky became People's Commissar for Military Affairs. He organized the Red Army that proved victorious in the bloody civil wars that followed the revolution and almost succeeded in conquering Warsaw in August 1920. Achille Ratti, papal nuncio to Poland in 1920 and Pope Pius XI from 1922 to 1939, was in Warsaw when the Polish capital was threatened by the Red Army under General Mikhail Nikolaevich Tukhachevsky, Trotsky's subordinate.[27] There had been debate among Bolshevik leaders concerning the feasibility of taking Warsaw, but the dissenters were overruled by Lenin, who aimed to create a "Red" Warsaw and "probe Europe with the bayonet of the Red Army."[28] From the perspective of the Vatican, Catholic Poland and Christian Europe were threatened by an army organized and led by a Russian Jewish revolutionary and his henchmen.

Christian fear of Bolshevism, widely seen as Jewish in both origin and spirit, was further intensified by the Spanish Civil War.[29] The Vatican was convinced that Franco was defending Christian civilization. Both the Vatican and the leadership of the German Evangelical Church were convinced that, if Franco lost, Germany would be caught in a vise

between Soviet Bolshevism in the East and a Bolshevik Spain and a France led by Léon Blum, that country's first Socialist and first Jewish prime minister, in the West. In August 1936, Hitler drafted a memorandum in which he asserted that Germany and Italy were the only European states "standing firm against Bolshevism."[30] That, of course, was precisely how the Vatican and Germany's religious leaders, both Catholic and Protestant, saw the situation. For the Roman Catholic Church, the threat of Bolshevik regimes in the Iberian peninsula and in Eastern Europe was reminiscent of a time when Christian Europe was threatened by Muslims in Spain and Portugal as well as in Eastern Europe. To this view was added the conviction that a Jewish conspiracy was placing Christian Europe in a vast encircling movement. Although the Catholic Church did not subscribe to Nazi racism, it did see Christian Europe as under a multifaceted religious, military, political, and cultural threat in which Jews were thought to play a hostile role. Admittedly, there were many other historical events that contributed to the acceptance by the German mainstream of the radical policies of the National Socialists. These include the overthrow of the *Kaiserreich*, the establishment of a Weimar Republic that lacked legitimacy in the eyes of a large segment of the German public, the devastating effects of the runaway inflation of 1923, which continues to this day to affect German politics and economics, and, of course, the Great Depression. Nevertheless, there is little doubt that the conviction that the Jews were a hostile alien presence in ways that gravely threatened Christian civilization was exacerbated by these events.

Sergio Minerbi has called our attention to another area in which the Church perceived Jews and Judaism as a threat in the first half of the twentieth century, namely the movement to end the diaspora of European Jews and restore them to Palestine. Under the leadership of Theodor Herzl, the first Zionist Congress met in Basle, Switzerland, in August 1897 to "lay the foundation stone" for the return of the Jews to the land of Israel. Plans for the Congress caught the attention of *Civiltà Cattolica*. Four months before the Congress, the journal published one of the first references to Catholic opposition to Zionism, and still one of the most succinct statements of the conservative Catholic position on Zionism:

> 1827 years have passed since the prediction of Jesus of Nazareth was fulfilled, namely that Jerusalem would be destroyed ... that the Jews would be led away to be slaves among all the nations, and that they

would remain in the dispersion till the end of the world. ... According to Sacred Scriptures, the Jewish people must always live dispersed and wandering among the other nations, so that they may render witness not only by the Scriptures ... but by their very existence. As for a rebuilt Jerusalem, which would become the center of a reconstituted state of Israel, we must add that this is contrary to the prediction of Christ Himself.[31]

The article reflects the attitude of Vatican leadership during most of the twentieth century. In another article on Zionism published in 1899, the journal referred to the Jews as "a race of murderers," echoing John 8: 41–45.[32] *Civiltà Cattolica*'s position, however, did not deter Herzl from seeking papal support for Zionism on humanitarian grounds. On January 25, 1904, he was received by Pope Pius X. In response to Herzl's plea for support, the Pope declared: "We are unable to favor this movement. We cannot prevent the Jews from going to Jerusalem, but we could never sanction it. The ground of Jerusalem, if it were not always sacred, has been sanctified by the life of Jesus Christ. As the head of the Church I cannot answer you otherwise. The Jews have not recognized our Lord, therefore we cannot recognize the Jewish people."[33]

Moreover, from the perspective of the Vatican, World War I ended very badly. Apart from the Bolshevik Revolution, the Vatican looked upon the Allied coalition of Protestant England, anticlerical France, Orthodox Russia, and the Protestant United States with much suspicion.[34] In spite of its official neutrality, the Vatican did not appreciate the Allied coalition's determination to dismember the Hapsburg Empire, then regarded by the Vatican as Europe's Christian nucleus. Austria–Hungary appeared to the Vatican to constitute a barrier against a Tsarist-directed, westward expansion of Orthodox Christianity, just as Nazi Germany was regarded as a bulwark against Bolshevik expansion in World War II.[35] Yet another affront to the Church was the Allied creation of Yugoslavia with the Orthodox Serbs in a position of dominance in a nation neighboring Italy.

Palestine was another area in which the Allied victory created problems for the Vatican. At the time of the First Crusade in 1096, the idea was prevalent that Palestine was Christ's patrimony. In addition to summoning the knights of Western Europe to a Holy War, the Crusaders were summoned to a vendetta, a very familiar enterprise for knights of the period, to avenge Christ who had been crucified and "banished from his estates" and who still cried out "desolate and begging for aid."[36] When

on November 2, 1917, Arthur James Balfour, the British Foreign Secretary, wrote to Lionel Walter Rothschild, 2nd Baron Rothschild, that the British government looked with favor on "the establishment in Palestine of a national home for the Jewish people," the Vatican was fearful that control of "Christ's patrimony" would revert to the Jews.[37] That fear was heightened when British troops led by Edmund Allenby won a decisive victory over the Turks at Gaza in November 1917 and captured Jerusalem on December 9 of the same year. Over the centuries the Christian Churches, both Orthodox and Latin, had achieved a modus vivendi concerning Palestine with the Ottoman Empire. The conquest of Palestine by Protestant England, which had made a qualified promise to the Jews for a "national home," did not sit well in Rome.

British control of Palestine as the mandatory power required the approval of the League of Nations, and the Vatican began a vigorous diplomatic campaign to prevent the creation of an organized Zionist community in Palestine. Typical of the Vatican opposition to a Zionist establishment was the speech delivered by Pope Benedict XV on March 10, 1919. Referring to the Holy Places, it read in part:

> Who can ever tell the full story of the efforts of Our Predecessors to free them from the dominion of the infidels, the heroic deeds and blood shed by the Christians of the West through the centuries? And now that, amid the rejoicing of all good men, they have finally returned into the hands of Christians, Our anxiety is most keen as to the decisions which the Peace Congress at Paris is soon to take concerning them. For surely it would be a terrible grief for Us and for all the Christian faithful if infidels were placed in a privileged and prominent position; much more if these most holy sanctuaries of the Christian religion were given into the charge of non-Christians.[38]

Several days later, Cardinal Pietro Gasparri, at the time Papal Secretary of State and Pacelli's mentor, explained the pope's words to a Belgian diplomat:

> The danger we most fear is the establishment of a Jewish state in Palestine. We would have found nothing wrong in Jews entering that country, and setting up agricultural colonies. But that they have been given rule over the Holy Places is intolerable for Christians. Balfour's reply to Lord Rothschild unfortunately gives us reason to fear that the British government supports the Zionist claims. ... These measures can be explained by the influence the Jewish element has on our Allied

statesmen. Sonnino is a Protestant but is of Jewish origins; the private secretaries of President Wilson, Clemenceau and Lloyd George are Jews. Add to this the activity of Jewish banking and you will understand the cause of our concern.[39]

To this must be added the further fear that hordes of Bolshevik-sympathizing Jews would descend upon the Holy Land and spread revolution.

The Vatican's antipathy to a Jewish settlement in Palestine continued throughout World War II. In March 1943, Archbishop Angelo Roncalli, the apostolic delegate to Turkey and later Pope John XXIII, transmitted a request from the Jewish Agency for Palestine that the Vatican intervene with the Slovak government to permit a thousand Jewish children to emigrate to Palestine. The archbishop indicated that the British were willing to let the children enter Palestine. Archbishop William Godfrey, the apostolic delegate to the United Kingdom, sent a similar message the same day but referred to the settlement of Jewish children from all of Europe. The requests were handled by Msgr. Domenico Tardini, Under Secretary of State for Extraordinary Ecclesiastical Affairs. Tardini exhibited some interest in the proposal to rescue the Jewish children from Slovakia, but the idea of endorsing the settlement of Jews in Palestine gave him pause. Tardini wrote: "The Holy See has never approved the project of making Palestine a Jewish home. But unfortunately England does not yield ... And the question of the Holy Places? Palestine is by this time more sacred for Catholics than ... for Jews."[40]

In his response to Archbishop Godfrey, Cardinal Luigi Maglione, appointed Cardinal Secretary of State by Pius XII upon his accession to the papal throne, expressed strong opposition to a Jewish majority in Palestine. He repeated the claim that the land of Palestine was sacred to Catholics because it was the land of Christ and, if Palestine were to become predominantly Jewish, Catholic piety would be offended. Maglione also instructed Archbishop Amleto Cicognani, the apostolic delegate in Washington, to communicate his views to President Franklin Roosevelt. Maglione was a skilled and experienced diplomat who had worked closely with the pope for decades and would not have been entrusted with high office had Pius XII any doubts about his utter fidelity to the pope's policies. Moreover, as one of wartime Europe's best-informed foreign secretaries, Maglione had no illusions concerning the fate of Jewish children under Nazi control. Clearly, the Vatican in the

twentieth century continued to take a political stand on Palestine on the basis of a religious position at least as old as the First Crusade, namely the idea that Palestine was Christ's patrimony.

Earlier, when Pacelli went to Germany in 1917, his purpose was not to witness a revolution but to change the relations between the Vatican and the German Catholic Church. The 1917 Codex endowed the pope with the sole right to appoint bishops. However, the new rule could not be implemented without the renegotiation of some major concordats. Pacelli's ultimate goal was to secure government acceptance of the 1917 Codex as binding on all Catholics. His strategy was first to negotiate a concordat with pro-papal Bavaria and then to use the Bavarian concordat as leverage to compel both the predominantly Protestant Prussian and the Reich governments to sign favorable concordats. He demanded that the Bavarian state guarantee the application of canon law to the faithful in the new concordat. He also insisted that the state agree to fire teachers the bishops found objectionable. The Bavarians found Pacelli's demands excessive but agreed to sign when Pacelli threatened to break off negotiations. Pacelli's bargaining tactics did not sit well in Protestant Prussia, Germany's largest state, and he was unable to get a concordat with the Reich until Hitler. Upon Gasparri's death in December 1929, Pope Pius XI appointed Pacelli to succeed Gasparri as Cardinal Secretary of State. Pacelli had witnessed the rise of National Socialism during his years in Germany and was undoubtedly the best-informed senior Vatican official on Germany of his time.

One of Gasparri's final achievements was the signing of the Lateran Treaty with Fascist Italy in 1929, a treaty drafted and negotiated by Francesco Pacelli, Eugenio's brother. Under its terms, the papacy recognized Rome as the capital of Italy and Italy recognized the pope's sovereignty over the 109-acre Vatican City. The treaty acknowledged the right of the Church to impose the Code of Canon Law within Italy, and Catholicism became the sole officially recognized religion. The Catholic Popular Party was disbanded, thus terminating an important center of opposition to Mussolini.

The Lateran Treaty anticipated the Reich Concordat of 1933 between the Vatican and the newly established Third Reich. Both Pacelli and Pope Pius XI had a strong aversion to Catholic political parties. The Vatican also strongly favored Fascism over Bolshevism. The vicious persecution of the Church in the Soviet Union had no counterpart in Fascist Italy. The treaty was also viewed favorably by Hitler who saw it as

a possible model for a future *Reichskonkordat*. On February 29, 1929, the *Völkischer Beobachter* reported on a speech by Hitler in which he observed that the Curia was able to make peace with the Fascist dictatorship, something it had never been able to do with the older liberal democratic Italian state before Mussolini. The Lateran Treaty, Hitler continued, proves that "the Fascist world of ideas" is more closely allied to Christianity than the "Jewish liberals" and "Marxist atheists" with which the "so-called Catholic party of the Center today feels itself so closely bound." According to the German church historian Klaus Scholder, Hitler grasped the significance of the dissolution of the Catholic Popular Party in Italy for a future concordat with the Reich. Dissolution of the Catholic Center Party would prove to be the price Hitler demanded for signing a *Reichskonkordat* on terms acceptable to the Vatican.[41]

By July 1930, the Nazi party had become the second largest in Germany and the question of its participation in government had become urgent. In August 1931, Heinrich Brüning, German's chancellor and a leader in the Catholic Center Party, called on Pope Pius XI. Both the pope and Pacelli urged Brüning to explore the possibility of cooperating with the Nazis to prevent "a still greater evil." Neither Brüning nor the German bishops shared this view. On May 30, 1932, Brüning resigned and Franz von Papen, a conservative Catholic willing to deal with Hitler, became chancellor. Papen lifted the ban on the SA, Hitler's brown shirts, and dissolved the Reichstag, necessitating new elections in which the Nazis became Germany's largest political party. Nevertheless, the bishops continued to reject National Socialism.

Aided by Monsignor Ludwig Kaas, leader of the Catholic Center Party, Papen sought an alliance with Hitler, who became chancellor on January 30, 1933, but failed to get the absolute majority he sought in the March elections. Although determined to render Catholic opposition impotent, Hitler was reluctant to employ against the Catholic Church the same methods the Nazis had used against the left. For Hitler, the ideal solution was an agreement similar to the Lateran Treaty in which Catholics voluntarily abandoned independent political action. Hitler was willing to agree to the Holy See's terms on the imposition of canon law on the German Church. As noted, his price was the dissolution of the Catholic Center Party and the withdrawal of Catholics from independent political action.

Hitler told his cabinet that the Center Party could only be defeated if the Vatican abandoned it. Pacelli was ready for a deal but not

the German bishops. On March 24, 1933, the Reichstag passed the Enabling Act that gave Hitler the power to enact laws and conduct foreign policy without the Reichstag's consent. The act was Hitler's method of attaining absolute power "legally." The leadership of the Center Party opposed passage but gave in at Kaas's insistence. Kaas later admitted that a deal was in the making in which the Center Party would vote for the Enabling Act, an act of political suicide that ended democratic opposition to Hitler, in exchange for the government's agreement to negotiate a Reich Concordat.

The first major test of the churches' attitude toward the Jews under Hitler came when the government called for a boycott of all Jewish business establishments on April 1, 1933. This was followed during April by the dismissal of all non-Aryan civil servants and laws excluding Jews from the professions. Church approval was almost universal.[42] Referring to the boycott, Cardinal Faulhaber wrote to Pacelli, "the Jews can help themselves."[43] Faulhaber did, however, express concern that baptized Jews would be subject to the same disabilities as the unbaptized.

The concordat was signed in the Vatican on July 20 by Pacelli as Cardinal Secretary of State and Franz von Papen. The document stipulated that only purely "religious, cultural, and charitable" Catholic organizations were entitled to protection. All others were to be abandoned or merged with Nazi organizations. As a prelude to the signing, on June 3 the German bishops announced the end of their opposition to the National Socialist regime. The Holy See thus became the first major international institution to sign a treaty with National Socialist Germany, an action that was widely interpreted as the Church's endorsement of National Socialism.

Hitler had achieved an extraordinary victory. With the voluntary dissolution of the Catholic Center Party, he had secured the end of the only German opposition he feared. He also demonstrated to the international community that the Holy See had seen fit to conclude a treaty on terms favorable to him. On July 22, 1933, Hitler wrote to the Nazi party claiming that the treaty amounted to an endorsement by the Church. He also saw the treaty as a license to proceed against the Jews. He told his cabinet that "a sphere of confidence has been created that will be especially significant in the urgent struggle against international Jewry."[44]

In an article in *L'Osservatore Romano*, Pacelli denied that the treaty constituted approval of National Socialism (July 26, 27, 1933). He stressed that the Code of Canon Law, now recognized by the Reich, was the

"essential legal presupposition of the concordat." Pacelli was not dissembling. His entire career had been so focused on securing centralized control over the appointment of bishops and state recognition of the authority of the Codex over Catholics that he failed to take seriously the warnings of German Catholic leaders concerning Hitler. Hitler wanted the kind of Reich Concordat that he easily extracted from Pacelli. For very different reasons, Pacelli wanted the same kind of document and was prepared to pay a very high price for it.

Pacelli had few illusions about Hitler and National Socialism, but he was prepared to make a pact with the devil because he was convinced the long-term interests of the Church were at stake. Nor can Pacelli be faulted for pursuing so relentlessly the implementation of the *Corpus iuris canonici*'s provision that only the pope could name bishops. There are situations in which local appointment of bishops may endanger the unity and integrity of the Church. For example, on January 6, 2000, just hours before Pope John Paul II consecrated 12 new bishops in St. Peter's Basilica, Beijing's state-sanctioned Catholic Church consecrated five new bishops without the consent of Rome. There can be little doubt that the new Chinese bishops' fundamental loyalty belongs to the Communist regime rather than to Rome.[45] Similarly, without an agreement with Hitler guaranteeing the right of the Holy See to name Germany's bishops, Hitler, rather than the pope, would ultimately have determined the appointment of bishops in Nazi Germany.

John Cornwell has argued that Pacelli displayed a "secret antipathy toward the Jews" and that he "betrayed an antagonistic policy toward the Jews, based on the conviction that there was a link between Judaism and the Bolshevik plot to destroy Christendom."[46] As the leader of a 2000-year-old universal institution, it is highly unlikely that Pius XII acted on the basis of personal feelings of antipathy. There is, however, no reason to doubt that at all times he acted on the basis of what he believed to be necessary for the health and well-being of the institution to which he had devoted his entire life. Cornwell also argues that Pacelli's concordat policy guaranteed Hitler's rise to absolute power and effectively thwarted any potential Catholic protest on behalf of the Jews. According to Cornwell, Pacelli believed that "the Jews had brought misfortune on their own heads." Theologically, Cornwell is correct. The pope who proclaimed as dogma that "the Immaculate Mother of God, Mary ever a Virgin, when the course of her life was run, was assumed in body and soul to heavenly glory" was hardly likely to regard the

Holocaust in any other way than as God's judgment against a sinful and refractory people who continued in their obstinacy to deny and reject Christ. Moreover, in so far as Pius XII regarded Bolshevism as a satanic Jewish invention, Cornwell's statement also rings true in the political sphere. Hence, as Roman pontiff he was determined to refrain from any public appeal on behalf of the Jews, although he was willing to permit the alleviation of Jewish sufferings on "the level of basic charity."

Let us remember that the pope's negative attitudes toward Jews and Judaism were by no means uniquely his. Such attitudes were widespread if not almost universal in Christian Europe at the time. Moreover, there is documentary evidence that important groups in the wartime American and British governments were apprehensive lest a successful attempt at rescue might result in the emigration of millions of unwanted Jews to their respective countries and the territories under their control.[47]

The pope's attitudes were partly culturally determined, partly a response to the history of Europe since the French Revolution, and partly the result of his own experience. There was little, if anything, in his culture that would have fostered a sympathetic view of the Jewish situation in the 1930s and 1940s. In focusing on the question of whether the pope could have done more to save the Jews during the war, we are likely to ignore the larger question of whether the legal disabilities imposed upon the Jews by National Socialist Germany, its allies, and client states were consistent with the Vatican view of the proper place of the Jews in European society. Let us also recall that, until Vatican II, the Holy See regarded the political emancipation of the Jew as a tragic mistake that the leaders of the Church in Europe were determined to bring to an end.

Unsurprisingly, we have evidence that the Vatican regarded the disenfranchisement of the Jews as a positive step forward. For example, the Vatican did not object to the explicit legal disabilities imposed upon French and foreign Jews by the *Statut des juifs* of October 3, 1940, and other anti-Jewish measures of Vichy France, nor did the Vatican see any reason to object to Nazi laws barring Jews from the civil service, the professions, and even depriving them of full Reich citizenship *as long as the basis of discrimination was religious rather than racial*. Although the *Statut des juifs* excluded French Jews from professions that influenced public opinion, barred them from the ranks of the officer corps, and limited their entrance into the liberal professions, when the highest circles in the Vatican were queried about their attitudes concerning the regulations, no objections were offered.

On August 7, 1941, Marshall Henri Phillippe Pétain directed Léon Bérard, Vichy's ambassador to the Vatican, to inquire concerning the papal view of Vichy's anti-Jewish measures. Bérard responded in a lengthy report that stated that there was every reason "to limit their activity in society" and that "it is legitimate to deny them access to public office ... to admit them only in a fixed proportion to the universities (*numerus clausus*) and the liberal professions."[48] When Monsignor Valerio Vallat, the papal nuncio to Vichy and an opponent of the *Statut*, inquired of Cardinal Maglione concerning the source of Bérard's opinion, he learned that Monsignor, later Cardinal, Domenico Tardini and Monsignor Giovanni Battista Montini had given it to him. Both prelates were very close to Pius XII. Tardini served as Deputy for Foreign Affairs in the Secretariat of State. Montini succeeded Pius XII as Pope Paul VI.

Such views can be characterized as reactionary, but those who at the time regarded Roman Catholicism as the one true religion did not see it that way. From their perspective there was nothing intolerant in barring the political participation of non-Christians in a Christian state, especially when Christianity was perceived as under mortal threat from both Bolshevism and Judaism.

Why then was Pius XII willing to tolerate in silence Hitler's program of mass extermination of every single Jew on the face of the earth? Simply put, I believe he was acting sincerely but mistakenly in what he regarded as the best interests of an endangered Christianity. I have long held the conviction that the Bolshevik Revolution and the Red uprisings in Bavaria and Hungary at the end of World War I served to confirm in Pacelli and his colleagues the conviction they already held, namely that Jewish emancipation had unleashed upon Europe a power potentially capable of bringing about the moral and spiritual destruction of Christendom. Emancipation had allowed Jews to become intellectuals, teachers, writers, politicians, financiers, and revolutionaries. As such, the Church regarded them as *internal enemies within Christendom with the unprecedented ability to lead the faithful astray*. When they were confined to the ghetto, they had no such power.

After Auschwitz, when the fundamental vulnerability of world Jewry in the first half of the twentieth century stands starkly revealed, it is difficult to understand how widespread was the apprehension that the Jews were a powerful universal force whose good will could yield favorable outcomes in international relations. Fear and respect for alleged

Jewish power was an important motive during the First World War for Great Britain's Balfour Declaration. In his memoirs, David Lloyd George, British prime minister at the time, explained the motives of his wartime cabinet in making their promise. He saw the Jews as having "every intention of determining the outcome of the World War." He also saw them as the real movers behind the Russian Revolution who also controlled Russia's attitude toward Germany. He was convinced that the Jews would offer themselves to the highest bidder. According to Lloyd George, the Balfour Declaration constituted Britain's successful attempt to outbid the Germans.[49] Moreover, as Israeli historian Tom Segev has pointed out, the prime minister's views were widespread. For example, Lord Robert Cecil, Under Secretary in the Foreign Office, wrote, "I do not think that it is easy to exaggerate the international power of the Jews."[50] Referring to the origins of the Balfour Declaration, Segev has observed, "The men who sired it were Christian and Zionist, in many cases, anti-Semitic. They believed the Jews controlled the world."[51] Similar views were manifest among Japanese antisemites. Leading Japanese antisemites were convinced of a Jewish conspiracy for world mastery, but they reacted to it very differently than did their German allies. In a January 18, 1939, report to the Naval General Staff, Naval Lieutenant Koreshige Inuzuka spelled out the difference: "[The Jews are] just like a *fugu* (blowfish) dish. It is very delicious but unless one knows well how to cook it, it may prove fatal to his life."[52]

The "experts" were convinced that they knew how to prepare this particular *fugu*. The infamous forgery, *The Protocols of the Elders*, which purported to see a worldwide Jewish conspiracy aimed at reducing non-Jews to slavery or exterminating them, enjoyed a worldwide success in the aftermath of the Russian Revolution and the massive slaughter of World War I. Hence, it was not surprising that the leaders of the Vatican saw the hand of the Jews in the Bolshevik Revolution as *Civiltà Cattolica* had seen it in the French Revolution.

Similarly, the Vatican had seen the same hand in the hated movement of secular Italian nationalism that deprived the Holy See of its temporal realms and made Pio Nono a "prisoner in the Vatican." As the new kingdom of Italy, with Count Camillo Benso di Cavour as its first prime minister and a Calvinist in religion, extended its jurisdiction throughout the peninsula, the emancipation granted to its Jewish subjects in 1848 was extended to the new territories. The Jews were beneficiaries of the unification of Italy and the Holy See the most important loser. That

was not a situation upon which the papacy could look with favor, and it was in this atmosphere that the young Pacelli was nurtured in a family intensely loyal to the papacy.

At few, if any, times in its entire history did the Roman Catholic Church perceive itself under a greater threat than when Europe's most populous empire fell into the hands of the Bolsheviks, whose virulently anti-religious revolutionary movement actively sought the destruction of Christianity. Pacelli believed that the Church and National Socialism shared two common enemies, Bolshevism and Judaism. Ultimately, both saw Bolshevism as a bastardized form of Judaism. There was nothing in the antisemitic policies of the Nazis concerning the Jews *before* World War II to which the Church would or could object as long as baptized Jews were excluded from the Nazi-mandated disabilities. In effect, the Nazis were implementing a long cherished Vatican goal, the disenfranchisement of non-believing Jews in Christian Europe and their ultimate return to the ghetto.

Violence and extermination were another matter. Or were they? The Inquisition or the Congregation of the Holy Office never executed condemned heretics, those regarded by the Church as its internal enemies. It handed the condemned over to the secular arm that alone was authorized to impose the death penalty. Moreover, the Inquisition was alive and well in the Papal States in Italy until 1870. After Pio Nono's restoration, the responsibilities of the Holy Office included oversight of the Jews. Jews were forbidden to provide Christians with food and lodging, own land, spend the night outside the ghetto, or have "friendly relations with Christians."[53] That was the state whose passing was mourned by the Pacelli family and whose restoration was sought by them.

I began this chapter by asking whether Pius XII took the elimination of Europe's Jews as a demographic presence to be a benefit for Europe *and Christendom*? The evidence suggests an affirmative answer. Unlike the Inquisition, the pope was not required to turn the internal enemy over to the secular arm. All that was required of him was to do nothing and say as little as possible. The secular arm did the rest. In conclusion, it must be stated that there is an enormous difference between the way the Roman Catholic Church has dealt with religious pluralism before and after Vatican II and most especially in its relations with Judaism.[54]

NOTES

1. Rolf Hochhuth, *Der Stellvertreter* (Reinbek bei Hamburg: Rowohlt Verlag GmbH, 1963); English translation, *The Deputy* (New York: Grove Press, 1964).

2. Pierre Blet, Robert A. Graham, Angelo Martini, and Burkhart Schneider, eds., *Actes et documents du Saint Siège relatifs à la Seconde Guerre mondiale*, 11 vols. (Vatican City: Libreria Editrice Vaticana, 1965–81).

3. Pierre Blet, S.J., *Pie XII et la Seconde Guerre mondiale* (Paris: Académique Perrin, 1997); English translation, *Pius XII and the Second World War: According to the Archives of the Vatican*, trans. Lawrence J. Johnson (New York: Paulist Press, 1999).

4. Among the many volumes that have appeared are Michael Phayer, *The Catholic Church and the Holocaust, 1930–1965* (Bloomington: Indiana University Press, 2000); Susan Zuccotti, *Under His Very Windows: The Vatican and the Holocaust in Italy* (New Haven, Conn.: Yale University Press, 2000); Saul Friedländer, *Pius XII and the Third Reich: A Documentation*, trans. Charles Fullman (New York: Alfred A. Knopf, 1966); John F. Morley, *Vatican Diplomacy and the Jews during the Holocaust: 1939–1943* (New York: KTAV, 1980); John Conway, *The Nazi Persecution of the Churches* (New York: Basic Books, 1968); Victoria Barnett, *For the Soul of a People: Protestant Protest Against Hitler* (New York: Oxford University Press, 1992); Doris L. Bergen, *Twisted Cross: The German Christian Movement in the Third Reich* (Chapel Hill: University of North Carolina Press, 1996); and Ernst Christian Helmreich, *The German Churches under Hitler: Background, Struggle, and Epilogue* (Detroit: Wayne State University Press, 1979).

5. John Cornwell, *Hitler's Pope: The Secret History of Pius XII* (New York: Viking, 1999).

6. *Ibid.*, viii.

7. See Anthony Rhodes, *The Vatican in the Age of the Dictators, 1922–1945* (London: Hodder and Stoughton, 1973), 272–3.

8. Galeazzo Ciano, *Diaries* (London), 538, cited by Cornwell, *Hitler's Pope*, 293.

9. Cornwell, *Hitler's Pope*, 296–7.

10. See David Kertzer, *The Kidnapping of Edgardo Mortara* (New York: Alfred A. Knopf, 1997), 49.

11. See Ernest L. Woodward, *Three Studies in European Conservatism: Metternich-Guizot—The Catholic Church in the Nineteenth Century* (London: Constable, 1929), 286.

12. See *ibid.*, 283–92.

13. For a critical view of how Pio Nono came to proclaim the dogma of papal infallibility, see August Hasler, *How the Pope Became Infallible*, trans. Peter Heinegg (Garden City, N.Y.: Doubleday, 1933).

14. David Kertzer's *The Kidnapping of Edgardo Mortara* (New York: Alfred A. Knopf, 1997) is an authoritative study of the case and its ramifications.

15. Woodward, *Three Studies in European Conservatism*, 328, n.1.

16. Kertzer, *The Kidnapping of Edgardo Mortara*, 113–15.

17. Cornwell, *Hitler's Pope*, 26.

18. See Norman Cohn, *Warrant for Genocide: The Myth of the Jewish World-Conspiracy and the Protocols of the Elders of Zion* (New York: Harper & Row, 1967).

19. See article "Civiltà Cattolica," in *Encyclopaedia Judaica* (Jerusalem: Encyclopaedia Judaica, 1972), Vol. 5, 599–600.

20. Cornwell, *Hitler's Pope*, 23.

21. On the Red Revolution in Munich, see Allan Mitchell, *Revolution in Bavaria, 1918–1919* (Princeton: Princeton University Press, 1965); Ruth Fischer, *Stalin and German Communism* (Cambridge: Harvard University Press, 1948); Charles B. Maurer, *Call to Revolution: The Mystical Anarchism of Gustav Landauer* (Detroit: Wayne State University Press, 1971); Rosa Leviné-Meyer, *Leviné the Spartacist* (London: Gordon and Cremonesi, 1978); Richard Grunberger, *Red Rising in Bavaria* (New York: St. Martin's Press, 1973).

22. Karl Dietrich Bracher, *The German Dictatorship* (New York: Praeger, 1973), 82.

23. On the impact of the *Protocols* on Japan, see Richard L. Rubenstein, "The financier and the finance minister: the roots of Japanese anti-Semitism," in Julius H. Schoeps, ed., *Aus zweier Zeugen Mund: Festschrift für Nathan P. und Pnina Navé Levinson* (Gerlingen: Bleicher-Verlag, 1992).

24. On Kun's rebellion, see Moshe Y. Herczl, *Christianity and the Holocaust of Hungarian Jewry*, trans. Joel Lerner (New York: New York University Press, 1993).

25. On Horthy, the Arrow Cross, and the extermination of Hungary's Jews, see "Introduction: the historical framework," in Andrew Handler, ed., *The Holocaust in Hungary: An Anthology of Jewish Response* (University, Ala.: University of Alabama Press, 1982), 18–29.

26. *Ibid.*, 240.

27. On the Red Army's campaign against Poland, see Richard M. Watt, *Bitter Glory: Poland and Its Fate 1918–1939* (New York: Simon & Schuster, 1982), 89–179.

28. Isaac Deutscher, *The Prophet Armed: Trotsky 1879–1921* (New York: Vintage Books, 1965), 466.

29. On the importance of the Spanish Civil War for the relations between the churches and Hitler, see Klaus Scholder, *A Requiem for Hitler and Other New Perspectives on the German Church Struggle* (Philadelphia: Trinity Press International, 1989), 140–56.

30. *Ibid.*, 143.
31. *Civiltà Cattolica*, May 1, 1897, cited by Sergio I. Minerbi, *The Vatican and Zionism: Conflict in the Holy Land 1895–1925* (New York: Oxford University Press, 1990), 96.
32. *Civiltà Cattolica*, September 1899, 749.
33. Theodore Herzl, *The Diaries of Theodore Herzl*, trans. and ed. Marvin Lowenthal (New York: Grosset and Dunlap, 1962), 428.
34. J. D. Gregory, Secretary of the British Legation at the Vatican in 1914 and a Catholic, described the Vatican attitude toward the combatants in World War I in his memoirs: "On one side of the conflict stood the Central Empires, representatives of Authority, Order, Law and Stability, involving the Catholic stronghold of Bavaria, the Rhine and Alsace, and the existence of the two remaining Catholic dynasties. On the other side stood Protestant England, Freemason France, Orthodox Russia: a combination of forces that could hardly fail, if victorious, so it was argued, to be inimical to the Church's interests." J. D. Gregory, *On the Edge of Diplomacy, 1902–1928* (London: Hutchinson, 1929), 89. The Vatican's attitude concerning England, France and Russia did not change during World War II. For this citation, I am indebted to Minerbi, *The Vatican and Zionism*, 10.
35. Luigi Salvatorelli, *La Politica della Santa Sede dopo la Guerra* (Milan: ISPI, 1937), 10–11.
36. Baldric of Bourgeuil, "Historia Jerosolimitana," in *Recueil des Historiens des Croisades, Historiens occidentaux* (1844–95), Vol. 4, 101, cited by Jonathan Riley-Smith, *The Crusades: A Short History* (New Haven: Yale University Press), 16.
37. "The Balfour Declaration," in Paul Mendes-Flohr and Jehuda Reinharz, eds., *The Jew in the Modern World: A Documentary History* (New York: Oxford University Press, 1980), 458.
38. *L'Osservatore Romano*, March 21, 1919.
39. Pierre van Zuylen (Rome) to Foreign Minister Hymans, March 16, 1919, No. 57/26, Archives du Ministère des Rélations Extérieures, Brussels, St. Siège, 1919–20.
40. *Actes et documents du Saint Siège relatif à la Seconde Guerre mondiale*, 9: 272; John Morley, *Vatican Diplomacy and the Jews*, 92.
41. Klaus Scholder, *The Churches and the Third Reich*, trans. John Bowden (London: SCM Press, 1987), Vol. 1, 164–5.
42. In addition to Scholder, *The Churches*, see Victoria Barnett, *For the Soul of a People*, and Doris L. Bergen, *Twisted Cross*.
43. Helmreich, *The German Churches under Hitler*, 276–7; cited in Cornwell, *Hitler's Pope*, 140.
44. Scholder, *The Churches*, Vol. 1, 104.

45. Mark Landler, "Beijing-backed Church, defying Vatican, installs 5 new Bishops," *New York Times*, January 7, 2000.

46. Cornwell, *Hitler's Pope*, 295–6.

47. Historian David Wyman cites a British Foreign Office memorandum written after William Temple, Archbishop of Canterbury, rose in the House of Lords on March 23, 1943, to plead for immediate efforts aimed at the rescue of Europe's Jews. The memorandum reads in part: "There is the possibility that the Germans or their satellites *may change over from the policy of extermination to one of extrusion*, and aim as they did before the war at embarrassing other countries by flooding them with alien immigrants." See David Wyman, *The Abandonment of the Jews: America and the Holocaust 1941–1945* (New York: Pantheon Books, 1984), 105.

48. See Michael R. Marrus and Robert O. Paxton, *Vichy France and the Jews* (New York: Basic Books, 1981), 200–1.

49. David Lloyd George, *Memoirs of the Peace Conference*, 2, 720. I am indebted to Tom Segev, *One Palestine, Complete: Jews and Arabs under the British Mandate*, trans. Haim Watzman (New York: Metropolitan Books, 2000), 35.

50. Mayir Verete, "The Balfour Declaration and its makers," *Middle Eastern Studies*, Vol. VI, No. 1, Jan. 1970, 69. Again, I am indebted to Segev, *One Palestine Complete*, for this citation.

51. Segev, *One Palestine Complete*, 33.

52. See David Kranzler, *Japanese, Nazis and Jews: The Jewish Refugee Community of Shanghai, 1935–1945* (Hoboken: KTAV, 1988), 169.

53. "Editto della Santa Inquisizione contro gl'Israeliti degli Stati Pontifici," in Achille Gennarelli, *Il governo pontifico e lo stato romano, documenti preceduti da una esposizione storica* (Rome: 1861), Part I, 304–5, cited by David Kertzer, *The Kidnapping of Edgardo Mortara*, 190.

54. On March 16, 1998, the Holy See's Commission for Religious Relations with the Jews released the Church's most important statement on the Holocaust, "We remember: a reflection on the *Shoah*." Although the statement's positive evaluation of Pius XII's wartime role remains divisive, the new spirit that animates the Church's attitude toward Judaism is well expressed in "We remember"'s hope for the future: "We wish to turn awareness of past sins into a firm resolve to build a new future in which there will be no more anti-Judaism among Christians or anti-Christian sentiment among Jews, but rather a shared mutual respect, as befits those who adore the one Creator and Lord and have a common father in faith, Abraham."

Evaluating Pius XII and His Legacy

Questions about Pope Pius XII and the Holocaust pertain not only to the past, nor are they simply about an individual leader and his responsibilities. What Pius XII did or did not do, what he could or could not have attempted, are issues with implications that carry forward into the present and the future because they require, in particular, reflection about the nature and destiny of Christianity, and especially that tradition's relationship to Judaism and the Jewish people. The chapters in Part III highlight concerns of this kind.

Urging that historical accuracy is essential, Susan Zuccotti questions the validity of frequent assertions that Pope Pius XII directed men and women of the Church to save Jews. She also re-evaluates often cited claims about Jewish expressions of gratitude to Pius XII after the Second World War ended. In a related vein, Michael Phayer appraises what he takes to be the main reasons why Pope Pius XII did not speak out more forcefully about the Holocaust. These reasons include Pius XII's fear of Communism, his belief that Germany would defend Europe against it, and his fear that Hitler might destroy the Vatican if he spoke out more directly. Acknowledging that the Catholic Church, partly but not exclusively because of Pius XII's leadership, shares responsibility for the fate of Jews during the Holocaust, James Doyle examines important post-Holocaust steps that the Catholic Church has taken to improve Christian–Jewish relations.

Much work remains to be done in this area. John Roth argues that Pius XII's policies and pronouncements—or the lack of them—have added to the credibility crisis that continues to plague post-Holocaust Christianity. From him to whom much is given, much is expected. Pope Pius XII, Roth argues, must receive mixed reviews at best, and Christians—Protestants as well as Catholics—must find ways to cope well with that outcome and its implications. Like Roth, but from his Jewish perspective, Albert Friedlander ponders the possible canonization of Pius XII. He emphasizes that the issue of sainthood for Pius is primarily,

but by no means exclusively, a Roman Catholic matter. The Catholic Church sends important signals to the world in the decisions it makes to bestow—or withhold—this significant status on its special sons and daughters. Carol Rittner agrees. Her comparison between Pius XII and a group of nuns known as Sister Stella and her Ten Companions not only provides a moving final chapter to the book but also raises fundamental issues about the very essence of Christianity itself.

Susan Zuccotti

Pope Pius XII and the Rescue of Jews during the Holocaust: Examining Commonly Accepted Assertions

"Are there two separate memories of the Holocaust, a Jewish memory and a Catholic one?" That was one of the questions that the contributors to this book were asked to consider. Surely the answer is that there are countless memories, for memory is, by definition, personal, selective, imprecise, and arbitrary. There is no single broad collective memory of the Holocaust that can be shared by all Catholics or by all Jews. But let us, for the moment, narrow the question. Let us avoid the word "memory" and use instead the term "historical interpretation." Let us, also, focus not on the Holocaust generally but on the question of the Vatican's response to it. There does then seem to be a single uncritical acceptance of certain assertions that is shared by a surprisingly broad group of people, extending well beyond the most extreme papal defenders to include otherwise well-informed historians and even critics of Pope Pius XII, both Jewish and non-Jewish. Three of the most important commonly accepted assertions involve the existence of a papal directive to men and women of the Church to save Jews, the significance of Jewish expressions of gratitude to Pius XII after the war, and the high numbers of Jews actually saved by the pope and his closest assistants.

These assertions were summarized most succinctly by the Holy See's Commission for Religious Relations with the Jews in March 1998. In its document, "We Remember: A Reflection on the *Shoah*," the commission declared, "During and after the war, Jewish communities and Jewish leaders expressed their thanks for all that had been done for them, including what Pope Pius XII did personally or through his representatives to save hundreds of thousands of Jewish lives."[1] An endnote attached to that statement provided four examples of Jewish

expressions of gratitude, as if that phenomenon itself proved the assertion of papal involvement.[2] The commission apparently saw no need to document the assertion that the pope and his representatives had saved hundreds of thousands of Jewish lives.

Still more remarkable, in his book *Hitler's Pope*, John Cornwell seemed also to accept the assertions. He too referred to Jewish expressions of gratitude to Pius XII for all that he had allegedly done to help them during the Holocaust. He commented simply, "One must respect a tribute made by people who had suffered persecution and survived."[3] Cornwell also declared, without evidence or a trace of skepticism, that the Vatican "increased its charitable activities [on behalf of Jews in Italy], especially assistance with emigration," and referred to the pope's "encouragement of the work of countless Catholic religious and laypeople bringing comfort and safety to hundreds of thousands."[4] It is ironic that Cornwell, of all people, should endorse assertions usually put forward by papal defenders.

It is time that the uncritical acceptance of these assertions is challenged. This chapter will contribute to the process. The primary but not the exclusive focus will be on Italy, the country where Pius XII would have been most comfortable instructing the clergy—his countrymen, after all—to take specific steps to protect Jews. Italy is also the country where this author has conducted extensive research on the subject.

Were there papal directives for rescue?

The first assertion regards the claim that Pope Pius XII directed men and women of the Church, particularly in Italy, to open their institutions to Jews fleeing for their lives during the Holocaust. Although not the first to state it, the German Jesuit Father Robert Leiber gave the claim considerable credibility when he mentioned it in an article in *Civiltà Cattolica* in 1961.[5] Leiber, Pius XII's closest advisor during his entire papacy, had been present at the scene. His words had the ring of authenticity.

Despite Leiber's endorsement, there is no solid evidence for such a claim, and much reason to doubt it. No written directive has ever been found. Although such a document, if discovered by the Nazis, would have compromised the pope, there is every reason to believe that priests, monks, or nuns aware of the growing criticism of the papal silence during

the Holocaust would have preserved a copy of a directive if they had received one. Hiding a single letter was not difficult. Far more compromising items, including precious objects from a neighboring synagogue or lists of individual Jews being helped by a particular priest, were frequently preserved.[6]

A papal directive for rescue, of course, might have been oral rather than written, but here too difficulties arise. During the immediate post-war period, no rescuer from among the religious or secular clergy in Italy, the country with the largest proportion of Jews hidden in Church institutions, claimed to have acted because of a papal directive. Some actually denied it.[7] Only years later did one priest, Don Aldo Brunacci, claim to have seen an order.[8] But Brunacci remained in a distinct minority. Except for him, none of the bishops and archbishops who set up elaborate regional Jewish rescue networks and none of the men and women most closely involved in those operations ever claimed to have received a papal directive.

Men and women of the Church who rescued Jews often explained that the pope had known what they were doing, although some asserted that he had suspected but had not wanted to know the details. Some, especially nuns in Rome, claimed that they had received extra food supplies from the Vatican to help them feed those whom they were sheltering.[9] On the other hand, other rescuers specifically denied post-war claims by papal defenders that they had received material aid from the Vatican for their activities.[10] Also, some priests declared after the war that they had acted to help Jews, secure in the knowledge that they were fulfilling the papal will to be merciful to all individuals in need.[11] Even during the war, some priests had probably whispered to a nun or monk, uneasy about accepting a stranger, that it was the "will of the Holy Father." But all of these claims were a far cry from declaring publicly for the historical record that the pope had ordered them to rescue Jews. That they did not do.

There are many other reasons to question the existence of a papal directive. The 11 volumes of wartime diplomatic documents published by the Vatican between 1965 and 1981 entitled *Actes et documents du Saint Siège relatif à la Seconde Guerre mondiale* do not contain a single letter directing men and women of the Church to rescue Jews.[12] Certainly the collection presents many communications from officials at the Vatican Secretariat of State to their envoys abroad, instructing them to take helpful diplomatic steps. Papal nuncios, apostolic delegates, and others in the German Reich and its occupied countries were asked to inquire about the intentions of local officials regarding the Jews, to express the Vatican's

concern, and, occasionally, to request privately that Jews be better treated. But there is no evidence of instructions to churchmen to save Jews. If such a document existed in the Vatican archives, it would surely have been selected for publication, for it would have greatly improved Pius XII's record with regard to the Holocaust. But the closest thing to such a document in the *Actes et documents* is the pope's letter to his long-time friend Bishop Konrad von Preysing in Berlin on April 30, 1943. "Regarding pronouncements by the bishops [about the persecutions of the Jews]," Pius wrote, "we leave it to local senior clergymen to decide if, and to what degree, the danger of reprisals and oppression, as well as, perhaps, other circumstances caused by the length and psychological climate of the war may make restraint advisable—despite the reasons for intervention—in order to avoid greater evils."[13]

The *Actes et documents*, of course, could only have published a written order or some recorded evidence of it. But there are still other reasons to doubt even an oral directive. Why, for example, would the pope have asked men and women of the Church in Italy or France to open their doors to Jews, but not have done the same in Poland, Slovakia, Croatia, or other countries? Many Catholics in the former two countries did indeed help Jews, but the record in the latter three is far more dismal. Why, for that matter, would the pope have asked some prelates and not others, even within a single country? Several Italian bishops expressed hostility to the sheltering of Jews and other fugitives.[14] Many Catholic institutions refused to accept them. Would such a thing have happened if the pope had issued an order or even just provided more guidance? Claims of a papal directive for Jewish rescue are sometimes based on the fact that several thousand Jews were sheltered in Catholic convents, monasteries, schools, and hospitals in Rome during the German occupation.[15] The implication is that such a phenomenon would not have occurred without an order from Pius XII. The argument is invalid, for many reasons. First, the rush into Church institutions in Rome occurred, with some exceptions, immediately after the German round-up of 1259 Jews on Saturday, October 16, 1943. There was little time for a papal order during the round-up, and no evidence of papal concern for the Jews before that time. On the contrary, Pius XII did nothing to warn Jewish leaders in Rome of the round-up that he knew was coming, and little to intervene on their behalf after they had been arrested.[16]

Furthermore, the directors of most Catholic institutions did not need to obtain Vatican permission to accept outsiders within their walls.

Nearly all of the convents that took in Jewish boarders had public areas in which to house them. Contrary to what is commonly believed, rules of cloister rarely had to be broken. Many nuns, also, had long operated what were known as *forestieri*, small dormitories or hostels for religious tourists and pilgrims. Such spaces were empty during the war, and available for refugees and fugitives. Most of the schools and hospitals that hid Jews also existed to serve the public, and could take in anyone who did not violate the rules and regulations of the individual order. Most rules, of course, involved gender. Schools operated by nuns usually accepted only women and girls. Those run by priests and monks took in men and boys. Directors may well have sought the approval of their immediate superiors before they burdened their schools, hospitals, or *forestieri* with outsiders who might not be able to pay their way, or who might expose the institutions to danger. They may, on occasion, even have advised their bishops or, in Rome where the pope was the bishop, his representative the vicar, of what they were doing. But they did not have to appeal to the pope himself.

The situation in Vatican-owned properties in Rome, of course, was rather different. Jews and other fugitives caught in such properties would compromise the pope in the eyes of the Germans and their Fascist allies. Several of these institutions in Rome did in fact take in Jews as well as non-Jewish political fugitives. For example, the extraterritorial Pontificio Seminario Romano Maggiore on the Piazza di Porta San Giovanni, near the Basilica di San Giovanni in Laterano, hid about 55 Jews and about 145 others.[17] The Seminario Lombardo, near the Basilica di Santa Maria Maggiore, sheltered 63 Jews and about 47 others.[18] Other smaller Vatican properties received additional fugitives. Even within Vatican City itself, about 40 Jews, of whom at least 15 were converts, had been brought in surreptitiously by individual prelates by June 1944 and sheltered in their private apartments, along with a larger number of non-Jewish fugitives.[19] Pius XII may not have known the precise numbers of outsiders being sheltered in Vatican properties inside and outside the walls at all times, but he and his advisors were certainly aware that they were there.

The presence of Jews in Vatican properties is not an indication of a papal order to save them. On the contrary, the bulk of the available evidence suggests that Vatican officials were deeply divided on the issue. Some, including Monsignor Giovanni Battista Montini, Secretary of the Section for Ordinary Ecclesiastical Affairs at the Vatican Secretariat of State and the future Pope Paul VI, were aware of fugitives hidden in Vatican properties and preferred to look the other way. Others were

strongly opposed to rescue efforts that could endanger the Church. Pius XII seems to have wavered between the two factions. Evidence for this interpretation includes a letter to the pope written on December 11, 1943, by Monsignor Roberto Ronca, rector of the Pontificio Seminario Romano Maggiore, in which he apologized for displeasing the pope by accepting too many "refugees."[20] Also revealing were the efforts of some Vatican officials on several occasions to expel fugitives from Vatican properties. Of the aftermath of a Fascist and Nazi raid on the basilica and monastery of San Paolo fuori le mura on February 3–4, 1944, for example, a priest from the Seminario Lombardo later wrote in a diary, "Orders from the Vatican to dismiss all non-clerics. Why such a brutal blow? Many were in disastrous conditions: with a death sentence on their heads. ... Where could they go?"[21] At about the same time, directors of the Pontifical Commission for the Vatican City State attempted to impose a similar expulsion order on the 50 outside guests, including some Jews, then being sheltered in the individual apartments of prelates within the Vatican walls. Other Vatican officials and the prelates directly involved objected strenuously, and the order was ultimately not enforced.[22]

The final argument sometimes put forward to prove the existence of a papal order to save Jews concerns Italy as a whole. Although precise statistics may never be known, it is clear that several thousand Jews hid in Church institutions throughout the country during the German occupation. Their presence does not prove papal involvement, but similarities of activities on their behalf by a group of archbishops in northern and central Italy is puzzling, and demands explanation. Beginning in the Autumn of 1943, the Archbishops of Genoa, Turin, Milan, and Florence asked trusted assistants to distribute subsidies and find shelter for Jewish refugees in their dioceses. The men assigned the task, all but one of them priests, eventually created broad rescue networks and extended their efforts well beyond the geographic limits of their own dioceses. They were aware of each other, and occasionally cooperated. How, it is sometimes asked, could such a phenomenon have developed in the absence of a papal directive?

On careful examination, another explanation clearly exists. After the Italian armistice with the British and Americans on September 8, 1943, well over a thousand Jewish refugees poured into northern and central Italy from Italian-occupied France to escape the rapidly advancing Germans. In Italy they joined thousands of other impoverished and helpless foreign Jews, many of whom had been interned by Mussolini since the beginning

of the war and had only recently been released. Unfortunately, the German army occupied Italy as well as Italian-occupied France at the time of the armistice, and the Allied offensive soon stalled in the south. Thousands of refugees were trapped. At about the same time, the leaders of a national Jewish refugee assistance organization called Delasem realized that they could no longer operate openly, as they had done during the Mussolini regime from 1939 to July 25, 1943, and then with Marshal Pietro Badoglio until the arrival of the Germans.[23] In desperation, they turned to the Cardinal Archbishops Pietro Boetto in Genoa, Maurizio Fossati in Turin, and Elia Dalla Costa in Florence. Could those prelates, they asked, accept Delasem funds and lists of clients, and continue the distribution of subsidies upon which so many Jewish refugees depended? The prelates immediately agreed, and charged their secretaries with the task. Those men recruited others, including, in November, Cardinal Archbishop Ildefonso Schuster in Milan. Responsibility for the distribution of subsidies soon grew into still riskier activities, such as the finding of hiding places for entire families and the escorting of groups of Jews across the Swiss frontier. Prelates and priests in several regions in northern Italy indeed acted similarly, but their behavior stemmed not from a papal directive but from a request from a national Jewish refugee organization.[24]

What about expressions of gratitude?

The second commonly accepted assertion to be addressed in this chapter concerns post-war Jewish expressions of gratitude to Pius XII for his help and support during the Holocaust. To explore this point, it is useful to look closely at the four examples cited by the Holy See's Commission for Religious Relations with the Jews in the endnote of "We Remember." As a first example, the note stated that on September 7, 1945, Dr. Joseph Nathan, who represented the "Italian Hebrew Commission," thanked the pope and referred to "the directives of the Holy Father" to men and women of the Church to save Jews.[25] Second, the note declared that on September 21, 1945, A. Leo Kubowitzki, then the Secretary General of the World Jewish Congress, met with the pope to present to him "in the name of the Union of Israelitic Communities, warmest thanks for the efforts of the Catholic Church on behalf of Jews throughout Europe during the war."[26] Third, according to the note, "on Thursday, November

29, 1945, the pope met about eighty representatives of Jewish refugees from various concentration camps in Germany, who expressed 'their great honor at being able to thank the Holy Father personally for his generosity toward those persecuted during the Nazi-Fascist period.'"[27] The fourth example cited was Golda Meir, then Israeli Minister of Foreign Affairs, who, according to the note, sent a message to the Vatican at the time of the death of Pius XII in 1958 which said in part, "When fearful martyrdom came to our people, the voice of the pope was raised for its victims. The life of our times was enriched by a voice speaking out about great moral truths above the tumult of daily conflict."[28]

There are countless other recorded expressions of Jewish gratitude to Pius XII, but these four will suffice.[29] Presumably the Holy See's Commission for Religious Relations with the Jews considered them the most convincing, and in any case they are representative of the others. But none of the four cases is convincing. Golda Meir's claim may be dismissed first, and most easily. The Israeli Minister of Foreign Affairs and future prime minister knew perfectly well that Pius XII had never raised his voice on behalf of the Jewish people during the Holocaust. The record shows clearly that the pope never used the word "Jew," "antisemitism," or "race" in a public speech during the war, and he briefly expressed sympathy for people who were sometimes dying because of their "descent" (*stirpe*) only twice in lengthy speeches covering many other matters.[30] Meir may have been genuinely grateful to the pope for other activities, real or imagined, but she certainly knew the truth about his silence.

The other expressions of thanks cited by the Holy See's commission came in 1945 from Joseph Nathan, actually Giuseppe Nathan, then president of the nationwide Union of Italian Jewish Communities (not the "Italian Hebrew Commission"); A. Leo Kubowitzki, later known as Aryeh L. Kubovy and henceforth referred to by that name here; and 80 representatives of Jewish refugees from concentration camps "in Germany" (surely the commission meant Poland?). But how could any of these individuals have known for certain what the pope had done for them? Kubovy lived in New York during the war.[31] He could only have learned at second hand of activities emanating from the Vatican. Similarly, the 80 representatives from concentration camps had been well beyond the reach of rescue activities during the war. They, too, could only have obtained their information from others. Only Giuseppe Nathan had actually lived in Rome during the German occupation, hidden in a monastery while his wife and children were sheltered in other homes and

convents.[32] He may have been told by his rescuers that his presence in the monastery was "the will of the Holy Father," or even that his admission resulted from a papal directive. He may even have believed it. But he had no concrete evidence for what he was told, and his own expression of thanks constituted no proof.

If, as has been seen, Pius XII did little to help Jews during the Holocaust, why did so many Jews later express their gratitude to him? There are several reasons. Many who thanked the pope after the war simply saw him as the majestic symbol of a Church whose lesser clergy had clearly been helpful to them and had perhaps even saved their lives. Others were just misinformed. Giuseppe Nathan was probably in one of these two categories. Jews hiding in religious institutions had no way of knowing for certain who had made the decisions to accept them. They often held an exaggerated view of a centralized, authoritarian, and smoothly running Church in which all decisions were made at the top and the lesser clergy did nothing but await instructions. They credited the pope with their acceptance at monasteries, convents, and Catholic hospitals and schools, and most priests, monks, and nuns were quite willing to allow the belief to continue. Rescued Jews then relayed their impressions to others who arrived with the Allied army at liberation or with Jewish charities soon after the war. Those newcomers, who knew little about the local scene, viewed the information uncritically and passed it along. Sometimes, they too thanked the pope.

Still other Jews who expressed their gratitude acted, at least in part, to achieve other objectives. Above all, they desperately hoped that Pius XII would attempt to prevent a resurgence of antisemitism in Europe after the war. Aryeh Kubovy put that objective eloquently when he wrote in 1967 of the immediate post-war period, "Our [presumably the World Jewish Congress] conclusion was that the breeding ground of anti-Semitism lay in some of the dogmas and doctrines of Christianity which had been responsible for the slaughter of our people over many centuries past. Unless the Church were to abandon its teaching that the Jews were cursed to all eternity for having crucified Christ, hostility towards the Jews was bound to recur through all subsequent generations in all the lands of Christianity."[33]

In that same account in 1967, Kubovy explained why he had conveyed the gratitude of Italian Jews to Pius XII "for the efforts of the Catholic Church on behalf of Jews throughout Europe during the war," as the Holy See's commission described it—an expression of thanks, by the

way, that did not mention the pope himself. After the war, Kubovy, representing the World Jewish Congress, wanted to ask the pope for "an encyclical concerning the position of the Church on the Jewish question," as he put it. He also planned to request papal help in securing the return of Jewish children who had been hidden in Catholic institutions. To secure a papal audience, Kubovy needed the help of Jewish leaders in Rome. Those leaders insisted that he also convey the gratitude of the Union of Italian Jewish Communities. Kubovy wrote, "After some hesitation I agreed, not only because I realized that these people were truly grateful to the Church, but also because I could not miss the chance of bringing my requests before the Pope."[34]

In addition to hoping that the pope would help combat a resurgence of antisemitism, many Jewish spokesmen wanted to persuade the Holy See to support and ultimately recognize the new state of Israel. Surely Golda Meir was one of these, and surely that objective partly motivated her words of praise for Pius XII at the time of his death. Later, during the years of the Second Vatican Council (1962–5), representatives of Jewish groups were also eager to encourage a new Church declaration sympathetic to the Jews. They may have felt that they suffered a setback when, on February 20, 1963, Rolf Hochhuth's play *Der Stellvertreter* attacking Pius XII's silence about the Holocaust opened in Berlin and caused an international furor.[35] It is probably not coincidental that one of the two most sweeping defenses of Pius XII by Jewish historians appeared at this time. "A Question of Judgment: Pius XII and the Jews," by Joseph L. Lichten, director of the Intercultural Affairs Department of the Anti-Defamation League of B'nai B'rith in New York, was first published in 1963.[36] Its claims of sweeping papal activity to help Jews during the Holocaust are wildly inaccurate.

The Holy See's long-awaited declaration condemning antisemit-ism was finally issued on October 28, 1965, despite fierce opposition from some of the delegates to the Second Vatican Council.[37] The document known as *Nostra Aetate* announced that the Church "deplores" antisemitism "in every time and on whoever's part." It stated that "what was committed during the passion [of Christ] cannot be imputed either indiscriminately to all Jews then living or to the Jews of our time."[38] In other words, Jews in general cannot be held responsible for the killing of Jesus. The document represented a significant step forward in Jewish–Christian relations. One can only speculate whether it was in part the product of a deliberate distortion of the historical record.

Distortion of the historical record for any reason is a serious charge, but it was perhaps understandable during the first two decades after the war, in the wake of the horrors that those involved had recently experienced and in the light of their fears for the future. It became less pardonable by the late 1960s. Joseph Lichten's work, along with that of Pinchas E. Lapide, who had been an Israeli consul in Italy in the early 1960s during the meetings of the Second Vatican Council, and whose book in 1967 praising Pius XII was equally filled with errors, have been cited endlessly by papal defenders.[39] The theory apparently is that, if Jews can praise the pope for his effort during the Holocaust, it must be true.

However, distortion of the historical record was often not entirely deliberate and complete, for many Jews, especially in Italy, realized that men and women of the Church, if not the pope himself, had been helpful to them. This being the case, they believed, why should they make life more difficult for themselves by criticizing Pius XII? This attitude was clearly expressed at the time of the Second Vatican Council by Raffaele Cantoni, a leader of the Italian Jewish Community who had worked with other Jews and Catholics during the war to rescue Jews. In May 1965, Cantoni wrote to Don Francesco Repetto, the secretary to the Archbishop of Genoa. Repetto had supervised a large and highly effective regional effort to rescue Jews during the German occupation. Cantoni wrote, "And here I am, I have come to Milan, to Bologna, to say what is in my heart, not only as a manifestation of well-deserved gratitude, but in the hope that an active understanding will arise, that will annul that which in the past has divided us."[40] From his own personal experience, Cantoni was certain about the merits of many Italian clergymen. He may have been less convinced about a papal directive, but he was willing to let that point slide by.

Were many Jews saved by Pius XII?

The third commonly accepted assertion to be addressed in this chapter is that Catholics saved "hundreds of thousands" of Jews. These statistics merit further scrutiny. The Holy See's document, "We Remember," mentioned hundreds of thousands, as did Cornwell, but papal defenders frequently refer to 860,000. They never explain that the number originated with the above-mentioned, unreliable Pinchas E. Lapide. The former Israeli consul never tried to disguise his method of calculating his

statistics. He declared without explanation that some two million Jews in Nazi-controlled areas had survived the Holocaust. About half of them, he continued, had succeeded in escaping to the free world. He then went on, "Of the resultant total, exceeding one million Jewish survivors, I deducted all reasonable claims of rescue made by the Protestant Churches ... the Eastern Churches ... as well as those saved by Communists, self-declared agnostics and other non-Christian Gentiles. The final number of Jewish lives in whose rescue the Catholic Church had been instrumental is thus at least 700,000 souls, but in all probability is much closer to the maximum of 860,000."[41] Lapide's methodology is obviously flawed, yet his statistics continue to be cited by individuals and groups as diverse as Pat Buchanan and the Catholic League, and to be evoked less precisely by others as different as the Holy See's Commission for Religious Relations with the Jews and John Cornwell.

It should be noted that even Lapide, for all his exaggeration and distortion, did not claim that the 860,000 Jews were saved by "the pope and his representatives," as the Holy See's Commission for Religious Relations with the Jews implied. There is no question that many Catholic clergymen, nuns and monks, and laypersons helped in the rescue of Jews. Most helped simply by not reporting what they saw. They were, in other words, passive bystanders in a positive rather than a negative sense. Fewer took active measures to save individuals or groups. The statistics of rescuers will never be known, but if the bystanders are included, they numbered in the thousands. That is important, but it is not the point of this analysis. The purpose here has been to examine common assertions about a benevolent, active, and even heroic Pope Pius XII. The conclusion is that there is currently no evidence to indicate that the Holy Father ever directed his flock to save Jews. Those who did engage in rescue may have believed that they were acting according to his will, but he never told them so in any but the most general terms.[42] Had he done so, surely many more Catholic laypersons would have helped their Jewish neighbors, and many more lives would have been saved.

NOTES

1. Published in *Catholics Remember the Holocaust* (Washington, D.C.: U.S. Catholic Conference, 1998), 47–56, 53.

2. *Ibid.*, 55–6.

3. John Cornwell, *Hitler's Pope: The Secret History of Pius XII* (New York: Viking, 1999), 317.

4. *Ibid.*, 301 and 317.

5. Robert Leiber, S.J., "Pio XII e gli ebrei di Roma: 1943–1944," *Civiltà Cattolica*, Vol. I, quad. 2657, February 25, 1961, 449–58, 451.

6. For example, Bishop Antonio Santin hid priceless books and historical documents for the Jewish Community of Trieste; Monsignor Vincenzo Barale's lists of Jews he was helping survived and may be found today in the Archivio della Curia di Torino; and Bishop Giuseppe Placido Nicolini of Assisi hid in his own office the real identification cards of a Jewish family he was helping. For details, see Susan Zuccotti, *Under His Very Windows: The Vatican and the Holocaust in Italy* (New Haven: Yale University Press, 2000), 239–40, 263, and 288.

7. See, for example, testimony of Brother Maurizio, steward at the Fatebenefratelli Hospital in Rome which hid at least 67 Jews during the occupation, in Federica Barozzi, "'I Percorsi della sopravvivenza,' (8 settembre '43–4 giugno '44): Gli aiuti agli ebrei romani nella memoria di salvatori e salvati," unpublished thesis, Università degli studi di Roma "La Sapienza," Facoltà di lettere e filosofia, 1995–6, 156.

8. Don Brunacci claimed that he had seen a letter of request from the Vatican in the hands of his superior, Bishop Nicolini. See his "Giornata degli ebrei d'Italia: Ricordi di un protagonista," public lecture, Assisi, March 15, 1982, printed in full in Brunacci, *Ebrei in Assisi durante la guerra: Ricordi di un protagonista*, Assisi, January 27, 1985, 7–15, 9.

9. For one example, see discussion of the Sisters of Our Lady of Sion in Rome, in Zuccotti, *Under His Very Windows*, 194.

10. *Ibid.*, 184, for post-war statements to that effect by Father Maria Benedetto in Rome.

11. See Francesco Motto, "L'Istituto salesiano Pio XI durante l'occupazione nazifascista di Roma: 'Asilo, appoggio, famiglia, tutto' per orfani, sfollati, ebrei," *Ricerche storiche salesiane: Rivista semestrale di storia religiosa e civile*, anno XIII, n. 2, July–December 1994, 315–59, 356; and Don Leto Casini, in his *Ricordi di un vecchio prete* (Florence: La Giuntina, 1986), 50, and as quoted in Sergio Minerbi, *Raffaele Cantoni, un ebreo anticonformista* (Assisi: Beniamino Carucci, 1978), 119.

12. These volumes were edited by an international team of Jesuit priests, including Pierre Blet, Robert A. Graham, Angelo Martini, and Burkhart Schneider. They were published in Vatican City by the Libreria Editrice Vaticana. They will subsequently be referred to as ADSS.

13. ADSS, 2, doc. 105, Pius XII to Preysing, April 30, 1943, 318–27, 324.

14. See, for example, Don Casini's description of the hostile Bishop of Perugia,

in *Ricordi di un vecchio prete*, 61. Also, the Bishop of Mantua was believed to
be a Fascist sympathizer. See the report from British Minister to the Holy
See Sir Francis d'Arcy Osborne to Foreign Secretary Anthony Eden, "Partiti
e movimenti politici in Italia," printed in full in Lamberto Mercuri, "La
Situazione dei partiti italiani vista dal Foreign Office (dicembre 1943),"
Storia Contemporanea, anno XI, n. 6, December 1980, 1049–60, 1057.
Pressure from prelates within Vatican City to turn away fugitives already
hiding there will be discussed below.

15. The number 4447 was first cited by Robert Leiber, S.J., "Pio XII e gli ebrei
di Roma," 451; and Renzo De Felice, *Storia degli ebrei italiani sotto fascismo*
(Turin: Einaudi, 1961), 610–14. According to Leiber, the list was compiled
by another Jesuit, Father Beato Ambord, immediately after the war, and
verified in 1954 by a close examination of the individual cases. The list is
not reliable, however, primarily because it makes no allowance for the
hundreds of Jews who moved from place to place and were undoubtedly
counted more than once. It is also probable that Father Ambord missed
some institutions that harbored Jews.

16. For discussion of what the pope knew about the round-up and what steps
he took to intervene with the Germans after it, see Robert Katz, *Black
Sabbath: A Journey Through a Crime Against Humanity* (Toronto: Macmillan,
1969) and Zuccotti, *Under His Very Windows*, 150–70.

17. See Pietro Palazzini, *Il Clero e l'occupazione tedesca di Roma: Il ruolo del
Seminario Romano Maggiore* (Rome: Apes, 1995), 27–8; and Michael
Tagliacozzo, "Perseguitati razziali rifugiati nella Zona extraterritoriale
lateranense durante l'occupazione tedesca di Roma (1943–1944),"
Tagliacozzo archives, Israel. Palazzini was a priest and the assistant to
the rector at the seminary during the war. Tagliacozzo was a Jewish student
sheltered there. For his rescue work, Palazzini was later named a Righteous
Among the Nations by Yad Vashem in Israel.

18. Archivio Seminario Lombardo, b.7.A.77, *1943: Periodo clandestino*, list of 110
outsiders sheltered at the seminary in December 1943. Henceforth cited as
ASL.

19. ADSS, 10, doc. 219, notes of the Secretariat of State, June 2, 1944, 300.

20. The letter from the seminary archives is printed in Carlo Badala, "Il
Coraggio di accogliere," *Sursum Cordo*, anno LXXVII, n. 1, 1994, 43–6, 44.
Don Badala is a parish priest in Rome and a skilled historian.

21. ASL, b.7.A.73, *Diario*, "Appendice," 17–18.

22. ADSS, 10, doc. 53, Monsignor Guido Anichini, head of the Canonica di San
Pietro to Pius XII, February 13, 1944, 127–9, and attached note by
Monsignor Domenico Tardini, Secretary of the Section of Extraordinary
Ecclesiastical Affairs at the Vatican Secretariat of State, 129.

23. Delasem is an acronym for the Delegazione per l'assistenza agli emigranti.

After the Fascist Grand Council's vote of no confidence in the Duce, and with the more or less explicit consent of the armed forces, King Vittorio Emanuele III dismissed Mussolini as head of government on July 25, 1943, and replaced him with Badoglio. The occupying Germans reinstated Mussolini on September 12, 1943.

24. For details of this story, see Zuccotti, *Under His Very Windows*, 233–59.

25. "We remember," 55–6. The note cited *L'Osservatore Romano*, September 8, 1945, 2, as its source.

26. "We remember," 56; from *L'Osservatore Romano*, September 23, 1945, 1.

27. "We remember," 56; from *L'Osservatore Romano*, November 30, 1945, 1.

28. "We remember," 56. The note provided no source.

29. Among many other sources, expressions of Jewish gratitude to Pius XII are cited by Robert A. Graham, S.J., "Relations of Pius XII and the Catholic community with Jewish organizations," in Ivo Herzer, ed., *The Italian Refuge: Rescue of Jews During the Holocaust* (Washington, D.C.: Catholic University of America Press, 1989), 231–53; Pinchas E. Lapide, *Three Popes and the Jews* (New York: Hawthorn, 1967), 223–9; Leiber, "Pio XII e gli ebrei di Roma," 458; Joseph L. Lichten, "A question of judgment: Pius XII and the Jews," in *Pius XII and the Holocaust* (Milwaukee: Catholic League for Religious and Civil Rights, 1988), 128–30; and Margherita Marchione, *Yours Is a Precious Witness* (Mahwah, N.J.: Paulist Press, 1997), 56–7. I discuss the issue also in *Under His Very Windows*, 300–5.

30. The first reference came during the pope's Christmas message of 1942; the second occurred in an address to the Sacred College of Cardinals on June 2, 1943. In a third speech, on June 2, 1944, the pope referred to his compassion and charity for all, "without distinction of nationality or descent," but did not mention that people were dying. Also, the Vatican newspaper *L'Osservatore Romano* wrote of the pope's compassion and charity which did not "pause before boundaries of nationality, religion, or descent" on October 25–6, 1943, ten days after the German round-up of 1259 Roman Jews. Finally, the newspaper actually used the word "Jews" in two articles published in December 1943 to protest an Italian, not a German, decree ordering local police to arrest Jews and intern them within the country. For details, see Zuccotti, *Under His Very Windows*, 1.

31. See his article "The silence of Pope Pius XII and the beginnings of the 'Jewish Document'," *Yad Vashem Studies*, VI (1967), 6–25.

32. Giuseppe Nathan was the son of Ernesto Nathan, the first Jewish mayor of Rome, elected in 1907. For his experiences during the war, see Susan Zuccotti, *The Italians and the Holocaust: Persecution, Rescue, and Survival* (New York: Basic Books, 1987), xiii–xv.

33. Kubovy, "The silence of Pope Pius XII and the beginnings of the 'Jewish Document'." 18.

34. *Ibid.*, 19.

35. The play opened as *The Representative* in London on September 25, 1963, and as *The Deputy* in New York on February 26, 1964.

36. The article was originally published by the National Catholic Welfare Conference, a forerunner of the United States Catholic Conference. It was reprinted and widely distributed by the Catholic League for Religious and Civil Rights in Milwaukee in 1988, as cited above. Lichten's first article on the subject, "Pius XII and the Jews," had been even more extreme and irresponsible in its defense of the pope. It was published in the *ADL Bulletin* in October 1958 and reprinted in the March–April 1959 issue of *The Catholic Mind*.

37. For the opposition, see Garry Wills, *Papal Sin: Structures of Deceit* (New York: Doubleday, 2000), 19–26.

38. Declaration of the Second Vatican Council, *Nostra Aetate*, October 28, 1965, n.4.

39. Lapide's above cited *Three Popes and the Jews*, its title in the United States, was also published in Britain as *The Last Three Popes and the Jews* (London: Souvenir Press, 1967).

40. Cantoni to Repetto, letter cited in Minerbi, *Raffaele Cantoni*, 249.

41. Lapide, *Three Popes and the Jews*, 214–15.

42. Defenders of Pius XII, including but not limited to Ronald Rychlak, David Dalin, and William Doino, continue to insist that there *was* a precise papal directive to save Jews. They draw on problematic sources such as Pinchas Lapide, and on undocumented claims attributed to several prelates and priests, including Monsignors Giovanni Battista Montini and Angelo Roncalli (both later popes) and Fathers (later Cardinal and Monsignor, respectively) Pietro Palazzini and J. Patrick Carroll-Abbing. Although publication deadlines make it impossible to include the details of my latest research on this issue here, I have found no reliable evidence to support these contentions. The issue is not whether Pius XII knew, for example, that some religious houses were accepting fugitives, including Jews, or whether he gave permission for such activities. The issue is whether there are verifiable sources and clear documentation of a papal directive for Jewish rescue—as opposed to second-hand reports of unprovable conversations or of declarations for which absolutely no evidence exists. For example, claims by papal defenders that Roncalli and Carroll-Abbing told them personally of a papal rescue order were both published after the two clergymen were dead. Lapide provided no documentation for Montini's alleged claim, and there is no evidence of Palazzini's declaration in his file as a Righteous Among the Nations at Yad Vashem, where he supposedly made it. A fuller report of my own research on this subject will appear in a forthcoming issue of the *Journal of Modern Italian History*.

Michael Phayer

Ethical Questions about Papal Policy

Hitler's Pope, John Cornwell's biography of Pope Pius XII, appeared in 1999, about three years after Daniel Goldhagen published *Hitler's Willing Executioners*, his study of Germans and the Holocaust. To their credit, the Cornwells and Goldhagens of the print world keep the public's attention focused on important Holocaust questions. However, both writers zeroed in on just one point, antisemitism, to explain Pope Pius XII and, in Goldhagen's case, the Germans regarding the Holocaust. What motivates a person and, even more so, masses of people is in reality much more complex. Is it possible to understand history without sacrificing the allure of simplicity? Can we figure out with some degree of certainty what fears, hopes, and feelings led Pope Pius XII to deal with the terrible reality of the Holocaust in the way he did? To do so is indeed a challenge.

For whatever reason, opinion is more divided on Pius than on any of his notable contemporaries, Franklin Roosevelt, Adolf Hitler, Joseph Stalin, or Winston Churchill. Why is this? A number of considerations, I suppose, account for it, including the following: where Pius XII is concerned, Jews and Protestants would be likely to have a somewhat different "take" from Catholics; Catholics themselves differ depending on their conservative or liberal bent; nationality would certainly play a role. African Catholics, who are now more numerous than North American Catholics, would probably not understand the "Western" views of Pius.

Other reasons for strong differences of opinion about Pope Pius XII are rooted in historical circumstances. A polarization of opinion arose immediately after *The Deputy*, Rolf Hochhuth's play, was first staged in the early 1960s, just a few years after the pope's death in 1958. Historical memory also figures in. People such as Gerhart Riegner, who appeared on "60 Minutes" in connection with the publication of Cornwell's book, and who was a first-hand witness to the Holocaust, may remember things somewhat differently after 50 years than earlier in his career. One final

point is perhaps most important. As long as the Vatican archives remain closed, there will not be closure to suspicion or to the debate about Pius XII and the Holocaust. Considering all of the factors that contribute to a difference of opinion about Pius, the task of evaluating his papacy during the Holocaust is not an easy one. As much as possible, the assessment demands an approach that is as unemotional, disinterested, and deliberate as sound scholarship permits.

Historians always depend upon and interpret documents. Since interpretations are bound to vary at least to some extent, an historical discourse quickly arises. Discussing Hitler's antisemitism is certainly a valid field of historical interpretation because of the abundance of documentary evidence available to us. But is a discussion of Pius XII's antisemitism a valid field? I hardly think so. There is scant documentary evidence bearing on the question of Pope Pius's antisemitism and what there is of it is contradictory.

Nevertheless, the question of Pius XII and the Holocaust remains a matter of interpretation of documents. Although it is very likely that the Vatican has not released all of its Holocaust-related documents or that some of them were intentionally destroyed after the war, still the documents at hand are voluminous. Rather than look for one blanket solution—such as his alleged antisemitism—to the question of why Pius did not protest against the Holocaust, we are able to review these documents to find specific historical circumstances to explain the pope's actions and inactions. Only in this way can we hope to avoid the "over-kill" of Pius's detractors and defenders, because, as a matter of fact, the pope sometimes helped Jews during the war and sometimes failed to do so.

Having made these points, I admit that there are pitfalls and detours ahead. Documents, for example, do not necessarily agree, even if they come from the same source. Or, a number of different documents might give differing explanations for the same development. Such is the case with Pope Pius XII. The Vatican gave different reasons at different times for its action or inaction regarding Jews during the Holocaust. This fact led the German historian Hansjakob Stehle to conclude that the Vatican simply did not know what to do on a day-to-day basis.[1] But it is also possible that the pope found himself in a position in which he could scarcely divulge his reasons for not being forceful and explicit in condemning the Holocaust.

Pius XII and the Holocaust: a flawed judgment

"Why did he not speak out?" That question is the one that is always raised about Pius XII and the Holocaust. Nevertheless, in my view this question is not the most important, because there were ways of intervening other than public protest. Still, the question is important, and not least because many of the pope's contemporaries asked it repeatedly. Certainly there was ample time for speaking out. The Vatican's firm knowledge of the Holocaust dated from early 1943, and the pope knew about genocides in Croatia and Poland in the years just before the murder of the Jews became unrelenting. Thus, we are talking about genocides occurring over a five-year period of time.

What did Pius or his clerical spokespersons say when asked why he did not use his moral authority to condemn the murder of civilians and Jews in particular? A review of the documents indicates that a number of different reasons were given at different times. One explanation stressed that it was unnecessary to speak out because whenever and wherever cardinals and bishops denounced Nazi crimes, or other crimes throughout the world, they spoke for the pope. This is what Harold H. Tittmann, the American chargé d'affaires at the Vatican, was told in September 1942.[2] Reference was made specifically to France and Germany, among other countries, in this connection.

If we accept this explanation, it seems that we must do so conditionally. For such an explanation to have full credibility, it would have been necessary for the pope to inform the bishops in Western Europe about the murder of the Jews—in other words, to relate all the details as the Vatican knew them in 1943. Pope Pius XII never did this. For example, Pius wrote more than a hundred letters to German bishops during the war. Jews were seldom mentioned, the atrocities not at all.

The most common Vatican explanation for papal silence was that the pope, knowing that he could not deter Hitler, refrained from saying anything to avoid making conditions even worse for the victims of Nazi persecution. There is one instance—the seizure of the Roman Jews in October 1943—when this explanation makes sense. In most cases, however, it does not. Leading Polish bishops begged the pope to speak out when Polish Catholics were being murdered. When Pius told them that he did not wish to make matters even worse by speaking out, Polish Church leaders told him not to worry because matters could not get any worse.[3]

This Polish experience took place before the actual Holocaust began. When the murder of the Jews was in full swing, Pius had recourse to the same explanation, even though it had been discounted by Polish Catholic victims. This explanation occurred most famously regarding the fate of Dutch Catholics of Jewish origin who were seized after Archbishop Johannes de Jong spoke out against the Nazis. Sister Pasqualina Lehnert, the pope's confidante and general secretary, later (much later) recalled this instance vividly, recounting how Pius burned the papers on which he had jotted down his denunciation of the deportation of the Dutch Catholic "Jews," saying that he could not jeopardize the remaining Catholics in Holland.[4]

Several considerations make it difficult to accept this explanation at face value. The pope knew that what was happening to European Jews was even more disastrous than the fate of some Catholic Poles. Could matters really get any worse in the face of European-wide genocide? We must also remember that, by speaking out, the pope might well have saved more Jews than he endangered, for they would have it from no less an authority than the Holy Father that they were in mortal peril. (I am thinking here of the Jews in Italy and in Hungary who had not yet been molested.) Also, we must ask why the pope did not denounce Nazi genocide later on when the Jews had already been murdered.

What, then, were the real reasons for papal silence? Having rather painstakingly sorted through Vatican justifications for silence, I have come to the conclusion that Pius had two reasons for not speaking out about the Holocaust, neither of which he could admit in a public forum. They were, first, his fear of Communism and his belief that Germany would defend Europe from it, and, secondly, his fear that Hitler might destroy the Vatican, probably by aerial bombardment, if he spoke out. Closely related to the first point was Pius's hope that he could play a leading role in mediating a peace that would have allowed Germany to remain a major force against Communist Russia. This hope was considerably diminished after Prime Minister Churchill and President Roosevelt announced in 1942 at Casablanca their intention of waging a war that would bring about Germany's complete defeat and unconditional surrender.

Pope Pius's commemoration of the twenty-fifth anniversary of the 1917 apparitions of Mary at Fatima, Portugal, clearly signals to us his first fear, Communism, which, not coincidentally in the pope's mind, took root in Russia that same year. It was believed that one of the secrets disclosed

by the Virgin to the three Portuguese children called for the conversion of the world, especially Russia, through Mary's intercession. Pius XII called together the entire diplomatic corps in full dress and the faithful of Rome to celebrate the anniversary of Fatima with him in St. Peter's Basilica in 1942. Radio broadcasts carried the event live to Portugal. By identifying in this way with the Fatima apparitions, Pius inaugurated a massive movement that became known throughout Europe and the United States as "the Blue Army of Mary." During the Cold War era, millions of Catholics sought Mary's intercession to bring down Communist Russia. We have to underscore, however, that the "Blue Army" movement began, not during the Cold War, but in 1942. Astonishingly, in the middle of a war begun by Germany, during which Hitler engaged in the mass murder of Jews, Pope Pius called for peace through the conversion of Russia!

Pope Pius's wartime diplomacy also provides a record that corroborates his fear of Communism. A negotiated peace became an overriding concern for the Holy See. Before the 1942 battle of Stalingrad, Pius believed that the Americans should help the Russians, but with restrictions so that hostilities on the Eastern Front remained far from Germany. After Stalingrad and the Allies' successful invasion of southern Italy in July 1943, Pius hoped that England and the United States would abandon the Russians, so that Germany could deal with the Communist threat. Ideally, he hoped England would recognize the danger Communism posed for the Christian West and conclude a separate peace with the Axis powers.[5]

Because of the wartime circumstances from 1942 to August 1944, the pope's second fear—the destruction of Rome and the Vatican— became more acute than the first. These years saw Pius spending most of his energy (successfully) solidifying Vatican relations with Germany and putting as much pressure as possible (unsuccessfully) on the Allied powers to gain assurance that they would not bomb Rome. The archival evidence of the pope's efforts in this connection is abundant.[6]

Of course, the pope could scarcely say openly that saving Rome and the Vatican from destruction was a higher priority than the murder of the Jews. Privately, however, Pius opened his mind and spoke from the heart. He did so, for example, in his March 21, 1944, letter to Bishop Konrad von Preysing of Berlin. This document, I believe, is the single most important one for arriving at an accurate historical interpretation of Pius and the Holocaust.[7] Pius told Preysing that he was "conscience

bound" to do all that he could to save Rome from destruction because, from the beginning of Christianity, the city had been the center of Christendom. Pius believed that the faith of Catholics around the world would be shaken if Rome were to be destroyed.

After the Germans retreated from Rome and the Americans occupied the city, the danger of Rome's becoming another Stalingrad had passed. At that point, Pius's attitude about the Holocaust changed as well. With the Germans still in northern Italy, the Jews there faced "resettlement," and the Vatican was asked to intervene on the Jews' behalf. Pius, now "eager to co-operate in the endeavor to save Jewish lives," told Myron Taylor that he would urge Ernst von Weizsäcker, the German ambassador to the Holy See, to press his government to desist from further deportations. As Meir Michaelis sums up the point, "the pope declared that neither history nor his conscience would forgive him if he made no effort to save at this psychological juncture further threatened lives."[8]

To the best of my knowledge, these are the only two occasions when Pope Pius made reference to his conscience. In the first instance, he said that he could not protest against the murder of the Jews because of retaliation against Rome (coming from Germany); in the second, after the danger to Rome had passed, Pius said that he could no longer keep silent about Germany's treatment of the Jews. (But note that he only promised to ask the German ambassador to urge his government to desist in "transportations.") The evidence is convincing: Pope Pius kept silent about the Holocaust because of his fears for the destruction of the Eternal City.

Is this a valid reason not to protest against the Holocaust? Perhaps more importantly, were Pius's words to Preysing truthful and sincere? Giving him the benefit of doubt, I find it credible that Pope Pius XII could genuinely entertain such thoughts. Pius made a critical mistake, but he made it without malice. His judgment was flawed.

My interpretation is just that, an interpretation. I can readily see that another historian could arrive at the opposite interpretation, namely that for Pope Pius XII the Jews were expendable. When the basilica of San Lorenzo in Rome was badly bombed in July 1943, Pius immediately visited it and commiserated with the Romans. Yet three months later he failed to visit the train station to commiserate with the Roman Jews who were being packed off to Auschwitz.

Pius XII, the Holocaust, and the Cold War:
unethical conduct

For Pope Pius XII, the Cold War began in 1945 not 1948. With the war over, there was no longer a danger of Rome being destroyed by bombs. But the pope's other great fear, Communism, hung over Europe, over Rome, and over him. For Pius, the Soviet occupation of Eastern Europe and eastern Germany was extremely worrisome, not the Germans who had just murdered between five and six million Jews.

Hoping to shore up the post-war situation of the Church against Communism, Pius XII met with Generals Dwight Eisenhower and Mark Clark in September of 1945, just a few months after the war's end. Believing that a groundswell of support would emerge for the restoration of the Hapsburg monarchy in Austria and for the creation of an entirely new, great monarchical state in Catholic Central Europe (including parts of Germany and also embracing Croatia, Hungary, and Slovakia), Pius pressed the generals to let the voice of the people be heard.[9] Not surprisingly, history texts have not taken note of this "movement."

The inability of Europe to improve economically during the immediate post-war years gave Communism political vitality even in Western Europe. With that vitality so close to Vatican City, the pope was extremely worried about the success of the Communist party in national elections, and about the attraction of youth to Communism. Because of these concerns, Pius overlooked some Holocaust-related issues and dealt with others in an ethically questionable manner.

In particular, there were two issues that Pius preferred not to attend to, at least not in a manner that would benefit European Jews after the war. When the Kielce, Poland, pogrom broke out in July 1946, taking the lives of more than 40 Jews, the French ambassador to the Vatican, Jacques Maritain, and the Jewish liaison officer to the Occupational Military Authority—U.S. (OMGUS), Rabbi Philip Bernstein, urgently pressed Pius to intervene. Before the Holocaust, Maritain, the great Catholic intellectual, had emerged as the most eloquent Catholic spokesperson opposing Nazi antisemitism. After the Holocaust, but before Kielce, Maritain articulately urged Pius to become the spiritual leader of Europe by crusading against antisemitism in memory of the six million Jews. Even after Kielce, Pius did not respond positively to the pleas of the rabbi or the ambassador.[10]

A second issue concerned survivors of the Holocaust who fled Eastern Europe, mostly after Kielce. A quarter of a million of these survivors, the majority of whom lived in displaced persons' camps in Bavaria, sought a permanent home in Palestine. Rabbi Bernstein brought their desire to the pope's attention, but Pius opposed the idea of Palestine becoming a Jewish homeland, preferring that the Jews emigrate to the United States.[11]

An additional and related issue that invites close probing of Pius XII's judgment concerns war criminals—including those who had murdered Europe's Jews. While turning a blind eye to post-Holocaust antisemitism, Pope Pius exhibited solicitude in a number of ways toward criminals and fugitives from justice. The evidence indicates a pattern of Vatican action in this regard.

Toward the end of the war, a U.S. intelligence report, not judged as highly reliable by the Office of Secret Service, asserted that the Vatican had instructed the German clergy not to identify Nazis for the occupational authorities.[12] True or not, the report accurately reflects Pope Pius's attitude toward Nazi war criminals. A second early sign of his sympathies occurred in January 1946. At that time, the U.S. Department of State had appealed to all wartime neutral countries to provide a list of Germans residing within their borders for the purpose of repatriation to occupied Germany. The records of the state department report that Vatican cooperation with the request was "negligible" (even though the Vatican had promised in 1943 to abide by international law in such matters).[13]

By 1946, the Nuremberg trials of the principal Nazi racists were under way, and soon thereafter the authorities in each of the four German zones of occupation brought to justice more of the many individuals who perpetrated the Second World War and the Holocaust. For the major perpetrators, the resulting convictions carried sentences ranging from capital punishment to life imprisonment. Very soon it became evident that Pope Pius opposed these trials. In March 1946, Bishop Clemens August Graf von Galen—the "Lion of Münster" who had dared to challenge the Nazis on euthanasia—published an address in Rome in which he sharply attacked the Nuremberg "show trials" (the International Military Tribunal at Nuremberg). The trials, Galen said, were not about justice but about the defamation of the German people.[14] Soon after these pronouncements, Galen was one of three German bishops elevated to the cardinalate by Pope Pius XII.

Along with German bishops, the pope began to take the initiative to have the death sentences and life sentences of convicted killers commuted.[15] In October 1948, when the ban on executions of war criminals was lifted after a special committee had found their trials to have been substantially just, Josef Cardinal Frings of Cologne sent the American military governor of Germany a telegram protesting against this decision. Coordinating his action with that of Frings in Germany, Pope Pius XII urged U.S. President Harry Truman to show leniency toward the condemned.[16] Later, the Vatican pressed General Lucius D. Clay, U.S. Military Governor of the American occupation zone in Germany, to extend a blanket pardon to all war criminals who had received death sentences, something that Clay refused to do, arguing that these individuals had been found guilty of specific, heinous crimes.[17] Polish authorities also refused Pius's plea to spare the condemned Nazi Arthur Greiser who had obliged Himmler with more than 100,000 murders during the early months of the Holocaust.

When the Vatican persisted in this matter, Pius's American envoy to occupied Germany, Bishop Aloysius Muench, warned the Vatican that it was in danger of being accused of collusion with a Nazi organization, the Association for Truth and Justice (*Bund für Wahrheit und Gerechtigkeit*). "This is why," Muench explained to Pius's close confidant, Monsignor Giovanni Montini, "I have not dared to advise the Holy See to intervene, especially if such intervention would eventually become public."[18]

Finally, there is the matter of the Vatican and Fascist fugitives from justice. I no longer doubt that the Vatican, directly or indirectly but in either case knowingly, abetted fugitives from justice who found refuge in Rome at the war's end. "Knowingly" applies to Monsignor Montini and to the pope himself. During the Croatian genocide, the Vatican had compiled a list of priests who participated in atrocities. The intention was to discipline them in peacetime.[19] When the war ended with a Communist state in the Balkans instead of a Catholic Croat state, the Vatican's resolve evaporated. Instead of punishing Croatian clergy, they were allowed to stay on Vatican properties.[20] Furthermore, there are questions about the Vatican's abetting the escape of these fugitives from Europe to South America and whether the Vatican knew that victim gold was being used for this purpose.[21]

Conclusion

In the first part of this chapter, I concluded that Pius XII had acted in poor judgment but not unethically (not conclusively so, at any rate) during the war and the Holocaust. In the chapter's second part, I have argued that some of the pope's post-Holocaust actions were not ethically defensible. Does Pius's post-war conduct throw a dark shadow on his inaction during the Holocaust itself? Considering the pope's Cold War improprieties, would not most people square the circle by concluding that he also acted unethically during the Holocaust itself?

One reality that we have overlooked thus far is Pius's assistance for Jews during the war. He certainly did not do all that could have been done for them, but he expressed his sadness for the Jews and actively helped them to a limited extent, both diplomatically and materially. Not for nothing did world Jewish leaders thank Pius after the war.

This concern for the Jewish people carried over into the post-war era. When Rabbi Bernstein visited the pope in 1946 after the Kiecle pogrom, he was disappointed by the pope's reaction to that atrocity, but at the same time he was impressed by Pius's charity toward Holocaust survivors. At little or no expense to them, Bernstein noted, the pope was sheltering a large number of Jewish displaced persons on Vatican property in Rome or its vicinities.

Is this not an astonishing inconsistency? While Pius extended one hand protectively over Jews, he reached with the other hand to free criminals and fugitives from justice—the very perpetrators of crimes against the Jewish people. But do not world leaders often act inconsistently? Was it not inconsistent for Abraham Lincoln to free the slaves in the rebel states during the Civil War but not those in the union states? Among Pius's contemporaries, was it not exceedingly inconsistent for President Roosevelt to proclaim grandly in the Atlantic Charter the freedoms of humankind while, on the west coast of the United States, Japanese-Americans were being deprived of their freedom?

Clearly, political leaders do not act consistently at times. But by mentioning this we should not delude ourselves into thinking that it throws a softer light on Pius XII. On the contrary. For political leaders to act inconsistently out of expediency is one thing; for the pope, the spiritual leader of much of the world, to do so is quite another. This point is exactly the one that a disappointed Jacques Maritain made upon

leaving his post as France's ambassador to the Holy See: "One is tempted to say that [Pope Pius XII's] attention to the political is too much considering the essential role of the church."[22]

To what political realities was Maritain referring? Communism and the fate of Vatican City should the Communists come to power in Italy. These were, of course, precisely the same matters that so much concerned Pius during the war. After the war, as Communism crept ever closer to Western Europe and to Rome itself, Pius became obsessed with its danger to the Church. Driven by his anxiety, Pope Pius acted unethically by helping anti-Communist, Fascist war criminals, for it is fundamental Catholic teaching that the end does not justify the means.

Although we may harbor suspicions, we cannot conclude from the pope's post-war impropriety that, with reference to his decisions regarding Jews, Pius also acted unethically during the war. We may certainly disagree with his decisions and find them unworthy of the papal office, but we have no cause to assert that the pope acted callously toward Europe's Jews. Both during the war and post-war eras, Pius XII severely limited his activities on behalf of Jews, but he harbored no malice toward them.

NOTES

1. Hansjakob Stehle, *Geheimdiplomatie im Vatikan: Die Päpste und die Kommunisten* (Zurich: Benzinger, 1993), 194. I argue, on the contrary, that Pius XII's policies were very consistent.
2. National Archives RG 59 740.00119, Tittmann Memorandum No. 109, September 8, 1942.
3. For a detailed discussion of this theme, see Michael Phayer, *The Catholic Church and the Holocaust 1930–1965* (Bloomington: Indiana University Press, 2000), 20–30.
4. M. Pasqualina Lehnert, *Ich dürfte Ihm dienen: Erinnerungen an Papst Pius XII* (Würzburg, n.p.: 1983), 117–18.
5. See Phayer, *The Catholic Church and the Holocaust*, 41–66.
6. *Ibid.*
7. Pius to Konrad von Preysing, the Vatican, March 21, 1944. Bistumsarchive Berlin V/16-4, Korrespondenz 1944–1945. Pius begins his letter: "Before me lie your eight letters of 1943 and 4 letters of 1944."
8. Meir Michaelis, *Mussolini and the Jews: German–Italian Relations and the*

Jewish Question in Italy 1922–1945 (Oxford: Clarendon Press, 1978), 395. Michaelis's judgment is verified by the records of the U.S. Foreign Office; see Foreign Relations of the United States (FRUS) I, 1123: the "Pope told Heathcote-Smith neither history nor his conscience would forgive him if he did not make this effort."

9. National Archives RG 84, Foreign Service Posts of the Department of State "Top Secret" file 1944–47, 822–844, Box 5. The audience with Pius took place on September 15, 1945.

10. For more detail on these themes, see Phayer, *Catholic Church and the Holocaust*, 159–83.

11. National Archives RG 59, Box 28, NARA; Bernstein to Gen. J. T. McNarney, September 14, 1946.

12. National Archives RG 226, entry 14, Box 427, Records of the Office of Strategic Services.

13. See Phayer, *The Catholic Church and the Holocaust*, 159–83.

14. Clemens August Graf von Galen, "Rechtsbewusstsein und Rechtsunsicherheit" (Rome, March 1946). Printed as a manuscript.

15. Catholic University of America Archives, 37/133 No. 112.

16. Ernst Klee, *Persilscheine und falsche Pässe* (Frankfurt: Fischer, 1991), 67.

17. Jean E. Smith, *Lucius D. Clay: An American Life* (New York: Holt, 1990), 301–2.

18. Muench to Giovanni Battista Montini, Kronberg, February 24, 1951, Catholic University of America Archives 37/133 No. 2.

19. U.S. National Archives RG 59, Box 28, NARA.

20. Strictly speaking, national seminaries are not Vatican property, but the Holy See can exert control over them. Other buildings in Rome, such as the Oriental College, do belong to the Vatican. Refugee Croatian priests found shelter in both types of institutions.

21. For a more extensive discussion of the Vatican's involvement with fugitives, see Phayer, *Catholic Church and the Holocaust*, 165–75.

22. Le Centre d'Archives Maritain de Kolbsheim, Cahiers Jacques Maritain, 4, Ambassade I.

James J. Doyle

The Catholic–Jewish Dialogue: A View from the Grass Roots

The horrors of the Holocaust have made very many people speechless. For them, the only responsible reaction is respectful silence. Elie Wiesel has suggested that the Holocaust transcends language. Echoing that view during his March 2000 visit to Yad Vashem, the Israeli Holocaust Memorial in Jerusalem, Pope John Paul II said, "There are no words strong enough to deplore the terrible tragedy of the Shoah."

For many others, however, the Holocaust demands more than silence. For them, silence has been the problem, not the answer; such an epochal event requires honest inquiry and discussion. What were the long-term and short-term causes of the Holocaust; could it have been prevented; what lessons does the Holocaust hold for us today? These and many other questions are of concern to Jews and Christians alike, indeed to the entire human community. These questions demand responses.

In the early 1960s, *The Deputy*, Rolf Hochhuth's play, promoted popular interest in the role of the Vatican and Pope Pius XII during the Nazi era. As a result, from about 1963 to the present, the literature on this matter has proliferated. It has been both scholarly and popular, sober and sensationalist, exonerating and condemnatory. As for Pope Pius XII, how much did he know, and when, of the Nazi genocidal plan; what were his options; was he "silent"; could he have done more; what influenced his decisions; what were his motives; what kind of man was he, saint or villain? Ultimately, was there a failure in moral responsibility on the part of the Roman Catholic Church and its leadership at this crucial period of modern history?

Scholarly debate about these questions can be contentious and divisive. Such is the price that must sometimes be paid for clarification and the dialogue that produces it. Where Pope Pius XII and the Holocaust are concerned, consensus may not be easily achieved, for the research

continues and its findings are still being sifted and sorted. As this important work develops, I am concerned about the divide that often seems to separate critical scholars from the rank and file at the grass roots of Catholic faith. The best scholarship about Pope Pius XII can create considerable dissonance for people who have traditionally been taught to see this pope in ways that differ from sound research. At the grass-roots level, how might a pastor narrow this divide?

The primary task is to provide more adequate adult religious education in our parishes. Specifically, the typical Catholic in the usual parish needs to be better informed about:

- Ancient Judaism, particularly as the Hebrew Bible presents it
- Judaism in the time of Jesus and Jesus' immersion in it as a faithful and observant Jew
- The Jewish roots of Christianity
- Christian–Jewish relationships over the centuries, including the history of antisemitism
- The Holocaust, its background and history
- The current debate concerning the role of the Vatican and of Pope Pius XII before, during, and after the Holocaust

In addition, the grass-roots Catholic needs to become familiar with official Catholic teaching on Catholic–Jewish relations. Adequate adult education in this area would begin by emphasizing the following key texts:

- Vatican II's "Declaration on the Relationship of the Church to non-Christian Religions, #4" (1965)
- "Guidelines on Catholic–Jewish Relations," by the U.S. National Conference of Catholic Bishops (1967)
- "Notes on the Correct Way to Present Jews and Judaism in Preaching and Catechesis," by the Vatican's Commission for Religious Relations with the Jews (1985)
- "Within Context: Guidelines for the Catechetical Presentation of Jews and Judaism in the New Testament," by the Secretariat for Catholic–Jewish Relations of the National Conference of Catholic Bishops (1986)
- "God's Mercy Endures Forever: Guidelines on the Presentation of Jews and Judaism in Catholic Preaching," by the Committee on the Liturgy of the National Conference of Catholic Bishops (1988)

- "We Remember: A Reflection on the *Shoah*," by the Commission for Religious Relations with the Jews (1998)

A close examination of these documents from 1965 to the present day will reveal a clarification of thought and a development of theological insight. This development can be attributed in large measure to the input of Jewish scholars and the willingness of Catholic leadership to listen to their reactions.

Priests, deacons, catechists, and seminarians alike need education in these areas to convey more adequately the Church's teaching to those they instruct. Given the broad scope of the material, nothing short of workshops, seminars, and courses (where possible in cooperation with Catholic universities, colleges, or institutes) will suffice. Meanwhile, individual pastors should offer homilies at the liturgy that clarify the lectionary readings which all too often give rise to negative images of the Jews. For example, this can appropriately be done where the gospel reading refers to the "Pharisees," and to the "Jews" in the gospel of John.

Cardinal William Keeler of Baltimore and Dr. Eugene J. Fisher of the U.S. Bishops' Secretariat for Ecumenical and Interreligious Affairs, speaking of the implications of the 1998 document "We Remember," say that, in addition to the joint scholarly work of studying the evidence surrounding the Holocaust so as to heal memories, we must in our educational programs rethink old categories and correct our misunderstandings of Judaism and of the New Testament. For Catholics to do less, they say, is not to take the Holocaust seriously. When Catholics do respond to the Holocaust in faithful seriousness, I believe that this reflection should encourage the following results:

- Sorrow and repentance (*teshuvah*) for any complicity or indifference on the part of Catholics in general and Catholic leadership in particular during the Holocaust and a seeking for forgiveness for such complicity or indifference.
- A sincere effort to root out of the Catholic mentality anything that might serve as the seedbed for future prejudice and bigotry against the Jews and to join in solidarity with the Jews to proclaim "Never again!"
- A concern for the rights of all others and a vigilance that the strong and powerful, including governments, should not be allowed to chip away at the human rights we all share, whatever our religious faith may be.

- Taking a public stand against all violations of human dignity, wherever perpetrated, by whomever perpetrated, and on whomever perpetrated. Here Catholics and Jews must work together in a way not always true in the past.

A recurrent and acutely painful issue in the Catholic–Jewish dialogue has been that of proselytism—Christian efforts to convert Jews. The 2000 declaration *Dominus Iesus*, issued by the Vatican's Congregation for the Doctrine of the Faith, has rekindled the controversy. The declaration aims at stating the Catholic Church's understanding of its relationship with other religions. While thought to be concerned chiefly with the Church's relations with religions in the Asian context, the declaration's views touch on Catholic–Jewish relations as well. The declaration warns about tendencies toward relativism and indifference that it perceives in certain Catholic theological views. The danger it detects in such tendencies is that they minimize the centrality of the saving work of Jesus ("the universality of the salvific event of Jesus Christ") long taught by the Church. Similarly, the declaration asserts that to downplay Jesus' saving work is to minimize the saving mission of the Church to the world. Exactly how God does his saving work beyond the boundaries of the Church remains a highly undeveloped area of theology and precisely for that reason lends itself to current theological speculation.

At the time of this writing, the reaction to the declaration worldwide has been mixed. Many long-time participants in interfaith dialogue are disappointed and dismayed, even predicting the end of the era of dialogue. Others, among them Cardinal Roger Mahony of Los Angeles, say there is no going back. In a September 9, 2000, statement, Cardinal Mahony said that the declaration may not fully reflect the deeper understanding that has been achieved through ecumenical and interreligious dialogue of the last 30 years or more. He pointed to Pope John Paul II's visit to Assisi in 1986, his 1987 visit with interreligious leaders in Los Angeles, and his recent visit to the Holy Land as representing a different approach to interreligious relations than the declaration seems to imply.

The Catholic–Jewish dialogue must continue on both the scholarly and grass-roots levels. The tragedy of the Holocaust demands our most honest and thorough scrutiny so as to know why the Holocaust happened and so as to prevent a Holocaust or anything like it from ever happening again.

John K. Roth

"High Ideals" and "Innocuous Reaction": An American Protestant's Reflections on Pope Pius XII and the Holocaust

> *Pope Pius XII's high ideals, transcending as they did opposing interests and rival passions, will always make difficult the task of understanding his policy and personality.*
> Pierre Blet, *Pius XII and the Second World War*

> *Hitler himself could not have wished for a more convoluted and innocuous reaction from the Vicar of Christ to the greatest crime in human history.*
> John Cornwell, *Hitler's Pope*

Late in the Summer of the year 2000, the conservative Catholic scholar Michael Novak used his *First Things* article, "Pius XII as Scapegoat," to ask who benefits by "denigrating" or choosing "to beat up on Pius XII."[1] In Novak's view, Pius was a wartime "prisoner in the Vatican" who had "cold steel in his spine." Judging that "coolness under fire would allow him to shepherd such strengths as could be deployed to alleviate suffering," Novak sees Pius as "steady and courageous," indeed as so far above reproach that criticism about the pontiff's response to the Holocaust "cannot stand scrutiny" and should be exposed as the scapegoating that Novak thinks it is.[2]

Coupled with the scapegoating charge, Novak's defense of the pope's virtues implies not only that Pius's critics distort history but also that they have done so in attempts to gain unwarranted, if not unjust, advantages of their own. Some criticism of Pope Pius XII fits Novak's charge that it warps history and serves vested interests—the same can be said of some defenses of Pius, too—but Novak's analysis overgeneralizes and allows scant room for scholarly and Christian disagreement with his

historical interpretation. This point is important because two crucial matters are at stake and related as one thinks about Novak's position. Is his historical analysis valid? How well does his description of Pope Pius XII fit a sound Christian understanding of the role that the most visible and influential Christian leader of his time should have played during the tumultuous years of his papal reign?

Michael Novak's post-Holocaust world

The two questions raised above will lead beyond the confines of Novak's brief but pointed article in *First Things*, but it will be instructive to follow his explicit analysis a bit further. Notice, then, Novak's view that no sooner did Nazi Germany collapse in the Spring of 1945 than the "scapegoating" of Pope Pius XII began. Although he dubiously asserts that Stalin feared Pius's "moral power" more than he had feared Hitler—how he knows this, his essay does not say—Novak's ground is firmer when he reports that Soviet propaganda "turned full-bore on Pius XII" to pave the way for Communist regimes in key parts of Catholic Europe. Then there was *The Deputy*, Rolf Hochhuth's 1963 play, whose anti-Vatican misrepresentations were conveniently overlooked or excused by those who wanted especially to deflect moral attention and pressure away from what Novak problematically labels "Protestant and pagan Germany."

More recently, Novak adds, some Jews and Catholics—including "former priests and seminarians"—have become fellow-travelers on the critical bandwagon. The former, he suggests, have denounced Pius XII—claiming he should have used his wartime knowledge to issue warnings to beleaguered Jews and to protest against genocidal Nazis—because Jewish failure to grasp what was happening, and the post-war recriminations that followed, were too much for many Jews to bear. Here, if Novak's faulty historical account does not blame the victims, he comes close enough to that questionable tactic to give one pause. As for the Catholic critics, Novak's brush tars them with discrediting Pius XII to diminish "the papacy in general," a step he thinks they have deemed necessary to advance their liberal agendas.

Allegedly tainted by papal scapegoating as it is, Novak's post-Holocaust world is a peculiar one. Apparently, his view suggests, those who stood to gain the most from criticism of Pope Pius XII were

Communists, German apologists of one kind or another, anguished Jews who want to escape the possibility that world Jewry could have done more to relieve Jewish plight during the Shoah, or liberal Catholics who dislike the papacy's traditional conservatism. At least in his *First Things* essay, Novak scarcely recognizes that criticism of Pius XII might not be ideologically driven or that his own historical understanding of Pius XII and the Holocaust might be less well grounded than he makes it out to be.

When, for example, Novak says of Pius XII that no wartime world leader "spoke as openly as he did or fed the world press with as much vital information about what was happening," judicious historical judgment is unlikely to be unified, let alone in agreement, about that appraisal. Similarly, when Novak contends that Pius XII exhibited cleverness as well as courage in "speaking out ... without formally violating neutrality," reasonable historical analysis will not easily endorse that claim.

Still further, when Novak writes that Pius XII "saved a large number of Jewish lives through opening convents, monasteries, and religious houses to clandestine sanctuary, and brought face-to-face, hand-to-hand relief to millions who suffered as refugees," no ideological axe-grinding is required to contest that claim. Nor is Novak as convincing as he would like to be when he wants to have the argument both ways: on the one hand, claiming that critics offer "nothing but speculation about what would have followed from ... an open, no-holds-barred papal condemnation of unprecedented evil," and, on the other hand, contending—presumably without any speculation—that, if Pius XII had been more confrontational toward Nazi Germany, the result would have been "draconian warfare on the Church" in which "the very best, ablest, and bravest would have been killed or imprisoned earliest. All would have been reduced to silent servility."[3]

The problems with Novak's confidence about his own historical claims multiply and intensify because his self-assurance never requires him to address what is arguably the most crucial question of all: namely, was Pius XII the Christian leader he should have been? Even if Novak's historical analysis is entirely correct, that is a fair question whose answer could still find Pius wanting, because Novak never makes the case that Pius did absolutely everything that might properly have been expected of him. But to the extent that historical scholarship finds Novak's defense of Pius XII wanting, and much of the leading scholarship in the field has that

outcome, then Pius XII's stature as the foremost Christian leader of his day becomes increasingly problematic. To fall back on a "scapegoating defense" to deflect criticism when the going gets tough for Pius XII's reputation as a Christian leader may be understandable as a strategy when the evidence is so strongly against a position such as Novak's, but that strategy is at best a rearguard action, and it is unlikely to trump the scholarship that rightly finds Pius XII unworthy of the veneration that sainthood would confer.

Christianity at its best?

John Cornwell's controversial *Hitler's Pope* provoked Novak's idiosyncratic defense of Pius XII. For the most part, however, Novak's essay unleashes sweeping, generalized indictments more than criticism directed at specifically named individuals. If he chose to turn his attention their way, scholarly critics such as Michael Phayer, Susan Zuccotti, and James Carroll would be unlikely to escape Novak's wrath. A word about their contributions to the debate about Pius XII will advance the line of inquiry I am pursuing.

In *The Catholic Church and the Holocaust, 1930–1965*, Phayer notes wartime communication between Pius XII and the German bishop Konrad von Preysing. Pius told Preysing that his papal responsibilities were the most difficult of modern times. Phayer credits the pope's evaluation, for he finds that "no other pope had to deal simultaneously with the problems of communism, world war, and genocide."[4] Accepting as fact that Pius XII and the Church "had no power over Hitler," Phayer thinks that during the Holocaust the pope sometimes helped Jews and sometimes did not, but "there was no deep-seated antisemitism in the man, contrary to John Cornwell's thesis in *Hitler's Pope*."[5] What did characterize Pius XII was what Phayer calls a sympathetic "preoccupation with Germany," a "fixation on diplomacy," and an "obsession with the threat of communism."[6] Driven consistently, even inflexibly, by these dispositions, Pius was a Christian leader whose "greatest failure, both during and after the Holocaust," Phayer says, "lay in his attempt to use a diplomatic remedy for a moral outrage."[7]

Phayer properly cautions his readers not to assume that "we today would act any more courageously than people of faith of another

time," but he finds—especially where moral support and financial assistance for relief of Jewish plight were concerned—there was much that Pius XII could and should have done during the Holocaust that would rightly produce "more words of praise and fewer words of regret for the history of the church during the Holocaust."[8] In sum, Phayer makes the point—contrary to Novak—that Pius XII "retreated from the ethical sphere" in favor of political considerations that depended on successful diplomacy. Without scapegoating, then, one can rightly say that politics and ethics are intertwined but not identical. Pius blurred the two in ways that proved costly for Christian credibility.

On October 17, 1943, Ernst von Weizsäcker, German ambassador to the Holy See, sent a report to his government. Susan Zuccotti indicates that the diplomat wrote the day after the Germans had rounded up 1259 Jews in Rome and the day before deportations took most of them to their deaths in Auschwitz. She takes the title of her award-winning book, *Under His Very Windows*, from Weizsäcker's report, which said, "I can confirm the reaction of the Vatican to the removal of the Jews from Rome. ... The Curia is dumbfounded, particularly as the action took place under the very windows of the pope, as it were."[9]

Contrary to Michael Novak, who thinks that Pius XII spoke out, "very strongly, in clear and unmistakable *principles*," Zuccotti shows that "the head of the Roman Catholic Church did not speak out publicly against the destruction of the Jews. ... Evidence of a public protest, if it existed, would be easy to produce. It does not exist."[10] Zuccotti believes that the factors behind Pius's reticence to protest against the Holocaust include, ironically, his fears for "the integrity of the Vatican itself."[11] In Pius XII's world-view, she argues, "the Church ... had to be defended in all places at all costs, for individuals could attain salvation only through the sacraments it offered."[12] Consequently, Pius XII was extremely reluctant to antagonize the Axis forces that controlled the Vatican's fate until the Allies liberated Rome on June 4, 1944. After that time, explicit protests against the Holocaust were embarrassingly late.

At the end of the day, Zuccotti concludes, not only were Pius XII and other leading figures in the Vatican "conservative bureaucrats" to whom "nothing could have been more alien ... than a loud radical act of direct public condemnation," but also "they seem to have forgotten that the pope was not only the leader of a government and an institution but also the spokesman of a Church whose moral and spiritual mission transcended practical considerations."[13] Against Zuccotti it might be

argued that Pius XII and his Vatican deputies forgot nothing, for no moral and spiritual mission could be more important than ensuring the eternal salvation of souls through Church-mediated grace. That point, however, only puts in bolder relief the issue that Zuccotti's analysis of Pius XII helps us to join: namely, from the perspectives of Christianity and ethics, how should this pope be evaluated? Did he represent Christianity at its best? Did his version of Christianity embody ethics at its best? Without scapegoating, Zuccotti makes an impressive case that the answer to both questions should be an emphatic "No."

For several weeks in 2001, James Carroll's *Constantine's Sword: The Church and the Jews, A History* achieved best-seller status. Authored by a former priest and still faithful Roman Catholic who says that "the Eucharistic bread keeps me alive, and I believe it always will," Carroll's history explores Catholic Christianity from the perspective of the Church's relationship with Jews, a perspective that, until the post-Holocaust Vatican II, combined what Carroll calls "an inability and a refusal to see Jews except through the clouded lens of the religious hatred that is the subject of [my] book."[14] *Constantine's Sword* begins with a trip to Auschwitz that Carroll took in conjunction with a writing assignment for *The New Yorker*, where some early parts of his book appeared before the 756-page volume was published. It was at Auschwitz, he reports, that he saw the ancient Christian symbol, the cross, "in its full and awful truth for the first time."[15]

The meaning of Carroll's phrase sheds additional light on Pius XII by deflecting attention from him as an individual Catholic leader and by putting the spotlight instead on a Christian tradition that took Jews to be a hostile counter-testimony to Christianity's truth. Until recent post-Holocaust times, the cross as Christian symbol of salvation has scarcely been separable from its signifying "the Jews" as Christianity's most decisively disconfirming, and therefore threatening, "other," for Christianity long regarded "the Jews" as those who rejected the Son of God, who was born in their midst as Jesus, a Jew from Nazareth. Steeped in this Christian tradition as he was, Pius XII is not so much the target of an indictment by Carroll as he is the evidence of Catholicism's "moral failure," which is embodied and epitomized in Pius's "silence" in response to the Holocaust. Importantly, when the word "silence" is linked to Pius XII's response to the Holocaust, it does not mean that Pius said or did nothing with regard to the Jews' plight under Hitler. For Carroll, the point is that Pius XII's leadership reflected attitudes and decisions that had been

entrenching themselves for centuries: namely, that in the final analysis Jews were not included decisively in the fundamental Christian obligations of respect, care, and love.

In Carroll's judgment, already in September 1933, after the Vatican Secretary of State Cardinal Eugenio Pacelli had negotiated the concordat between the Vatican and Hitler's Third Reich but well before Pacelli became Pope Pius XII, clear evidence of the Church's moral failure can be seen in the future pope's position with respect to Germany's baptized Jews. On September 2, 1933, Cardinal Adolf Bertram, Archbishop of Breslau, wrote to Pacelli to ask for help. He wanted Pacelli to petition the German government for relief from what Bertram called the "wretched fate" to which the Nazi regime would still subject the converts as racially defined Jews. Pacelli did as he was asked, and in the process he made clear that the Church's concern about "non-Aryan Catholics" did not extend to other "non-Aryans." Carroll's narrative continues as follows:

> Thus, right at the outset of the Nazi regime, and after its savage anti-Jewish intentions were indicated, the Catholic Church at its highest level sent a signal both to Hitler and to the German Catholic Church that the Jews, "facing a wretched fate," were on their own. The Church laid a tentative claim to authority regarding baptized Jews, which would be reflected in occasional objections to Nazi "racism," as opposed to "antisemitism," but otherwise, it would have nothing to say. As, indeed, it did not. Obviously, Hitler was not waiting for this signal before resolving to eliminate the Jews one way or another, but it surely helped him realize that the way ahead of him in this campaign was clear. The Church, for its part, had come to a decision it would stick with, almost without exception—that the "wretched fate" of the Jews was unconnected to its own fate, or to that of anyone else.[16]

Unlike John Cornwell, Carroll does not overtly press allegations that Pius XII was antisemitic. Such allegations about Pius as an individual would underplay the more basic point that Christianity, for centuries, has been tainted by a deep-seated antipathy toward Jews. It is no surprise that this antipathy found expression in Pius XII, but to Carroll and many others it is surprising that the post-Holocaust Roman Catholic Church, which clearly deplores anti-Judaism and antisemitism, has taken steps to canonize the pontiff who reigned so ambiguously during the Holocaust years. Contrary to what Michael Novak might say, Carroll is not scapegoating when he draws his conclusion: "In the light even of the

most favorable reading of Pius XII's World War II history, the move to canonize him is, in the words of István Deák, 'a very strange undertaking indeed.' "[17]

From Rome to New Market and beyond

On March 12, 1939, ten days after his papal election and less than six months before Adolf Hitler unleashed the world war that provided cover for the Holocaust, Cardinal Eugenio Pacelli was crowned Pope Pius XII in Roman Catholic ceremonies that were unusual for their majesty, triumphalism, and worldwide publicity.[18] Nearly 20 years later, what had arguably been "the most absolutist papacy in modern history" came to its end when Pius XII died on October 9, 1958.[19] Described by *L'Osservatore Romano* as the "greatest in the long history of Rome," the pontiff's funeral was no less resplendent than his coronation.[20]

The reign of Pope Pius XII coincided with my boyhood, which I lived primarily in the American Midwest after being born in the late Summer of 1940. My mother's roots were Quaker. My father's German pietist upbringing led to his becoming a Presbyterian pastor. More than I understood at the time, my boyhood years were ones when strong Protestant ties, cultural and religious, still involved anti-Catholic feeling. John F. Kennedy had not yet been nominated for the American presidency, let alone elected. His political star was rising, but his Roman Catholic identity was an issue. Fully adequate explanations for the intense athletic rivalries between my public school teams and those from Catholic parochial schools could only be found by taking account of religious factors. It would understate the case to say that dating between Protestant and Catholic teenagers was scarcely encouraged. More than once, I remember my father's bristling over his sense that Roman Catholicism—including particularly its claims regarding papal infallibility—entailed an exclusivist perspective that would render his Christian ministry invalid if it could.

I can claim no vivid boyhood memories of Pius XII, save for an occasional glimpse of him in movie theater newsreels or through the coverage that I infrequently saw once television entered my home in the mid-1950s. As I recall, however, this pope seemed distant, stern, even a bit sinister to me. His regal trappings and ritualistic gestures were

definitely at odds with my markedly "low church" Protestant tradition, which had much more to do with the priesthood of all believers than with concerns about St. Peter and his Rome-anointed successors. As I think about this contrast now, I am reminded of a stormy night in the early 1950s when I accompanied my father to the very small Presbyterian church in a southern Indiana hamlet called New Market. At the time, my father served a larger congregation near Louisville, Kentucky, and also held an appointment in that city's Presbyterian seminary. His seminary work involved the supervision of student pastors who staffed what was known as the Todd-Dickey Parish, a loosely affiliated group of 13 churches in the southern Indiana hills. New Market was among them. My father's work meant that he had to preside when the sacrament of the Lord's Supper was celebrated, because the student ministers were not yet ordained to do so. I frequently accompanied him on his rounds, which included stops in obscure places with biblical names such as Hebron and Bethlehem. To reach New Market, one had to ford an unbridged creek, and on the Sunday night I have in mind, the thunder and lightning storm made those waters higher than usual. We made it to the very modest church. Less than a dozen people had braved the weather, but no less than James Carroll they were there to receive "the Eucharistic bread that keeps me alive." That night, in a decidedly "low church" celebration of Christian communion that was still so solemn and impressive that I have never forgotten it, the communion bread, after my father had blessed it, was distributed to the congregation on a simple, paper-napkin-covered tray by a faithful farmer whose knee-high boots were not entirely free of the mud that persistently stuck to them. That night, the Rome of Pope Pius XII and the New Market of that Presbyterian farmer were Christian places about as far apart from each other as they could be, but for me they are inextricably linked.

Christianity was a vital factor in my boyhood—it still is in my adulthood—but my early and limited attention to things Roman Catholic was characterized largely by indifference, ignorance, and some suspicion if not prejudice. As for my direct knowledge about World War II and the Holocaust, nothing very remarkable could be said. I vaguely remember the August 1945 announcements about the dropping of atomic bombs on Hiroshima and Nagasaki. I am aware that German prisoners of war could be seen from time to time in areas near the Michigan town where I was born. My kindergarten class saved tinfoil and bought bonds for the war effort. My mother had rationing books for shoes and sugar. Beyond those

memory fragments, no direct recollections of World War II are part of my life. None of those fragments includes the Holocaust, although after the war ended, my father's churches did have programs that were aimed at helping those who were in the so-called displaced persons' camps of Europe. I cannot be sure, but perhaps there were Jews among the haggard images that reached me through the grainy film strips and movies that I saw.

History changed my awareness. In particular, my eventual involvement in the study of the Holocaust grew as I became aware of Christianity's complicity in that catastrophe and as I found my own identity affected by Franklin Littell's trenchant judgment that the Holocaust left the Christian tradition so drenched in guilt as to face an unprecedented and ongoing credibility crisis.[21] As a result, my autobiographical comments must continue for several sentences more before some further analysis follows.

The first point I want to make is that I have found no evidence to suggest that research about the Holocaust ever makes that event less dark and deadly than we thought it was. Yes, there are more stories of rescue, for example, than scholars or laypersons were aware of when my Holocaust studies began in earnest in the early 1970s. Yet even those findings underscore how overwhelming the number of bystanders was in comparison. The Holocaust never gets better. The more one learns about it, the worse it becomes.

In my view, none of the recent books about the Vatican and the Holocaust does anything to reverse that judgment.[22] Although I hope and believe that I put behind me the somewhat anti-Catholic bias of my boyhood, I confess that the more I learn about Pope Pius XII, the less I like him. *Like* is not a dispassionate scholarly term, but I want to speak plainly, and the fact of the matter is that I do not like Pope Pius XII. The reason for my dislike is not subtle. To be blunt, I believe that Pope Pius XII did more than any other single practicing Christian of his generation to create the credibility crisis that plagues post-Holocaust Christianity.

That judgment is as provocative as it is harsh. Both of those qualities, moreover, emerge from a destructive irony: namely, Pope Pius XII's determination to make his vision of Christianity prevail led to an undermining of Christian credibility because it played into the hands of forces that were fanatically dedicated to the annihilation of Jewish life. Simply put, when the most influential Christian in the world failed to speak out decisively and directly about the Holocaust, the price that

would be paid was, at least in part, the Christian credibility crisis that will not go away any time soon, if at all.

The crisis may include elements of a blessing in disguise, for it has energized considerable change in the Christian world as far as Christian attitudes toward Jews are concerned. When, for example, Pope John Paul II visited Israel in March 2000, his humble silence at Yad Vashem and at the Western Wall of the Second Temple, Judaism's most sacred place, spoke volumes that can be heard, at least faintly, as expressing regret for, if not an indictment of, the policies and postures of his World War II papal predecessor. There is nothing, however, that Pope John Paul II can do to remove the conclusion that Christian regret and repentance are too late and perhaps too little to mend completely Christianity's broken condition. After the Holocaust, Christian triumphalism is consigned to oblivion.

Certainly steps in right and necessary directions are being taken, and they are likely to result in better forms of Christianity than the world knew before and during the Holocaust. Nevertheless, the price paid for such change has been immense. Strictly speaking, no change in Christianity can justify that price. The best one can say, I believe, is that in spite of that unforgivable cost, the least that Christians can do is to learn how to avoid future versions of Pius XII's Holocaust-related example.

My candor, I realize, is not free of difficulties. Let me speak to two of them. First, I may be criticized for turning Pope Pius XII into a kind of scapegoat, villain, or monster, if not for demonizing him. In no way, however, am I making any of those moves. Where the Holocaust is concerned, Christian shortcomings and failures reach far and wide. By no means does Pope Pius XII alone bear responsibility for them. Pius XII, moreover, was neither a villain nor a monster; nor was he demonic. To the contrary, he was all too human, like the rest of us. He was fallible, like the rest of us. He can and did make mistakes, like the rest of us. Pope Pius XII was definitely more religious, more pious, than the overwhelming majority of human beings. He was decisively more interested than the vast majority to see that papal authority was centralized and made dominant in the world. In addition, his responsibilities, unlike those of the rest of us, were huge, difficult, and awesome because of the brutal times and the unique position that formed the world of his papacy. Just for that reason, Pius XII's potential to be praiseworthy or blameworthy was greater, too. From him to whom much is given, much

is expected. In his all-too-human ways, Pope Pius XII must receive only mixed reviews at best.

Second, I may be criticized for basing my evaluation of Pope Pius XII on hindsight, which, among other things, overlooks the fact that, as the pope's apologist Robert Graham puts it, "certainly Pius XII had a very limited sphere of action."[23] In one sense, there can be no historical or ethical appraisal without some degree of hindsight, for such appraisal involves analysis of the consequences of decisions and policies that become clear only after they are made. Furthermore, even granting Graham's judgment, Pius XII still had some latitude for protesting action. Too little that he said or did can be credibly construed as decisively protesting against Hitler's murderous anti-Jewish policies, let alone hastening the end, of Nazi Germany's "Final Solution." If one could make the case otherwise, the controversy that rightly swirls around his papal reputation would be—thanks to unavoidable hindsight—much different and much better.

Meanwhile, it is important, of course, not to make anachronistic appraisals, but there is nothing anachronistic in what is obvious: namely, that Pius XII always had a voice, that his knowledge of European affairs— including the Holocaust—was extensive, that he was implored repeatedly to speak out against the persecution and slaughter of European Jewry, and that his pronouncements along those lines were as rare and convoluted as his policies were neutral and his tone measured. Here I both follow and reject John Cornwell in saying that the pope's statements about the Jews were innocuous. I agree with Cornwell's judgment—it is found in the quotation that serves as the second of this chapter's two epigraphs—to the extent that Pius XII said very little, particularly in that problematic Christmas Eve homily that he broadcast to the world in 1942. The Nazis and their collaborators had murdered millions of Jews by that time. Both Pius XII and his apologists claimed that he said a great deal on behalf of the Jews on that occasion and others, but the pope's words scarcely support that defense. What Cornwell aptly calls the "fullest extent" of Pius XII's public protest consisted of denouncing what was happening to "the hundreds of thousands of people who, through no fault of their own and at times only because of their nationality or race, are destined to be killed or are allowed simply to waste away."[24]

Here is a case where Pius XII's "high ideals" do indeed, to use Pierre Blet's words from the first epigraph above, "make difficult the task of understanding his policy and personality," for Pius XII's language was

abstract and, arguably, little more than evasive. It made no explicit mention of Jews in particular and the pope's "data" also minimized the extent of the destruction that was then well under way. Innocuous in one way, Pius XII's Holocaust-related reactions unfortunately were anything but innocuous in another. They said too little, and by saying so little they gave comfort to the Holocaust's perpetrators, whether Pope Pius XII intended that comfort or not.

At least three popes in one

To amplify the argument I am making, it can be maintained that history gives us not one Pope Pius XII but three. What I mean is that there are at least three broad perspectives that can be taken on Pius XII if one tries to develop an appraisal of his Holocaust-related policies and pronouncements. Ranging from ultra-apologetic to more grimly dark than most people have cared to contemplate, the three-popes-in-one each warrant comment.

First, there is the Pope Pius who did the very best he could, if not virtually everything right. This Pope Pius XII is the candidate for canonization. Pierre Blet's description fits him. According to Blet, this pope "did everything possible to avoid war."[25] He exercised "not neutrality ... but rather impartiality, which judges things according to truth and justice." His choice of "silent action" was taken deliberately, for to act otherwise "would have furnished ammunition to Nazi propaganda" and worsened "the fate of the victims." Furthermore, Pius XII's "reserve was completely contrary to any indifference regarding the victims." Even his disagreement with the Allies' insistence on unconditional German surrender was based on the conviction that such insistence would only "prolong the destruction and the killing." Peace was "the focal point of everything he said and did," and never did Pius XII relax "his efforts to alleviate the sufferings brought about by the war." Few could understand, let alone endorse, the pope's "high ideals," but that fact only makes Pius XII's moral tenacity and perseverance stand out in bolder relief.

The chief problem with Blet's version of Pius XII is that it has to make a strong case out of a weak position. Blet acknowledges that the pope was reserved, largely silent, and impartial. Then he has to show that such ingredients add up to the taking of high moral ground even, or

especially, when the consuming fire of the Holocaust was raging. That high moral ground has to make credible the claim that more harm than good would have been done if Pius XII had acted more boldly, overtly, and aggressively than he did. Even at the time, this argument was less than thoroughly convincing. After Auschwitz, it can scarcely be more so. There are also various testimonials that were bestowed on Pius XII at the time of his death by various Jewish and non-Jewish leaders—Golda Meir, Harold Macmillan, and Dwight Eisenhower among them. Those accolades should be taken for what they are worth. Suffice it to say that they were probably given with less than perfect knowledge and with protocol's civility dictating that, upon the death of one so prominently spiritual as Pope Pius XII was deemed to be, one says good things or nothing at all. These tributes are real but insufficient to redeem him fully. Unintentional though it surely must be, the effect of pleading such as Blet's on the pope's posthumous behalf does little to relieve Christianity's credibility crisis.

Cornwell's view is markedly different from Blet's. Far from being "a saintly exemplar for future generations," Cornwell concludes, Pius XII was "a deeply flawed human being from whom Catholics, and our relations with other religions can best profit by expressing our sincere regret."[26] Cornwell's picture of Pius XII presents us with a man who believed that his papally based version of Christianity was the Truth. Accenting papal primacy and the conviction that the Roman Church had prerogatives unmatched by any nation, government, or alternative religious creed, Pius XII—by disposition and personality as well as by ideology—refused to dirty his pristine hands by taking sides, except when his vision of Christian supremacy enabled or required him to do so. Pius XII, Cornwell believes, was "not inclined to make a distinction between the moral claims of the belligerents."[27] The pope might speak in generalities about "the fate of civil populations defenseless against the aggressions of war," but such words from Pius XII contained "not a word" about the Jews or Nazi Germany.[28] Cornwell is loath to accept that Pius XII's words could be heard in more specific ways, which is a key point at issue between him and the pope's defenders. The preponderance of the evidence, however, clearly gives Cornwell's hand the greater strength at this point. How Pius XII could have thought, as he apparently did, that his words were clear and crisp in their meaning seems to be a comment more about his self-deception than about the accuracy of his self-estimation.

A third view of Pius XII, admittedly one in the form of a

hypothesis, has been gradually advanced over the past several years by Richard L. Rubenstein. In significant ways, his view draws heavily from Cornwell's but actually ends up—albeit in an inverted, if not subverted, way—closer to Blet's. As I understand Rubenstein, he thinks that many critical commentators on Pius XII have been asking the wrong questions. They wonder why a Christian leader with the pope's immense authority did not speak out more clearly, more often, more decisively, more ethically. Like Cornwell, they conclude that the pope's failure to do so renders him flawed at best and probably "a hypocrite" as well.[29]

As I understand Rubenstein, he downplays flaws and hypocrisies in favor of Pius XII's clarity of role responsibility. The pope's role required putting the hegemony of Christianity—Roman Catholic Christianity—first. In Pius XII's mind, that commitment entailed papal primacy and the belief that anything threatening it could be—in fact, in some cases must be—jettisoned. He carried no special brief for Soviet Communism, German Nazism, or the capitalist/materialist democracies of the Western Allies. It was the Church's divine prerogative—carried out through papal authority—to be on top. In the cosmic scheme of things, nothing else really mattered. In the waxing and waning of historical power, however, there were times and places where important work could be accomplished. Some of that work involved eliminating the threat posed by Jews, who had long been linked with anti-Christian Communism in the pope's mind. Hitler's Germany could be useful in that work. The Third Reich's own anti-Christian corruption would bring it down in due time. Meanwhile, the Nazis' "Final Solution" could also provide a cleansing action. That action would require no dirty work by the Vatican, which was functionally impossible anyway, but the elimination of the Jews would nonetheless advance the cause of Roman Catholic hegemony for which Pope Pius XII so devoutly hoped and worked within the limits that he faced.

Rubenstein's Pius XII is less flawed than focused on his role responsibility. Less the hypocrite and more the papal Machiavellian, he knew what he was after and was not reluctant to play the cunning hand that might bring the success he wanted. If Pius XII does not fit Blet's image of a papal leader who never compromised his efforts to relieve the defenseless plight of the suffering, Rubenstein's Pius XII definitely had the "high ideals" of his role responsibility, which explains why he often spoke in such convoluted and innocuous ways. In the long run, Pius XII would never have been "Hitler's pope," for the Führer had to be his mortal

enemy. Even in the short run, it is too much to say that Pius XII fits Cornwell's invidious description. More to Rubenstein's point is the possibility that the pope gambled on Hitler's doing valuable work before his pagan, anti-Christian regime met the fate it so richly deserved. Without lifting a hand, except to bestow blessings on the faithful, Pope Pius XII could have European Christendom *judenrein*. One more obstacle to the hegemony of Roman Catholic Christianity would be gone. In due course, godless Communism would also be crushed. Perhaps even the Western Allies would see the light beyond their materialistic capitalism as well. But it was enough for one thing to happen at a time.

If this is at least a version of Rubenstein's hypothesis, and I think I have its basic outline in focus, then the vision is nothing less than chilling. In his papal way, Pius XII would be not much less totalitarian than Hitler or Stalin. In basic ways, Rubenstein may imply, the Nazi and Communist dictators would not have understood Pope Pius XII at all. Nonetheless, they may have been his "cousins." Pius XII, moreover, may have understood them much better than they knew.

Like all of Pius XII's interpreters, Rubenstein will continue to have difficulty with the empirical evidence. In Rubenstein's case, as I have argued before, the evidence is mostly circumstantial at best.[30] Time will tell if it is more than that. Meanwhile, Rubenstein has made an important contribution by making us consider whether the questions we have been asking about Pius XII are the most penetrating. If we stop asking how to defend him, or how to account for his flaws, and focus instead on a tough-minded interrogation of his papal role responsibilities, perhaps we will learn still more about this man who probably, in Blet's words, "will always make difficult the task of understanding his policy and personality."[31]

Be all of this as it may, my American Protestant perspective leaves me with little to like about Pope Pius XII. At the time of his reign, after all, no Christian leader was more prominent, visible, or influential than he. Protestants, no less than Catholics, must acknowledge this fact, and that recognition continues to be applicable for the papacy today. Then and now, all Christians, as well as Jews, needed Pius XII to be a better leader, a better Christian, than he was. Unfortunately, given the position that he held, none of the several-popes-in-one that interpretations of this man give us changes my mind that he retains the singular distinction of having done the most of any individual practicing Christian of his generation to bring on the credibility crisis that the Holocaust

created for Christianity. Such a claim, I am well aware, does not leave Pius XII without plenty of Christian accomplices—hordes of Protestants, American and non-American, among them.[32] How we Protestants will respond to the Christian legacy that is ours, including Pius XII's and his papal successors' parts in it, must remain a story "to be continued."

NOTES

1. The author of many important books in philosophy, religion, and politics, Novak serves on the editorial board of *First Things* and holds the George Frederick Jewett Chair in Religion and Public Policy at the American Enterprise Institute, Washington, D.C.
2. See Michael Novak, "Pius XII as scapegoat," *First Things*, August/ September 2000, 20–2. Owing to the brevity of Novak's essay, I have not provided a separate note for each quotation from it. The interested reader should have no trouble verifying the quoted material.
3. For five studies that amplify points similar to Novak's—and often in no less problematic ways—see Pierre Blet, *Pius XII and the Second World War: According to the Archives of the Vatican*, trans. Lawrence J. Johnson (New York: Paulist Press, 1999); Margherita Marchione, *Pope Pius XII: Architect for Peace* (New York: Paulist Press, 2000); Ronald Rychlak, *Hitler, the War and the Pope* (Columbus, Miss.: Genesis Press, Inc., 2000); Ralph M. McInerny, *The Defamation of Pius XII* (South Bend, Ind.: St. Augustine's Press, 2001); and David G. Dalin, "Pius XII and the Jews," *Weekly Standard*, 6, No. 3, February 26, 2001, 31–9. Some of Blet's views are discussed below. For more on Dalin's article, which is notable partly because he is a vigorous Jewish defender of Pius XII, see the editors' introduction to this book.
4. Michael Phayer, *The Catholic Church and the Holocaust, 1930–1965* (Bloomington: Indiana University Press, 2000), 224.
5. *Ibid.*, xv, 222.
6. *Ibid.*, 218–20.
7. *Ibid.*, xii.
8. *Ibid.*, xviii, 224.
9. See the unnumbered page of epigraphs at the outset of Susan Zuccotti, *Under His Very Windows: The Vatican and the Holocaust in Italy* (New Haven, Conn.: Yale University Press, 2000).
10. Novak, "Pius XII as scapegoat," 21 (Novak's italics), and Zuccotti, *Under His Very Windows*, 1.
11. Zuccotti, *Under His Very Windows*, 315.

12. *Ibid.*, 316.

13. *Ibid.*, 318–19.

14. See James Carroll, *Constantine's Sword: The Church and the Jews, A History* (Boston: Houghton Mifflin, 2001), 615 and 510. For significant responses to Carroll's book, see Daniel Terris and Sylvia Fuks Fried, eds., *Catholics, Jews, and the Prism of Conscience: Responses to James Carroll's* Constantine's Sword: The Church and the Jews, A History (Waltham, Mass.: Brandeis University, 2001).

15. Carroll, *Constantine's Sword*, 12.

16. *Ibid.*, 510.

17. *Ibid.*, 530. The quotation from Deák comes from his article "The Pope, the Nazis, and the Jews," *New York Review of Books*, 47, No. 5, March 23, 2000, 49.

18. According to John Cornwell, Pacelli's papal coronation was the first to be broadcast by radio. It was also filmed from start to finish. Pacelli, says Cornwell, "had decreed that no expense should be spared." See *Hitler's Pope: The Secret History of Pius XII* (New York: Viking, 1999), 211.

19. The quoted phrase is Cornwell's. See *Hitler's Pope*, 358.

20. See *ibid.*, 357.

21. Littell advanced this view especially in *The Crucifixion of the Jews* (New York: Harper and Row, 1975).

22. In addition to Cornwell's controversial *Hitler's Pope* and other works already mentioned in this chapter, I also have books such as the following in mind: Robert A. Graham, *The Vatican and Communism during World War II: What Really Happened?* (San Francisco: Ignatius Press, 1996); Moshe Y. Herczl, *Christianity and the Holocaust of Hungarian Jewry*, trans. Joel Lerner (New York: New York University Press, 1993); and Carol Rittner, Stephen D. Smith, and Irena Steinfeldt, eds., *The Holocaust and the Christian World: Reflections on the Past, Challenges for the Future* (New York: Continuum, 2000).

23. Graham, *The Vatican and Communism during World War II*, 183.

24. I quote from Blet, *Pius XII and the Second World War*, 284. Cornwell's citing of the same passage employs a translation with somewhat different emphases. It refers to "those hundreds of thousands who, without any fault of their own, sometimes only by reason of their nationality or race, are marked down for death or gradual extinction." See *Hitler's Pope*, 292.

25. The quotations in this paragraph are taken from Blet, *Pius XII and the Second World War*, 281–9.

26. Cornwell, *Hitler's Pope*, 384.

27. *Ibid.*, 290.

28. *Ibid.* The first quoted phrase contains Pius XII's words. The second contains Cornwell's.

29. *Ibid.,* 297.
30. See John K. Roth, "The Holocaust as a Holy War: an exploration of Richard Rubenstein's recent thought," in Michael Hayse, Didier Pollefeyt, G. Jan Colijn, and Marcia Sachs Littell, eds., *Hearing the Voices: Teaching the Holocaust to Future Generations* (Merion Station, Pa.: Merion Westfield Press International, 1999).
31. Blet, *Pius XII and the Second World War,* 289.
32. A useful study in this regard is provided by Gerald L. Sittser, *A Cautious Patriotism: The American Churches and the Second World War* (Chapel Hill: University of North Carolina Press, 1997).

Albert Friedlander

Interfaith Anguish

On November 9, 1999—since I was in hiding in Berlin on that date in 1938, it is a day that always fills me with emotion—I was invited to the House of Lords in London to represent the Jewish community and to hear a "Confession" from leading representatives of the Church of England. It is short enough to be quoted in its entirety.

> We come humbly before Almighty God this day to remember nearly 2,000 years of anti-Semitism perpetrated by the Christian Church. We acknowledge that from the first century of the Common Era through to this day, the common preaching of the Church has often claimed that God has finished with His covenant people, the Jews, despite the clear evidence of scripture to the contrary, thus perpetuating a misunderstanding of the scriptures. We confess that the Jewish people have often been accused of deicide and have been the object of blood libel, by those acting in the name of the Messiah. We recognize that many persecutions, including the Holocaust, which we remember especially on this day, had their origins within the Christian Church.
>
> We therefore plead with Almighty God that He might have mercy upon us for the many sins of the Church and her children. We repent of our wrongdoing towards the Jewish people, and pledge ourselves to work tirelessly against anti-Semitism in all its forms, and especially within the Church.
>
> In praying for God's forgiveness for the Church and her members, we seek His blessing upon His covenant people, the Jews, both in Israel and in the Diaspora.

As an Associate President of the Council of Christians and Jews (CCJ) of Great Britain, I often go to Lambeth Palace to discuss issues of the Holocaust with Archbishop of Canterbury George Carey, Chief Rabbi Jonathan Sacks, and leading Protestants and Catholics. The sad, sudden death of Cardinal Basil Hume has deprived us of his guidance and wisdom in this as in so many areas. In his preface to *The Six Days of Destruction:*

Meditations Towards Hope, the liturgy and stories written by Elie Wiesel and me, Cardinal Hume had written:

> Part of the process of reconciliation has to be the healing of memories in shared grief and the patient effort to accept the other's history and to identify with it. ... In our day that process has begun between Christian and Jew. Together we have to explore the mystery of evil and suffering and what it means to be God's chosen. ... We must retrace the paths of division and hostility along which others once trod. Then Christian and Jew wandered far from each other, and forgot how to recognize family features in each other. For the future, those who acknowledge Abraham as their father in faith must witness together to God's love and His purpose for mankind.[1]

I thought of Basil Hume's words when *The Tablet,* a Catholic periodical in London, asked me to address the issue of Pius XII and the Jews. That issue has divided our faith communities all over the world. The American community for some time expressed its concern that the apostolic nuncio, Archbishop Amleto Giovanni Cicognani, failed to give vital wartime information to the United States government concerning the treatment of the Jews in Europe. In our day, even papal actions clearly designed to address the pain of the Jews were deemed an attack on the identity of the Jew—the case of Edith Stein's canonization, for example. Thus, in an effort to achieve a re-creation of dialogue, I felt I had to accept the invitation to write on the topic. As it happened, my effort was helpful; but there were also bitter attacks. These generally came from within a dedicated laity who often presented a highly personal approach not related to official doctrine. In terms of the representatives of religion, the arguments were couched in moderate language. We are fortunate to live in a world where interfaith dialogue is no longer the activity of merely pointing out what we have in common with our neighbor's religion—we can also enunciate our differences. Martin Buber's principle of the "I and Thou" encounter has been enlarged by the Emmanuel Lévinas's instruction that this must be a face-to-face confrontation. When I go to the *Katholikentag* in Germany, or when I meet Christian colleagues in international conferences, we trust each other sufficiently to engage in strong arguments.

During conferences I recently attended in Prague, Vienna, and Trier, many of us were perplexed at our differences on the topics of the sanctification of Edith Stein and the proposed beatification of Pope Pius

XII. A number of priests and Catholic scholars did share my concern in these matters, including the criticisms I expressed. Others worried greatly. Should a rabbi enter the internal discussions of the Catholic Church, particularly in regard to Church doctrine? Should not the Catholic Church engage in its soul-searching without interference from the outside? Furthermore, I was clearly not an objective judge in some of these areas, for my family and I had suffered in the Holocaust. I carried a great deal of emotional baggage into this situation of conscience. Could I really act as the *kategor*, the biblical accuser who is normally played by Satan (see the Book of Job)? Each individual—or Church—must probe his or her conscience to make good decisions.

A wonderful poem by Dandie Able deals with the surgeon Lambert Schneider in the hospital theater. He is probing the brain of a patient who should be unconscious, but whose voice is suddenly heard: *Leave my soul alone, you sod!* In a more elegant, philosophic mode, Hegel referred to our conscience as *this deepest, inner loneliness within itself.* On that level, the Church and the individual Catholic must turn inwardly, without advice from the outside. Nevertheless, the Church lives in *this* world; its thoughts and actions of yesterday and of today affect its neighbors. And yesterday was the time of the Holocaust.

Have all of us really confronted that world in terms of the inheritance it has left us? My Christian colleagues start with the assertion that we are all sinners. I have my doubts: if we all sin—nobody sins! I know a rabbi cannot tell Christians what to believe; but should he not criticize actions by neighbors that hurt his own community? Memories should not be flawed. I do recall Jews who collaborated with the Nazis because they were powerless victims, placed alongside those who became involved with the Nazis without being forced to do so. I find myself making judgments but know that we must look at individual cases and not issue blanket condemnations. We must examine the history. The Catholic Church *was* under pressure from the Nazis, and at times took the easy road, which was seldom the right road. Must we not look at these realities? The Church *could* hide from its conscience inside doctrines that became rationalizations. At times, its theology was wrong; and this pains me. Religion must be prepared to suffer; it cannot always be diplomatic. And, today, even acts of contrition and Holocaust remembrance that are diplomatic can be wrong enough for a rabbi to express his disappointment in a faith and its leaders whom he respects highly.

In a sermon given in the St. Vitus Cathedral in Prague, I

acknowledged Pope John Paul II's desire to place the Holocaust into the prayers and memories of the Church through Edith Stein. Yet, as Stein herself said, she went into death "to join her people," and the nuns around her were spared. She remains a Jewish figure. My friendly priests wonder why I object to her becoming a figure of saintly veneration. Perhaps they are right, but I know we Jews are uncomfortable about it. Priests who enter the gas chambers may well acquire sainthood in the Church. Somehow, Edith Stein was different.

It becomes clear to me that we cannot just examine the Holocaust as historians. We must place our anguish into our liturgy so that our faith can confront it. These steps also have their dangers. Elie Wiesel and I wrote *The Six Days of Destruction* as a prayer book that can be used by Christians and Jews on Holocaust Memorial Day. Another passage in this book—this time from the preface contributed by Bishop Richard Harries—is significant in this context. Bishop Harries wrote:

> We tend to be very selective in our memories and this is particularly true of religious traditions. We like to define ourselves by our good memories, by the lives of the Saints and the heroic examples of faith that tradition puts before us. But there are also the tragic memories. ... It is important for Christians to remember, liturgically if possible, the Holocaust.[2]

Was Edith Stein a Catholic saint, a good memory of someone ready to be a martyr? And what about Pope Pius XII, an important Catholic leader? This *is* an internal matter—or is it? Bishop Harries's words—"we like to define ourselves by our good memories, by the lives of the Saints"—have a direct impact here. It is clear that the Vatican's role during the Holocaust is the issue here, and thus the proposed beatification addresses and affects the Jewish community. Even within the Catholic community, are there not doubts about the appropriateness of eventual sainthood for Pius XII? How could it permit a direct antisemitic attack by the vice-postulator Fr. Kurt-Peter Gumpel in Rome in defense of the beatification procedure for Pope Pius XII? Gumpel takes the Jewish awareness of the pope's "timidity" to be a direct attack upon the Vatican and demands that one should examine again the Jewish attacks upon Christianity through the centuries.[3] Is this a good way for the Church to defend itself? Do his wildly inaccurate claims for Pius XII as a defender and savior of the Jews during the Holocaust advance a sound beatification process?

It is easy enough to dismiss Gumpel as an old-fashioned bigot

whose claim to be "a friend of the Jews" only shows his obtuseness when looking at his neighbors. The Jewish community sees Gumpel as the bigot he is—but what is happening within the Church? Again, the voices from outside should lead to an inner examination. Has the Church taken any action of censure against Gumpel? And does the pain expressed by the Jewish community have any impact upon the deliberations leading to sainthood for Pius XII? A rabbi cannot put himself into the position of being the Church's "devil's advocate"; that procedure within the Church's process must express its own doubts within its own system. Yet it would be disastrous for all of us, Jews and Christians, if this debate were to result in a closing of ranks and of the mind in Rome. The fact remains that the dark history of the Holocaust is part of any assessment of individuals during that testing period.

Who is a saint in the time of evil? The rabbis take the Genesis text: *"And Noah was a righteous man in his time"* and examine it closely. Does "in his time" suggest that the standards were much lower in Noah's day, so that anyone who was not totally evil could be called righteous? Or does the passage mean that in such an evil time anyone fighting against evil had to be *particularly* good? The end decision was in Noah's favor, even though his actions after leaving the ark cause much concern. In the time of the Nazis, we find a similar situation: does silence or indirect action constitute the moral resistance required when one does not put one's life at risk? Many individuals had to choose as they faced versions of that dilemma. As I indicated, there were moral failures among the victims as well. But I am concerned with the apathetic onlookers. Standing on the outside, I would and should not act as judge. But I must ask the Church to reassess its conscience. Does not "sainthood" indicate a superhuman effort? And: if the Church wants to be a teaching testimony to everyone, should it not take extra care in making decisions about beatification and canonization, even if those decisions reveal the wartime papacy to have been less than perfect? After the loneliness of the inner search, we have to confront one another face to face; and we have to share the common pain alongside the moments of light which reach out from our past.

The past recedes from us at a breakneck pace, and some of the events and issues become blurred and uncertain—historians are selective in the details they preserve for us. The cases discussed above illustrate this point. Thus, Edith Stein, one of the great philosophers of the twentieth century, converted to the Catholic faith with the deep belief and conviction that this was now her spiritual home; and she was right.

Living in a convent, she found spiritual salvation there, and her work on Augustine, for example, was as important to the religious thought of our time as her philosophic writings. The Nazis swooped down upon that convent in a reprisal action for the resistance they felt from the Catholic community in the Netherlands. Yet the fact remains that they only removed two Jewish women from that convent: Edith Stein and her sister—because they were Jews, not because Edith was a nun. The Jewish community has always felt the loss of those members of its family who were murdered because of their Jewish roots, and Edith Stein and her sister are numbered among the six million Jews slain by the Nazis. Pope John Paul II's action of sanctifying her was an attempt to reach out towards the Jewish community, but in Jewish eyes it was likened to the Christian attempts to become the true inheritors of the Hebrew Bible (the "Old" Testament).

The attempt to declare Pius XII a saint is, of course, a different issue. Here, as indicated, we Jews are outsiders who want to understand why the historical situation is not considered fully. I noted the positive aspects of Pius's actions, which did reach out to some members of the Jewish community. Yet the accommodation with the Nazi regime was one of the facts of that time. It can be argued that there were many who had noble motives in trying to work with that system in order to achieve positive results. Nevertheless, the Vatican, representing a faith which could not and should not condone the acts of genocide which marked the German government of that time, had a special role to play. Even as the past recedes, it is clear to most of us that grave mistakes of judgment took place within the Vatican. Our question endures: will not the act of sanctifying Pope Pius XII obscure the events of that time? Once the question is asked, the answer remains with the Church, not with us Jews.

Pius IX, a nineteenth-century pope, was beatified—a necessary step toward sainthood—in 2000. Again, as an outsider, I can only wonder why this happened. I am sure the answer lies within the Vatican's political realities. To us, as Jews, Pius IX remains a contradictory figure. Early on, he acted with some kindness toward the Jewish community but later turned against them. Until beatification was bestowed upon Pius IX, the "Mortara Case" was a largely forgotten moment in history.[4] The Catholic nurse of a small Jewish boy, Edgardo Mortara, claimed she had baptized him. Church officials subsequently entered the family home, kidnapped the boy, and had him brought up as a Catholic who was favored by Pius IX. Eventually Mortara became a priest. Meanwhile, the anguished

protests of his family and the larger, international Jewish community were dismissed. Again, it makes *us* doubt the saintliness of that pope. However, within the Vatican, Pius IX represents the authoritarian face of the papacy that ensured the fullest power of the pope. There are observers who believe that Pius IX was beatified quickly as part of an answer to the controversy concerning Pius XII—the latter's case seems to have been postponed for a more propitious time. We can still discuss these matters as caring friends who have entered the post-Holocaust age of dialogue between Christians and Jews.

In that spirit, I feel emboldened to offer a postscript comment about another event in the year 2000. The world does not stand still, and each day may bring confrontations between faiths in which current situations accentuate the different approaches of our religions. They do not only deal with the shared past, but also with anguishing problems that exist presently in the general community. Thus, I was deeply touched on August 27, 2000, when Pope John Paul II issued an invitation to the unhappy parents of the "Siamese twins" to come to Rome where their children might die with dignity. With one of the children able to survive momentarily only by sharing the other child's heart and lungs, they would both soon die unless the surgeons separated their bodies, killing one child and giving the other some chance for a normal existence. The parents wanted "to leave the decision to God," while a British court ruled that the operation should take place. My religious faith would reach out to the parents to comfort them and to suggest that God's will can manifest itself through legal justice and compassionate doctors who would save a child. Catholic doctrine and indeed many adherents of varying faiths, including Judaism, would insist that this killing of an unformed, damaged living entity cannot be permitted, even if a life is thus saved. Reason and faith both tell me that one child should be given the chance to live.

The issue was resolved in favor of surgical procedures to give one of the children a chance for life. In our faith communities, my Catholic friends and I have prayed for the twins' parents and for those two children as well. Although the fact remains that we will continue to be in disagreement about basic issues raised by this case, and probably by others mentioned in this chapter, it is good that we live in a world where our disagreements can be shared.

NOTES

1. Elie Wiesel and Albert Friedlander, *The Six Days of Destruction: Meditations Towards Hope* (Oxford: Pergamon, 1988), viii.
2. *Ibid.*, ix.
3. For further information on these topics, see "The tragedy of Pius XII," and "Pius XII as he really was," in *The Tablet*, January 2, 1999, and February 13, 1999, respectively.
4. For a worthwhile account of the Mortara case, see David I. Kertzer, *The Kidnapping of Edgardo Mortara* (New York: Alfred A. Knopf, 1997).

Carol Rittner

What Kind of Witness?

Should the question of Pius XII's "silence" be this important?
James Carroll, *Constantine's Sword:*
The Church and the Jews, A History

To be honest, I hardly ever think about the Roman Catholic Church's cult of saints, probably because, rightly or wrongly, I believe canonization is a highly problematic process, one that is both political and costly. Another reason I do not think about saints per se is because I believe there are people whose lives, in some extraordinary fashion, proclaim the mystery of goodness—indeed, proclaim the mystery of God—but because they are not part of my faith tradition, or perhaps not even part of *any* faith tradition, they are not considered candidates for canonization. I am thinking, for example, of people like Albert Schweitzer, Abraham Joshua Heschel, Etty Hillesum, Dietrich Bonhoeffer, Albert Camus, and Martin Luther King, Jr., among others. And if I am really honest, I have to admit that I rarely think about saints because nobody ever asks my opinion about who should or should not be canonized. If they did, however, Pope Pius XII would not be high on my list. Neither would *Pio Nono*—Pius IX—the pope who had a 6-year-old Jewish boy (Edgardo Mortara) kidnapped, brought to Rome, and raised as a Christian.[1] The former is under consideration for sainthood; the latter is on his way. From time to time, however, Rome does get my attention when it comes to saints. This was true in March 2000 when Pope John Paul II beatified 11 Polish nuns, members of the Congregation of the Holy Family of Nazareth, a few weeks before his historic visit to Israel. What was it that caught my attention?

In July 1943, these 11 nuns were living in Nowogrodek, a small town on the eastern border of Poland, when soldiers of the Nazi Third Reich arrived and arrested 150 men. The Germans fully intended to execute these men as a warning to others who might be tempted to

engage in armed resistance against the occupier. Michael J. Farrell recounts their story as follows:

> The nuns, known since then as Sister Stella and Her Ten Companions, told the local pastor that they were willing to be sacrificed to save the lives of the men. In a letter to a nearby convent, Sr. Stella said she prayed: "My God, if sacrifice of life is needed, let them kill us rather than those who have families."
>
> The death sentences of the Nowogrodek prisoners were soon revoked, and they went free. On July 31, Sister Stella and Her Ten Companions departed early from evening prayer to answer their summons to report to the German commissar. They were taken to a wooden grove before dawn and shot and buried in a common grave. ... All that is known of the nuns' final moments is the testimony of a Nowogrodek woman who was forced to have a German officer as a boarder in her home. On the morning of the execution he arrived at the house drunk, repeating over and over, "How they went! How those sisters went to their deaths."[2]

Usually, when I think, write, or teach about World War II and the Holocaust, my focus is on the genocide of the Jews, but as Elie Wiesel has often said, "Not all victims of the Nazis were Jews," even though we know that all Jews were victims. What does that mean but that I *also* have to pay attention to non-Jewish victims of the Nazis in my thinking, writing, and teaching. That is why Sister Stella and her Ten Companions caught my attention.

Of course, it is highly unlikely that any of the 150 men arrested in Nowogrodek in July 1943 were Jewish—by 1943, most Jews in Poland were already dead, murdered by death squads or starved in ghettos, worked to death in concentration camps or gassed in places like Auschwitz and Treblinka. Those still living in the ghettos and camps were all but dead. If there were Jews in Poland who had managed to get beyond the clutches of the Germans, they were in hiding with righteous gentiles, or they were in the forests fighting with partisans against the Germans. Whether or not Jews lived in Nowogrodek prior to July 1943, I cannot say, but if they did and the nuns turned their backs on them because they considered them outside their universe of moral concern, I would certainly have to rethink this essay. The truth is, I do not know if Jews were living in Nowogrodek before World War II and the Holocaust, but if they did, I can only hope the nuns tried to help them. What I *do know* is what Sister Stella and her Ten Companions *did do* on that July day in 1943: They "[laid] down [their] lives for [their] friends" (John 15 : 13),

and in doing so, "they present humanity with a question: What kind of life does one lead to be able to pray, 'My God, if sacrifice of life is needed, let them kill us rather than those who have families'?"[3]

Karl Rahner, S.J., one of the preeminent Roman Catholic theologians of the twentieth century, has written that saints "are the imitators and the creative models of the holiness which happens to be right for, and is the task of, their particular age. They create a new style; they prove that a certain form of life and activity is a really genuine possibility; they show experientially that one can be a Christian even in 'this' way; they make such a type of person believable as a Christian type."[4] Robert Ellsberg, who has written extensively about this topic, comments further: "The saints are those who, in some partial way, embody—literally incarnate—the challenge of faith in their time and place. In doing so, they open a path that others might follow."[5] Against such criteria, given what I know about them and that July day in 1943, I think Sister Stella and her Ten Companions more than qualify to be included in the Church's calendar of saints.

A few weeks after reading about the Polish nuns of Nowogrodek in the *National Catholic Reporter*, I read another article in the same paper by Raymond Lucker, the Roman Catholic Bishop of New Ulm, Minnesota, a man I admire because of his positions on many issues of justice, which sometimes have put him at odds with his brother bishops. His article, "A Strong Leader, a Holy Man" made me think again about Sister Stella and her Ten Companions. Why? Because Lucker's article was about Pope Pius XII and the controversy surrounding his behavior during World War II and the Holocaust,[6] a controversy that surfaced with a vengeance in 1964 when Rolf Hochhuth's play, *The Deputy*,[7] hit the American stage. It was reignited in 1999 when John Cornwell's book, *Hitler's Pope: The Secret History of Pius XII*,[8] appeared. Lucker, I suspect, wrote his short essay in response to Cornwell's very critical—some would say extremely "biased"—comments about Pius XII, a pope Lucker admires, and has admired since he was a youngster in sixth grade and heard the announcement come over the radio in his Catholic school classroom, "We have a pope!" The date was March 2, 1939, a few weeks after the death of Pius XI (Achille Ratti), the pope who in 1937 issued the encyclical letter, *Mit brennender Sorge* (*With Burning Concern*), and six months before the outbreak of World War II in Europe. In one of the shortest conclaves on record, Cardinal Eugenio Pacelli, Vatican Secretary of State, was elected to succeed Pius XI as head of the Roman Catholic

Church. Pacelli took the name Pope Pius XII, in honor of his predecessor. He was pope from March 1939 until October 1958. These were Lucker's formative years as an adolescent, a seminarian, and as a young priest in the Roman Catholic Church. In 1957, a year before Pius XII's death, Father Raymond Lucker met and spoke briefly to the pontiff during a papal audience in Rome. A year later, Pius XII was dead, succeeded by Cardinal Angelo Roncalli, who took the name Pope John XXIII.

Pope Pius XII, writes Lucker, "lived in a time of world-wrenching struggle, bringing changes that would continue until the end of the century." His strong personal rule and scholarship "helped to prepare the church for the Second Vatican Council." In Lucker's view, Pius XII was no ordinary pontiff. He "had a reputation for holiness," and he was "a great pope … a great figure and because of his greatness he also made some mistakes."[9] Reading Lucker's article, however, it is clear to him that those "mistakes" had nothing to do with the pope's behavior during World War II and the Holocaust: "To go back to the present controversy, I believe that Pius XII did in fact speak out against the Nazi and fascist regimes … He did speak and act in defense of the Jews and in support of human rights, against racism and the anti-Semitic policies of the Nazi government. Through him hundreds of thousands of Jews were protected in the Vatican and in the convents and monasteries of Rome and elsewhere, saving them from deportation and death."[10] After the war, writes Lucker, Jewish leaders thanked the pope for all he had done to help the Jewish people during the war (a not insignificant fact, I would add, that has to be taken into consideration by Pius's critics). Nevertheless, having stated his perceptions about Pius XII and having drawn attention to the widespread praise Pope Pius XII received after World War II, Lucker does raise two important questions: "Could [Pius XII] have done more? Could he have been more explicit in his defense of the Jewish people and in his condemnation of the Holocaust?"[11]

To both questions, Pope Pius XII's critics answer Yes! He *could have*, and *should have*, done more, in particular by speaking more clearly in defense of the Jews and in condemnation of Adolf Hitler and the Nazis. Pius XII's defenders, on the other hand, answer No! to both questions. Not only did Pius XII do more than any other world leader (Churchill, Roosevelt, and Stalin), they say, but he did all that was *humanly* possible, given his position and the circumstances at the time. Margherita Marchione, for example, one of Pope Pius XII's staunchest defenders, writes, "It is well known that, in obedience to the Pope's direct urging, hundreds of convents, monasteries,

and other religious buildings were opened to shelter and to hide thousands of men, women, and children from Nazi cruelties, not only in Italy, but also in Poland, France, Belgium, and Hungary."[12]

While this may be true, the controversy is not about whether Pius XII secretly instructed convents and monasteries in Rome and elsewhere to open their doors to Jews and war refugees, as Marchione claims. The controversy is about whether Pope Pius XII, Vicar of Christ on earth, should have, indeed, given his position as supreme head of the Roman Catholic Church, *had an obligation* to condemn—publicly, clearly, and unequivocally—Adolf Hitler, the Nazis, and their genocidal campaign to murder the Jews of Europe.

That the Holy See had information about what was happening to the Jews of Europe during the Holocaust is not in dispute. The Vatican probably had such information as early as 1941.[13] The Holy See, after all, had a vast network of bishops, archbishops, nuncios, and apostolic delegates all over German-occupied and unoccupied Europe. They constantly funneled information to the Vatican. Even with all the difficulties and disruptions caused by the war, documents, reports, and information flowed into the Vatican from all over Europe. *Information* was available in abundance to the Vatican, and to much of the rest of the world as well. *Information*, however, is one thing, while *awareness* is another, as Michael Marrus points out in his chapter for this volume.[14] The former requires collecting documents and reports, recording statistics—any bureaucrat can do that. The latter requires empathy, insight, and analysis—and morally sensitive human beings who understand that their universe of obligation is not limited to their "own kind." In this regard, the Vatican was not much different from other governments or groups of officials, which is to say that its excellence in information gathering was not matched by awareness of the kind I have identified.

Those who defend Pope Pius XII's behavior during World War II and the Holocaust argue he was doing all that was *humanly* possible, given the complexity and chaos of the times. The pope was working through diplomatic channels, writing private letters to various bishops and nuncios throughout Europe, "repeatedly [condemning] invasions, killings, treatment of prisoners (including Jewish), but always in terms of Christian and humanitarian principles, never specifically attacking leaders and nations."[15] To have attempted to do anything more was impossible because of what the Nazis could do in retaliation. To have "named names," say Pius's defenders, would have resulted in greater suffering for

the Jews. This, of course, is as difficult to prove as is its opposite: that for the pope to have been more vocal or clearer in his condemnations would have halted the Holocaust.

According to Sister Pasqualina Lehnert, Pacelli's close associate from his days as papal nuncio to Bavaria, Pius wrote a fiery denunciation of the Nazis in the Summer of 1942, including a condemnation of the genocide of the Jews. But, when he heard about the brutal Nazi retaliation against the Dutch bishops on July 26, 1942, after the bishops of Holland openly condemned the German deportations of Dutch workers and Jews, Pius XII had second thoughts and burned the statement.[16] As a result of the Dutch experience, Pope Pius XII determined that for the rest of the war he would maintain strict neutrality in terms of condemning one side or the other when it came to war atrocities, the category within which he apparently placed the extermination of the Jews of Europe. "To condemn Pius XII for his faith, his pacifism, his 'church language,' his neutrality and for deciding not to incite a half-mad dictator," writes Marchione, "is to ignore Pius XII's virtues and courage and to overlook the historical circumstances in which he acted."[17]

Others, of course, see it quite differently. For example, Albert Camus: in 1948, he was asked to respond to a question put to him by a group of Roman Catholic priests and brothers. They asked him, "What do unbelievers expect of Christians?" He had this to say:

> For a long time during those frightful years I have waited for a great voice to speak up in Rome. I, an unbeliever? Precisely. For I knew that the spirit would be lost if it did not utter a cry of condemnation when faced with force. It seems that the voice did speak up. But I assure you that millions of men like me did not hear it ... It has been explained to me since that the condemnation was indeed voiced. But that it was in the style of the encyclicals, which is not at all clear. The condemnation was voiced and it was not understood! Who could fail to feel where the true condemnation lies in this case and to see that this example by itself gives part of the reply, perhaps the whole reply, that you ask of me? What the world expects of Christians is that Christians should speak out loud and clear, and that they should voice their condemnation in such a way that never a doubt, never the slightest doubt, could rise in the heart of the simplest man.[18]

What else do Pius XII's critics have to say? That Pope Pius XII— Eugenio Pacelli—was a Roman Catholic of his time, formed and disabled by traditional theological anti-Judaism that fed the "underside" of

Christian theology for centuries. That one should not underestimate the impact of Christian anti-Judaism upon him and his views of Jews and Judaism. That he also was tainted by the racist attitudes of his day, a racism that was exhibited in Christian circles by widespread social contempt for Jews and Judaism. In an interview with Ed Bradley on CBS News's "60 Minutes," John Cornwell, one of the pope's most vociferous critics, said, "Defenders of Pius XII say he had a great love of the Jewish people and that all he did during the war was tactical, for their best interests. I knew this was simply not true, that he did harbor a sense of revulsion towards the Jews."[19] Then there are those who argue that the reason Pius was "silent" was that he feared Communism more than he feared Fascism, that he viewed Hitler and Nazism, despite its excesses, as the "lesser of two evils," and that he thought only Nazi Germany was powerful enough to save Europe from godless Communism. As a result, the pope and the Vatican opted to turn a blind eye to the horrors inflicted by the Nazis and their collaborators on Jews, and non-Jews, especially in Poland. Still others say that Pope Pius XII may have been *spiritually* committed to his Lord and Savior Jesus Christ, but he was *practically* committed to the institutional Church, for which he felt an enormous responsibility. Some even suggest that Pius XII was more concerned about saving the buildings and treasures of the Catholic Church than stopping the murder of the Jews of Europe. Other critics, like Paul Baumann, for example, think Pius XII's "unwillingness to protest explicitly the murder of the Jews was, in large part, the result of a misplaced faith in diplomacy and his religious parochialism."[20]

We shall not settle the controversy over Pius XII's behavior during World War II and the Holocaust until scholars are given free access to all the Vatican archival material from this period. Even then, as suggested by the preliminary report issued by the International Jewish–Catholic Historical Commission in October 2000, all the questions will not be laid to rest.[21] Historians will continue to argue about these issues for a long time to come. As for myself, I side with Michael Phayer, another contributor to this book, who thinks Pope Pius XII's greatest failure, both during and after the Holocaust, was not that Pius XII feared Communism more than Nazism, not that he was tainted by anti-Judaism, antisemitism, or anything else, and not that he wanted to save the treasures of the Vatican. His greatest failure was that he attempted to use a diplomatic remedy for a moral outrage.[22] This point brings me back to Sister Stella and her Ten Companions.

What interests me is the contrast between the behavior of those nuns in July 1943 and the behavior of Pope Pius XII during the years 1939–45. No one has to ask if those women could have done more for the 150 men arrested and condemned to death by the Germans. No one needs to do so because it is so obvious that not only did they do all they could have humanly done, but they also did more, even to the point of "laying down [their] lives" (John 15: 13). On the other hand, even as loyal a defender of Pope Pius XII as Bishop Raymond Lucker asks if the pope "could ... have done more? Could he have been more explicit in his defense of the Jewish people and in his condemnation of the Holocaust?"

I admit to a certain distaste for those who would make moral evaluations of other people. Who knows another's inner struggles? Another's motivations? I cannot see "inside" the nuns to know if they were truly so selfless that they would have done what they did for Jews, too. I cannot see "inside" the pope to know what he thought and what he was attempting to accomplish. And thus far the Vatican will not let scholars into its archives to see "inside" the historical record, so all we are left with is Bishop Lucker's observation that Pius XII "had to make the best decisions he could in very troubling circumstances."[23]

Still, as I look at these two examples—the nuns and the pope— which I have held in a sort of wry juxtaposition, the witness of Sister Stella and her Ten Companions seems so extraordinary and challenging, and the witness of Pope Pius XII seems so ambiguous and weak, I am left wondering why Pius XII is even being proposed for canonization. Of course, I know the argument: Sister Stella and her Ten Companions had only themselves to worry about in 1943, while Pius had the whole Church to worry about in 1943, and after. I also have thought about the argument that Pius XII—Eugenio Pacelli—was, by necessity, a bureaucrat and that, had he been a "simple" priest, he might have done more, and done it more dramatically, like the nuns, but under the circumstances he had to keep in mind the welfare, indeed the lives, of millions of Roman Catholic Christians throughout Europe. Nevertheless, as a friend of mine said, "history places us in a crucible fit just for us, and it is within that context that we must live out our commitments."[24]

Was Pope Pius XII concerned that more lives would be lost? Did he feel personally responsible for the deaths of Catholics that might result from his statements? We shall probably never know for sure. What I do know is that it seems hideous to me to think that his life, even the life of "the Church as such,"[25] was, or is, more valuable than the life of *any*

human being. It pains me to say it, but I think this is the message that is being communicated by those in the Roman Catholic Church who want to have Pope Pius XII beatified. Institutions, however, no matter how sacred, are not more sacred than human beings.

Pope Pius XII should have, and I believe *could have*, done more, been more explicit in his defense of the Jewish people and in his condemnation of the Holocaust. Doing so might have cost him his life. But then, "What kind of life does one lead to be able to pray, 'My God, if sacrifice of life is needed, let them kill us rather than those who have families'?"

NOTES

1. Garry Wills, *Papal Sin: Structures of Deceit* (New York: Doubleday, 2000), 40. "How did a Pope in the nineteenth century get into the kidnapping business? It happened because a young Christian woman in the papal state of Bologna told friends that she had secretly baptized a sick child, Edgardo Mortara, in the Jewish home where she was a servant. The child was only a year old at the time. The Inquisition in Bologna investigated the matter— very possibly at the instigation of Pius IX himself. ... Bologna was still part of the Pope's temporal domain, so the police were his officials. ... Edgardo [was] sent to Rome, where the Pope received him fondly and said he would be brought up a Christian. ... The Pope maintained that he was defending spiritual values against a secular world indifferent to matters of faith—a Christian boy could not be trusted to be brought up by Jewish parents" (40–1).
2. Michael J. Farrell, "When it comes to saints, how do you spot the right stuff?," *National Catholic Reporter*, February 25, 2000, 2.
3. *Ibid.*
4. Quoted in Robert Ellsberg, "Taking saints seriously for the needs of our time," *Sojourners*, September–October 1997, 34.
5. *Ibid.*
6. Raymond A. Lucker, "A strong leader, a holy man," *National Catholic Reporter*, March 31, 2000, 21.
7. Rolf Hochhuth, *The Deputy* (Baltimore, Md.: Johns Hopkins University Press, 1997).
8. John Cornwell, *Hitler's Pope: The Secret History of Pius XII* (New York: Viking, 1999).
9. Lucker, "A strong leader, a holy man," 21.

10. *Ibid.*

11. *Ibid.*

12. Margherita Marchione, *Pope Pius XII: Architect for Peace* (New York: Paulist Press, 2000), 69.

13. In conjunction with this point and others I am examining, I will not mention all the books that have recently appeared in English, but I do want to draw attention to two important volumes: Michael Phayer, *The Catholic Church and the Holocaust, 1930–1965* (Bloomington: Indiana University Press, 2000), and Susan Zuccotti, *Under His Very Windows: The Vatican and the Holocaust in Italy* (New Haven: Yale University Press, 2000).

14. See further Michael Marrus's chapter (Ch. 1) in this volume, "Pius XII and the Holocaust: ten essential themes."

15. Marchione, *Pius XII: Architect for Peace*, 22.

16. *Ibid.*, 23.

17. *Ibid.*, 24.

18. Albert Camus, "The Unbeliever and the Christian," in *Resistance, Rebellion, and Death*, trans. Justin O'Brien (New York: The Modern Library, 1963), 53.

19. John Cornwell, "Pope Pius XII: Hitler's Pope?," interview by Ed Bradley ("60 Minutes," March 19, 2000).

20. Paul Baumann, "Pius XII and the Holocaust: sorting out a tragic legacy," *Commonweal*, December 1, 2000, 9.

21. See further, International Catholic–Jewish Commission, "Preliminary report: the Vatican and the Holocaust," *Origins*, November 9, 2000, 341, 343–51.

22. Phayer, *The Catholic Church and the Holocaust, 1930–1965*, xii.

23. Lucker, "A strong leader, a holy man," 21.

24. I am grateful to Revd. William Ax, O.ss.T., Pastor of St. Lawrence Church, Olney, Md., for these insights.

25. This is the controversial phrase used in "We remember" that seems to suggest that some entity, "the Church as such," exists pure and undefiled in some abstract heavenly realm, an idea that contradicts Vatican II's understanding of the Church as "the people of God."

Carol Rittner and John K. Roth

Postscript: What We Must Remember

> *[The Holocaust] cannot be fully measured by the ordinary criteria of historical research alone. It calls for a "moral and religious memory" and, particularly among Christians, a very serious reflection on what gave rise to it.*
> "We Remember: A Reflection on the *Shoah*"

In March 1998, the Holy See's Commission for Religious Relations with the Jews released "We Remember: A Reflection on the *Shoah*," a document that was widely expected to be the Church's long-awaited statement about the Vatican's posture during the Holocaust. Especially in Jewish circles, it received a lukewarm reception.

Two points made the document particularly vulnerable: first, it unconvincingly separated Nazi antisemitism from Christian anti-Judaism. Differences exist between the two, but "We Remember" stressed them too much while emphasizing their connections too little. Second, "We Remember" acknowledged that Christian conduct during the Holocaust "was not that which might have been expected from Christ's followers" and went on to say that "for Christians, this heavy burden of conscience of their brothers and sisters during the Second World War must be a call to penitence."[1]

Many Jews and Christians felt that such language misplaced responsibility for Christian failure, for "We Remember" had little, if anything, to say—implicitly or explicitly—about the shortcomings of Roman Catholic leadership during the Holocaust. It created the dubious impression that the rank and file, more than its Catholic leaders, were responsible for Christian failings. The Commission for Religious Relations did not improve its credibility by emphasizing that Pope Pius XII, whose highly controversial reign—starting in 1939—covered the crucial Holocaust years, had been thanked by Jewish communities and leaders

during and after the war for all that he and his representatives had done "to save hundreds of thousands of Jewish lives."[2]

As this book and others show, Pius XII—sometimes unfairly but often justifiably—has been a lightning rod in Holocaust-related storms. He has been sharply and persistently criticized for failing to do what he could and should have done to intervene on behalf of Jews during the Holocaust. As "We Remember" indicates, his reputation has also been defended—so much so, in fact, that he may be canonized as a saint during the twenty-first century. No matter how that prospect unfolds, Pope Pius XII's place in world history and in the history of Christianity in particular is not likely to achieve closure or finality. Arguably, that outcome is appropriate, for the life and times of this Christian leader leave questions in their wake that will long continue to merit reflection and inquiry.

With that point in mind, it is worth recalling that one part of "We Remember" features the subheading "What We Must Remember." It is from this section that the epigraph at this postscript's outset is taken. That part of "We Remember" calls for "a moral and religious memory." It is hoped that this book contributes to memory of that kind, and thus a word from each of its contributors can help to sum up some of what ought to be remembered when Pope Pius XII and the Holocaust are under consideration.

1. From Michael R. Marrus: "When it comes to the Holocaust ... practically no one 'did enough'—and interpretations that focus on what did *not* happen, as well as being driven by hindsight, often duck the historians' challenge to comprehend what actually *did* happen."

2. From John T. Pawlikowski: "Pius XII does not deserve the label of 'silent' because most who hear that term interpret it to mean that he did nothing for Jews and other victims. There may be more of an authentic argument for the term in the restricted sense of his not going public with criticism of the Nazis with reference to the Jews. But the unqualified use of the term 'silent' obscures the results of recent scholarship regarding some of the positive efforts Pius XII did undertake, almost exclusively through diplomatic channels."

3. From Eugene J. Fisher: "The Vatican and its leadership were carefully attuned to cope with one set of historical circumstances that had affected the Holy See over the course

of several centuries. Then, a world at war created a miasma, which, with unprecedented rapidity, turned into a maelstrom of issues for which nothing in their collective training could possibly have prepared them."

4. From Sergio I. Minerbi: "By limiting themselves to the exchange of diplomatic notes instead of making serious efforts to save the Jews, the Church's highest authorities in fact abandoned the Jews to their fate."

5. From Doris L. Bergen: "Neither mourning nor 'working through' the Shoah is possible without informed confrontation with the past, and meaningful Christian–Jewish dialogue can only be based on honesty. Perhaps most important, we can accept the impossibility and undesirability of closure."

6. From Eva Fleischner: "Clearly, Pius was a sensitive man, not impervious to the sufferings of the war's victims, whether within or outside the Church. Nevertheless, the means with which he chose to fight the evil were inadequate. What was needed was a strong, prophetic voice."

7. From Gershon Greenberg: "Pius XII viewed Jews and Judaism through the partition of the crucifixion, which cast Hebrew Scripture, institutions, and rituals into oblivion. They did not appear to him as living entities, let alone as the particular target that they were for the Nazis. Nor did they belong to the world of suffering, except to the possible extent that they were potentially part of the Church."

8. From John F. Morley: "It is pitiable, and, indeed, painful, to realize that these and other Jewish officials believed that the pope would intervene on behalf of the Jews of Hungary, and that, when he did, the results would be effective."

9. From Richard L. Rubenstein: "There was nothing in the antisemitic policies of the Nazis concerning the Jews *before* World War II to which the Church would or could object as long as baptized Jews were excluded from the Nazi-mandated disabilities. In effect, the Nazis were implementing a long cherished Vatican goal, the disenfranchisement of non-believing Jews in Christian Europe and their ultimate return to the ghetto. Violence and extermination were another matter. Or were they? ... There is an enormous difference

between the way the Roman Catholic Church has dealt with religious pluralism before and after Vatican II and most especially in its relations with Judaism."

10. From Susan Zuccotti: "The purpose here has been to examine common assertions about a benevolent, active, and even heroic Pope Pius XII. The conclusion is that there is currently no evidence to indicate that the Holy Father ever directed his flock to save Jews. Those who did engage in rescue may have believed that they were acting according to his will, but he never told them so in any but the most general terms. Had he done so, surely many more Catholic laypersons would have helped their Jewish neighbors, and many more lives would have been saved."

11. From Michael Phayer: "We may certainly disagree with his decisions and find them unworthy of the papal office, but we have no cause to assert that the pope acted callously toward Europe's Jews. Both during the war and post-war eras, Pius XII severely limited his activities on behalf of Jews, but he harbored no malice toward them."

12. From James J. Doyle: "The Catholic–Jewish dialogue must continue on both the scholarly and grass-roots levels. The tragedy of the Holocaust demands our most honest and thorough scrutiny so as to know why the Holocaust happened and so as to prevent a Holocaust or anything like it from ever happening again."

13. From John K. Roth: "At the time of his reign ... no Christian leader was more prominent, visible, or influential than [Pope Pius XII]. Protestants, no less than Catholics, must acknowledge this fact, and that recognition continues to be applicable to the papacy today. Then and now, all Christians, as well as Jews, needed Pius XII to be a better leader, a better Christian, than he was."

14. From Albert Friedlander: "Does not 'sainthood' indicate a superhuman effort? And: if the Church wants to be a teaching testimony to everyone, should it not take extra care in making decisions about beatification and canonization, even if those decisions reveal the wartime papacy to have been less than perfect? After the loneliness of the inner search, we have to confront one another face to face; and we have to share the

common pain alongside the moments of light which reach out from our past."

15. From Carol Rittner: "The controversy is about whether Pope Pius XII, Vicar of Christ on earth, should have, indeed, given his position as supreme head of the Roman Catholic Church, *had an obligation* to condemn—publicly, clearly, and unequivocally—Adolf Hitler, the Nazis, and their genocidal campaign to murder the Jews of Europe. ... What interests me is the contrast between the behavior of those nuns in July 1943 and the behavior of Pope Pius XII during the years 1939–45. No one has to ask if those women could have done more for the 150 men arrested and condemned to death by the Germans. No one needs to do so because it is so obvious that not only did they do all they could have humanly done, but they also did more, even to the point of 'laying down [their] lives' (John 15 : 13)."

These words and the chapters from which they come are not part of a single, seamless interpretation that closes the accounts on Pope Pius XII and the Holocaust. On the contrary, they are invitations to further research, inquiry, and dialogue as the unavoidable debates about Pius XII persist. It is our belief, however, that insights such as those selected to sum up this book ought to remain in the "moral and religious memory" that the world badly needs after the Holocaust. To the extent that this book contributes to memory of that kind, the hopes that the contributors have invested in it will be fulfilled.

NOTES

1. Quotations from "We remember" are taken from the version of the document reprinted in Carol Rittner, Stephen D. Smith, and Irena Steinfeldt, eds., *The Holocaust and the Christian World* (New York: Continuum, 2000), 257–62. See especially 260 and, for the epigraph above, 258. The opening paragraphs of this postscript draw on material written by John K. Roth for *The Holocaust Chronicle* (Lincolnwood, Ill: Publications International, Ltd., 2000), 683–4.

2. "We remember," 260.

Select Bibliography

Listed below are some of the major books, primarily in English, that are especially important for the issues discussed by the contributors to this work.

Aarons, Mark, and John Loftus. *Unholy Trinity: How the Vatican's Nazi Networks Betrayed Western Intelligence to the Soviets.* New York: St. Martin's Press, 1992, 1998.

Alexander, Edgar. *Hitler and the Pope: Pius XII and the Jews.* New York: Thomas Nelson, 1964.

Alvarez, David, and Robert A. Graham. *Nothing Sacred: Nazi Espionage against the Vatican, 1939–1945.* London: Frank Cass, 1997.

Barnett, Victoria J. *Bystanders: Conscience and Complicity during the Holocaust.* Westport, Conn.: Greenwood Press, 1999.

Barnett, Victoria J. *For the Soul of a People: Protestant Protest against Hitler.* New York: Oxford University Press, 1992.

Bauer, Yehuda, *et al.*, eds. *Remembering for the Future. Jews and Christians during and after the Holocaust.* Oxford: Pergamon Press, 1988.

Bentley, Eric, ed. *The Storm over the Deputy.* New York: Grove Press, 1964.

Berenbaum, Michael, ed. *A Mosaic of Victims: Non-Jews Persecuted and Murdered by the Nazis.* New York: New York University Press, 1990.

Berenbaum, Michael, and Abraham J. Peck, eds. *The Holocaust and History: The Known, the Unknown, the Disputed, and the Reexamined.* Bloomington: Indiana University Press, 1998.

Bergen, Doris L. *Twisted Cross: The German Christian Movement in the Third Reich.* Chapel Hill: University of North Carolina Press, 1996.

Blet, Pierre, S.J. *Pius XII and the Second World War: According to the Archives of the Vatican.* Translated by Lawrence J. Johnson. New York: Paulist Press, 1999.

Blet, Pierre, Robert A. Graham, Angelo Martini, and Burkhart Schneider, eds. *Actes et documents du Saint Siège relatifs à la Seconde Guerre mondiale,* 11 vols. Vatican City: Libreria Editrice Vaticana, 1965–81.

Braham, Randolph A., ed. *The Vatican and the Holocaust: The Catholic Church and the Jews during the Nazi Era.* New York: Columbia University Press, 2000.

Browning, Christopher R. *The Final Solution and the German Foreign Office.* New York: Holmes and Meier, 1978.

Burleigh, Michael. *Death and Deliverance: "Euthanasia" in Germany c. 1900–1945.* New York: Cambridge University Press, 1997.

Burleigh, Michael. *The Third Reich: A New History.* New York: Hill and Wang, 2000.

Burleigh, Michael, and Wolfgang Wippermann. *The Racial State: Germany 1933–1945.* New York: Cambridge University Press, 1991.

Caracciolo, Nicola. *Uncertain Refuge: Italy and the Jews during the Holocaust.* Urbana, Ill.: University of Illinois Press, 1995.

Cargas, Harry James, ed. *Holocaust Scholars Write to the Vatican.* Westport, Conn.: Greenwood Press, 1998.

Carlen, Claudia, I.H.M., ed. *The Papal Encyclicals,* Vol. IV: *1939–58.* Raleigh, N.C.: McGrath, 1981.

Carpi, Daniel. *Between Mussolini and Hitler.* Hanover, N.H.: Brandeis University Press, 1994.

Carroll, James. *Constantine's Sword: The Church and the Jews, A History.* Boston: Houghton Mifflin, 2001.

Carroll-Abbing, John Patrick. *But for the Grace of God.* New York: Delacorte Press, 1965.

Chadwick, Owen. *Britain and the Vatican during the Second World War.* Cambridge: Cambridge University Press, 1986.

Chinigo, Michael, ed. *The Pope Speaks: The Teachings of Pope Pius XII.* New York: Pantheon, 1957.

Cianfarra, Camille Maximilian. *The Vatican and the War.* New York: E. P. Dutton & Co., 1944.

Conway, John S. *The Nazi Persecution of the Churches.* New York: Basic Books, 1968.

Conway, Martin. *Catholic Politics in Europe 1918–1945.* New York: Routlege, 1997.

Coppa, Frank J., ed. *Controversial Concordats: The Vatican's Relations with Napoleon, Mussolini, and Hitler.* Washington, D.C.: Catholic University of America Press, 1999.

Coppa, Frank J. *Encyclopedia of the Vatican and Papacy.* Westport, Conn.: Greenwood Press, 1999.

Cornwell, John. *Hitler's Pope: The Secret History of Pius XII.* New York: Viking Press, 1999.

Darragh, James A. *The Pope and Fascism.* Glasgow: John S. Burns & Sons, 1944.

Delzell, Charles F., ed. *The Papacy and Totalitarianism between Two World Wars*. New York: Wiley, 1974.

Dietrich, Donald J. *Catholic Citizens in the Third Reich: Psycho-Social Principles and Moral Reasoning*. New Brunswick, N.J.: Transaction Books, 1988.

Dietrich, Donald J. *God and Humanity in Auschwitz*. New Brunswick, N.J.: Transaction Books, 1995.

Duffy, Eamon. *Saints and Sinners*. New Haven: Yale University Press, 1997.

Ericksen, Robert P., and Susannah Heschel, eds. *Betrayal: German Churches and the Holocaust*. Minneapolis: Fortress Press, 1999.

Falconi, Carlo. *The Silence of Pius XII*. Boston: Little, Brown and Co., 1970.

Fein, Helen. *Accounting for Genocide: National Responses and Jewish Victimization during the Holocaust*. Chicago: University of Chicago Press, 1979.

Fisher, Desmond. *Pope Pius XII and the Jews*. New York: Paulist Press, 1963.

Fleischner, Eva, ed. *Auschwitz: Beginning of a New Era? Reflections on the Holocaust*. New York: KTAV, 1977.

Fogarty, Gerald. *The Vatican and the American Hierarchy from 1870 to 1965*. Collegeville, Minn.: Liturgical Press, 1985.

Friedlander, Henry. *The Origins of Nazi Genocide: From Euthanasia to the Final Solution*. Chapel Hill: University of North Carolina Press, 1995.

Friedländer, Saul. *Nazi Germany and the Jews*, 2 vols. New York: HarperCollins, 1997, 2001.

Friedländer, Saul. *Pius XII and the Third Reich: A Documentation*. New York: Alfred A. Knopf, 1966.

Gilbert, Martin. *Auschwitz and the Allies*. New York: Holt and Company, 1981.

Gilbert, Martin. *The Holocaust: A History of the Jews of Europe during the Second World War*. New York: Holt, Rinehart & Winston, 1986.

Gonella, Guido. *The Papacy and World Peace: A Study of the Christmas Messages of Pope Pius XII*. London: Hollis and Carter, Ltd., 1945.

Graham, Robert A. *Pius XII's Defense of the Jews and Others: 1944–45*. Milwaukee: Catholic League for Religious and Civil Rights, 1987.

Graham, Robert A. *The Pope and Poland in World War Two*. London: Veritas, 1968.

Graham, Robert A. *Pope Pius XII and the Jews of Hungary in 1944*. United States Catholic Historical Society (undated).

Graham, Robert A. *The Vatican and Communism in World War II: What Really Happened?* San Francisco: Ignatius Press, 1996.

Graham, Robert A. *Vatican Diplomacy*. Princeton: Princeton University Press, 1959.

Gushee, David P. *The Righteous Gentiles of the Holocaust*. Minneapolis: Fortress Press, 1994.

Gwynn, Denis. *The Pope and the War*. London: Catholic Truth Society, 1941.

Halecki, Oskar, and James F. Murray, Jr. *Pius XII: Eugenio Pacelli, Pope of Peace*. New York: Farrar, Straus and Young, Inc., 1951.

Hatch, Alden, and Seamus Walshe. *Crown of Glory: The Life of Pope Pius XII*. New York: Hawthorne Books, Inc., 1957.

Helmreich, Ernst C. *The German Churches under Hitler: Background, Struggle, and Epilogue*. Detroit: Wayne State University Press, 1979.

Herczl, Moshe. *Christianity and the Holocaust of Hungarian Jewry*. Translated by Joel Lerner. New York: New York University Press, 1993.

Herzer, Ivo, ed. *The Italian Refuge: Rescue of Jews during the Holocaust*. Washington, D.C.: Catholic University of America Press, 1989.

Hilberg, Raul. *Perpetrators Victims Bystanders: The Jewish Catastrophe 1933–45*. New York: HarperCollins, 1992.

Hlond, H. E. Cardinal. *Persecution of the Catholic Church in German-Occupied Poland: Reports by H. E. Cardinal Hlond, Primate of Poland, to Pope Pius XII, Vatican Broadcasts and Other Reliable Evidence*. New York: Longmans Green & Co., 1941.

Hochhuth, Rolf. *The Deputy*. New York: Grove Press, 1964.

Hochhuth, Rolf. *The Vatican and the Jews*. New Brunswick, N.J.: Transaction Books, 1983.

Holmes, Derek J. *The Papacy in the Modern World*. New York: Crossroad Publishing Co., 1981.

Hughes, H. Stuart. *Prisoners of Hope: The Silver Age of the Italian Jews 1924–1974*. Cambridge, Mass.: Harvard University Press, 1983.

Katz, Robert. *Black Sabbath: A Journey through a Crime against Humanity*. Toronto: Macmillan, 1969.

Katz, Robert. *Death in Rome*. Cambridge, Mass.: Harvard University Press, 1967.

Kent, Peter C., and John F. Pollard, eds. *Papal Diplomacy in the Modern Age*. Westport, Conn.: Praeger, 1994.

Kertzer, David I. *The Kidnapping of Edgardo Mortara*. New York: Alfred A. Knopf, 1997.

Kertzer, David I. *The Popes against the Jews: The Vatican's Role in the Rise of Modern Antisemitism*. New York: Alfred A. Knopf, 2001.

Kulka, Otto Dov, and Paul R. Mendes-Flohr, eds. *Judaism and Christianity under the Impact of National Socialism*. Jerusalem: Historical Society of Israel and the Zalman Shazar Center for Jewish History, 1987.

Lapide, Pinchas E. *Three Popes and the Jews*. New York: Hawthorn, 1967.

Lapomarda, Vincent A. *The Jesuits and the Third Reich*. New York: Edwin Mellen Press, 1989.

Lehmann, Leo Hubert. *Vatican Policy in the Second World War*. New York: Agora Publishing, 1946.

Levai, Jeno. *Hungarian Jewry and the Papacy: Pope Pius XII Did Not Remain Silent: Reports, Documents and Records from Church and State Archives*. London: Sands & Co. Ltd., 1967.

Lewy, Guenter. *The Catholic Church and Nazi Germany*. New York: McGraw-Hill, 1964.

Littell, Franklin H. *The Crucifixion of the Jews*. New York: Harper and Row, 1975.

Lubac, Henri de. *Christian Resistance to Anti-Semitism: Memories from 1940–1944*. San Francisco: Ignatius Press, 1990.

Lukas, Richard. *The Forgotten Holocaust: The Poles under Nazi Occupation 1939–1944*. Lexington, Ky.: University Press of Kentucky, 1986.

McInerny, Ralph M. *The Defamation of Pius XII*. South Bend, Ind.: St. Augustine's Press, 2001.

Manhattan, Avro. *The Vatican in World Politics*. New York: Gaer Associates, 1949.

Marchione, Margherita. *Pope Pius XII: Architect for Peace*. New York: Paulist Press, 2000.

Marchione, Margherita. *Yours Is a Precious Witness: Memoirs of Jews and Catholics in Wartime Italy*. New York: Paulist Press, 1997.

Marrus, Michael. *The Holocaust in History*. Hanover, N.H.: University Press of New England, 1987.

Marrus, Michael, and Robert O. Paxton. *Vichy France and the Jews*. New York: Basic Books, 1981.

Martin, Malachi. *Three Popes and the Cardinal*. New York: Farrar, Straus and Giroux, 1972.

Matheson, Peter, ed. *The Third Reich and the Christian Churches: A Documentary Account of Christian Resistance and Complicity during the Nazi Era*. Edinburgh: T. & T. Clark, 1981.

Michaelis, Meir. *Mussolini and the Jews: German–Italian Relations and the Jewish Question in Italy, 1922–1945*. Oxford: Clarendon Press, 1978.

Mickelm, Nathaniel. *National Socialism and the Roman Catholic Church*. London: Oxford University Press, 1939.

Minerbi, Sergio. *The Vatican and Zionism*. New York: Oxford University Press, 1990.

Modras, Ronald. *The Catholic Church and Antisemitism: Poland, 1933–1939*. Chur, Switzerland: Harwood Academic Publishers, 1994.

Morley, John F. *Vatican Diplomacy and the Jews during the Holocaust, 1939–1943*. New York: KTAV Publishing House, Inc., 1980.

Murphy, Paul I., and R. Rene Arlington. *La Popessa*. New York: Warner Books, 1983.

Murray, J. *Why Didn't the Pope—?* London: Catholic Truth Society, 1948.

Newman, Louis I. *A "Chief Rabbi" of Rome Becomes a Catholic—A Study in Fright and Spite*. New York: Renascence Press, 1945.

O'Carroll, Michael. *Pius XII, Greatness Dishonoured: A Documented Study*. Dublin: Laetare Press, 1980.

O'Mikle, Stephen, ed. *Pope Pius XII: His Voice and Life*. New York: Wilson, 1958.

Padellaro, Nazareno. *Portrait of Pius XII*. London: J. M. Dent & Sons, 1956.

Passelecq, Georges, and Bernard Suchecky. *The Hidden Encyclical of Pius XI*. Translated by Steven Rendall. New York: Harcourt Brace & Co., 1997.

Perry, Marvin, and Frederick M. Schweitzer, eds. *Jewish–Christian Encounters over the Centuries: Symbiosis, Prejudice, Holocaust, Dialogue*. New York: Peter Lang, 1994.

Phayer, Michael. *The Catholic Church and the Holocaust, 1930–1965*. Bloomington: Indiana University Press, 2000.

Pius XII, Pope [Eugenio Pacelli]. *An Appeal for Prayers for Peace (Communium Interpretes Dolororum)*, 1945.

Pius XII, Pope [Eugenio Pacelli]. *Darkness over the Earth (Summi Pontificatus)*, 1939.

Pius XII and the Holocaust: A Reader. Milwaukee: Catholic League Publications, 1988.

Purdy, William A. *The Church on the Move: The Characters and Policies of Pius XII and John XXIII*. London: Hollis & Carter, 1966.

Ramati, Alexander. *The Assisi Underground: Priests Who Rescued Jews*. New York: Stein and Day, 1978.

Reese, Thomas J. *Inside the Vatican: The Politics and Organization of the Catholic Church*. Cambridge: Harvard University Press, 1996.

Rhodes, Anthony. *The Vatican in the Age of the Dictators, 1922–1945*. New York: Holt, Rinehart & Winston, 1973.

Rittner, Carol, and John K. Roth, eds. *"Good News" after Auschwitz? Christian Faith within a Post-Holocaust World*. Macon. Ga.: Mercer University Press, 2001.

Rittner, Carol, Stephen D. Smith, and Irena Steinfeldt, eds. *The Holocaust and the Christian World: Reflections on the Past, Challenges for the Future*. New York: Continuum, 2000.

Roth, John K. *Holocaust Politics*. Louisville, Ky.: Westminster John Knox Press, 2001.

Roth, John K., and Elisabeth Maxwell, eds. *Remembering for the Future: The Holocaust in an Age of Genocide*, 3 vols. New York: Palgrave, 2001.

Roth, John K., et al. *The Holocaust Chronicle: A History in Words and Pictures*. Lincolnwood, Ill.: Publications International Ltd., 2000.

Rubenstein, Richard L., and John K. Roth. *Approaches to Auschwitz: The Holocaust and Its Legacy*. Atlanta: John Knox Press, 1987. [Revised second edition forthcoming in 2003.]

Rubinstein, William D. *The Myth of Rescue: Why the Democracies Could Not Have Saved More Jews from the Nazis*. New York: Routlege, 1997.

Rychlak, Ronald. *Hitler, the War and the Pope*. Columbus, Miss.: Genesis Press, Inc., 2000.

Sanchez, Jose M. *Pius XII and the Holocaust: Understanding the Controversy*. Washington, D.C.: Catholic University of America Press, 2002.

Schaefer, Catherine. *Pius XII and Peace: 1939–1944*. Washington, D.C.: National Catholic Welfare Conference, 1944.

Scholder, Klaus. *The Churches and the Third Reich*, 2 vols. Philadelphia: Fortress Press, 1988.

Schrader, Frederick Franklin. *Church and State in Germany: The Concordat of 1933 between the Holy See and the German State*. New York: Friends of Germany, 1933.

Scrivener, Jane [Jesse Lynch]. *Inside Rome with the Germans*. New York: Macmillan, 1945.

Sereny, Gitta. *Into That Darkness*. New York: Vintage, 1983.

Sittser, Gerald L. *A Cautious Patriotism: The American Churches and the Second World War*. Chapel Hill: University of North Carolina Press, 1997.

Smit, Jan Olav. *Angelic Shepherd: The Life of Pope Pius XII*. New York: Dodd, Mead, 1950.

Stehle, Hansjakob. *Eastern Politics of the Vatican, 1917–1979*. Translated by Sandra Smith. Athens, Ohio: Ohio University Press, 1981.

Stehlin, Stewart A. *Weimar and the Vatican 1919–1933: German–Vatican*

Diplomatic Relations in the Interwar Years. Princeton: Princeton University Press, 1983.

Stewart, Ralph. *Pope Pius XII and the Jews.* New Hope, Ky.: St. Joseph Canonical Foundation, 1999.

Tardini, Domenico Cardinal. *Memories of Pius XII.* Translated by Rosemary Goldie. Westminister, Md.: Newman Press, 1961.

Taylor, Myron C., ed. *Wartime Correspondence between President Roosevelt and Pope Pius XII.* New York: Da Capo Press, (1947) 1975.

Terris, Daniel, and Sylvia Fuks Fried, eds. *Catholics, Jews, and the Prism of Conscience: Responses to James Carroll's* Constantine's Sword: The Church and the Jews, A History. Waltham, Mass.: Brandeis University, 2001.

Van Hoek, Kees. *Pope Pius XII: Priest and Statesman.* New York: Philosophical Library, 1944.

Walker, Reginald F. *Pius of Peace, a Study of the Pacific Work of His Holiness Pope Pius XII in the World War 1939–1945.* Dublin: M. H. Gill and Son, Ltd., 1946.

"We remember: a reflection on the *Shoah*." The Holy See's Commission for Religious Relations with the Jews, 1998. See http://www.jcrelations.com/stmnts/vatican3-98.htm

Weisbord, Robert, and Wallace P. Sillanpoa. *The Chief Rabbi, the Pope, and the Holocaust: An Era in Vatican–Jewish Relations.* New Brunswick, N.J.: Transaction Publishers, 1992.

Wiesel, Elie, and Albert Friedlander. *The Six Days of Destruction: Meditations Towards Hope.* Oxford: Pergamon, 1988.

Weiss, John. *The Ideology of Death: Why the Holocaust Happened in Germany.* Chicago: Ivan R. Dee Company, 1997.

Wills, Garry. *Papal Sin: Structures of Deceit.* New York: Doubleday, 2000.

Wyman, David. *The Abandonment of the Jews: America and the Holocaust 1941–1945.* New York: Pantheon Books, 1984.

Yzermans, Vincent A. *The Major Addresses of Pope Pius XII.* St. Paul, Minn.: North Central, 1961.

Zahn, Gordon C. *German Catholics and Hitler's Wars: A Study in Social Control.* New York: Sheed and Ward, 1962.

Zolli, Eugenio. *Before the Dawn: Autobiographical Reflections.* New York: Sheed and Ward, 1954.

Zuccotti, Susan. *The Italians and the Holocaust: Persecution, Rescue, and Survival.* New York: Basic Books, 1987.

Zuccotti, Susan. *Under His Very Windows: The Vatican and the Holocaust in Italy.* New Haven, Conn.: Yale University Press, 2000.

Index